CUBA

CUBA

THE SIGHTS, SOUNDS, FLAVORS, AND FACES

IMAGES BY PIERRE HAUSHERR. TEXT BY FRANÇOIS MISSEN

BLACK DOG
& LEVENTHAL
PUBLISHERS
NEW YORK

CONTENTS

SHADES OF CUBAN COLOR 7

In his book *Concierto Barroco*, the Cuban writer Alejo Carpentier, who at one stage of his career was also his country's ambassador to France, tells the tale of an anonymous warrior who once fought against a Lutheran who wore a protective coat of mail of Norman manufacture. The exploit is not dated and is, in fact, fictional. But the fact that it takes place in Oriente Province suggests that this was not a random choice on the part of the author. Here we are not far from La Demajagua, where Carlos Manuel de Céspedes freed his slaves, the first Cuban to do so.

From the Caribbean Sea to the Atlantic Ocean, from Baracoa to Bayamo, from Santiago to Manzanillo, from Contramaestre to Mayarí, the walls and signs along the roads throughout Oriente Province seek to outdo one another in proclaiming the multifarious roots of the Cuban people. The ethnic mix is made up of a variety of different peoples: forced immigrants (abducted Africans); the few, rare descendants of the indigenous Carib Indians who survived the genocide of their people; the Spaniards, longtime masters of the country; and a medley of new immigrants, refugees and exiles, who were never turned away. In the late 19th century, for example, attracted by fabricated stories of a boom in the sugar industry, Japanese settlers traveled to the Isla de la Juventud (Isle of Youth); there they founded a harmonious community that still cultivates its ancestral traditions. And Havana, just like any other city in Europe or North America, has its own Chinatown (here called the *Barrio Chino*), while Old Havana boasts the oldest synagogue in Latin America.

Cuba is no average sponge. It absorbs without ever becoming saturated. However, the predominant element contributing to the Cuban mosaic is, of course, African. This can be most clearly seen in the *Santería*, the syncretic religion in which Cuban saints are the cousins of their Christian counterparts. Santería, Babalao, Yemayá, Changó, Obatala, Toque de Santo—everyday life in the Spanish-speaking Caribbean resonates inescapably with these names. Whether they are dedicated revolutionaries, practicing Catholics, or hard-core atheists, Cubans live in the waters of this salty-sweet religion (as the experts call it), which is a mix of diverse African beliefs and Christian dogmas that simply cannot and will not be argued away. And in the face of—or beside, or despite—the dialectical materialism of Marxist ideology, the *Santería* lies at the heart of

"God smokes Havanas."

Serge Gainsbourg

local life. Countless gatherings take place in honor of the *orishas*, the saints in the *Lucumí* pantheon. And the fervor of their worshippers does not preclude a definitely festive feeling. As they say, the saints don't mind a drop or two of Havana Club rum and have a serious weakness for sweets. These fast foods of the local liturgy are as necessary as the prayers of the *babalao*, the high priests who intercede between the saints and their spiritual sons.

"*¡Ache!*" (Amen!)

Art isn't missing from this multicolored mix. When Wifredo Lam moved to Paris, he was welcomed with open arms by André Breton, Pablo Picasso, Paul Éluard, Salvador Dalí, Max Ernst, Tristan Tzara and others of the Montparnasse Surrealists when the movement was in its glory days. Lam is an excellent example of what multiethnicity, Cuban style, means. He was born at Sagua la Grande, right in the middle of Cuba, but his facial features reveal what Cubans describe laughingly as a jet-lagged family background. Wifredo's father, Lam Yam, was born in Guangzhou, China, and emigrated to the Caribbean in 1860. There he met and married Ana Serafina, who had been born in Cuba and was herself the

descendant on the one side of an African family, and on the other a Spanish family. By an extraordinary stroke of fate, Lam's neighbor in Sagua la Grande went by the name of Picasso, for Pablo Picasso's maternal grandfather had left Málaga, Spain, toward the end of the 19th century and had emigrated first to Peru and then to Cuba, seeking to make his fortune. After meeting Cristina, a beautiful, freed African slave, he did not bother to return home, but went on to start an important Cuban family that bears the name of Picasso.

Another Cuban painter of mixed descent is Manuel Mendive. In the shade of the palm trees at his *finca* (country house) in Cotorro, twelve miles or so from Havana, with the chorus of birds all around, Mendive communes with an Africa that has bequeathed to him its legends, its magic, its mythology. As he himself said on returning to his beloved island after a visit to Benin, "I went there to discover new things but found I already knew them, as if in a dream that acted as a mirror to reality. . . . My reference to Africa, it was in Cuba and from Cuba that I received it. I have been raised in a world of fantasy, a world full of poetry, of altars, candles, colors. . . . Part of our living room was the altar to the God we called upon . . . "

Cuba is a mosaic painting.

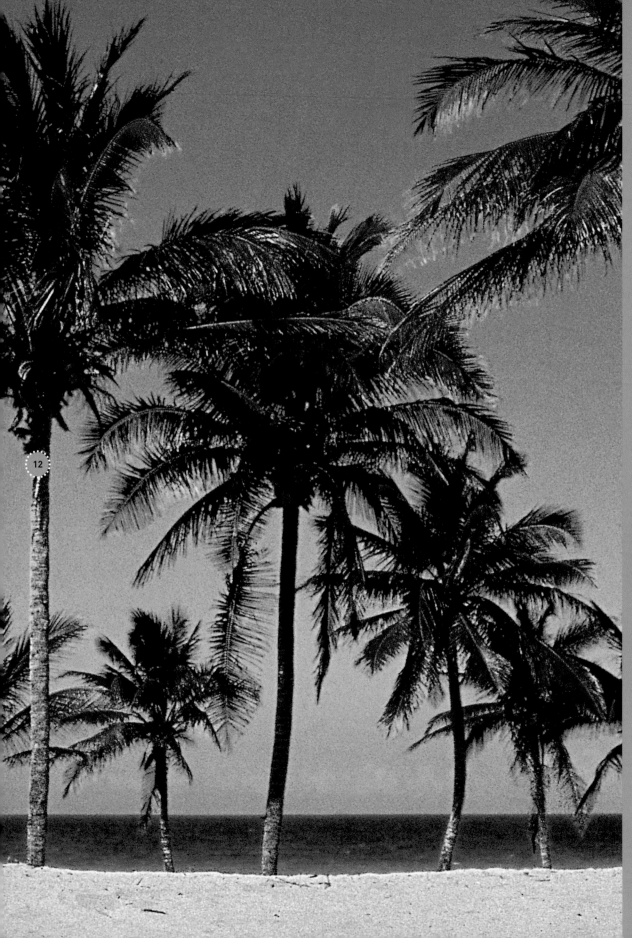

Al sol, a la sombre . . .
Here these words
("In the sun or in the
shade . . .") do not refer
to the seats in a bullring, but
rather to the indissoluble
marriage between the dazzling
heat of the Cuban sky and the
interiors of Cuban houses,
where the people devise
ingenious schemes to tame
the heat. Glowing on faces that
seem to have stepped out of a
painting by Gauguin, the light
catches moments of tender
intimacy and sweeps through
a burned-out landscape at the
very moment when the sun is
setting. Blithely indifferent
to the wear and tear of each
passing day, the palm trees
shade the virgin sand with
their enormous fans. Life
down here is sweetness and
serenity. Amen!

PREVIOUS SPREAD
Staying awake to the sound of the guitar
of a *trobador*, Los Hoyos de Santiago.
LEFT
The Playa del Este, twenty minutes from
central Havana.
RIGHT
On the Malecón, Havana.

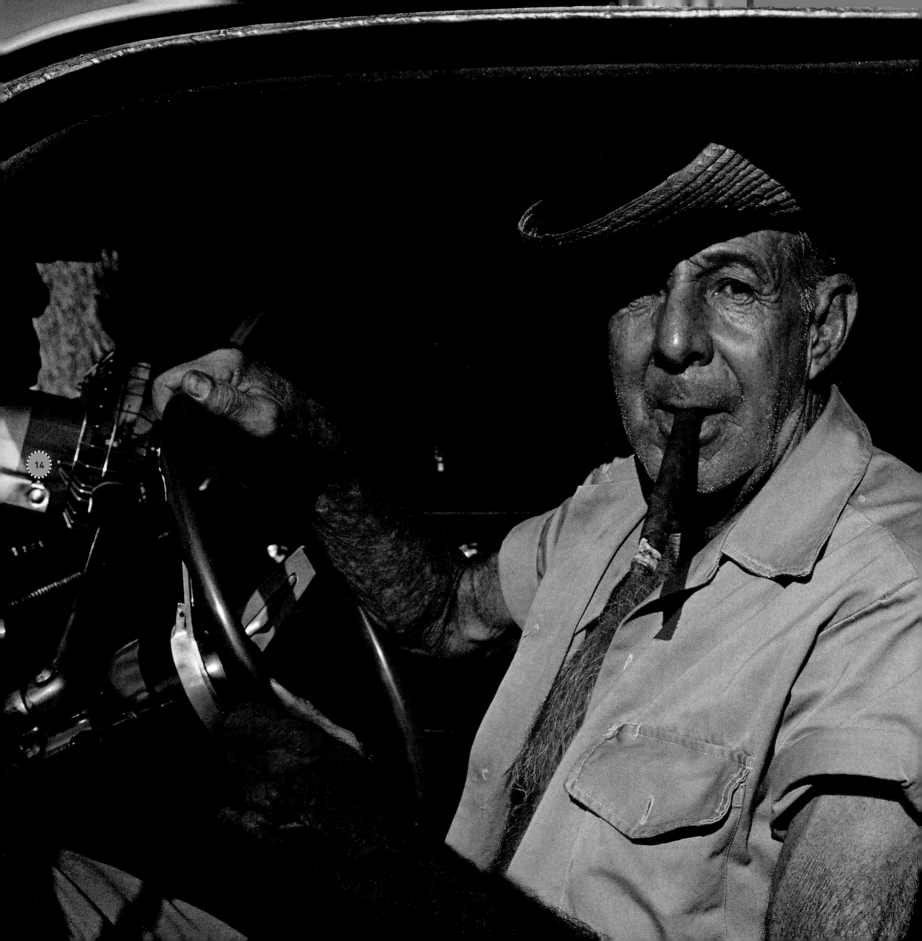

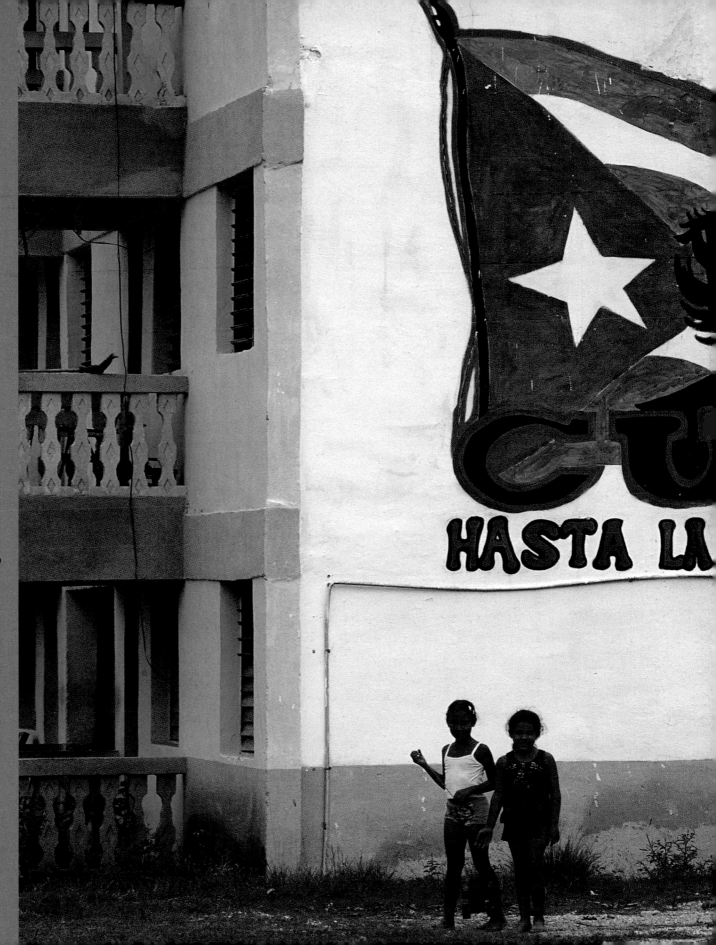

¡Hola amigo! Tell me: don't you think life is just beautiful? My automobile—a '56 Buick— a great year, '56—runs like a clock. I've got a cigar firmly planted between my teeth and the sun's not being cheap today. . . . What more do you want? Oh yes, I nearly forgot. My wife has asked me to bring back a *lechón* (suckling pig) for Mislady's birthday. She's our youngest; she'll be celebrating her *quince* (fifteenth birthday) at the end of the week. There'll be good beer and rum, not that *chipetren*, stinking of sulphuric acid. *Todo bueno, compañero.*

LEFT
Portrait of a Cuban at the wheel.
RIGHT
Entering San Antonio del Sur: *¡Hasta la victoria, siempre. Comandante!* In Cuba, even color is patriotic.

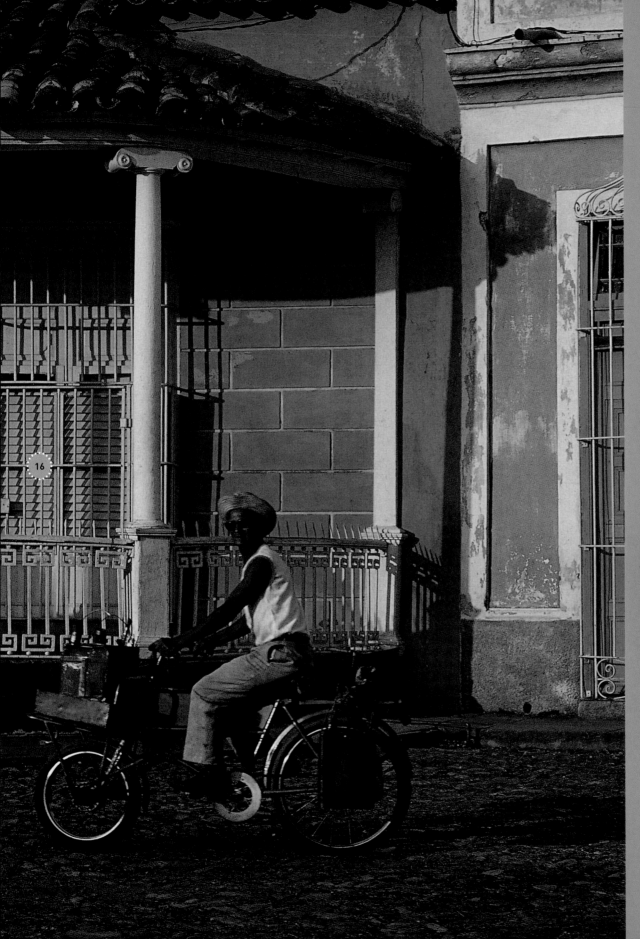

16

Just like the centuries-old stones of Trinidad, the light in Cuba belongs to the world's heritage. It coils in the nooks and crannies of narrow alleyways, slips into homes locked away behind wrought-iron gratings, etches furrows of fatigue on the faces of cyclists, gently touches the young officers as they call for their vessels, and forms part and parcel of the shopkeepers' new stock and permanent inventory—perhaps one of the most insufferable evils of the bureaucratic structure inherited from the Soviets' time on the island. On facades that refuse to show the wear and tear of time, pastel shades and ochres blend invisibly into each other. They have seen much, these facades, and will see more.

LEFT
A street in Trinidad.
RIGHT
A Havana street stall.

AGROMERCADO
UNIDAD: LA J

JUGO de GUAYABA 232g 1.00 CIG

PAN y CROQUETA 29g 100 TA

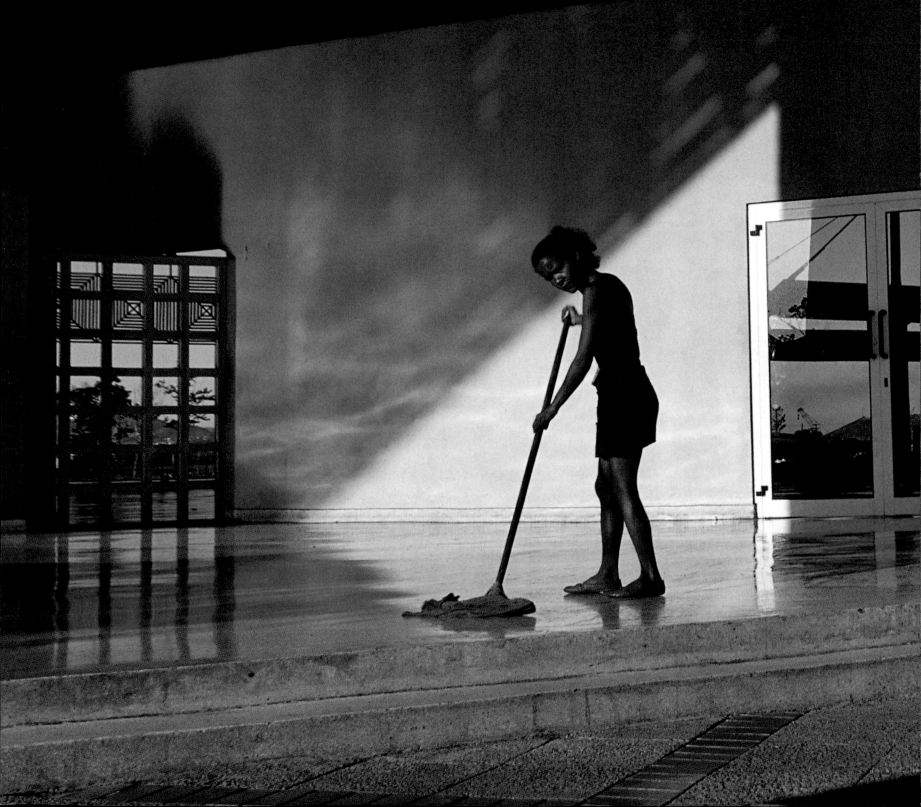

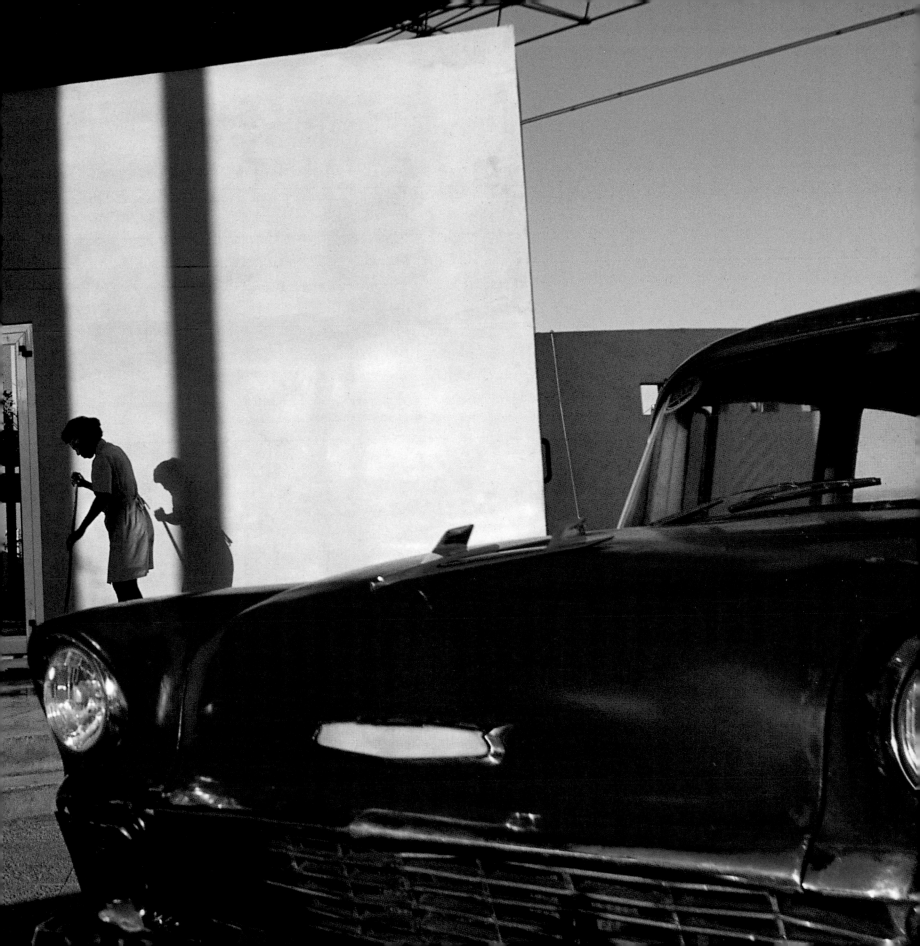

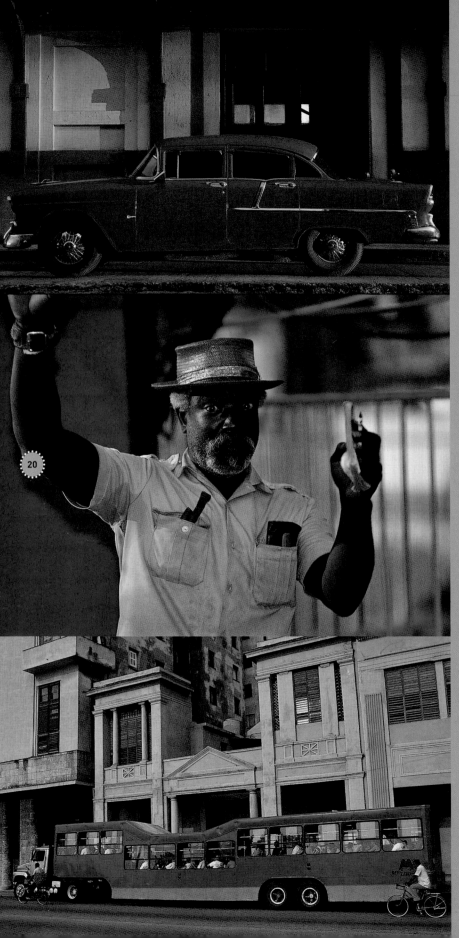

At day's end, one's eyes become saturated with an exuberant palette of color, a state of chromatic intoxication fed by a cobalt blue *camelo*, (the two-humped Cuban bus).
A black-and-white Lada.
A cart drawn by a white horse.
A cockerel standing proudly on a public bench.
A green beer cap.
The multicolored bathing suits of the crowds of water nymphs.
Glowing eyes.
Biblical landscapes.
Lofty palms.
And the *compañeros*, black, white and mestizo.
No more! No more! What a cartoon strip, gentlemen!

PREVIOUS SPREAD
The new station in Santiago.
LEFT
An American classic on a Camagüey street.
The ticket collector on the train from Havana to Regla.
A *camelo* in Havana.
RIGHT
A view of the Escambray Mountains.
A cart on a Camagüey street.
A Havana street scene.
In a window in Havana.
Young woman in San Lázaro, Havana.
A palm grove on the south coast.
The Riviera Cinema on Calle 23, Havana.
Swimming on the Playa del Este, near Havana.
VINTAGE PHOTOGRAPHS
LEFT The big wheel in the Parque de Palatino, Havana, c. 1909.
RIGHT La Machina dock, Havana, c. 1909.

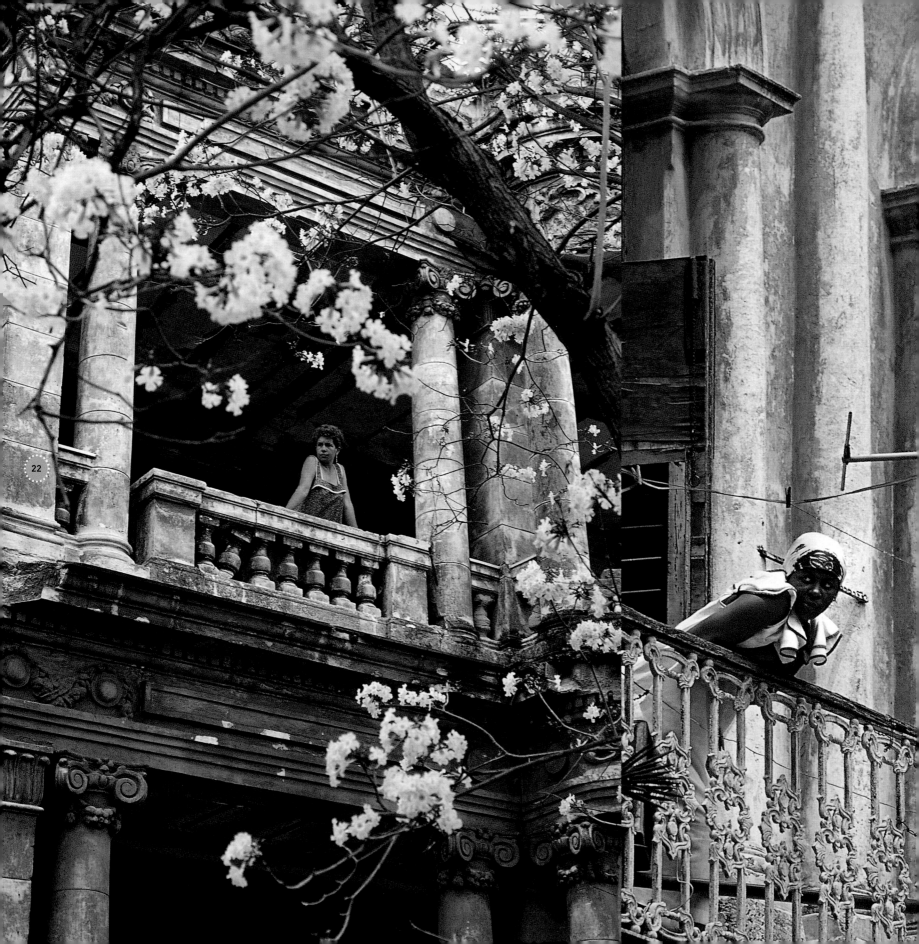

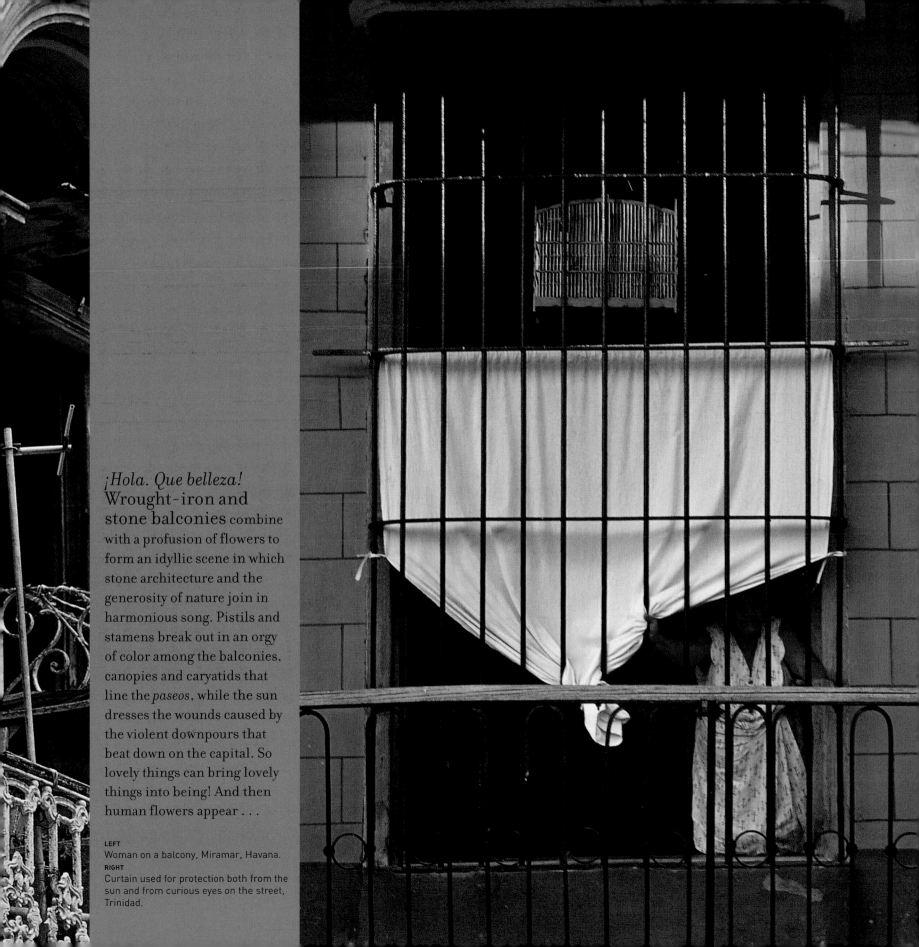

¡Hola. Que belleza!
Wrought-iron and
stone balconies combine
with a profusion of flowers to
form an idyllic scene in which
stone architecture and the
generosity of nature join in
harmonious song. Pistils and
stamens break out in an orgy
of color among the balconies,
canopies and caryatids that
line the *paseos*, while the sun
dresses the wounds caused by
the violent downpours that
beat down on the capital. So
lovely things can bring lovely
things into being! And then
human flowers appear . . .

LEFT
Woman on a balcony, Miramar, Havana.
RIGHT
Curtain used for protection both from the
sun and from curious eyes on the street,
Trinidad.

FABRICA DE

LOS ST

DE LU

ACOS

HABAN

24

"No matter which country, no matter which color, music is a cry from within." Bernard Lavilliers's words run through the streets of Santiago during the wild *comparsas* week, when competing percussion bands set the city streets on fire. Friends of the dead Chan, Nene, El Mudo beat on drum skins and cymbals, jump and sweat, and get drunk together. They'll be drinking beer out of paper cones and dancing until dawn. And then they'll start all over again!

LEFT
Label on a cigar box.
RIGHT
Carnival in Santiago.

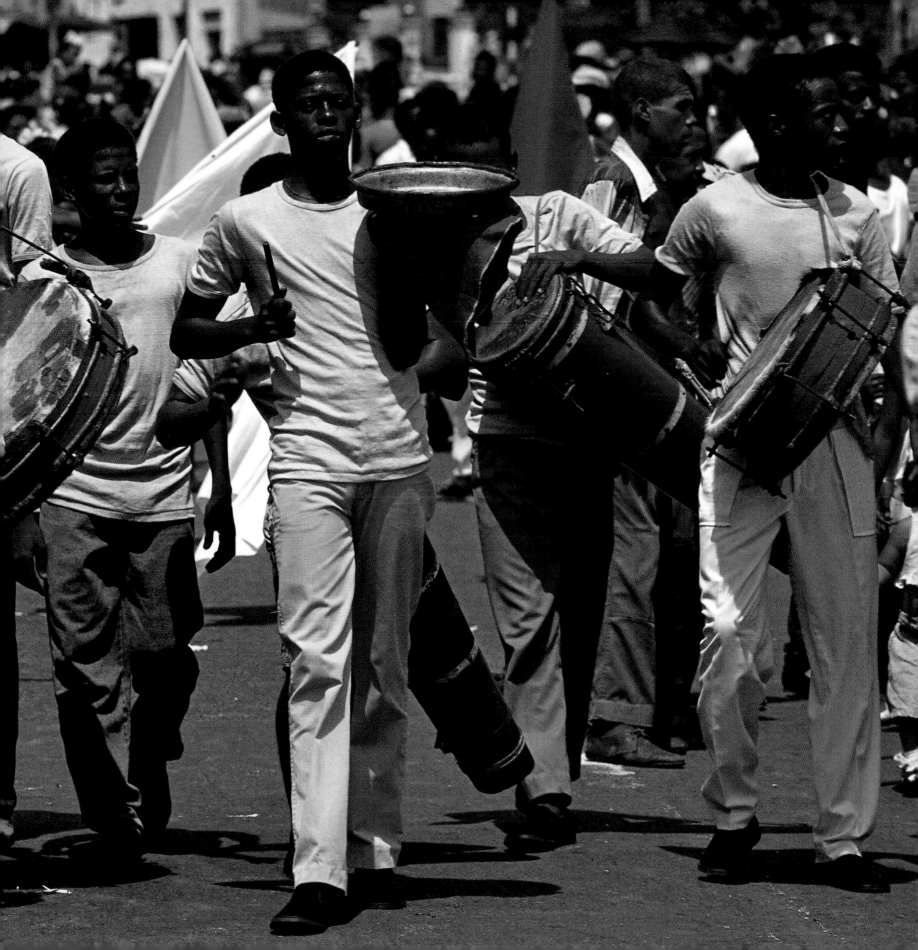

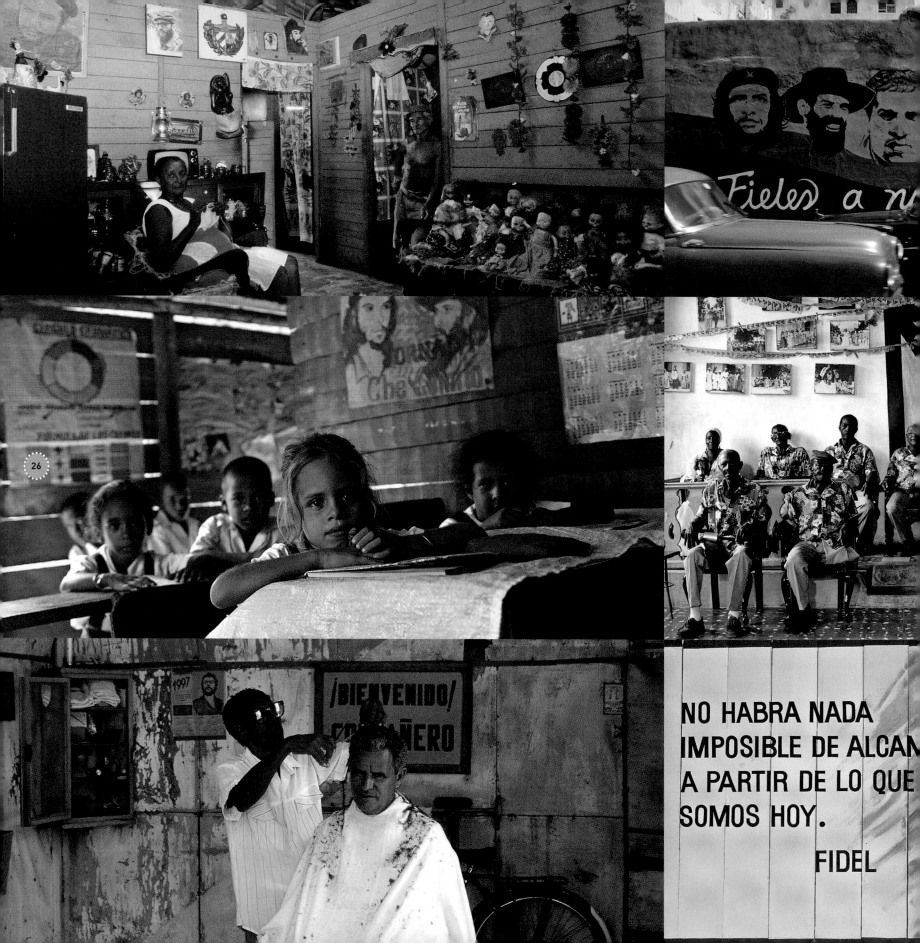

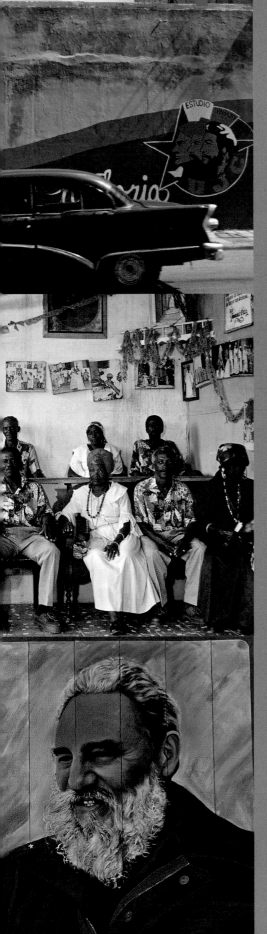

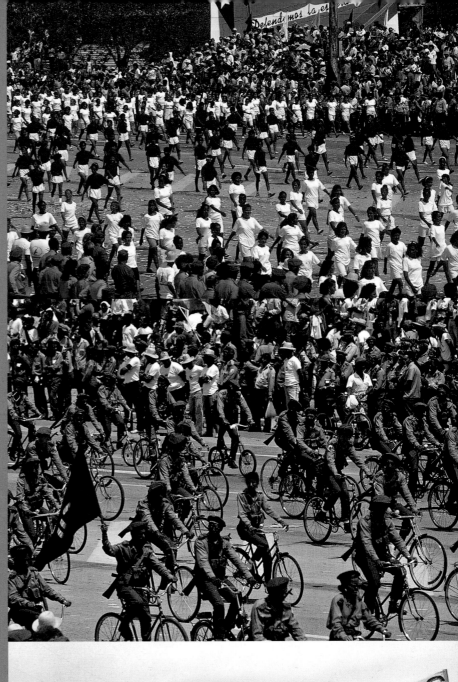

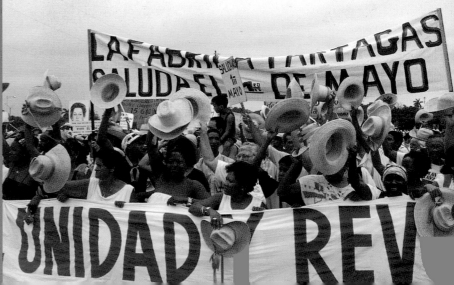

"From what we are today, nothing will be beyond our reach." Fidel Castro's revolutionary calls can be read on walls everywhere and still bring out crowds beyond number to the mass rallies called by the Cuban Communist Party. In the tropical light, huge banners flutter in memory of Che, Camilo and other heroes of the Revolution. Nor are the schools absent from these demonstrations of political faith. At the same time as they learn their alphabet, Cuba's multicolored schoolchildren learn about the Revolution too.

LEFT
A countryside interior, Baracoa.
A Havana street.
A school at Alto de Naranjo.
A tumba francesa group in Guantánamo.
At the hairdresser's, Holguín.
Portrait of Fidel Castro with revolutionary slogan, "From what we are today, nothing will be beyond our reach," Havana.
RIGHT
May Day parade, Havana.

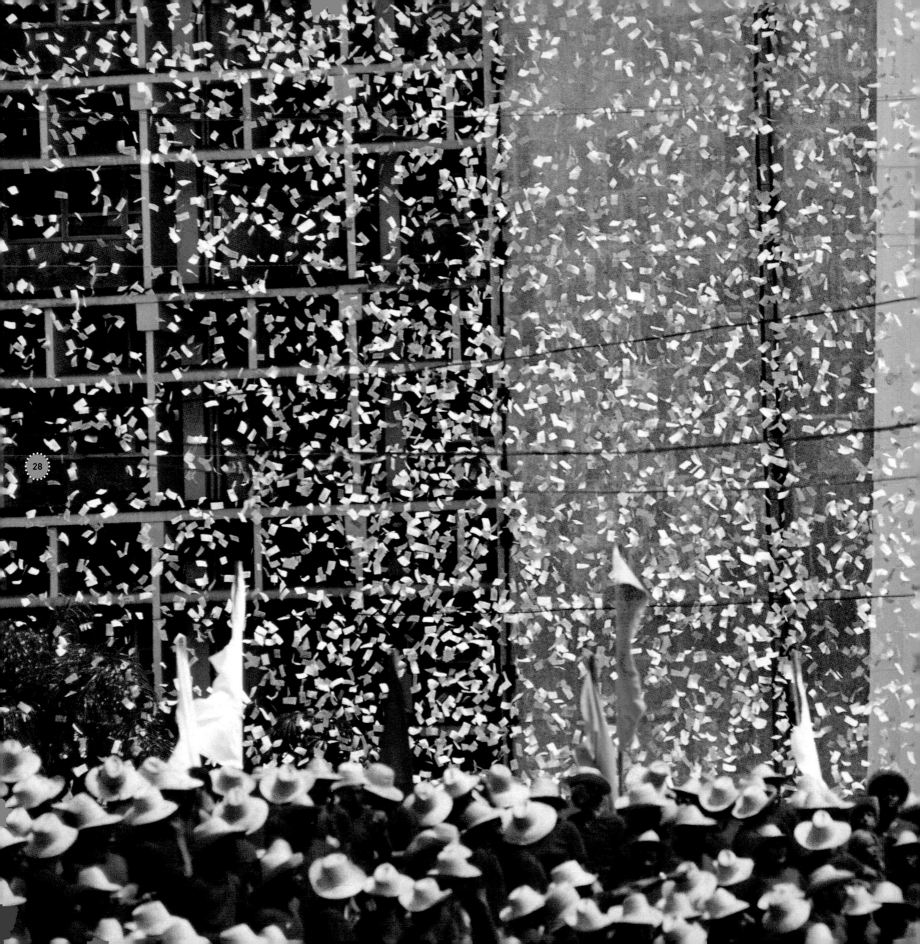

"We are born in a free country
handed down to us by our fathers,
and the island will drown in the sea
before we allow ourselves
to be enslaved by anyone."

—José Martí, *Moncada*

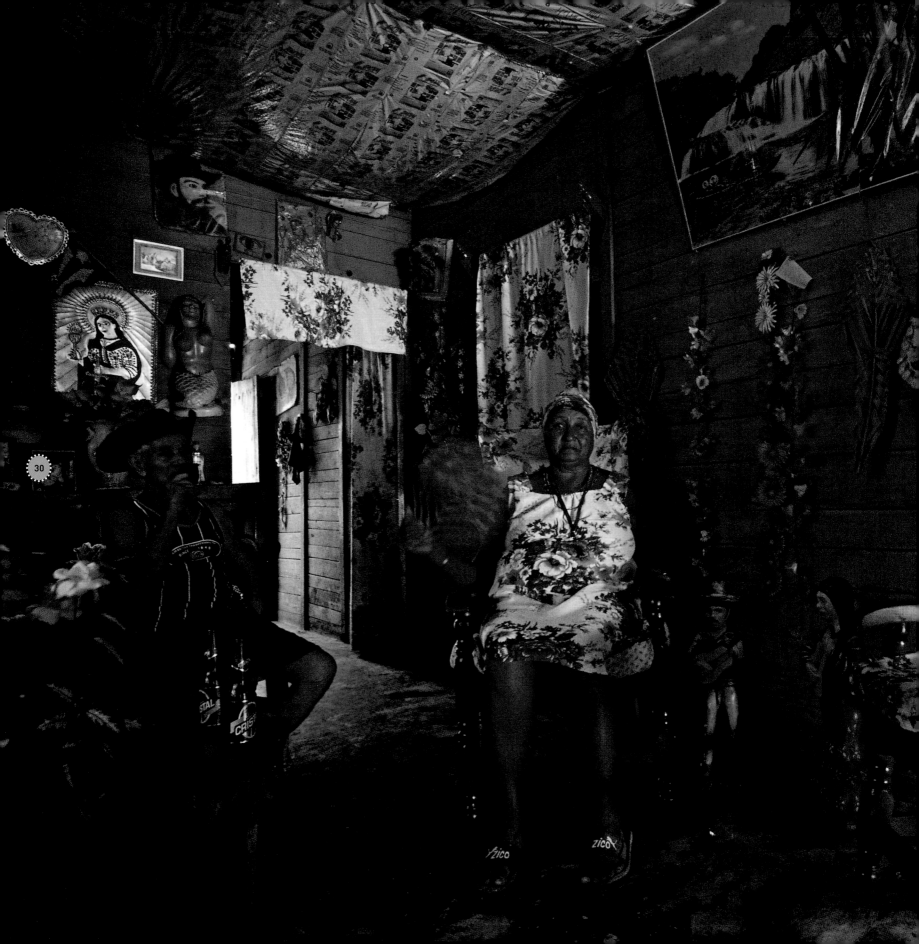

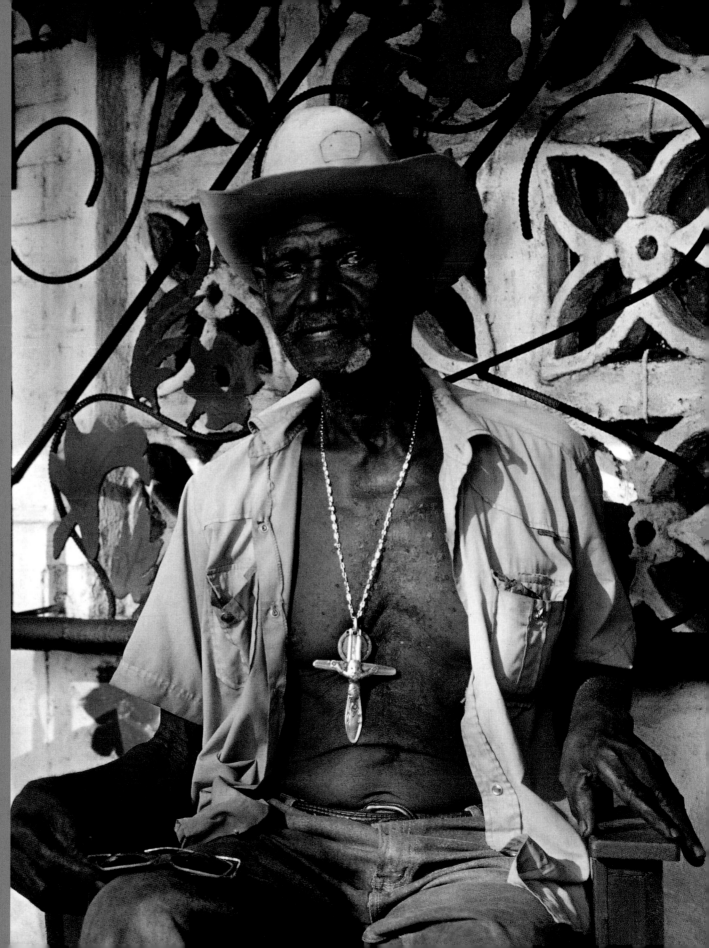

Carmen is Rafael's wife. She is a Carib Indian, he of Majorcan descent, just like Paul and Virginia from the 1787 novel of that name by Bernardin de Saint-Pierre, and they are alive and well and living in Baracoa. Carlos lives in La Troya, about twenty miles from Manzanillo. His life is like a storybook. He would have liked to have been a pilot, but was prevented from moving to the United States by the outbreak of World War II. As the grandson of a Haitian general, he had the ferment of the Cuban Revolution in his blood. Sure enough, he joined Castro, Guevara and Cienfuegos to help set up their guerrilla base in the Sierra Maestra. His father was the Castro family sharecropper. A scale model of an airplane on the roof of his house tells the story of his never-appeased desires.

LEFT
Carmen and Rafael at their home in Baracoa.
RIGHT
Carlos posing in front of his home in La Troya.

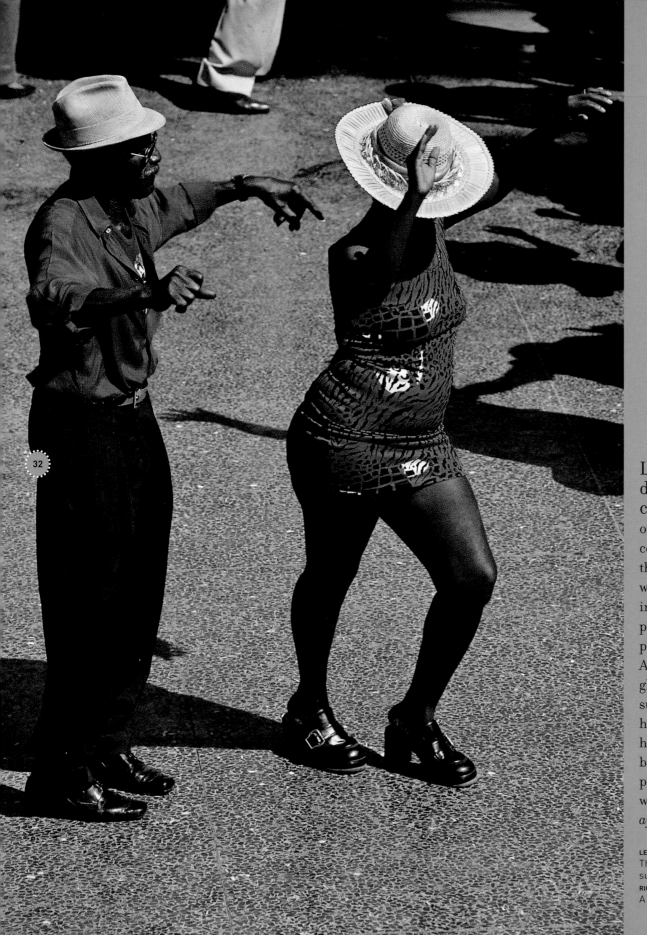

Like music and dancing, art has colonized the streets of Oriente. What canvas can compare in its vastness with the facade of a house? Here, woman, the painter's eternal inspiration, is raised to the point of deification. Even in paint she can set men on fire. And they return the favor, glorifying her on immense surfaces. She accepts their homage as her due, both to her and to her undulating beauty. When these women pass by, you almost expect the walls to move with them. *¡Ay, ay, ay, mulata!*

LEFT
The Cabaret La Tropicale in the Havana suburbs.
RIGHT
A street mural, Havana.

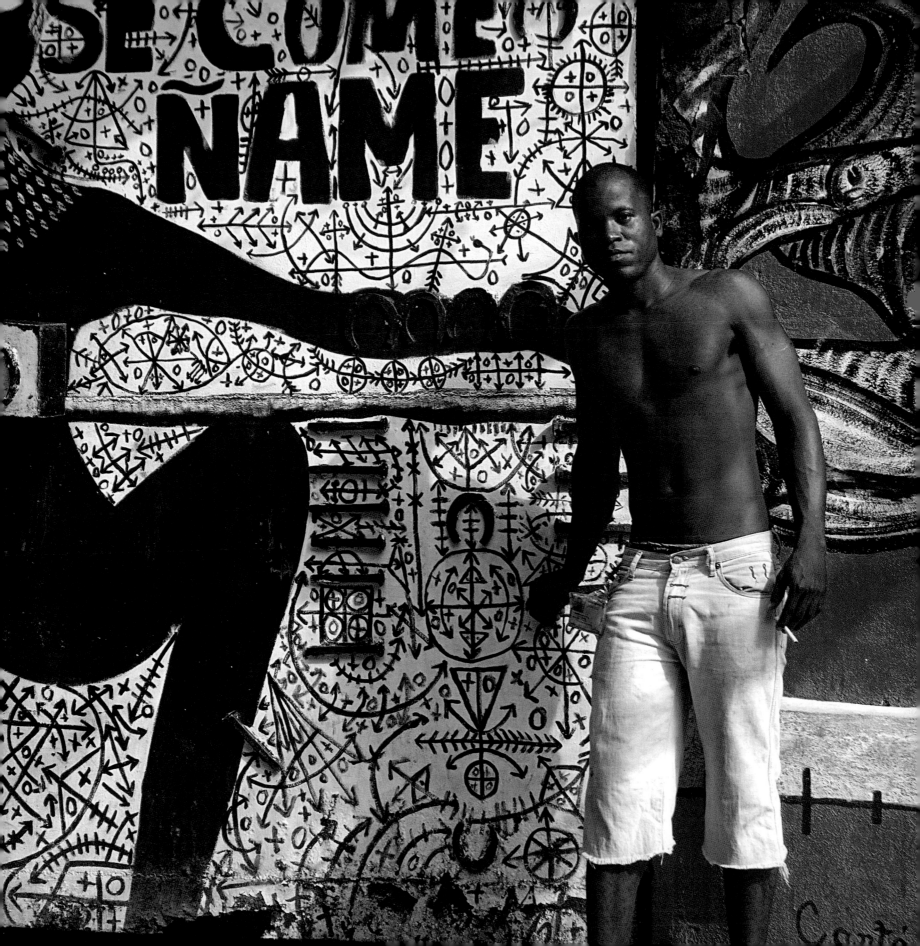

FROM ISLAND TO ISLAND

In the atlas of this country, you can find tableaux that could just as easily have been borrowed from the world of Jules Verne as from that of Rudyard Kipling.

At María la Gorda, in the extreme west of the country, which the experts rate as the finest scuba diving location in the world, the province's geopolitical importance is plain to see. This is where the galleons sailed, laden with gold or Chinese porcelain, and this is where they were sent to the bottom of the sea by buccaneers and privateers like Francis Drake, Henry Morgan, or Jean-François de La Rocque. And here, lying beneath the waves barely a league from a beach that is to die for, the pirates left behind fortunes that are still untouched, safely encased in their treasure chests.

There are countless—superlatives here are hard to resist—coral paradises, with names like Cayo Coco, Cárdenas, Guardalavaca, Sabana, Santa Lucía on the north of the island, and the Canarreos Archipelago and the Jardines de la Reina in the south. On the causeway leading from Morón to Cayo Coco, pink flamingos accompany the torrent of cars heading for the sea, completely unafraid. At Cayo Iguana, the reptiles seem to mock the tourists, who are plastered from head to foot with sunscreen, like snail slime or donkey manure, while they cram their faces full of grilled crawfish. Meanwhile, the lizards just doze away under the tropical sun. Here, one is tempted to praise all the gods and all their saints for having invented this tropical confetti. For these islands are jewels that have been snapped up, with varying degrees of good fortune, by a tourist industry peddling turquoise waters and sapphire depths.

There is peace and sensual pleasure in the Caribbean.

At the risk of destroying these sweet illusions, potential and unconditional sun and sand worshippers need to be alerted to one or two serious issues related to mass sunbathing. The brochures printed on thick, glossy paper suggest that pale-skinned blondes can change color in a mere two weeks. Now, it cannot be denied that Varadero is an idyllic spot. The only drawback is the terrible concentration of concrete here, even though it is brightly colored, and that this is a closed environment where you are more likely to hear Anglo-Italo-Franco-Germanic spoken than Spanish. The beauty of the place has been corrupted because the local people have been pushed to one side, some giving the excuse that this shields them from certain temptations prohibited by their modest incomes.

> **And now a Cuban poor as Cuba
> I am free and my wife is the color of sand,
> If there is nothing to eat we dance the conga.**
>
> Henri Gougaud

When asked, "What would you like to be when you grow up?" one child's bittersweet reply was: "I'd like to be a tourist at Varadero."

So we dream of our secret Guatemala, a straggling village near Mayarí, on the Bay of Nipe, in Oriente Province in the northeast of the country. There is no sublime beach here or multi-starred hotel, but there is Pipín, a fisherman who can catch a *cubera* snapper or a sawfish and cook it with *congri* (rice and black beans). And as seasoning for the meal, there is Carlos, an eighty-year-old singer who does a great job imitating Cuba's aging stars.

Cayo Largo . . . Here we leave behind the misgivings expressed by observers longing for authenticity in the face of an economy basically in thrall to tourism. This is a little island of such beauty that the artistic directors of magazines squabble over bringing Ukrainian or Scandinavian models here. Braided cotton hammocks dangle between the trunks of palm trees growing here and there among straw huts that look like dollhouses.

The aim here, that of providing a fleeting retreat for overworked foreigners, is clear to see. The island plays host to a sort of provisional emigration chosen by tribes who are happy to accept six hours' time zone difference and nine hours' flying time in return for a single week of guaranteed removal from their habitual element. The local market is essentially in the hands of Italian tour operators, who benefit from the fact that there is a direct flight from Milan to these longed-for beaches, especially Paraíso. When Hurricane Michelle (a Category 4 storm) struck in November 2001, it took Cayo Largo just two weeks to recover and get back to business once more.

If you can avoid having to fly via Canada or Europe from Cayo Largo in order to make your mandatory trip to the capital, the transition is sweet. You take a small ferry that drops off its suntanned passengers at Batabanó, on the south coast of Havana Province. There, in full view of curious fishing vessels, it moors at the dock, where, as the fishermen hang their nets to dry in the sun or take up needle and thread to mend them, huge squashy lumps create a lunar landscape among the masts and rigging. They are sponges, one of the great specialities of the local divers, who hand this trade down from father to son, gaining a taste for the light-headedness caused by the repeated breath holding.

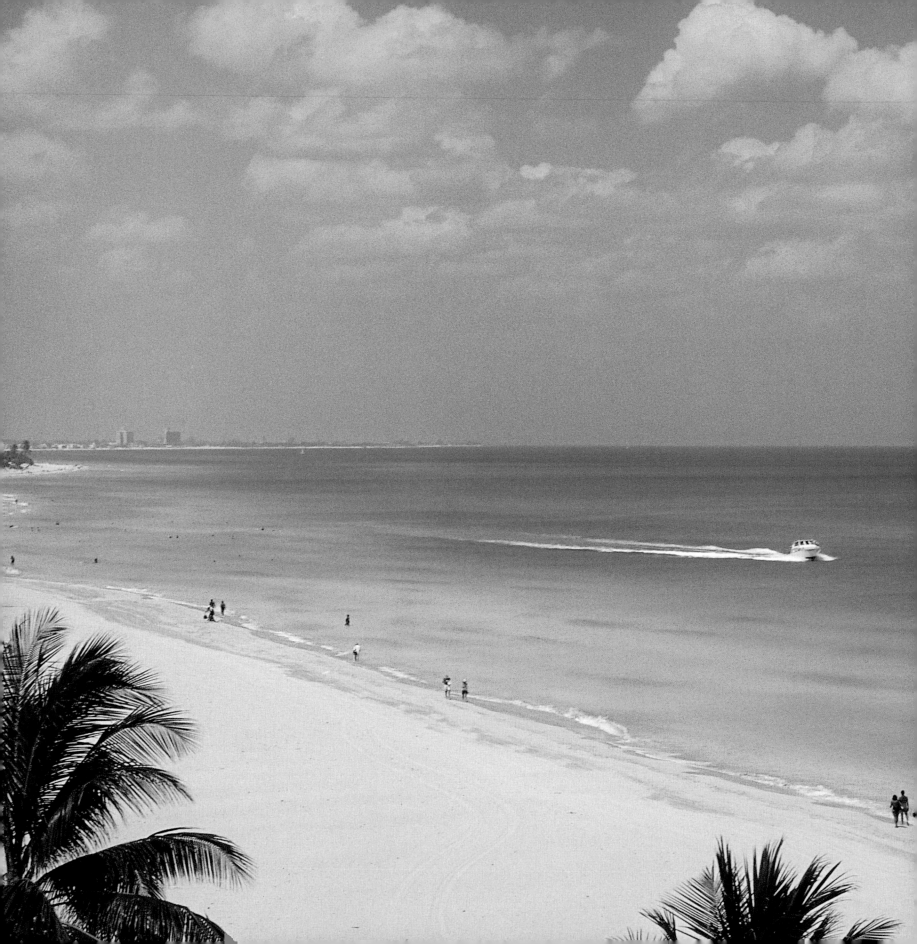

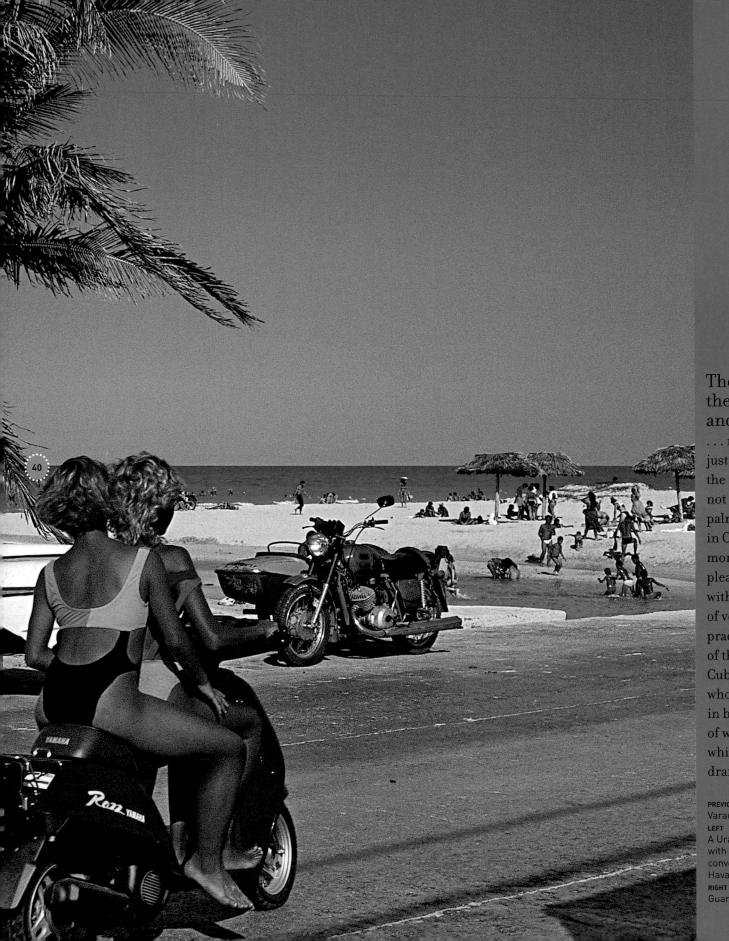

There is the sky,
the sun and the sea . . .
and the palm trees

. . . natural parasols that grow just as easily in the sand as in the forest. A postcard would not be complete without a palm tree on it. The weekend in Cuba begins on Monday morning. The hedonistic pleasure of the sea comes with the *Santería*, the cousin of voodoo, the most widely practiced faith on the island of the green lizard.

Cubans are peaceful saurians who like sunning themselves in bathing suits. It's one way of warding off the weather, which sometimes gets dramatically inclement.

PREVIOUS SPREAD
Varadero Beach.
LEFT
A Ural Scooter, a Russian motorcycle with sidecar, and various bicycles converge on the Playa del Este, near Havana.
RIGHT
Guanabo Beach.

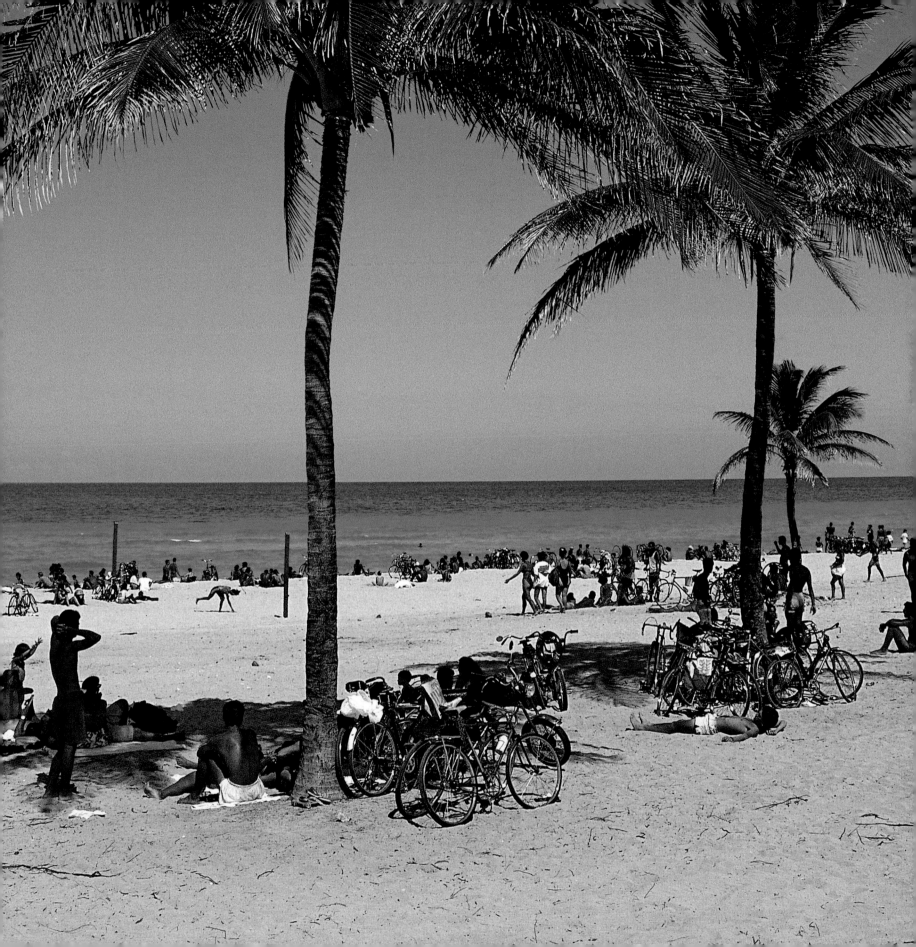

"In the afternoon I swim in the branch that goes
out from the lagoon to the sea. I throw my bag on the patio,
take off my uniform, hang it over the hammock, and, plop, I'm
in the water. I am a fish in the current, it wants to carry
me off but I fight back and it takes me a long time to get back
to the beach. I lie there, floating peacefully, I let myself float
wherever it wants to take me. I am a piece of glass, a canoe,
a broken doll, a little freshwater fish flapping its fins,
floating aimlessly. Until a salty taste in my mouth tells me
I need to be careful because I am out in the bay."

—Wendy Guerra, *Todos Se Van (Everyone's Leaving)*

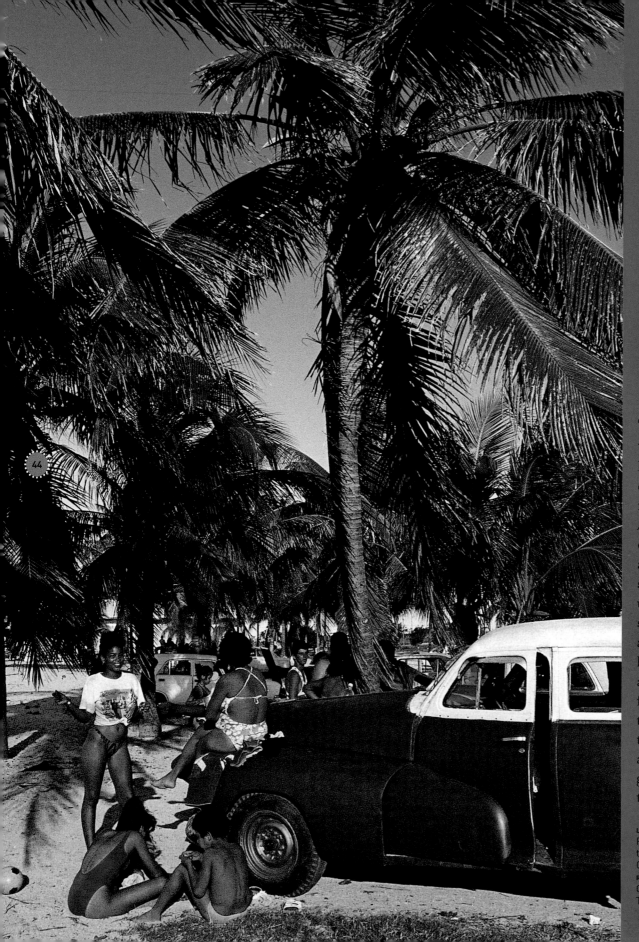

The roads that go to the beaches in Cuba look like the ones that you came across in Europe back in 1936. In these Latin American tropics, people cultivate their days off with an art of living fed with smiles. *¡Gozar!* Take unfettered advantage of the simple things of life, like an afternoon down at the beach. With a good horse or a six-cylinder *colectivo*, the few miles from Old Havana to the Playa del Este are no trouble at all, just a song and a dance. Who cares how you get there as long as the thrill's there too!

LEFT
Picnicking near Puente de Madera, ten miles from Havana, with a 1956 Chevrolet.
RIGHT
Off to the Playa Ancón, the beach in Trinidad.

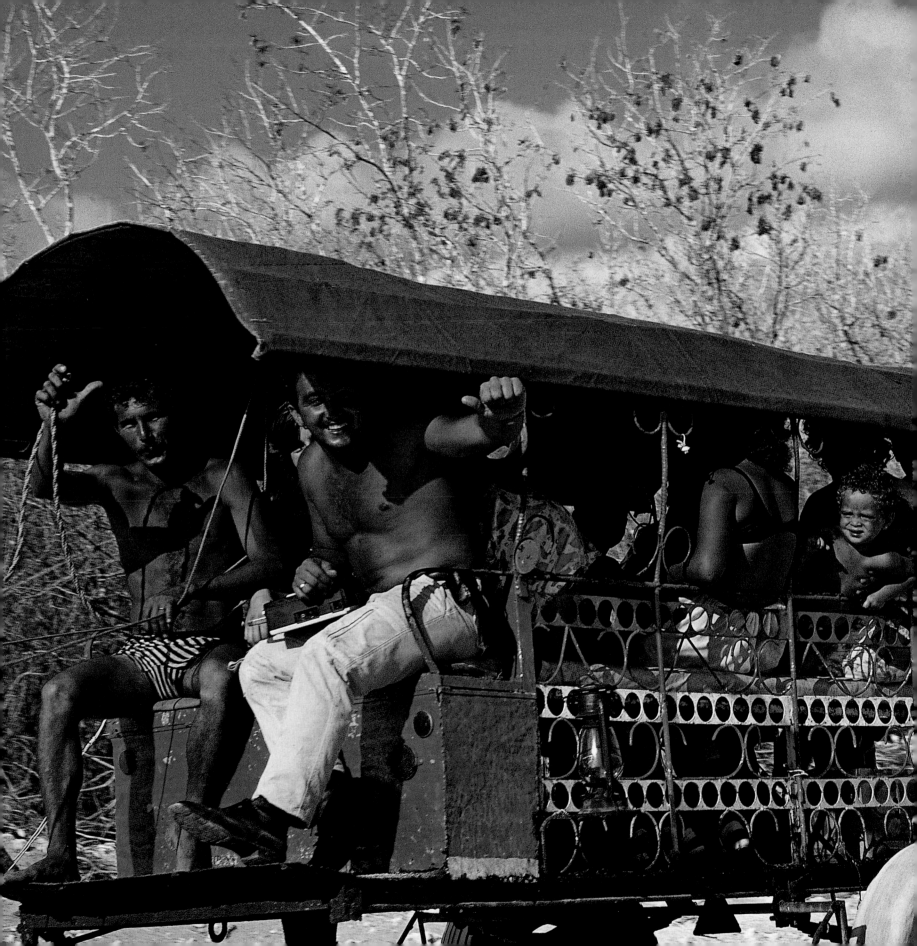

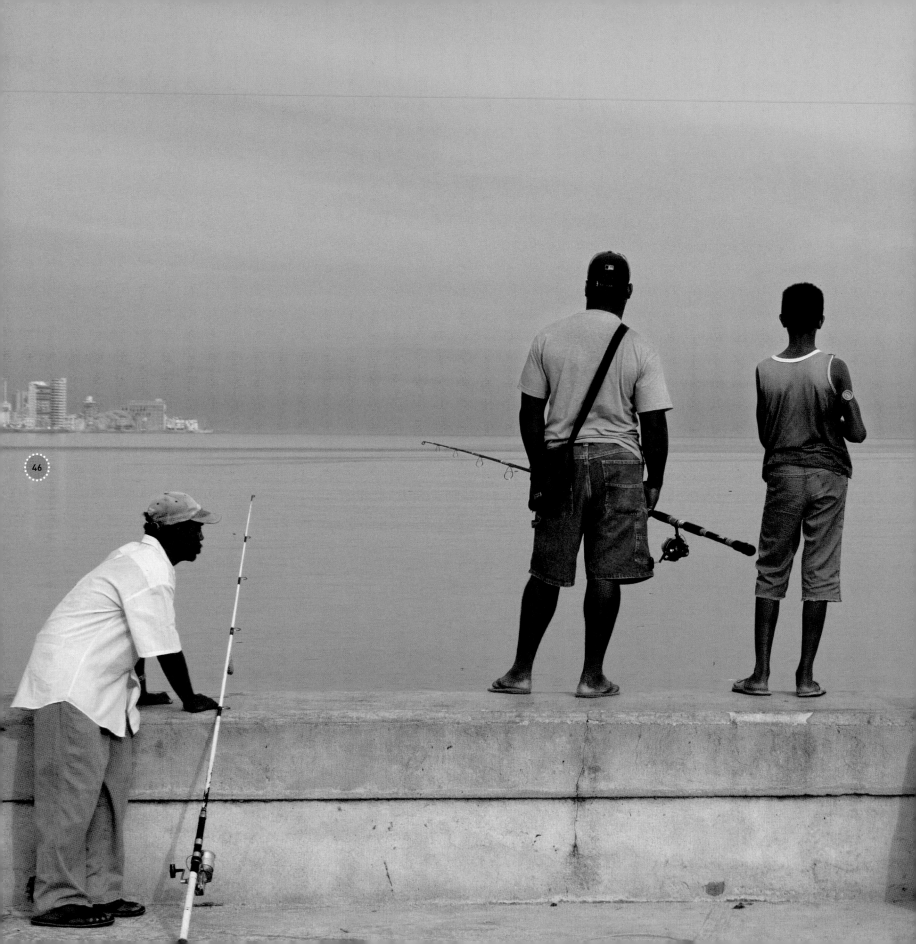

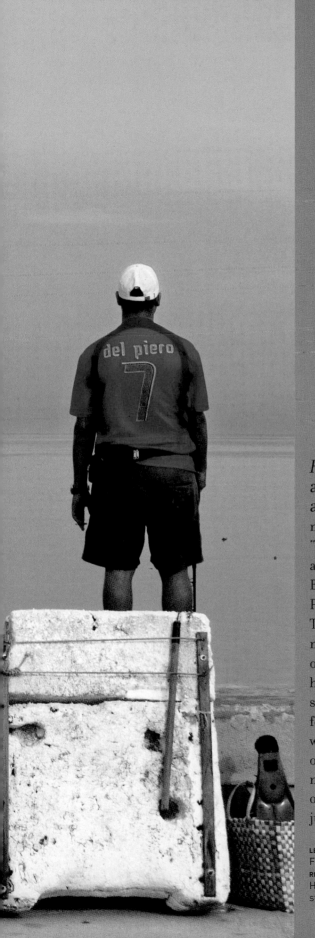

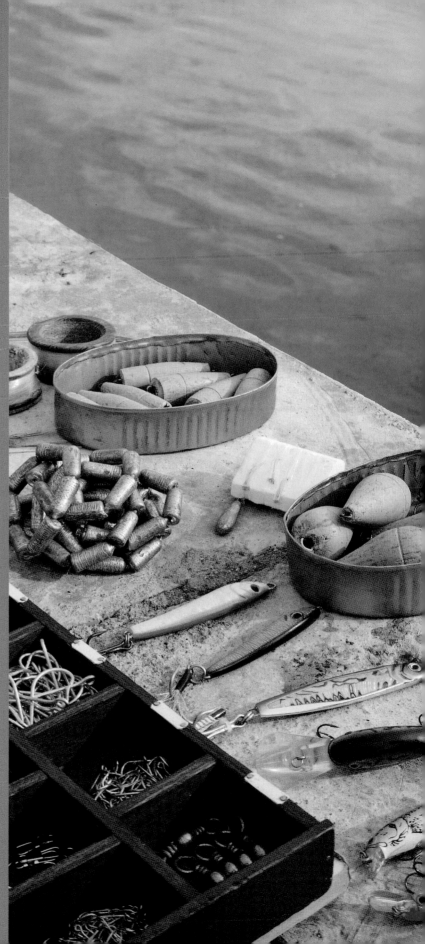

Havanero, you will always cherish the sea and will never forget to make it bring up its treasures. "A people who fish with rod and line," says Luís Adrián Betancourt, a poet from Palatino, "cannot be bad." Those men are the "Malecón maritime *guerrilleros*," as our friend Luís Adrián humorously calls them. The seafront at Havana is known for its wild seas; its lovers who, for lack of a room of their own, set up their evening love nests here; and its dreamers of far-off voyages. Miami is just over there.

LEFT
Fishermen on the Malecón, Havana.
RIGHT
Hooks, swivels and bait on an improvised stall on the Malecón, Havana.

Eusebio Leal, the man responsible for the remarkable way in which Old Havana has been restored, is said to have the intention of establishing a maritime museum along the same lines as the museum of Old Havana and its fortifications, now a UNESCO World Heritage Site. When that happens, our artist will have a good deal of difficulty in drawing up an inventory of every kind of vessel that navigates the seas, be it with engines, sails, oars, paddles, whatever . . . Whether it be a cockleshell or a giant trawler, everything here is out there fishing. Even if a hundred or so large lobster boats have been scrapped for lack of spare parts.

LEFT
Off Cayo Largo.
Havana harbor.
The boat linking Cayo Largo with the smaller, neighboring *cayos* (Cayo Ávalos, Cayo Rico, and Cayo Iguana).
RIGHT
A *goma*, the inner tube from a truck, is still a boat.
A fisherman carrying his *goma* on his back.
Fishermen coming home after their trips, María la Gorda.
A crab and shrimp fisherman, Manzanillo.

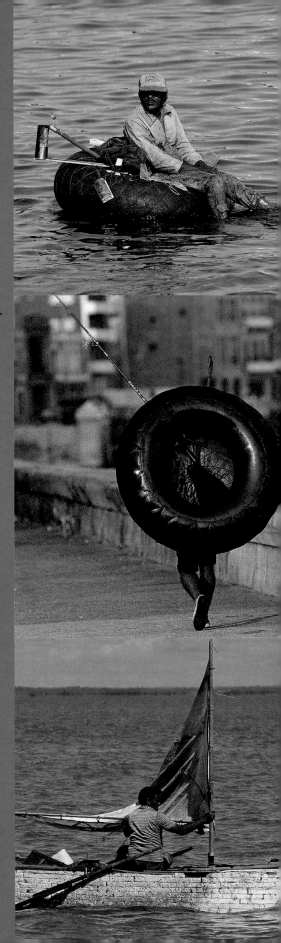

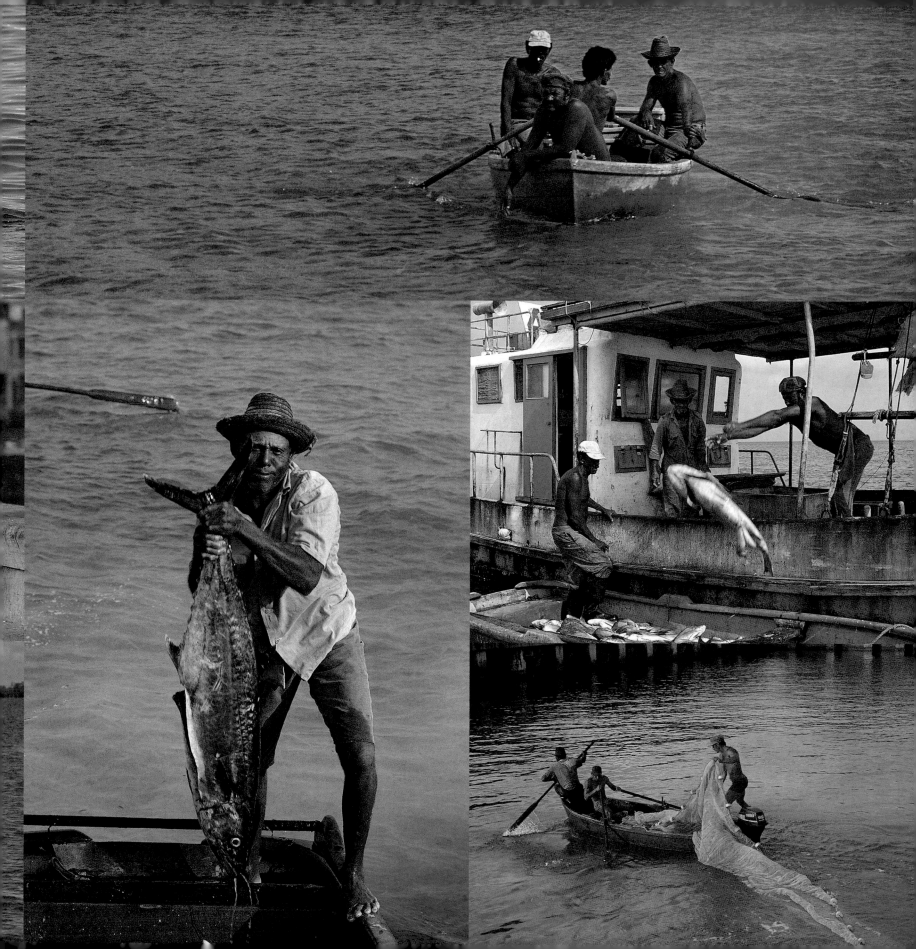

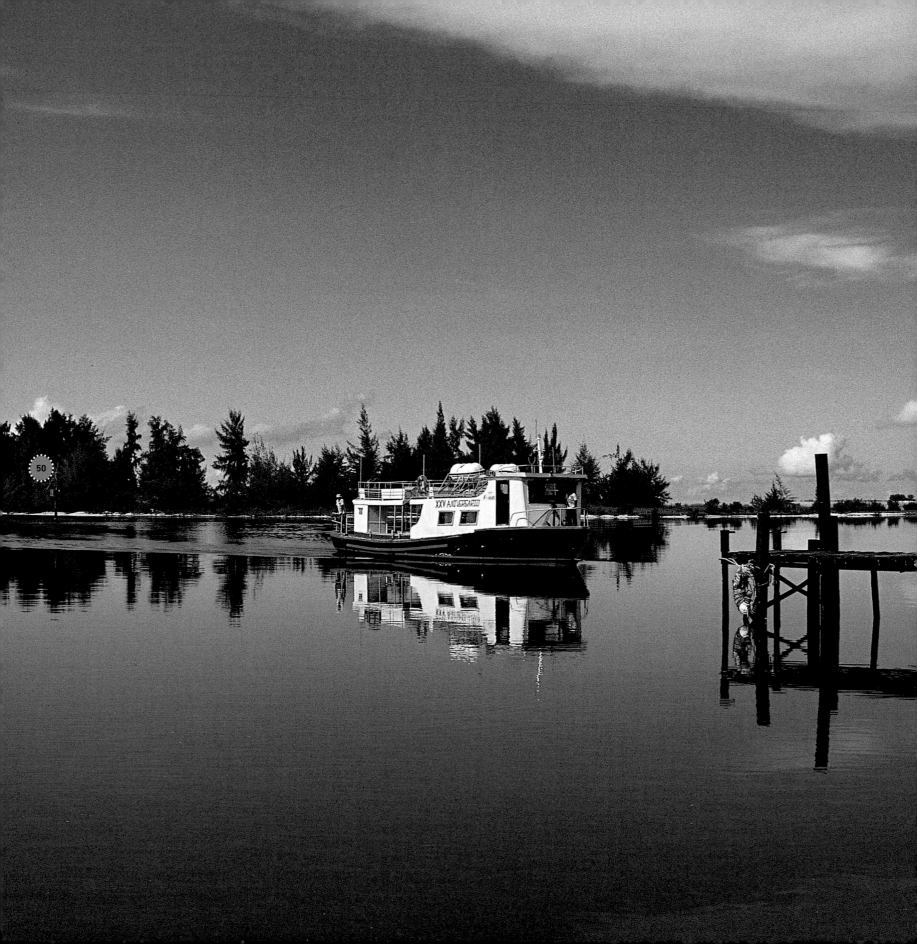

Cuba is spread out languidly on postcards that look as if they are from the Garden of Eden. The lagoon of the Jardines de la Reina, painted by a Caribbean Gauguin using the same colors as for the Marquesas Islands, a carpet woven by a magician in love. The eye simply wallows in it all, and you leave with regret, the turquoise waters darkening further in, as you enter estuaries fringed by austere mangrove swamps. This lovely line by Margherita Guidacci comes to mind: "The breaths of the sea are moments of eternity."

LEFT
On the way from one *cayo* to the next.
RIGHT
A typical wooden house in Baracoa.

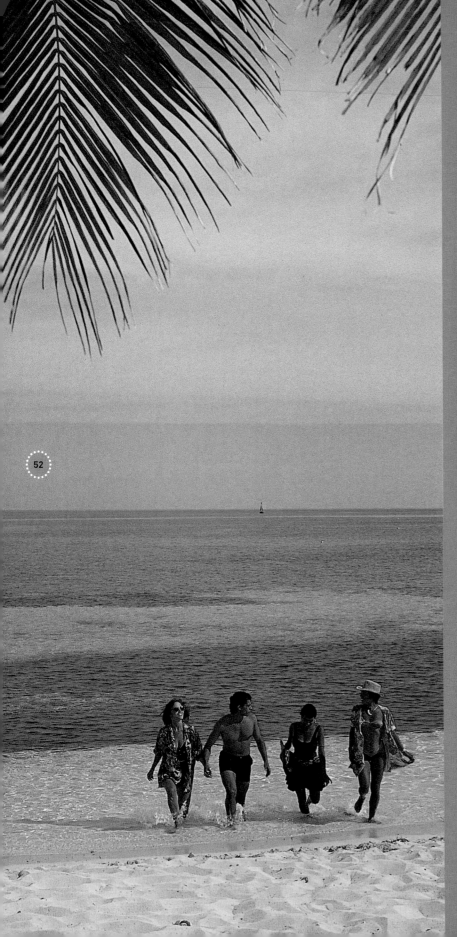

Looking down from
on high, the gull never
tires of eating its fill of
this multicolored paradise.
It knows everything about
the seekers of happiness,
who in their bathing suits go
out every day in their horse-
drawn carriages and boats to
check on the harmony of their
domain.
Eleven million Cubans
regularly dip into this
great work of history and
geography, forgetting, with
the charms of the latter, the
troubles of the former.
From the boats belching
smoke to the giant swimming
pool that is the sea, from the
houseboats to the Cadillac
taxicabs, all are part
owners of this Caribbean
sugared almond . . .

LEFT
Santa Lucía Beach.
RIGHT
Cayo Guillermo, a small island in the
Jardines del Rey archipelago.
On Coquites Beach, Santa Lucía.
Diving at Cayo Coco, the island adjacent
to Cayo Guillermo.
Tropical fish in coastal waters, on the
Playa del Este, near Havana.
VINTAGE PHOTOGRAPHS
LEFT Havana anchorage in 1909.
RIGHT Swimming pool, Havana, 1909.
POSTCARD Mariano Beach, near Havana,
1950s.

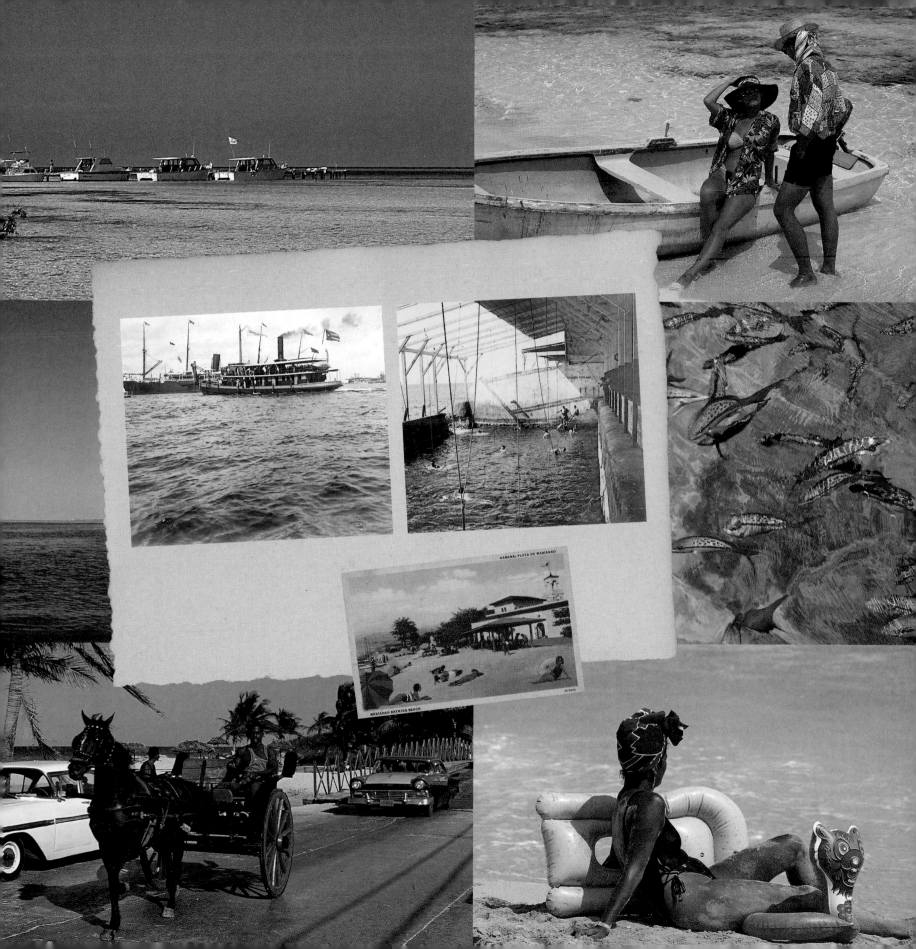

HABANA, PLAYA DE MARIANAO

MARIANAO BATHING BEACH

"Oh Cuba, if I told you
I who know you so well,
Oh Cuba, if I told you
That your palm tree is made of blood
That your palm tree is made of blood,
And your ocean all of weeping
In the Sea of the Antilles,
Also called the Caribbean,
Beaten by rough waves
And adorned with soft foam
Beneath the sun that besets it,
And the wind that repels it
Singing, eyes filled with tears,
Cuba sails on its map
Like a long green lizard
With eyes of water and stone"

—Nicolás Guillén, "A Long Green Lizard"

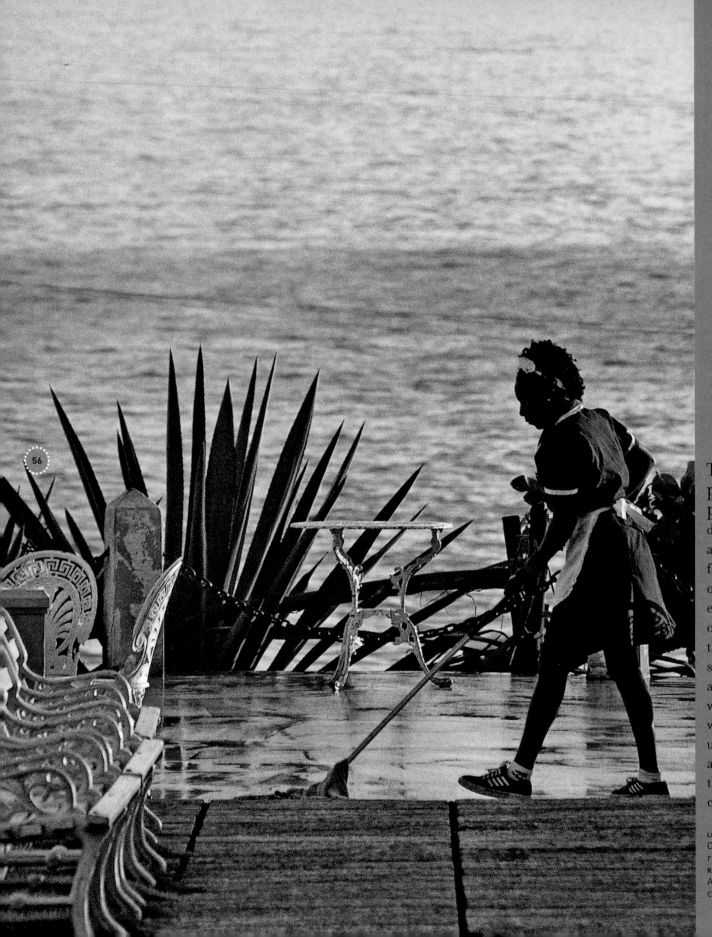

The swing of the pendulum that obliges people to keep their dwellings spick and span and in sound repair in the face of the constant threat of heavy seas is a sort of eternal renewal. And the job of unremittingly protecting this fragile harmony is a sinecure entrusted to a small army of Sisyphuses armed with brooms and floor cloths, who defy the capricious and unpredictable Caribbean. The aloes are man's allies, telling the vast blue expanse that they can resist its cyclical fury.

LEFT
On the terrace of the Hotel Nacional, right above the Malecón, Havana.
RIGHT
A pair of rocking chairs on a porch in colonial Trinidad.

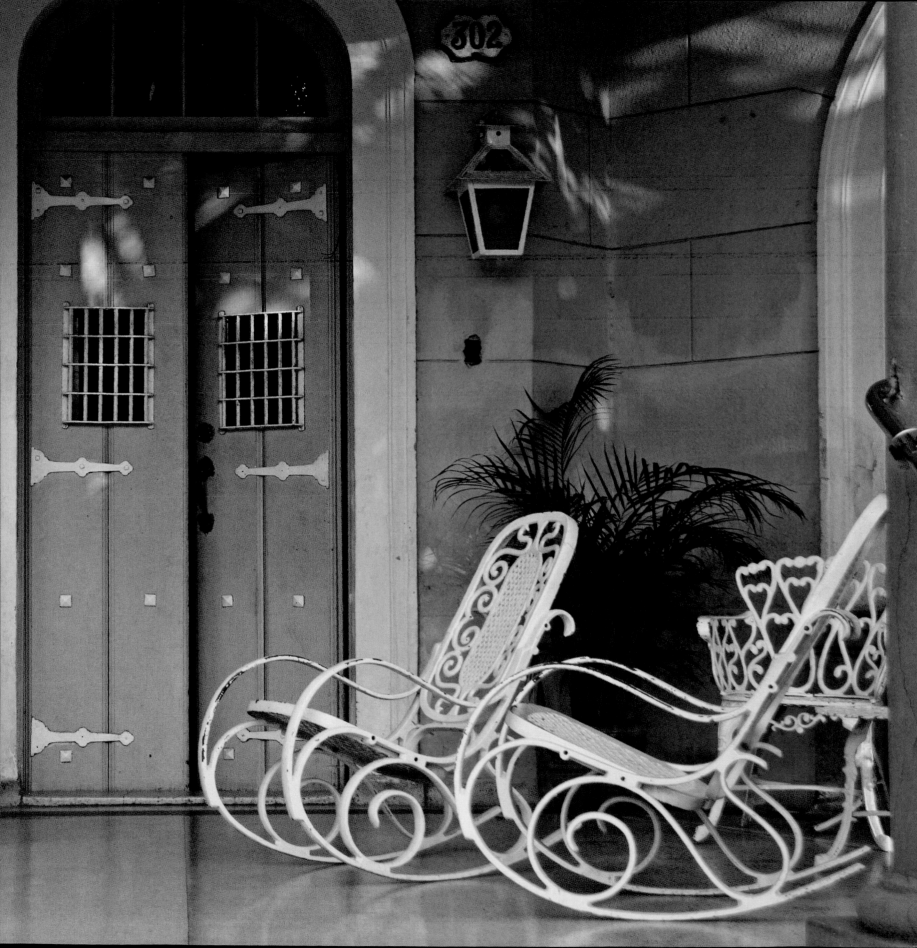

HAVANA

59

The aroma of coffee filters through the half-light. The concert of the afternoon chatterers is carried on gentle, musical voices. Comfortably ensconced in armchairs collapsing under the neglect of decades, it feels good to be here in the Dos Hermanos. The bar faces the harbor basin, the place where for centuries ships have docked, stuffed with cargo and adventures. Here, a glass or cup of something or other within reach, you can slip away in time and become a pirate, a Hollywood star, or more modestly a sailor from Mozambique serving as stoker aboard a Filipino liner that has just stopped in to Havana. So places do exist that can help you relive sepia-tinted memories, or set sail on virtual cruises to mythical destinations. Wedged together on benches pregnant with the odor of old rum and tobacco, you feel yourself pitching and rolling without moving a hair. The Dos Hermanos is an aid to sailing by proxy. These are time cruisers, and Havana is one of the loveliest stops on a voyage of nostalgia.

Entering the harbor, which is dominated by the fortress of La Cabaña, is like a promise to sailors from the whole world, the promise of sorcery in the old city. The availability of maddening flesh,

the bottles of rum that are already open, the rogues lurking in the shadows. We've been expecting you, sea dogs.

After all, this is a port, isn't it?

If by some miracle you've managed to avoid making your first stop in these parts, it is because the offshore air has not yet succeeded in backing down before all the devilry taking place ashore. You simply cannot get enough of breathing in the air along the front, the Malecón, a promenade some eight miles long, bursting with passionate, erotic, sporting images. That's its name, the Malecón, and it is the love map of Havana. This is where the locals come on to one another, start kissing, and sometimes go even further on the rocks that serve as their love nests, because the capital's overcrowded housing stock does not provide for more comfortable trysts. All in full, enraptured view of the tourists: fisherman perched on their *gomas* (inner tubes), waiting hopefully for dinner; children performing jackknife or swallow dives from the seawall that looks straight down into the Atlantic.

Close by, Old Havana is a magic enclave in a city where everything seems to have been preserved for centuries. Tourist policy—ever since the Soviet Union threw in the towel, tourism has been an essential cash cow topping up the government budget—has led officials to renovate and rebuild . . . and in some cases to demolish, once

 New worlds need to be lived before being explained.

Alejo Carpentier

and for all, ruins that were inevitably destined to be dumped, a quarry already full of hideous cankers, at the very heart of a UNESCO World Heritage Site. All the credit for having preserved this city from the horrible excesses of modernism lies with one man, Eusebio Leal. So despite the fact that the grand old houses that surround the cathedral have been converted into bars and restaurants, a museum of handicrafts, stores where you can buy cheap trash, the Plaza de la Catedral is still a real jewel.

Taking a little side street, you step straight into history. This is the Palacio de los Capitanes Generales, since converted into an open-air library, and farther down, facing the Port Customs building, stands the church of San Francisco de Paula. The area is crisscrossed with alleys lined with hotels, all remarkably restored and named in honor of the Catholic conquistadores . . . Los Frailes, Beltrán, Valencia, Santa Isabel. We pass a house whose worm-eaten facade has been turned by its rebellious owner into a clotheshorse for oversize ladies' panties, sheets and terry cloth towels, and can't help smiling. Oh, the outrage to the Plaza Vieja! From the Calle Obispo we go down to the Prado and its boulevard, which leads to the sea. Here grand old houses, their names so evocative—Casa de los Arabes, Casa del

Científico—bear witness to past splendors, and on we walk to the more conventional Hotel Sevilla, just a few cable lengths from the Hotel Inglaterra, where Enrico Caruso used to serenade Sarah Bernhardt.

Another world starts at the intersection where Calle 23, the main thoroughfare crossing Havana, joins the Malecón. This district is called the Vedado. It is more modern than its historic cousin, and is the core of a rollicking, industrious, bourgeois, commercial city. The Americans made no mistake about it. During the dictatorship of President Batista, the big *"amigos obligados"* invested in hotels with a sulfurous reputation, such as the Nacional, the Capri, the Deauville and the Riviera. These were the headquarters and amusement parlors of mobsters from New Jersey and Florida. When all is said and done, Lucky Luciano, Meyer Lansky and Santo Trafficante did more good for the crime novel than they did for the city, but with the benefit of hindsight, you might say that this agitated period also helped make the fortunes of screenwriters who told the tales of what used to be called the bordello of America.

The city then stretches away to the west, to the residential district of Miramar and the secret houses of El Laguito, the closely guarded residences of apparatchiks designated for public denunciation by the counterrevolutionaries.

Havana needs to be experienced. As for explaining what it's all about, you'd need an eternity . . .

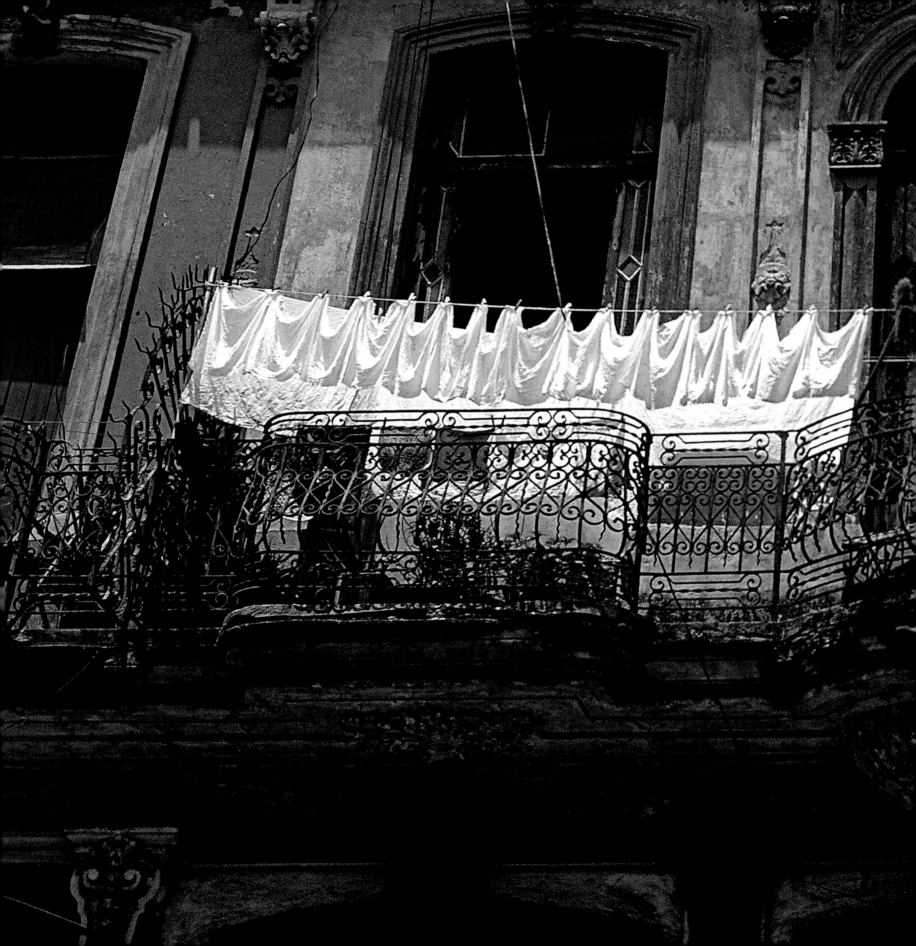

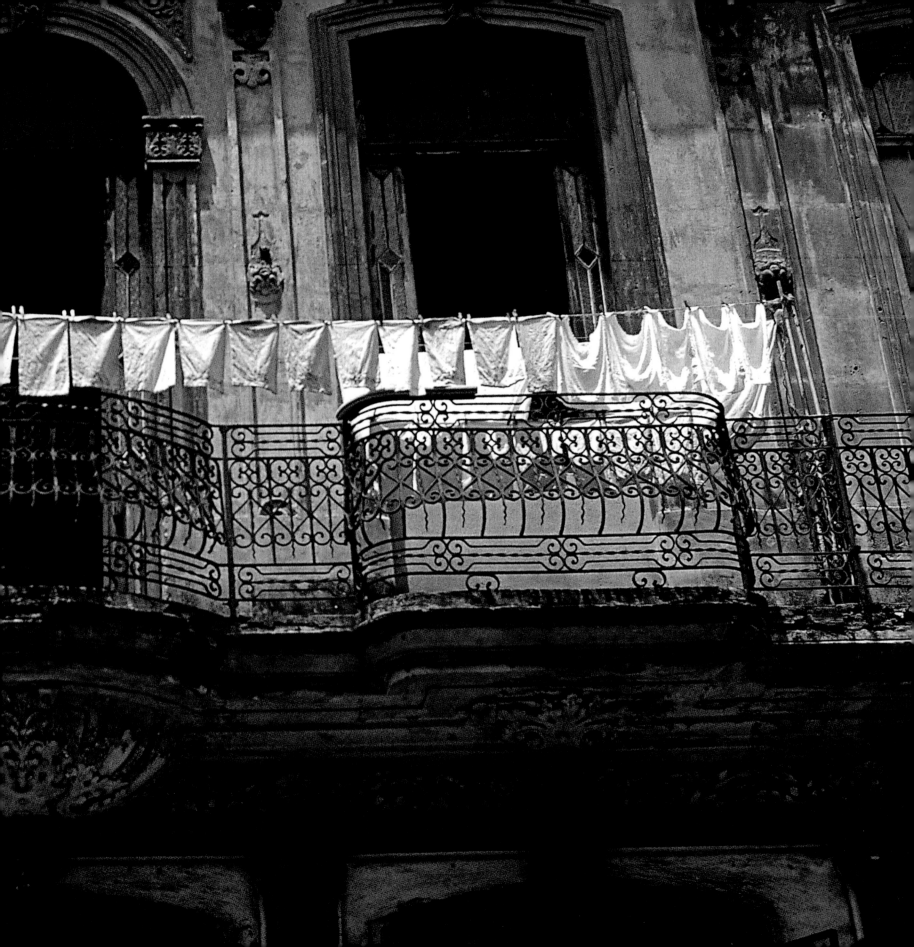

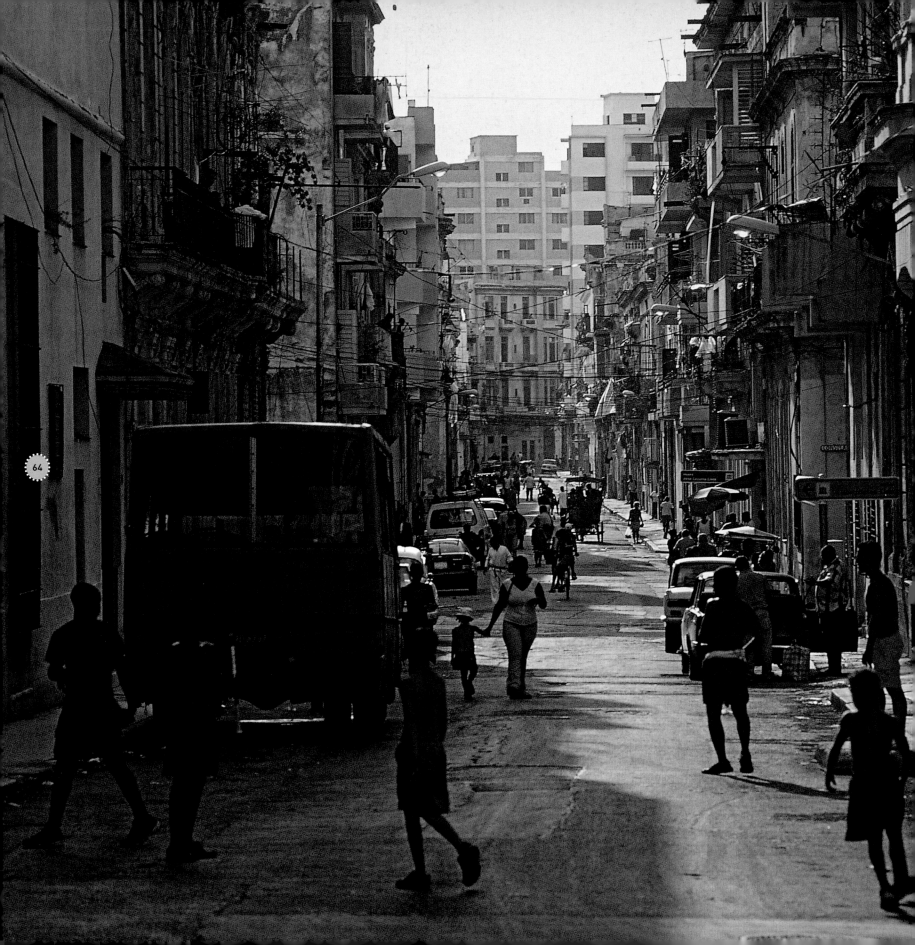

Havana has given its name to a color: the color of cigars. But the eye adds other shades: the sepia of the narrow streets that even at noon are shaded by houses so close to one another, they almost touch; and other, fresher colors— the hues of the tableaux of life pouring out of houses that haven't been in existence long enough, or lack the means, to make themselves over in the image of beauty betrayed by age . . . The latest wash—shorts, pants, brassieres—sways at the mercy of Phoebus, the free, guaranteed clothes dryer.

"Cuba, this is how it is
at this hour of the morning.
Ghosts walking gravely
Or pedaling their bicycles
Like speedy knights
Of adversity."

—Hermann Bellinghausen,
in *Ojarasca*, August 1993

RIGHT
A street scene in Old Havana.

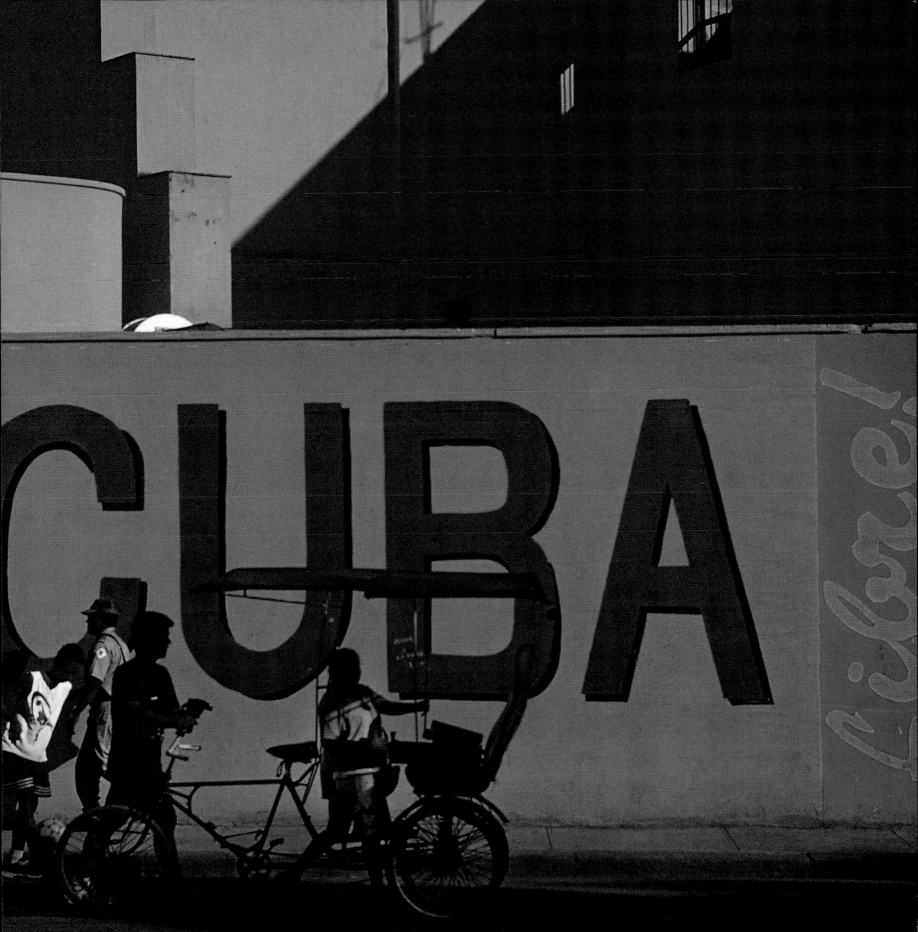

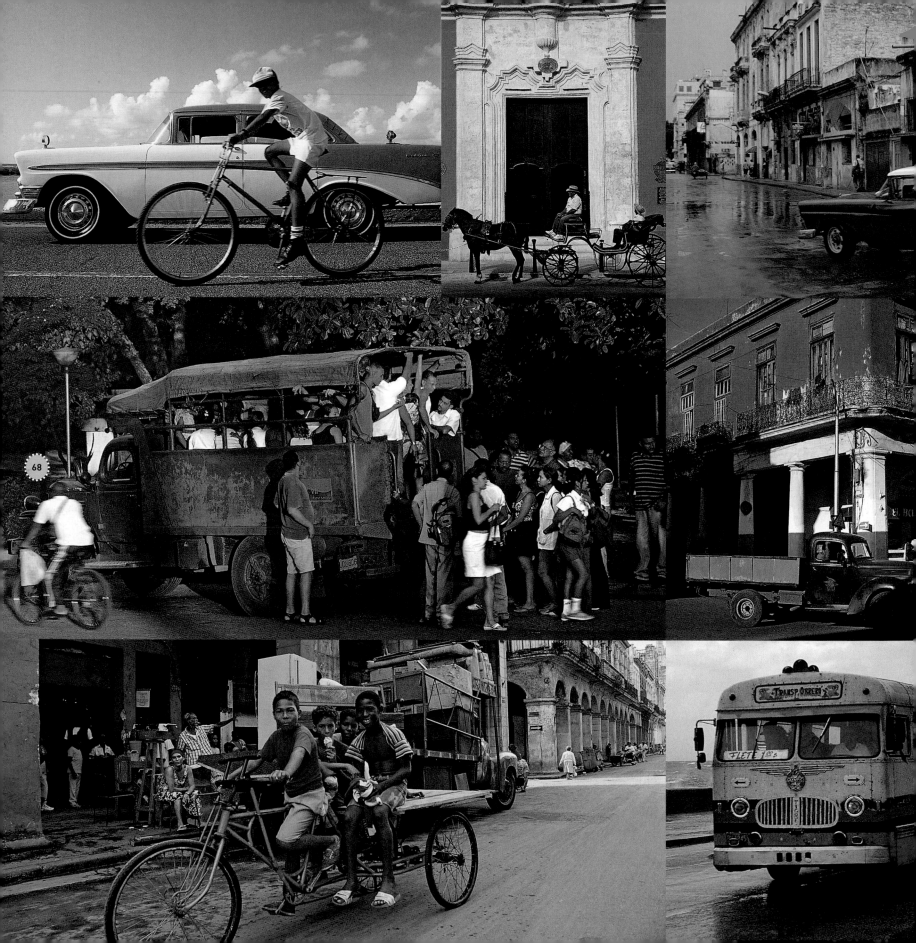

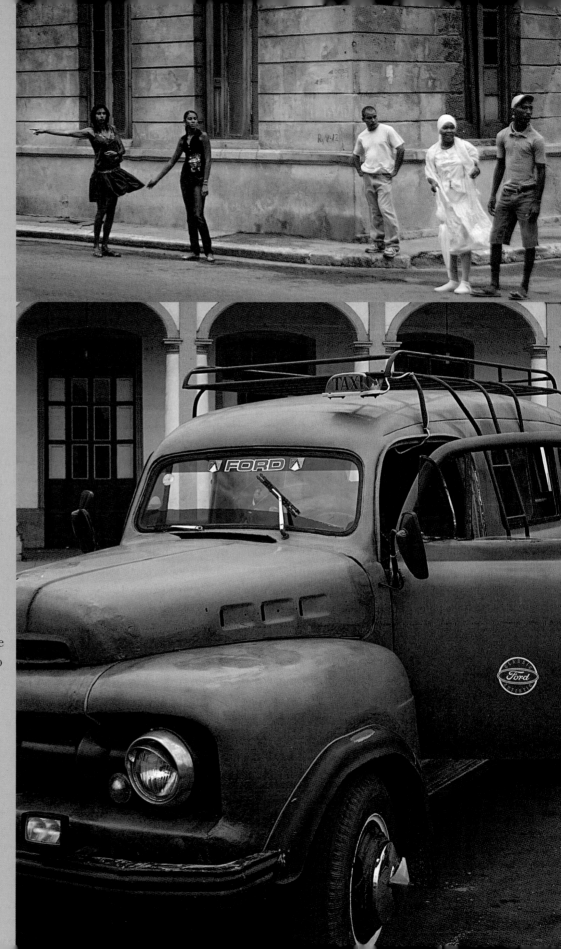

Transportation.
This word is the key to everyday life in Cuba: for the tourists, quaint as folklore; for the locals, a nightmare. The departure of the country's Soviet sponsors in the late eighties left Cuba drastically short of energy resources. Since then, its fatalistic population has had to rely on bicycles, sixty-year-old Chevrolets that are short of breath, and the indescribable dual-humped *camelo* bus to get them around—though recently some have started coming around to Hondas, Toyotas and Mazdas.

LEFT
A classic American automobile and a bicycle on the Malecón.
A carriage in front of the Rum Museum.
A street in central Havana after a downpour.
Off to work in the early morning in Old Havana.
Delivering goods to a market in Old Havana.
Bicycle rickshaw, central Havana.
A bus on the Malecón.

RIGHT
La botella, a nickname for hitchhiking, is as famous in Cuba as the salsa. In the Calle San Lazaro, in central Havana.
A taxi for the locals, Plaza del Capitol.

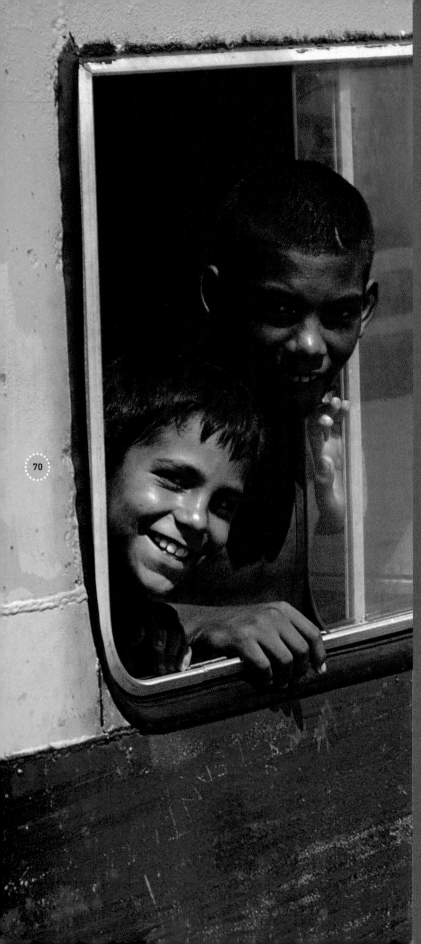

The hardships that Cubans face because of the country's failing economy mean that, despite the oil from Venezuela, they have to walk a veritable marathon each day to get to jobs that are themselves hardly permanent. The only people benefiting from the automobile recession are the professional cyclists, who pedal miles and miles each day on their *bicitaxis*. In reality, these are Cuban-style bicycle rickshaws that travel about to the accompaniment of *La Charanga Habanera*. The music helps the drivers get up the hills.

LEFT
Cerro district children on board a *camelo*, Havana.
RIGHT
A *bicitaxi*, Havana.

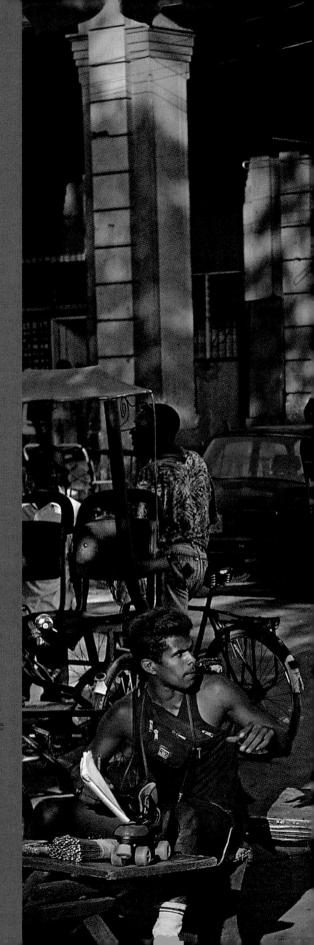

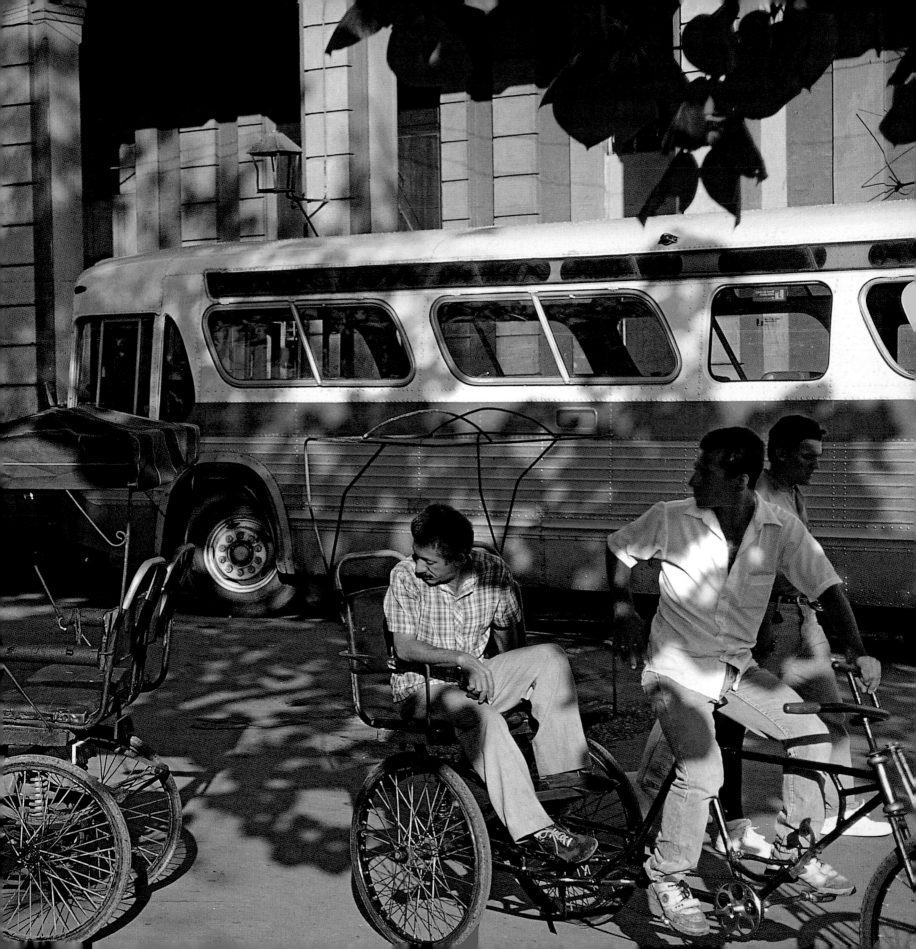

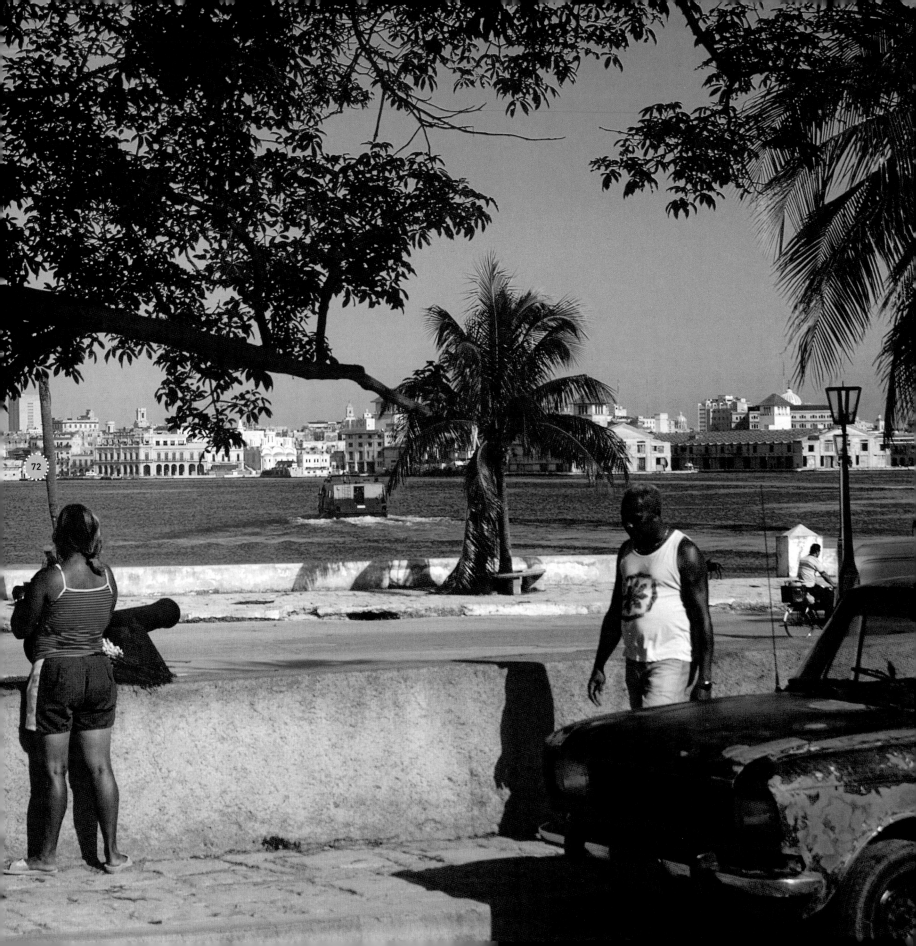

Despacio, despacio...
Take it easy, take it
easy, there's no rush.
What's the use in running by
the harbor under the sun?
Why work up a sweat? The
Lada here just decided to
stop inflicting agonies on
its pistons and gave up the
ghost months ago, maybe
because its carburetor quit
or its transmission couldn't
take it any longer. So isn't it
better just to leave the poor
thing in plain view of the ferry
that goes from Old Havana to
Regla on the other side of the
bay? Or just take off—*despacio,
despacio*—in search of a fish or
a pound of rice?

LEFT
A view of Havana from Regla.
RIGHT
Ménage à trois. Lovers alone in the
world . . . with their bicycle.

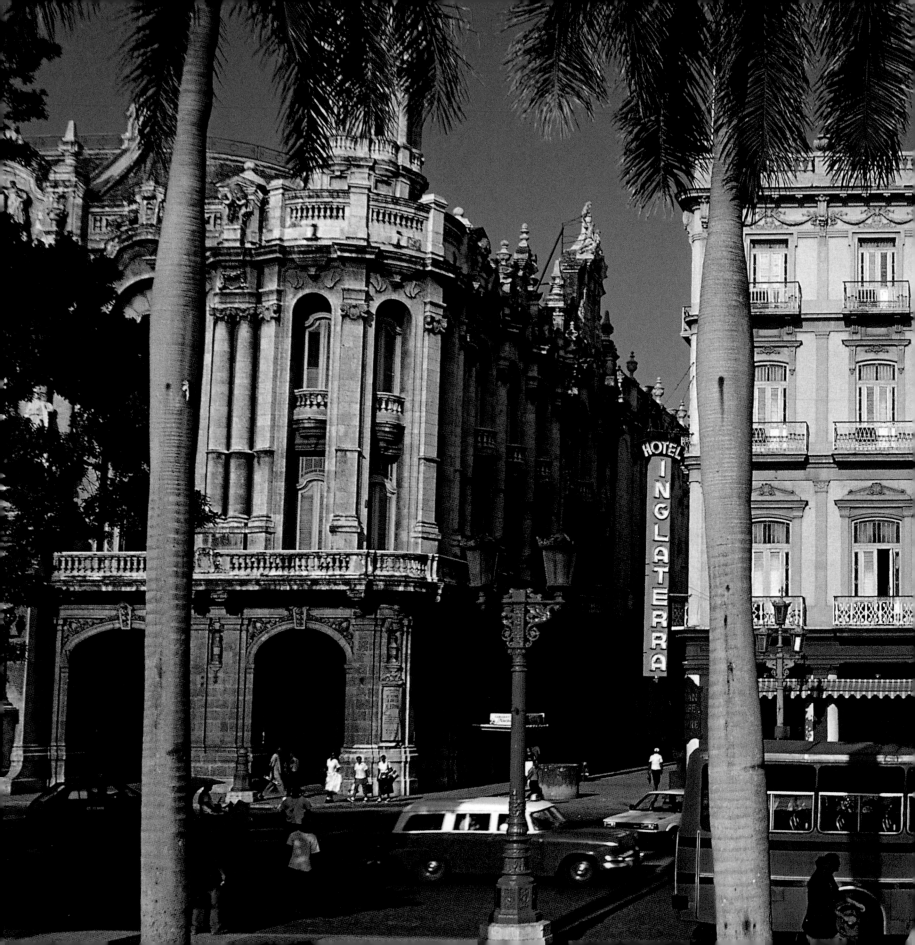

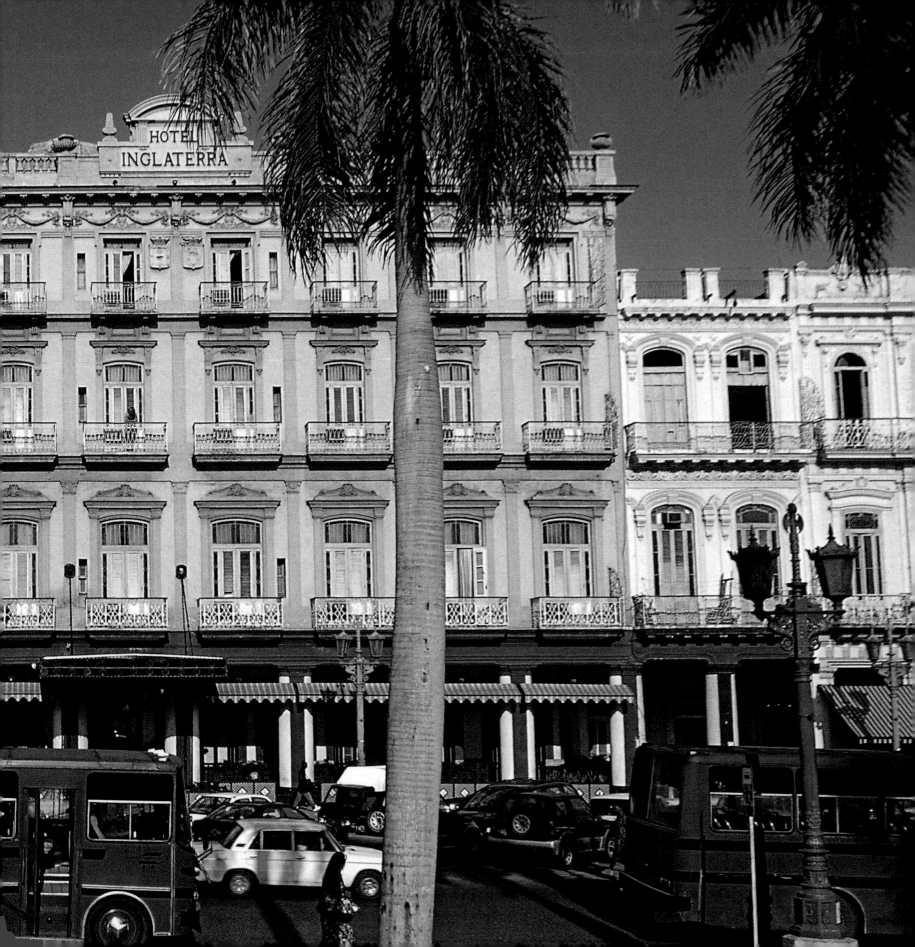

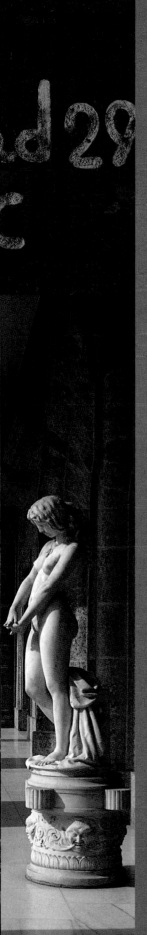

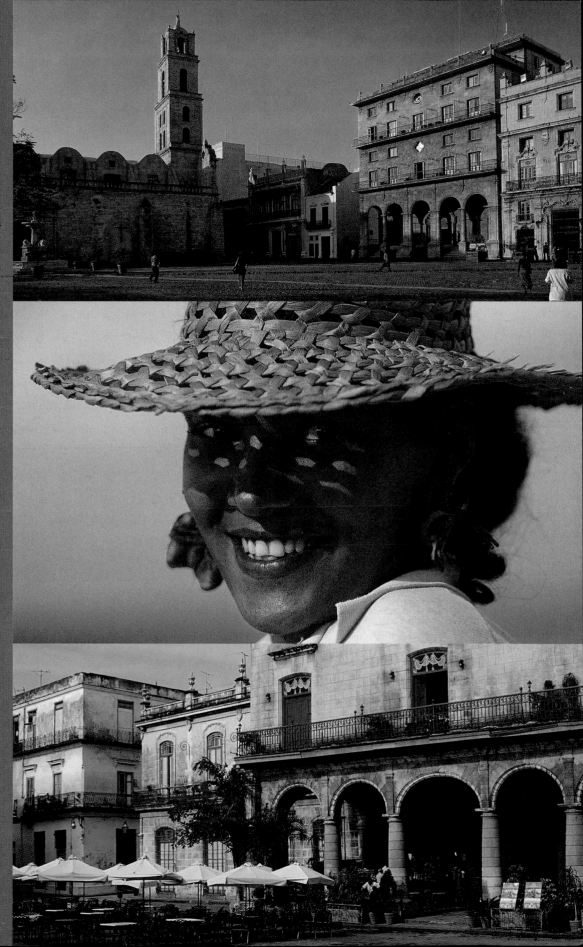

Havana's centuries-old stones store memories that today, at the beginning of the 21st century, resonate in a special way. Walking around the city streets you find images that seem emblematic of a history forgotten because of geopolitical agitation, such as the Hotel Nacional, where Lucky Luciano used to receive his trusties; the marble statue of Venus, which remained following an appeal by CDR (Committees for the Defense of the Revolution) de la Unidad 29; or the Hotel Inglaterra, where you enter Old Havana.

PREVIOUS SPREAD
The Hotel Inglaterra, on the Parque Central.
LEFT
The Hotel Nacional and Havana Bay.
On the door of a local boutique selling articles for people who have a *libreta*, a ration book.
Detail of a portrait in Vedado.
Classic automobiles on parade in Vedado.
On the front steps of a building in the Plaza de San Francisco.
RIGHT
The Plaza de San Francisco, Havana.
No matter what the occasion, no matter the price of oil or the price of coffee, a smile from a *Havanera* is a delicacy that comes free of charge.
The Plaza de la Catedral.
VINTAGE PHOTOGRAPHS
LEFT Ferry in Havana harbor, 1909.
RIGHT Streetcar on Almendarès Bridge, Havana, 1909.
POSTCARD The reservoirs at Palatino, near Havana, 1930s.

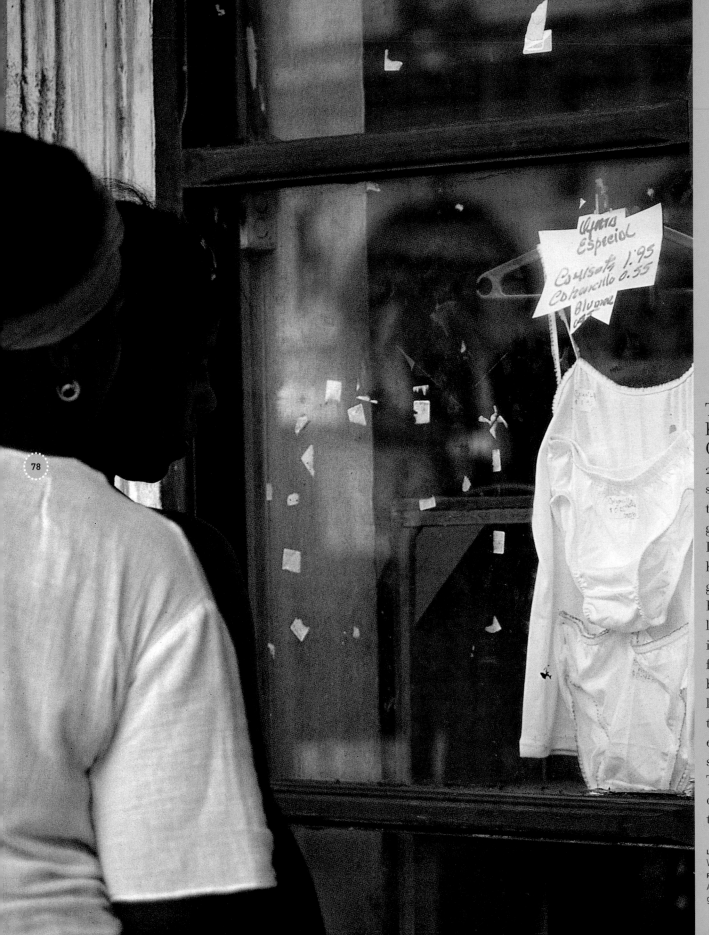

The tourist hordes that have swarmed down to Cuba since the end of the 20th century have basically stuck to the beaches; but, as the saying goes, you'll never get smart while sunbathing. It's a pity, because the country has other riches that too often go unrecognized, such as the European culture that has left behind indelible traces in the capital, like that of fashion. Take El Quitrín, a boutique where the elegant ladies of Havana used to buy their cotton dresses, finely embroidered by the skilled seamstresses of Old Havana. They look just as gorgeous on the sleek necks of ladies tanned by the sun of Varadero.

LEFT
Window shopping in Reina.
RIGHT
A game of chess under way in a Vedado games club.

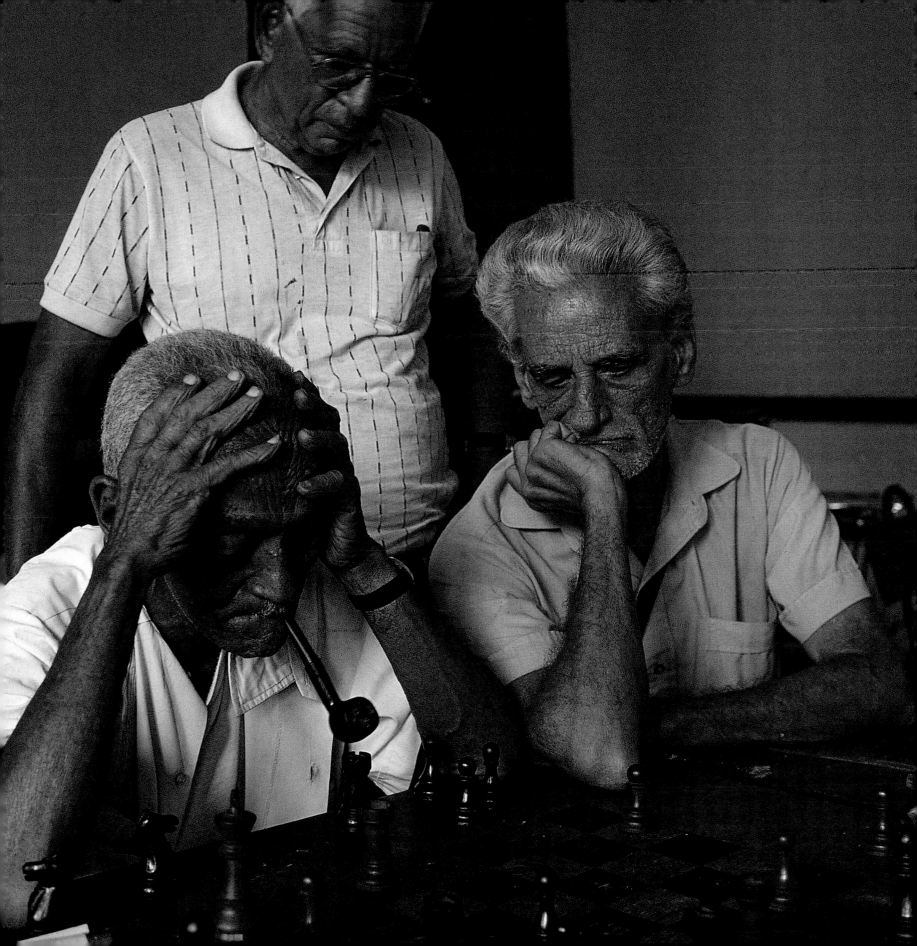

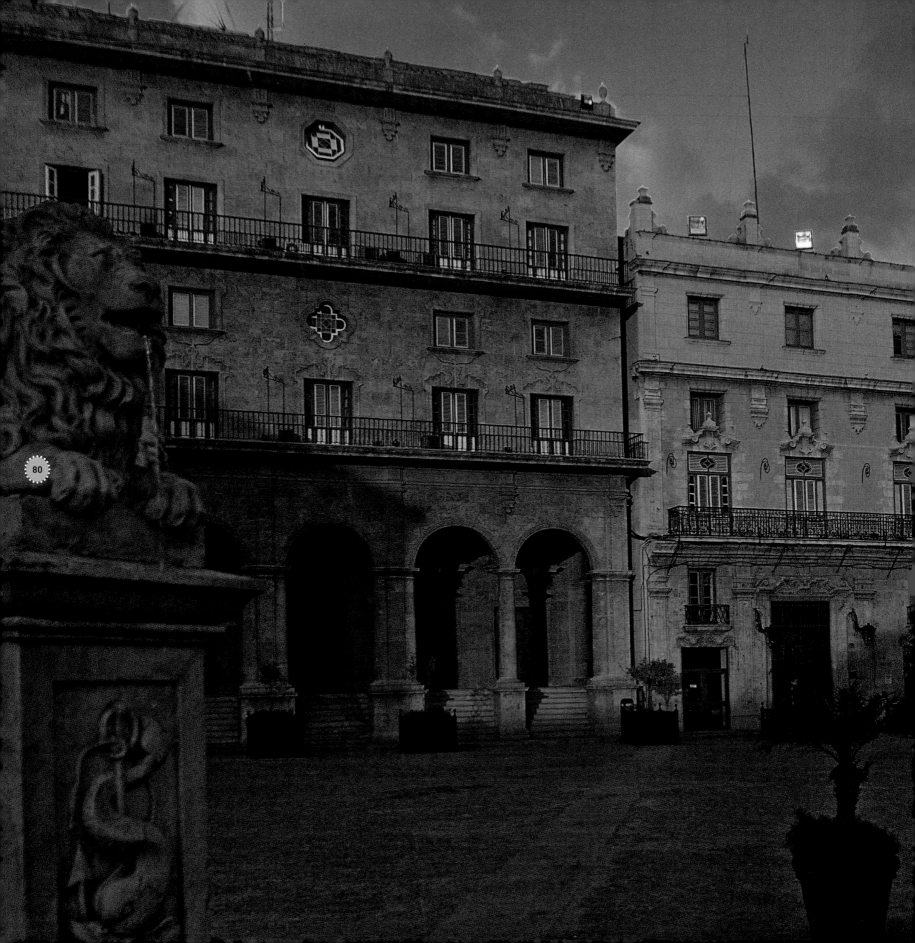

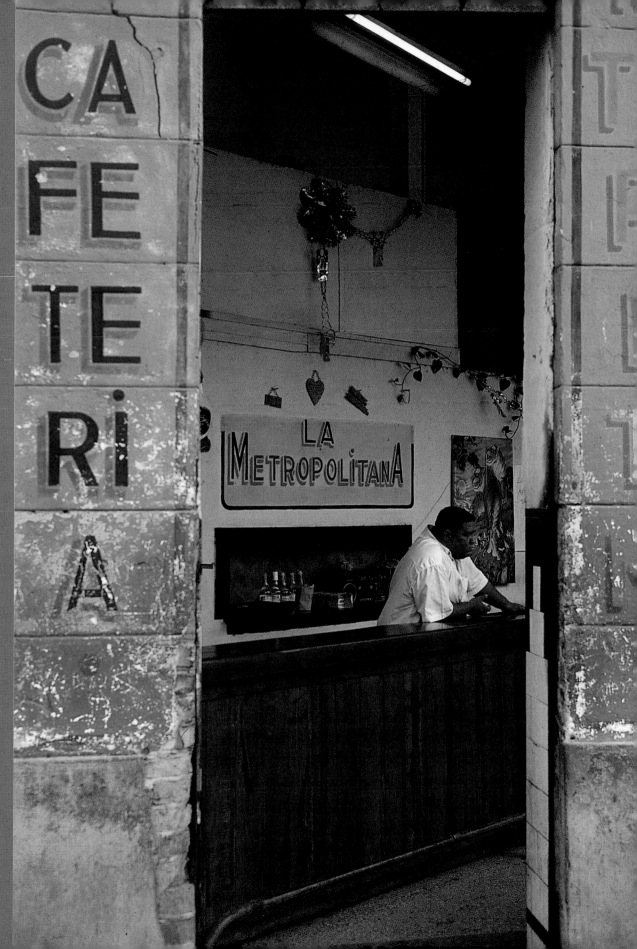

When photographers stop in Cuba, their paranoia is fed by the daily weather forecast. What could be worse than trying to capture on film a facade hemmed with wrought-iron balconies and supported by beautiful-breasted caryatids under a sky turned leaden by the midday sun? Ah, the relief that is brought on by those wonderful late afternoons, when the setting sun grazes the roofs, breathes over the buildings around the Plaza Vieja, and sets the terrace of El Patio, on the Plaza de la Catedral, on fire! There's more than enough sunlight for everyone, and the crimson flames even creep up the austere church of San Francisco. What a treat!

LEFT
The Plaza de San Francisco, with its lion fountain carved by Giuseppe Gaggini in 1836.
RIGHT
A lonely barman with nothing to offer except an empty glass.

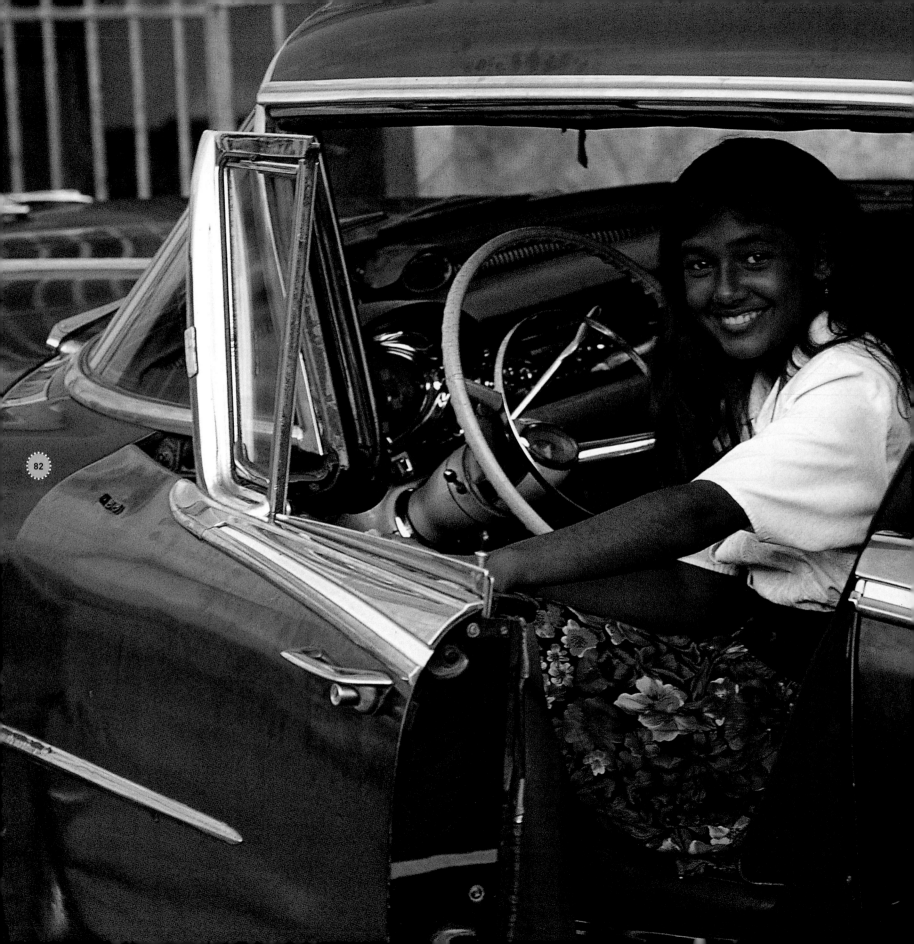

"Looking to buy
one nurse
in good condition,
healthy and blameless
for a refinery:
apply at
Calle de Cuba, no. 114."

—Manuel Moreno Fraginals,
"Diario de La Havana, Monday, March 5, 1835," *El Ingenio*

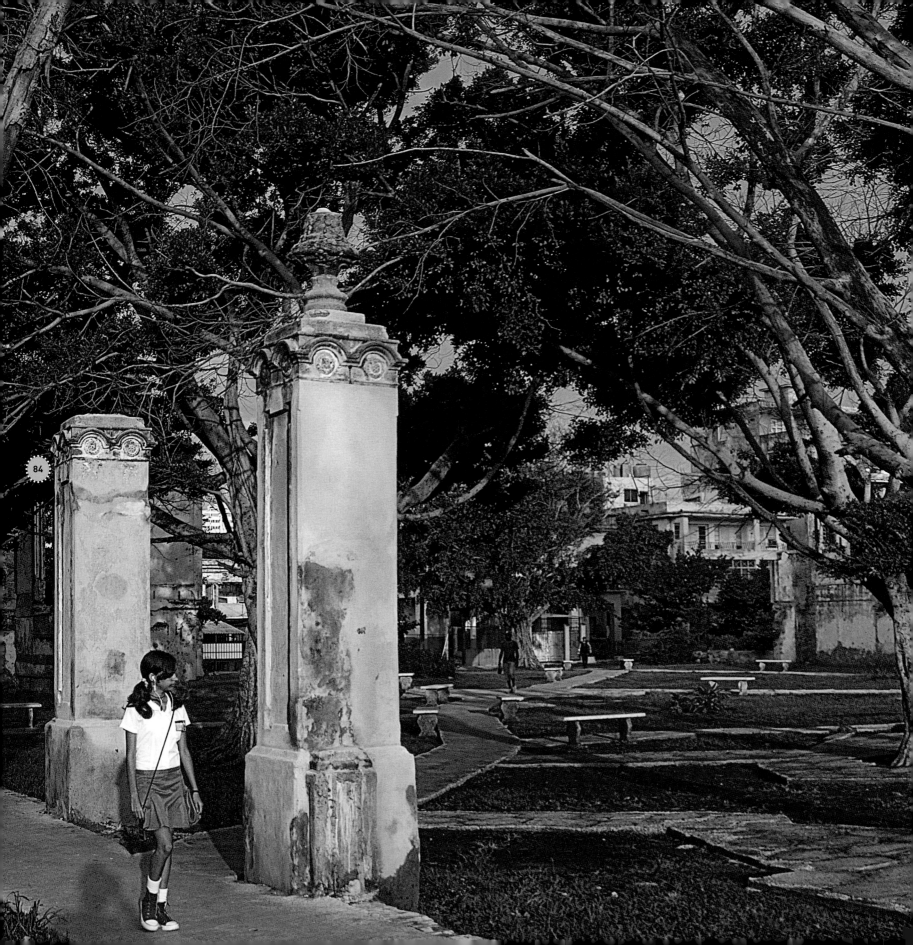

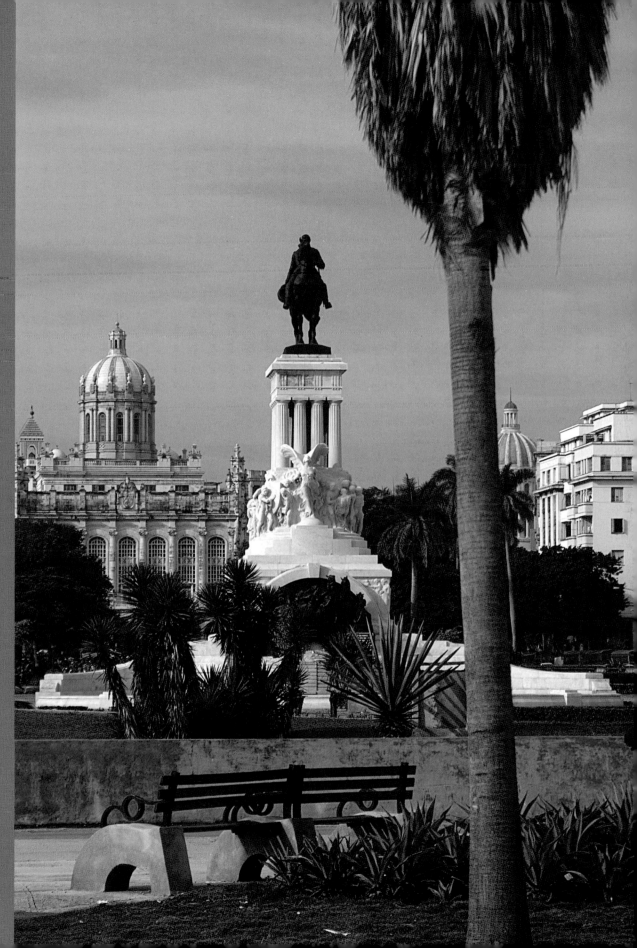

History is present everywhere in Havana. It steps up proud and imposing, in the shape of equestrian statues such as that of Calixto Garcia on the Malecón, and becomes shy and self-effacing when it runs up against revolutionary dogma—the explosion of the USS *Maine*—or triumphant beneath the dome of the capitol, inspired by the Capitol in Washington, D.C., and takes its place in the glass casings in the Museum of the Revolution behind the Hotel Sevilla, a brief distance from the Prado. Or it takes a more modern approach, embellishing the immense banners that proclaim the glories of the heroes of the Revolution and the country's passionate determination to preserve its independence.

LEFT
An escort of *ceibas* (ancient, sacred trees) for a schoolgirl as she crosses a park in Vedado, near the Paseo.
RIGHT
The statue of General Máximo Gómez, unveiled in 1935, with the Museum of the Revolution (the former Presidential Palace) in the background.

FROM THE JUNGLE TO THE SEA 87

Guamá, in the Matanzas Province, is on the shores of the Caribbean. So that the tourists will go crazy with their camcorders, they have mocked up nature here, turning it into a sort of baroque Disneyland, Cuban style, complete with trashy statues of Indians made out of pieces of scrap metal, and exotica in the form of key rings and lighters.

And then there are the crocodiles! That's all there is left of anything genuine, a few dozen yards away from this artificial pueblo pompously heralded as a tropical Venice. We are in the Ciénaga de Zapata, the Zapata Swamp, where Castro's revolutionary exploits reached their high point, the Bay of Pigs, that catastrophic attempt by the United States to pull off a Pearl Harbor in the Caribbean by sending in an army of mercenaries to destroy the new regime in Cuba. The adventurers who escaped the hail of fire from the locals were sometimes less fortunate than the giant reptiles who found themselves being showered with unexpected tidbits from the sky. It is as if the new rulers in Havana had determined to confirm that theirs was indeed a special land, as the great Cuban poet Nicolás Guillén had pointed out.

The isle of the "green lizard," as Guillén called it, stretches over seven hundred and fifty miles, from the Yucatán Channel and Mexico in the west to the Windward Passage and Haiti in the east. When Christopher Columbus first sighted El Yunque, the anvil-shaped mountain at the entrance to the Bay of Baracoa, at the farthest eastern point of the island, he wrote ecstatically in the log of the Santa Maria, the flagship of his flotilla of three caravels, "I have never seen so beautiful a country, with palm leaves so large they serve as roofs for the houses, on the beach shells in their thousands, a water so clear, and always the same dizzying symphony of birdsong." As we all know, Columbus's ecstatic feelings did not last long.

After discovery came the conquest, not a very peaceful period in the history of the Caribbean, when Hernán Cortés's troops faced off against the peaceful Taíno Indians in their lairs. They were at home, in their mountains.

Since the beginning, the Cubans have been caught up in a love story with their wild yet generous land. Here nature provides them equally with

 Every man has two mothers:
nature and circumstance.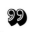

José Martí

their pittance and a dearly bought independence. You try to flush out a rebel when he is hiding in impenetrable undergrowth, in terrain with which only he is familiar, where if he needs to eat he'll catch a bobwhite or a snipe if he's in the area of Florida and Morón, or go fishing for scampi in the Yumurí River, and then head back to his *bohio* (hut) deep in the forest.

The shape of the land is a secret in itself, and has played its part in the turbulent story of the country. Behind Trinidad, in Sancti Spíritus Province, the Escambray Mountains conceal peaks, valleys and waterfalls, and stories of blood and violence in equal numbers. After the coming of the guerrillas in the late 1950s, the counterrevolutionaries set up in secret places in the Escambray. Barely twenty miles from Trinidad, you can hike on trails up in El Cubano national park, beneath the El Rocio waterfall in Guanayara Park, or beneath the Caburni and Vegas Grandes falls. The peace that reigns here helps erase the memory of the violence that raged through these mountains during Batista's fall. The

Topes de Collantes lie at the center of ten or so nature reserves. Here coffee shrubs crowd the abrupt slopes, while the woods echo the boisterous, joyous song of woodpeckers, cockatoos, the Cuban tody, and the Cuban *trogon*, that most emblematic of all the local birds.

From the sugar fields of Ciego de Ávila, Camagüey, Las Tunas and Holguín, we descend eastward to Granma, Santiago and Guantánamo, the three provinces of Oriente. Here, between Cape Cruz and Punta Maisí, rises the Sierra Maestra. This mountain range, dominated by Pico Turquino, is the watchtower of Cuban history. The dense jungle sneaks down to the very outskirts of Bayamo, Santiago, Manzanillo and Guantánamo. Baracoa seems to have been a refuge for the opponents of every regime to have ruled in Cuba. The *cimarrones*, African slaves who succeeded in running away from their masters, survived here, protected by a nature of such density it is impenetrable even to the light of day. Here more than anywhere else on the island, history and geography blend naturally into each other. You can see it on the walls on the buildings, on the road signs: Santiago, *ciudad heróica*; Bayamo, *rebelde*. As for Guantánamo . . .

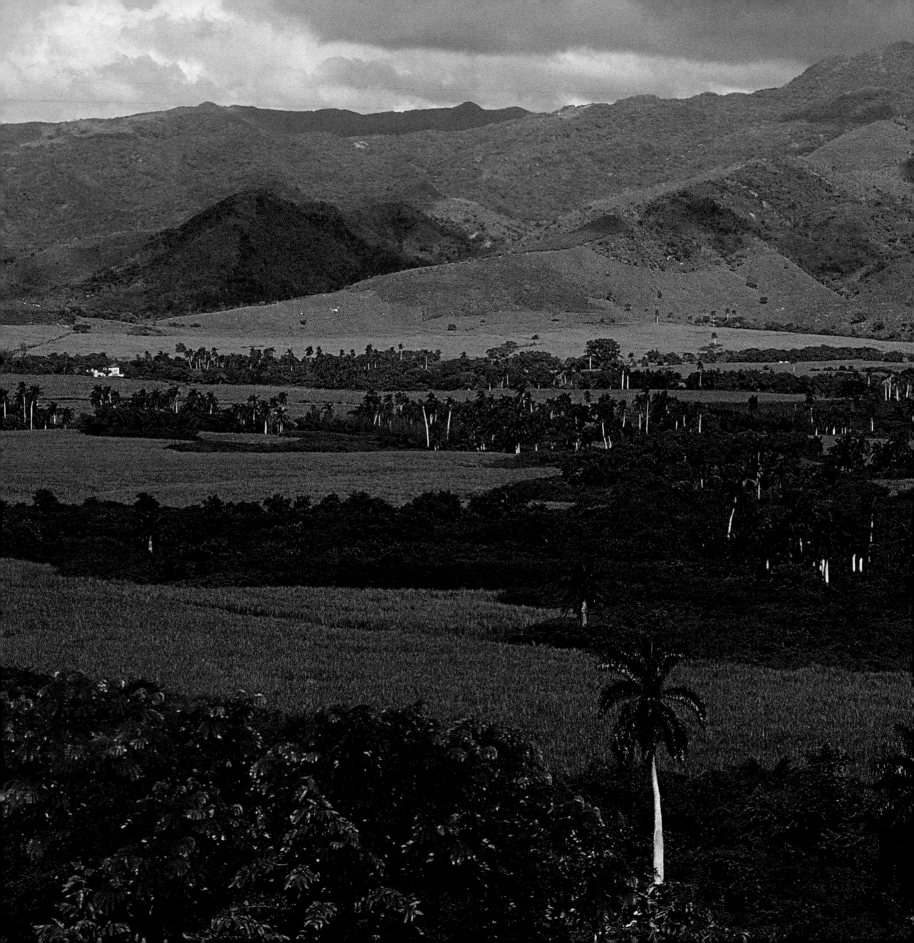

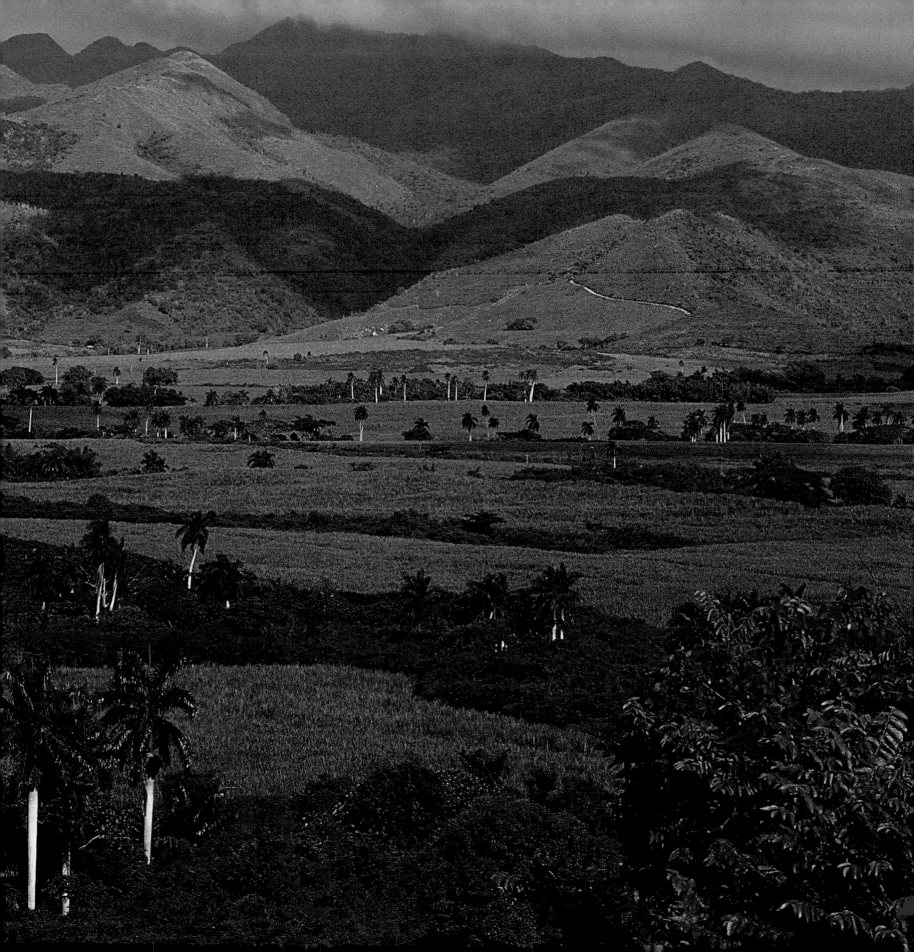

92

In Cuba, geography
shrinks away from
uniformity. Don't think
for a moment that you could
build ski slopes out here
in the tropics, even though
the mountains at Bayamo
and Chivirico are more
than six thousand feet high.
These are secret mountains,
shrouded in the jungles of
the Sierra Maestra and the
Escambray. At their feet lie
more welcoming foothills,
where farmers grow sugarcane
and cultivate a lifestyle based
on serenity. This is the Valle
de los Ingenios (Sugar Mill
Valley), near Trinidad.
Such peace on earth so
long forgotten!

PREVIOUS SPREAD
The Valle de los Ingenios at the foot of
the Escambray Mountains.
LEFT
El Rocio waterfall in Guanayara Park.
RIGHT
The Viñales Valley and its *mogotes*.

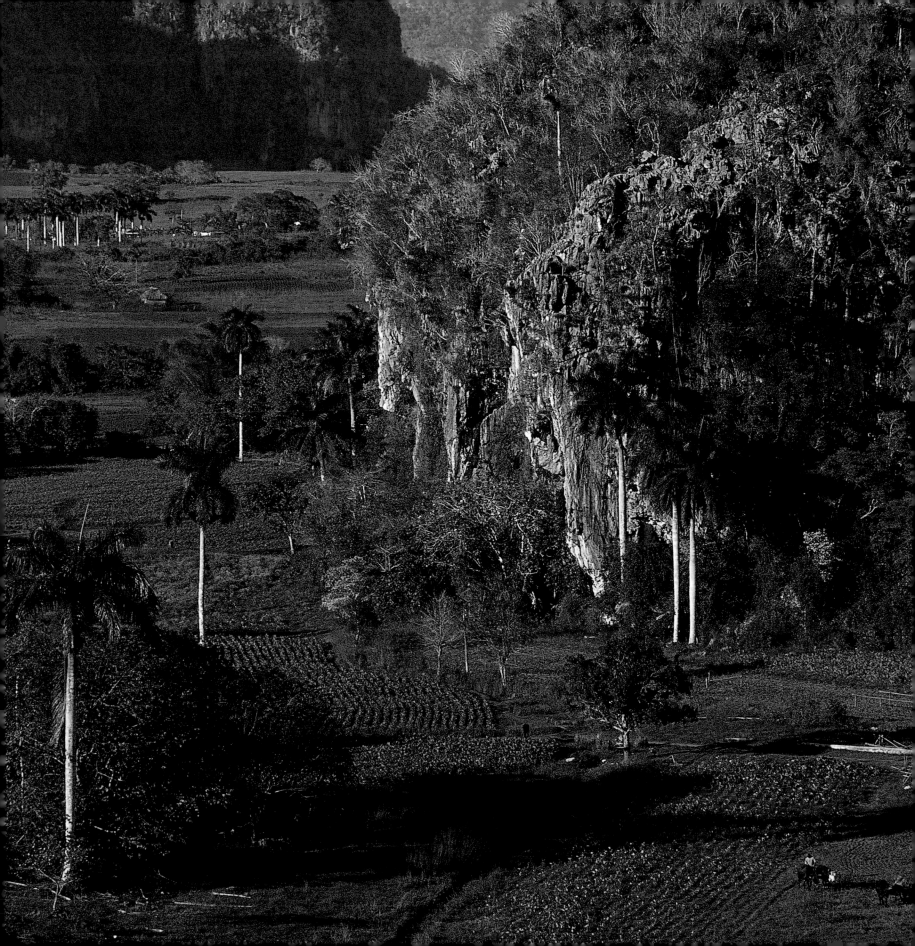

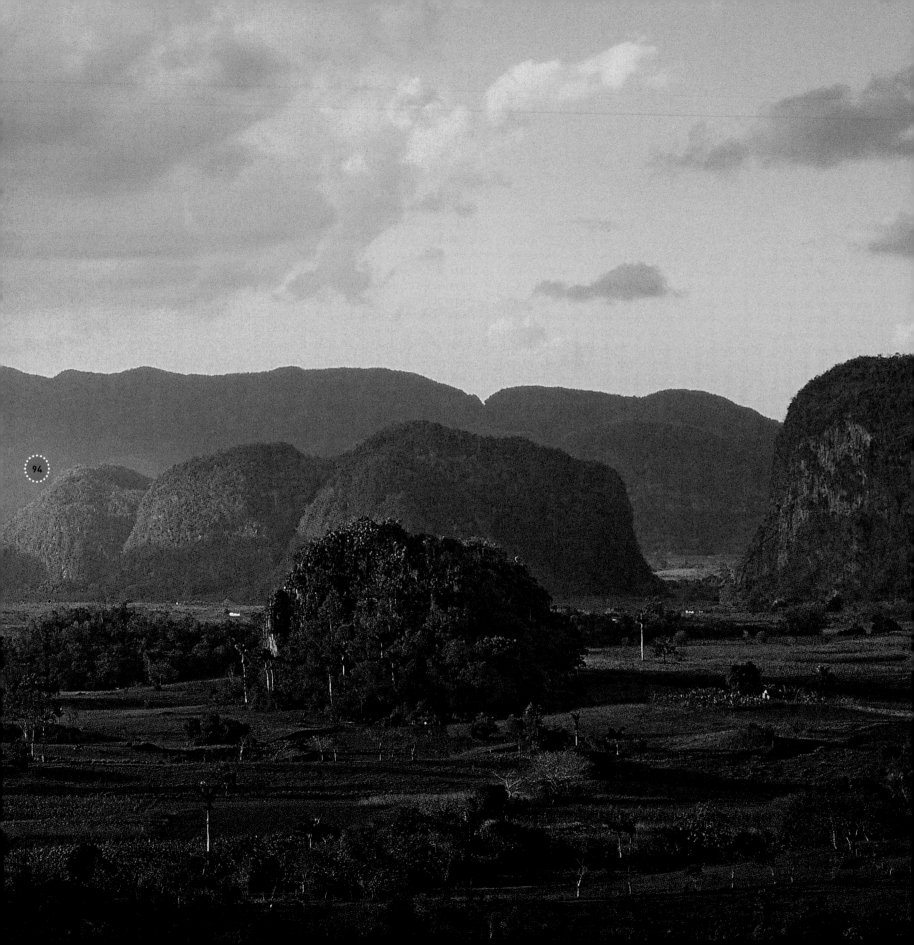

The *mogotes* in
Viñales Valley are
vast outcrops that
seem to have been dropped
here from a lunar world of
extraordinary vivacity, or
perhaps enormous spongy
babas on display on a gigantic
baker's stand belonging to
some megalomaniac, celestial
pastry chef for his clientele
here below. As for the rum,
of course, there's all we need
down here. The fields, tamed
by the plough, are among the
most fertile in the country.
It is hard to imagine a lovelier
showcase for tobacco to
grow in.

LEFT
The Viñales Valley and its *mogotes*.
RIGHT
Baconao Park, an area of some 330
square miles, declared a World Heritage
Biosphere Reserve by UNESCO.

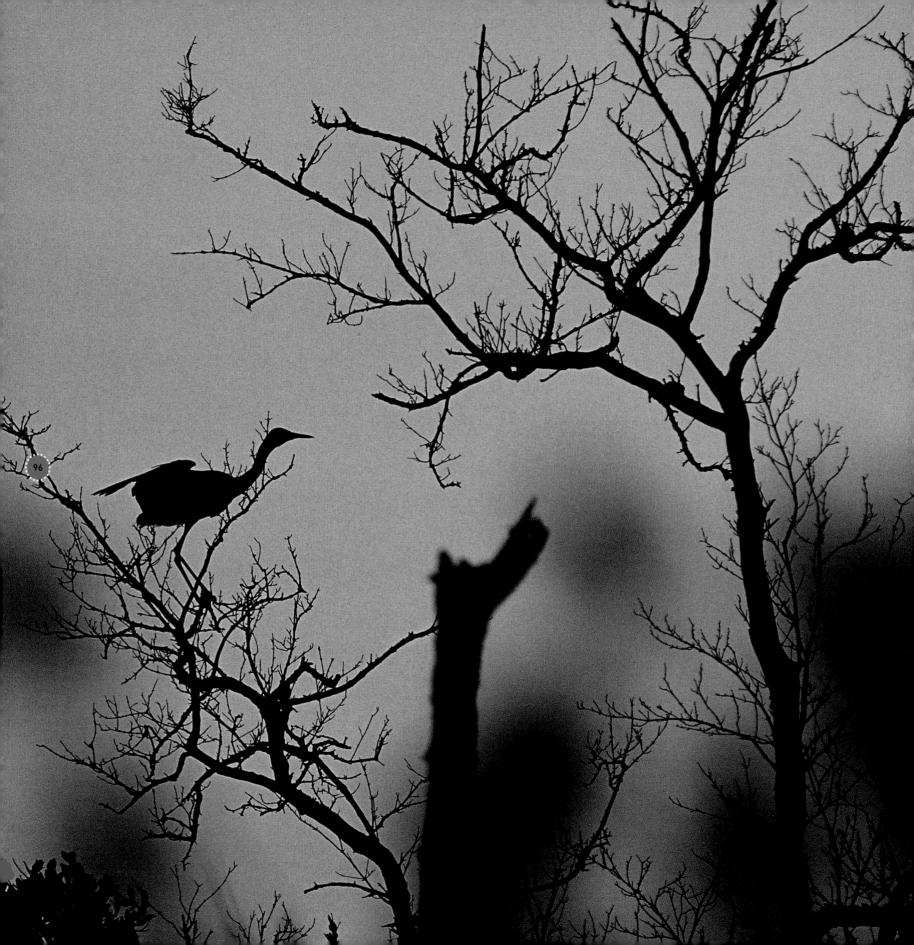

"Two miracles.
A mischievous child walking
Chasing butterflies
He chased them, the rogue, kissed them
And then among roses set them free.

Here below, near an estuary,
Once a sycamore stood
The sun sends a ray and from the dead wood
A golden bird takes flight, escapes."

—José Martí, *La Edad de Oro*

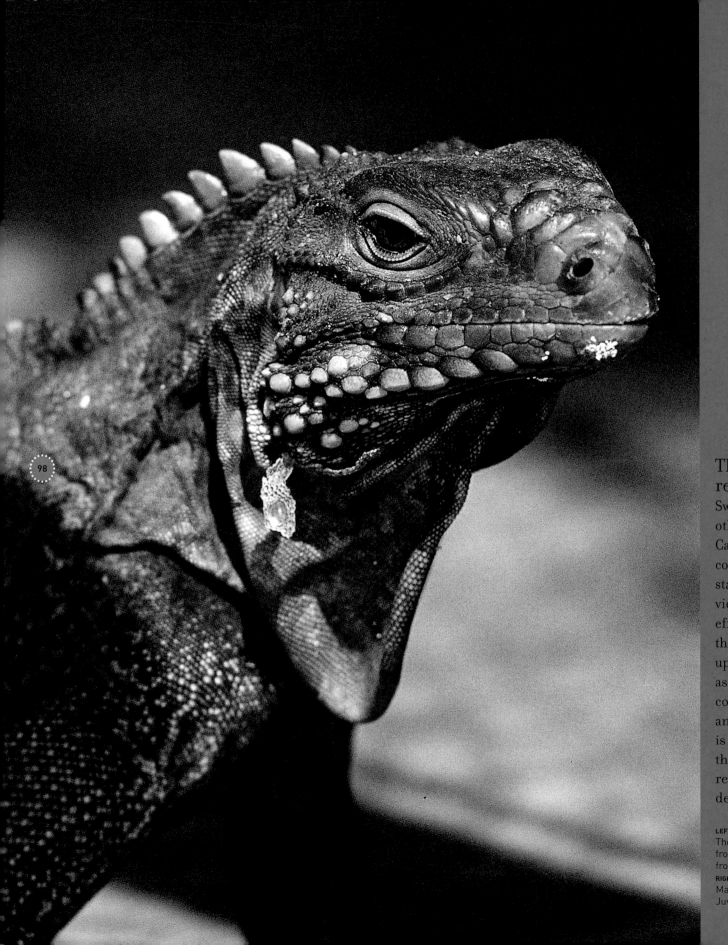

98

The earth is a revolutionary too. Swept by hurricanes and other disasters typical of the Caribbean, the country seems condemned forever to have to start anew. The roads are the victorious result of Herculean efforts to force a way through the rock, and they often break up under the cyclical, violent assaults of the weather. The coastal road between Chivirico and El Pilón, west of Santiago, is often closed because of the need for almost constant repair. Being a driver out here demands great patience.

LEFT
The iguanas of Cayo Blanco, half an hour from Trinidad, are rigorously protected from hunters by national park wardens.
RIGHT
Marble quarries on the Isla de la Juventud.

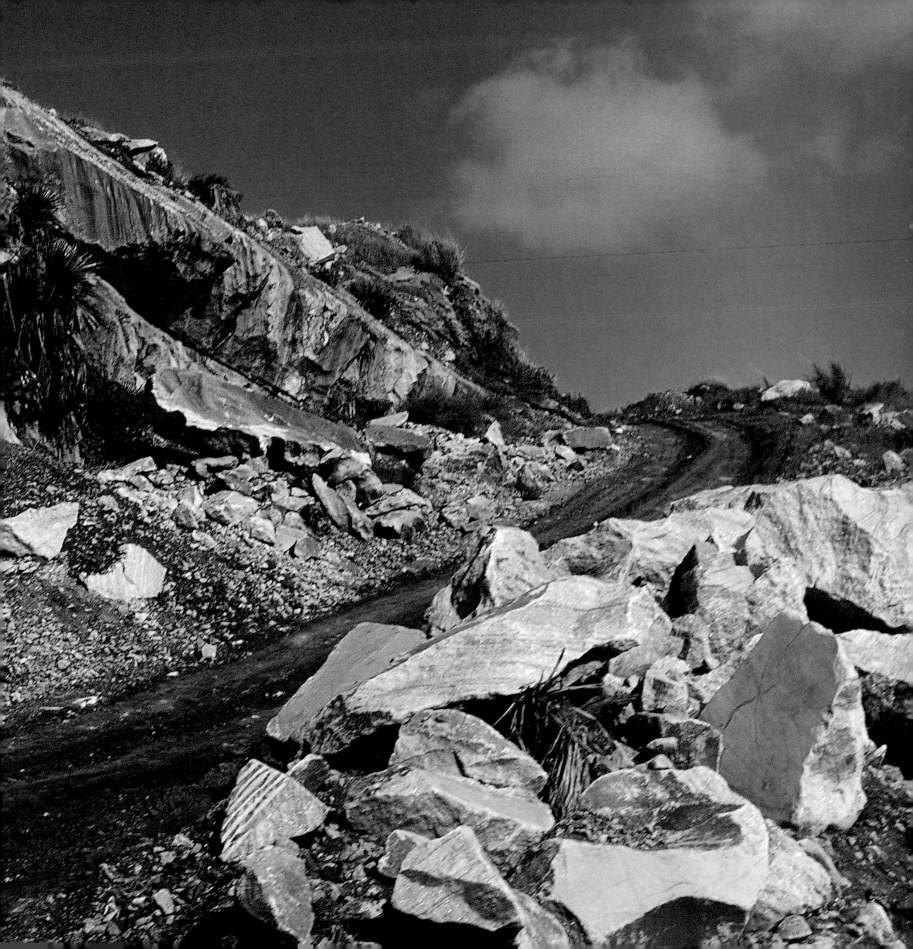

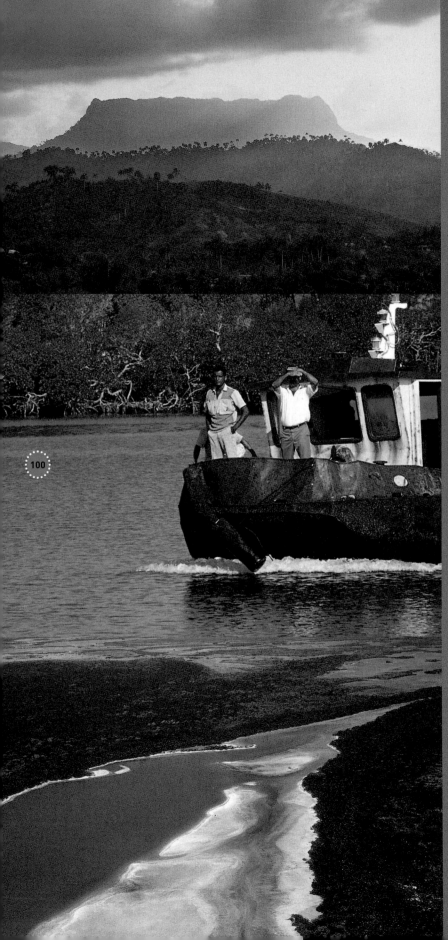

Cubans are born
wielding a paddle and
a fishing rod. To survive,
they have to count on the
sea, but here the sea is one
of plenty and, it must be
admitted, not overprotective
of its bounties. For it too
gathers its riches from
treasures deposited in the
river estuaries by countless
streams full of freshwater
fish. That is where the people
go to catch *cubera*, *sierra* and
tetis, delicious small fry that
are Cuba's caviar, while out
on Cayo Granma the scent of
shrimp titillates the nostrils
of the tourist legions landing
from Santiago.

LEFT
The Yunque de Baracoa, the mountain
whose anvil shape inspired its name.
A boat used for carrying passengers
between Cayo Granma and Santiago.
A view of the coastline between Cayo
Coco and Cayo Seitía, near the Jardines
del Rey.
RIGHT
Fishermen on the banks of the Yumurí
River.
Santiago Bay and Cayo Granma.
A Sunday fishing party on the Yumurí
River.
Cayo Sabinal.
Baracoa beach.
VINTAGE PHOTOGRAPHS
LEFT The Almendarès River, Havana,
1909.
RIGHT A spring in the Chorrera, near
Havana, 1909.

100

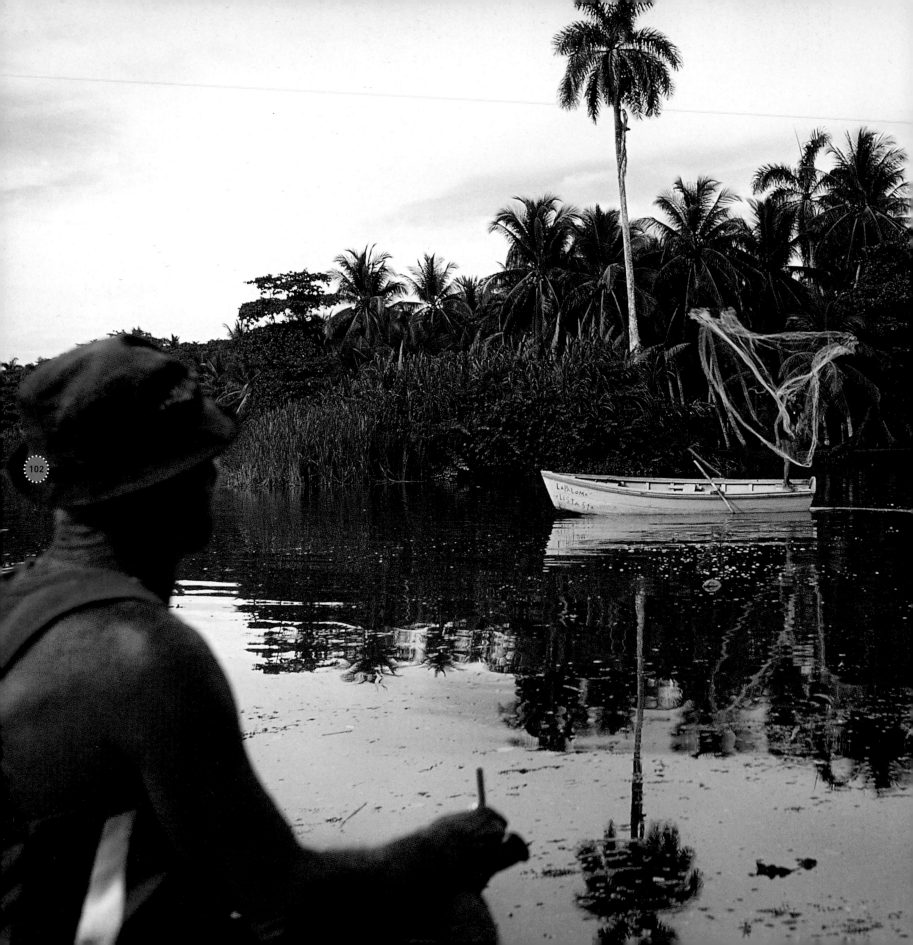

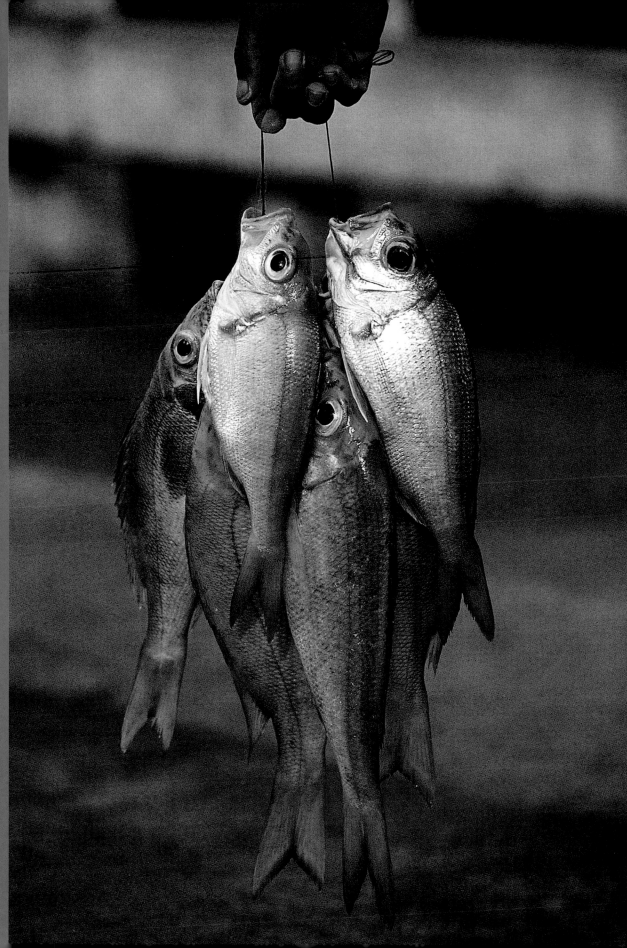

In the mangrove swamps, Hemingway's Old Man and the grandeur of fishing for giant marlin are both far away. But old Rafael has an advantage over "Papa" Hemingway: the sea actually laps at his *bohio* and all he has to do is turn around and there's the river, full of *tetis* for him to take home to Carmen, who will then turn them into an appetizer worthy of a gourmet. When it comes to fishing, Rafael goes from one extreme to the other, from swordfish to small fry. The recipe works, though. At eighty-four he's still strong on his feet, and he's still madly in love with Carmen.

LEFT
An august gesture from the sower of the river: a fishnet floats over the Toa River.
RIGHT
Fish on its way to the plates of customers at El Castillo or Puerto Ante, two of Baracoa's restaurants.

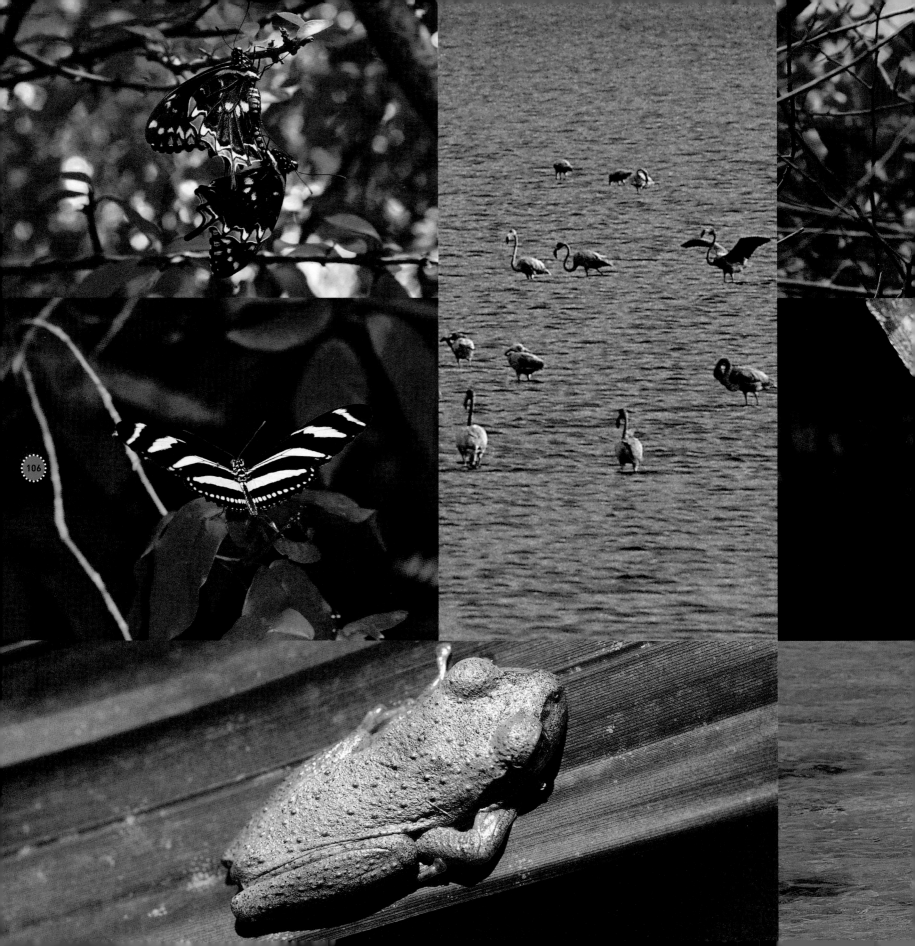

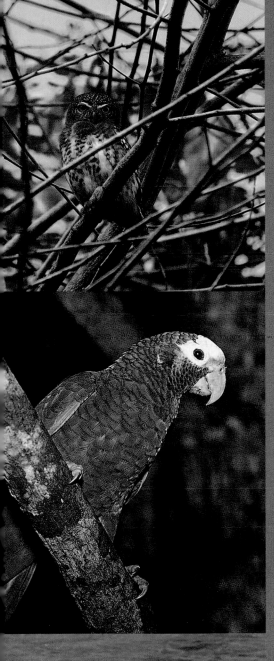

Zoologists have their work cut out for them down here. There is wildlife that swims, wildlife that flies, and wildlife that climbs, enough of it to fill textbooks that would need constant updating: a multitude of species living in complicity with nature. Sea turtles showing off their bronzed carapaces that are like artists' palettes, parakeets displaying their exuberant plumage, and a beak competition setting the herons of the Zapata swamp against the pink flamingos of Cayo Coco. The party goes on day after day, evening after evening.

PREVIOUS SPREAD
The Laguna de la Leche, near Morón, is a vast expanse of saltwater, twenty-three square miles in extent, and home to countless waterfowl.
LEFT
Butterflies.
Pink flamingos of Cayo Coco.
Pygmy owl.
Cuban Amazon.
Tree frog.
Brown pelican.
RIGHT
Heron.
Crocodiles.
Turtle on the Isla de la Juventud.

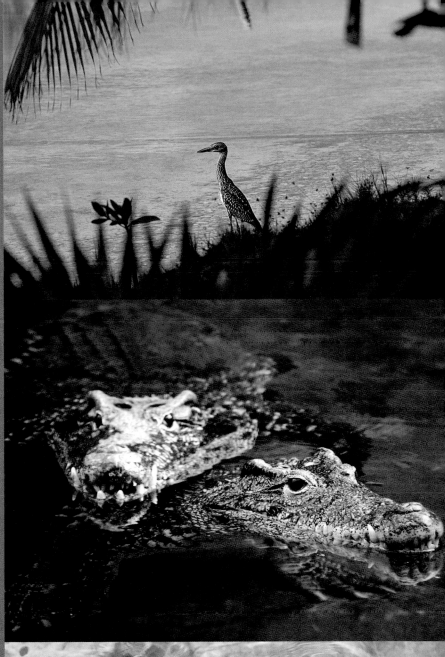

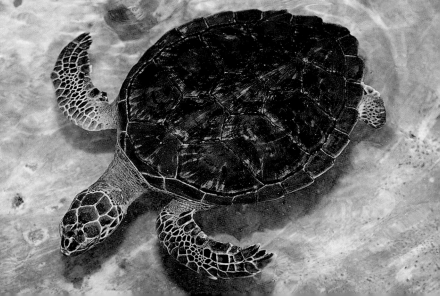

In contrast to the generous sea—which proudly shows off its foam, its lagoons, its infinite variety of blues, from the indigo of its depths to the turquoise of its surface—the dark, green mangroves seem to cultivate the art of secrecy. Here are plants so cunningly hidden that the eye has the greatest difficulty in detecting them, for the mangrove has set traps for the curious: sticky humus into which their feet will sink. The sea proudly raises these royal palms and invites its table companions to yet another feast of *dolce farniente*, pleasant idleness. *¡El sol, a la sombra!*

LEFT
Exuberant vegetation in the Escambray Mountains.
RIGHT
The coastline along the Sierra Maestra.

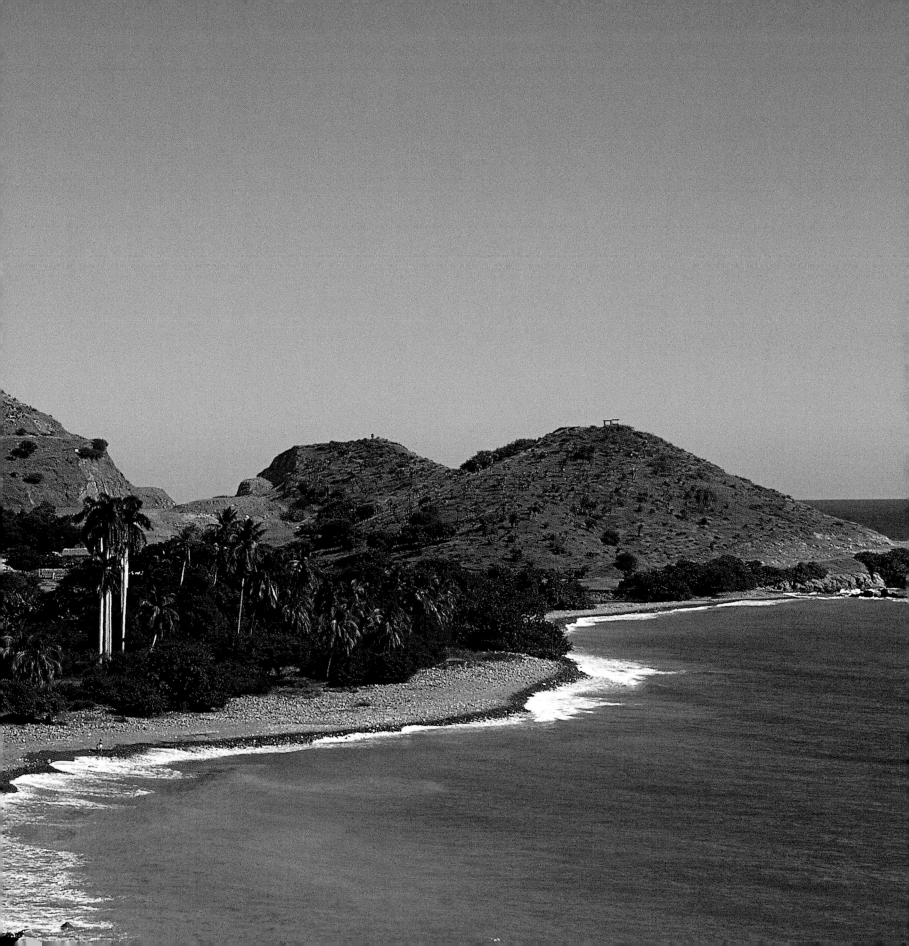

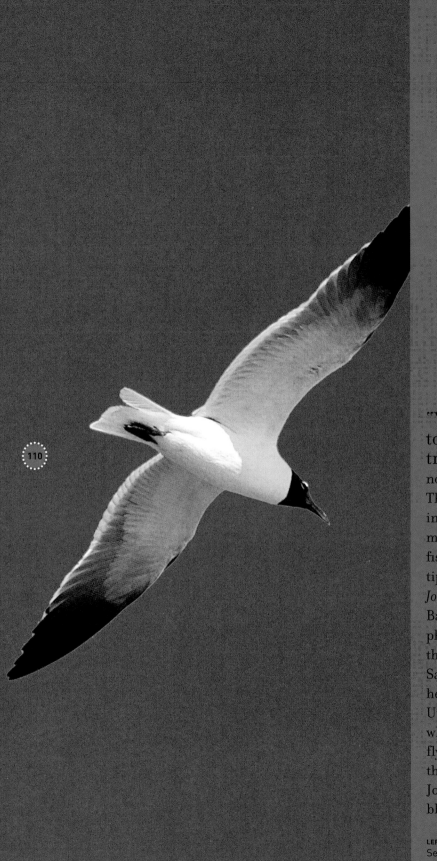

"You have the freedom to be yourself, your true self, here and now, and nothing can stand in your way. There are better things to do in life than squabble over a miserable fish head behind a fishing boat or in the rubbish tips," wrote Richard Bach in *Jonathan Livingston Seagull*. Bach and his web-footed philosopher are soul mates of the French author Antoine de Saint-Exupéry and the sheep he created in *The Little Prince*. Up on high, Saint-Exupéry, who knew a thing or two about flying, could well be crossing the path of this Cuban Jonathan, intoxicated with the blue above the Caribbean Sea.

LEFT
Seagull in flight.
RIGHT
South of the island, in the Caribbean, the coral reefs of the Jardines de la Reina.

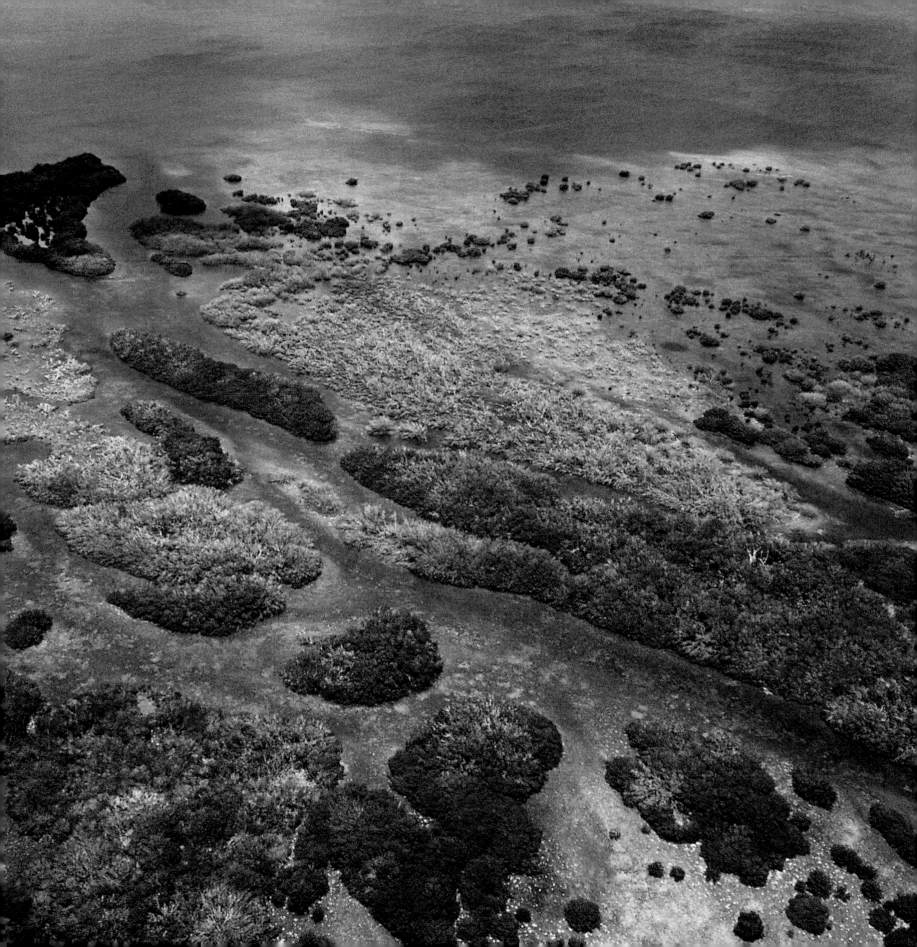

TASTES AND FLAVORS

Some people say it was here in Cuba that Hemingway tried and tested the formula he dedicated to Paris. Havana was a party long before Paris. And La Floridita, at the top of the Calle Obispo in the old city, was one of the temples where good eating, washed down with the best vintages, was honored. The place has been sanctified by the Burke's Peerage of the entire international who's who. Just flip through the visitor's book in the restaurant and you will find the initials of such celebrities as Gary Cooper, Sophia Loren, Marlene Dietrich, Luis Miguel Dominguín, and Ava Gardner. And this photo . . . ah, the photo taken at the bar! Ernest and Mary Hemingway, his fourth wife, reveling in the fascination of their friend, the celebrated movie actor Spencer Tracy, in front of an array of glasses of every color of the rainbow— garden green, fuchsia pink, mimosa yellow, lagoon blue, cotton white—in which, above a dense pack of ice cubes in total deliquescence, mint leaves float accompanied by slices of lime. *¡Buen provecho!*

Which, in translation, comes out as *prosit*, *skål*, *à votre santé*, cheers!

So now you're a student at the International University of Cocktails. A recipe? Over to you, Mr. Hemingway.

This is a daiquiri invented by Antonio Meilán, "Papa's" favorite barman. That's what they used to call Hemingway here, affectionately. So, take two ounces of Carta Blanca rum, a spoonful of sugar, half an ounce of lime juice, five drops of maraschino. Shake it just a bit and pour it over crushed ice spread over a nice, wide glass.

Ah, yes, now we have to go and see my journalist friend Fernando Campoamor at the Bodeguita del Medio, behind the cathedral. How can you turn down my favorite *mojito*? It slips down your throat like a waterfall. Here, make a note of the recipe. An ounce and a half of Carta Blanca rum, half an ounce of lime juice, three sprigs of *yerba buena* (fresh mint), a spoonful of sugar and two ice cubes. Add some sparkling water.

Hey, it's not over yet. Mary is waiting for her old scrapper at the Ambos Mundo, his haunt in the old city.

This is the last trap we'll set for the novelist. Before heading back to his typewriter, our American graciously accepts the homage paid to him by the barman, a Hemingway Special. The ingredients are

the same as for a daiquiri, plus some grapefruit juice and, for decoration, a slice of pineapple.

Rum is as inextricably tied to Cuba's identity as Camembert is to France's, roast beef to England's, and sushi to Japan's. *The Joyful Child of the Sugarcane* (*El Hijo Alegre de la Caña de Azúcar*) is the title of a book by Fernando Campoamor that is dedicated to rum. *El Hijo Alegre* would fight to the last against any attempt to impose prohibition here. It would be like trying to ban baguettes in Paris or hamburgers in Cincinnati.

Or to try to prevent a *compañera* from breathing in the delicious smoke swirling up from a Partagás *vitola*. Even if the great brands of cigars are inaccessible to those of little means, you can always get away with a *cacique de Guantánamo puro de guajiro*—a Guantánamo peasant cigar—at a dollar for a pack of twenty-five.

Other, more modest aromas of everyday life deserve more than a passing mention on the country's roll of honor. A coffee, hand ground in a pestle and mortar, in the *bohío* of El Gallego, at Topes de Collantes, up country from Trinidad, is well worth the two hours' wandering under the fierce sun it takes to get here. And even if there's no point in risking a diabetic attack, there's no reason why you can't have your friends enjoy a *cucurucho*, a mix of caramelized fruit wrapped in a cone-shaped palm leaf. This is the delicacy the children try to press on you all along the Farola, the dizzying road that leads from Imías up to Baracoa, in Oriente.

Which brings us back to Baracoa, where Cuba's history started. Not the most positive experience for the Taíno Indians, who were exterminated by the conquistadores newly arrived from Europe. Yet from under the pall cast by this genocide, there remain traces that speak eloquently of the peaceful, ancient Indian culture. At El Guirito, a hamlet beside the Yumurí River, the *cacique* reigning over his little community watches over the making of the casabe, the bread made of *yuka* (cassava). At the table, they enjoy *bacán*, made of dry coconut, green bananas, various spices, pork, beef or chicken; and *calalu*, which is a freshwater fish, *joturo*, in a cauliflower stuffing, all wrapped in a gourd shell and boiled in coconut milk.

And to complete this, still remaining with the Indian culinary tradition, let's go down to the beach at Duaba, to our friends Rafael and Carmen. He is of Majorcan extraction and goes fishing for *tetis*, the tiny fish that is the Cuban cousin of Armenian caviar. His wife, Carmen, is Indian, and she freezes small fry for friends who drop by.

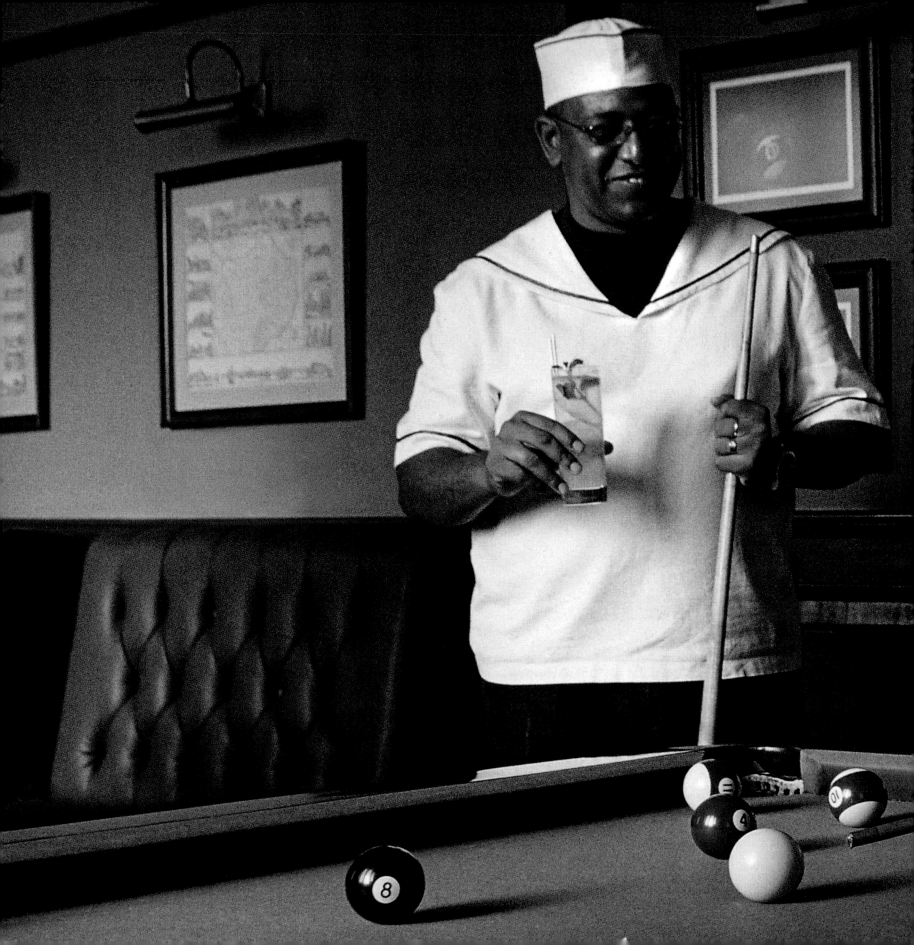

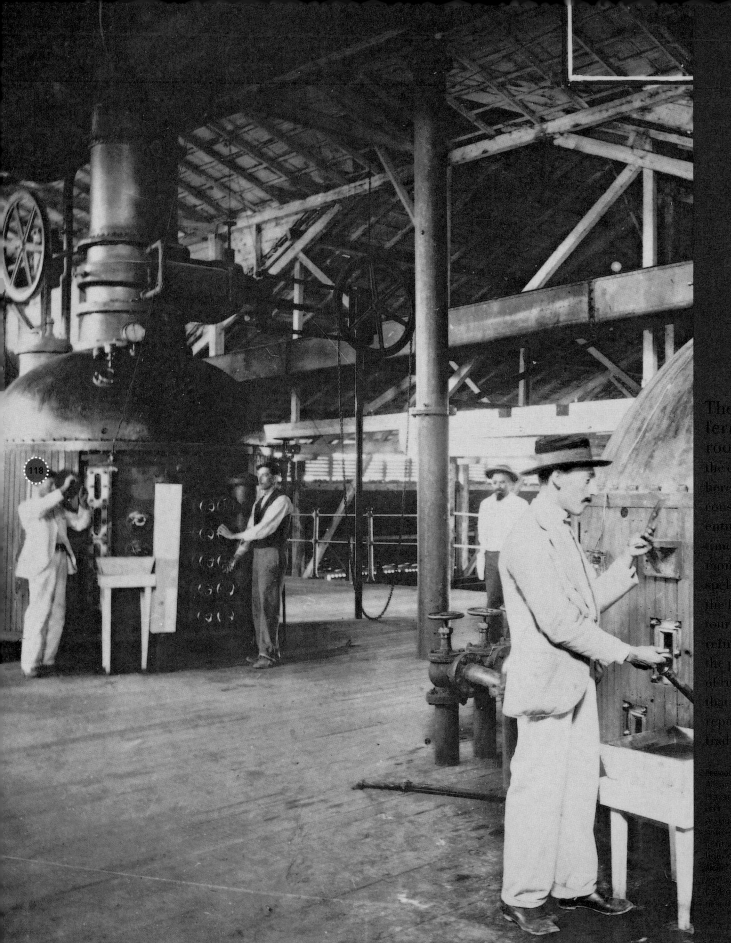

118

The Cuban art of living ferments in the back room of a large hotel in the capital. The employees here do not shy away from consumers, but instead are entitled to spend their free time together and enjoy a few moments off between hot spells in the kitchens, where the food is prepared for the tourists. As for the sugar refineries — *central* — they offer the promise of the delights of rum and other cocktails that have built the country's reputation, as well as its traditional economy.

PREVIOUS SPREAD
Avenue of poplars in the early morning mist
1900

LEFT
A sugar refinery in the early years of the twentieth century

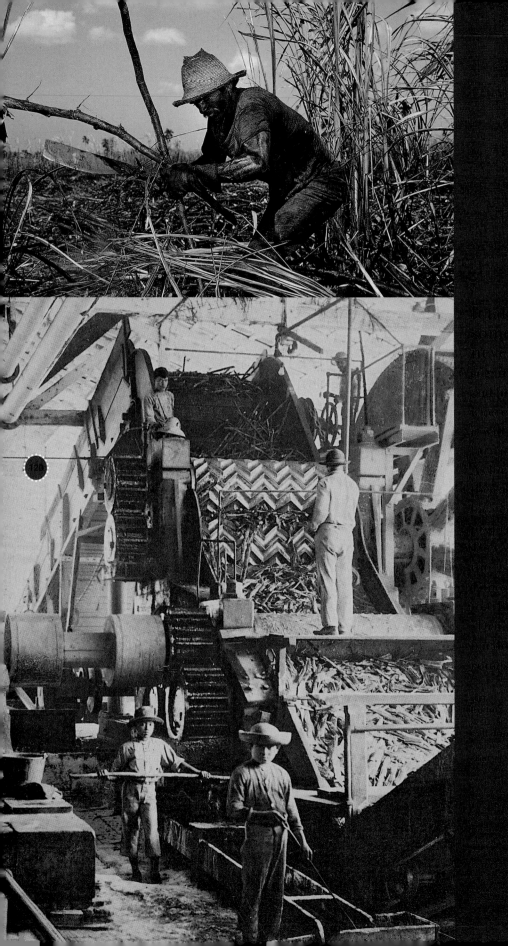

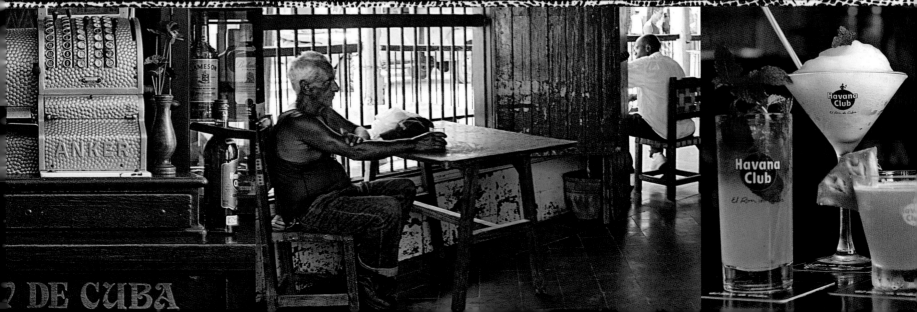

REPUBLICA DE CUBA

sello de
Garantia

de procedencia para el ron

Government's warranty for cuban rum

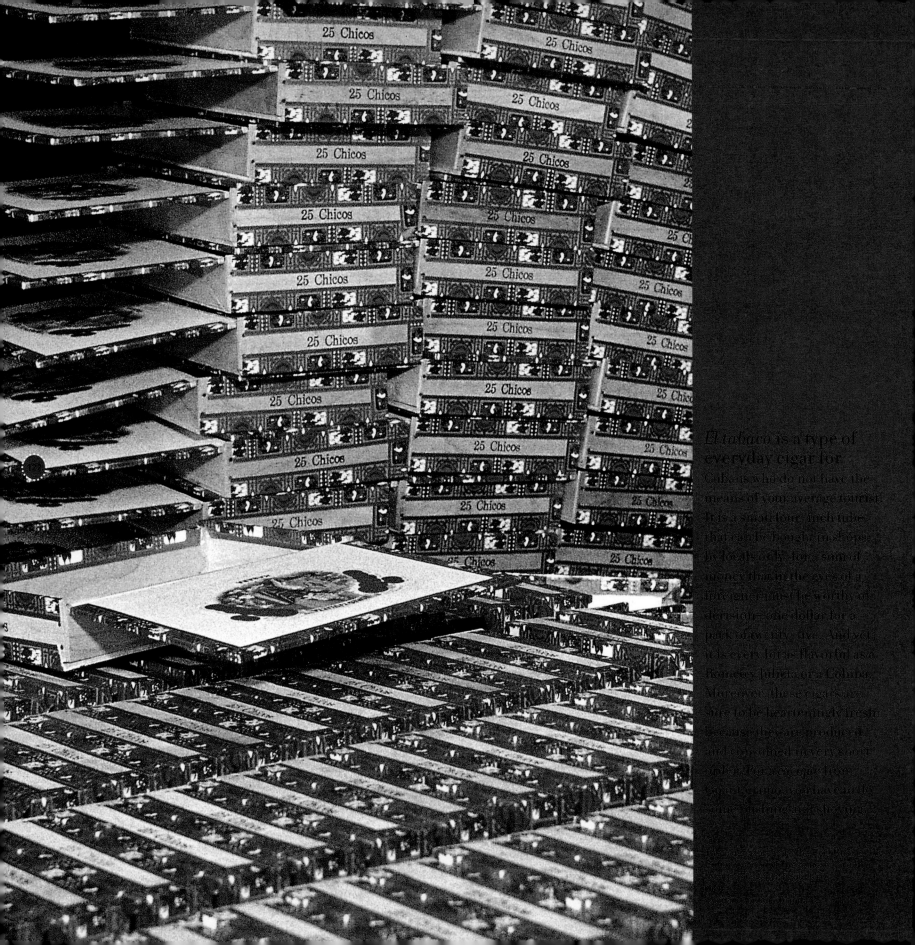

El tabaco is a type of everyday cigar for Cubans who do not have the means of your average tourist. It is a small four-inch tube that can be bought in shops by locals only for a sum of money that in the eyes of a foreigner must be worthy of derision: one dollar for a pack of twenty-five. And yet it is every bit as flavorful as a Romeo y Julieta or a Cohiba. Moreover, these cigars are sure to be heavenly fresh because they are produced and consumed in very short order. For *a cigar joint* from any Havana, you have only to be walking past the cigar

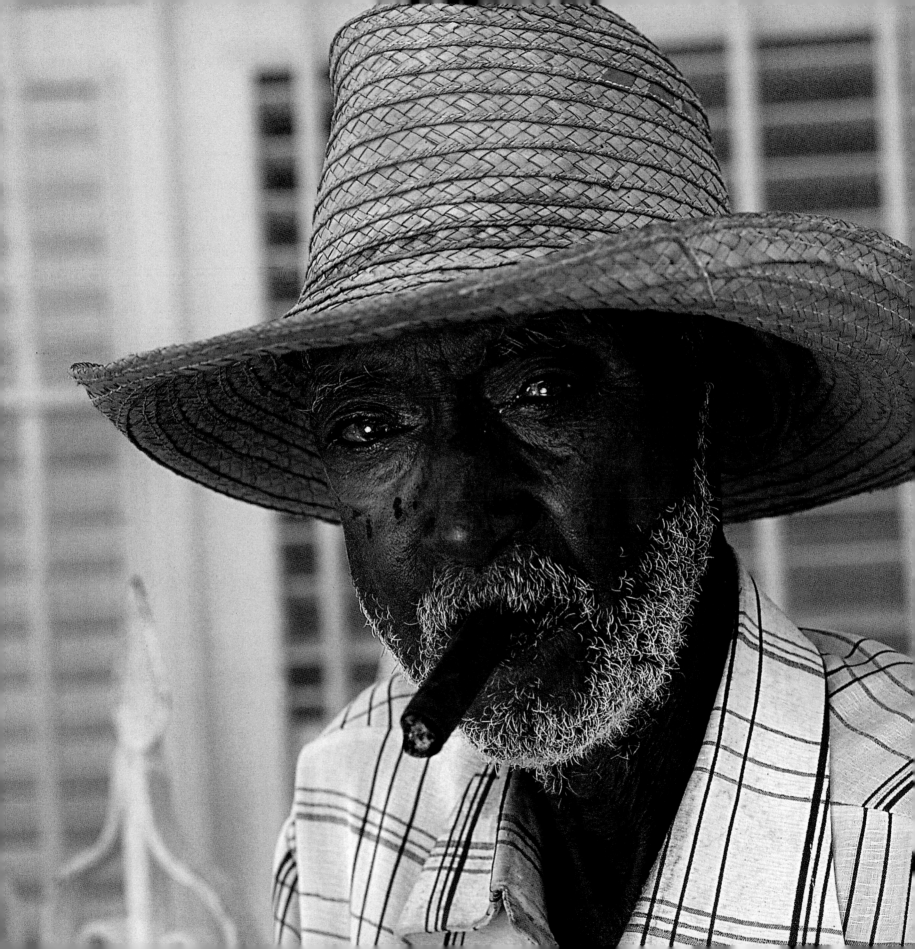

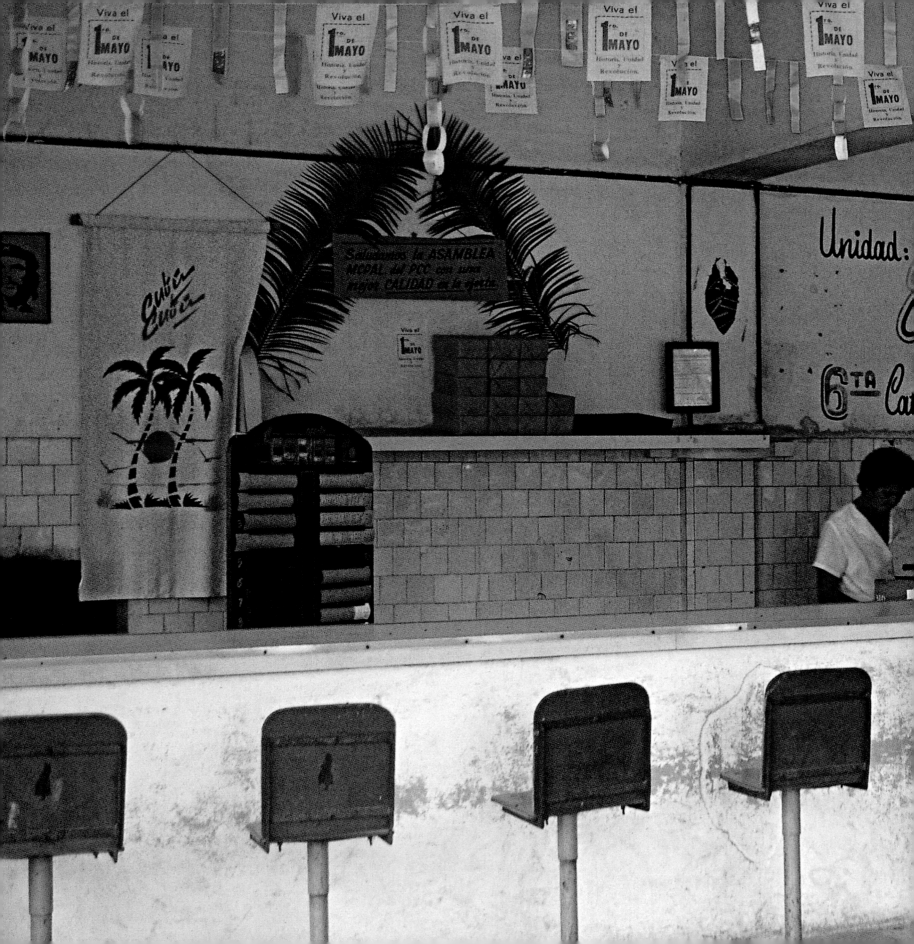

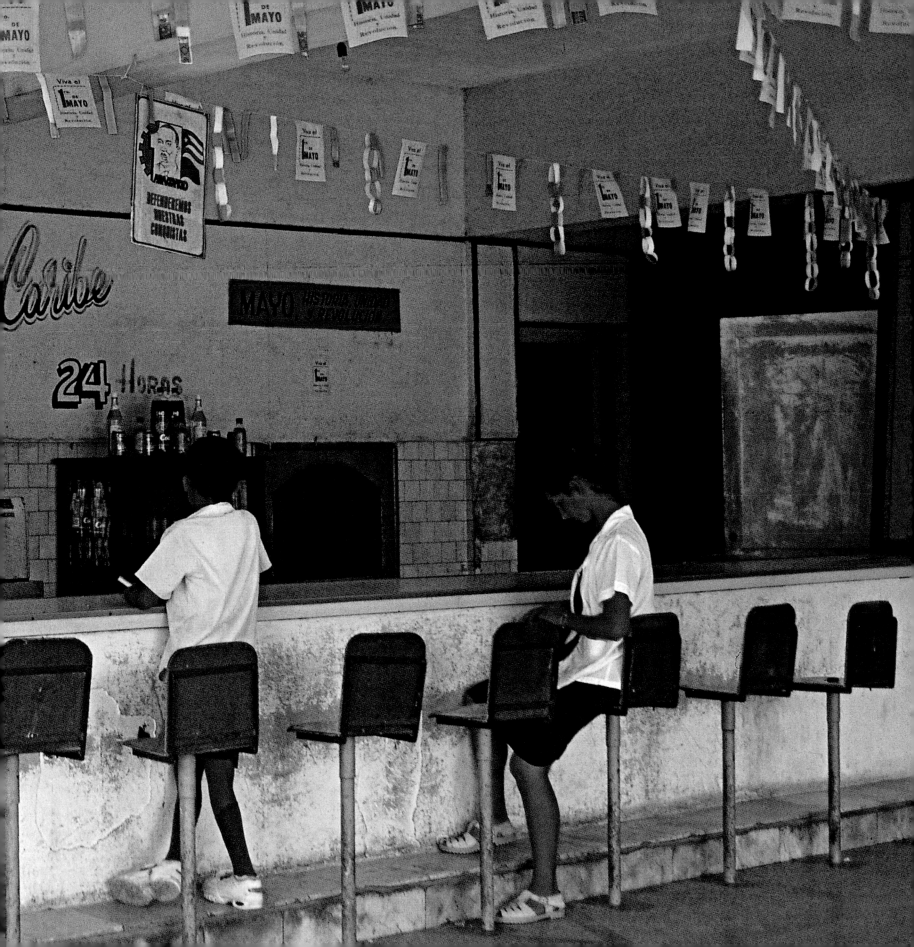

In every Cuban family there is a chef who shows off and never dozes off. Because the external pleasures—eating and drinking—raise the eternal question: what to give today's customers? Coffee, *guarapo, lechón, pollo, congrí, ensalada de tomates?* And if all that fails? You always have to be able to come up with some eye-opening substitute. But never be out of stock for the sake of a smile.

Cafetería at Santa Lucía de Caibarién
A Santa Lucía, just weeks before the fiftieth anniversary of the revolution on the road to its next one.

A young woman waits to sell her wares. Megano Beach.

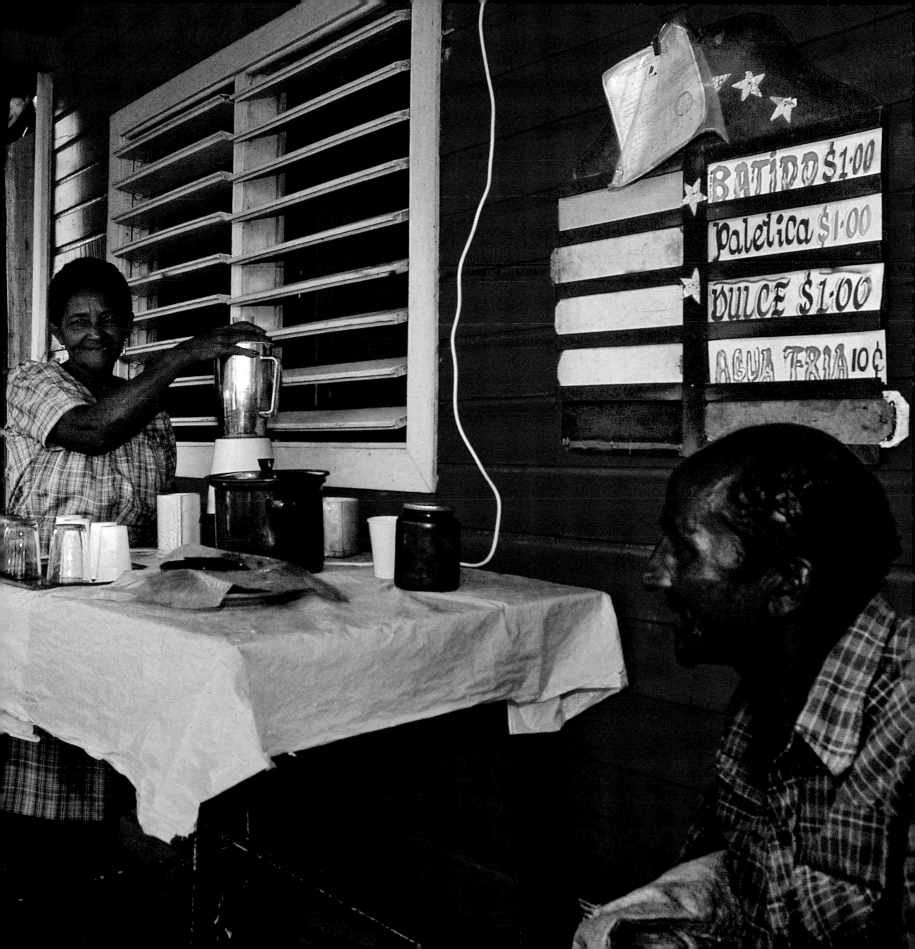

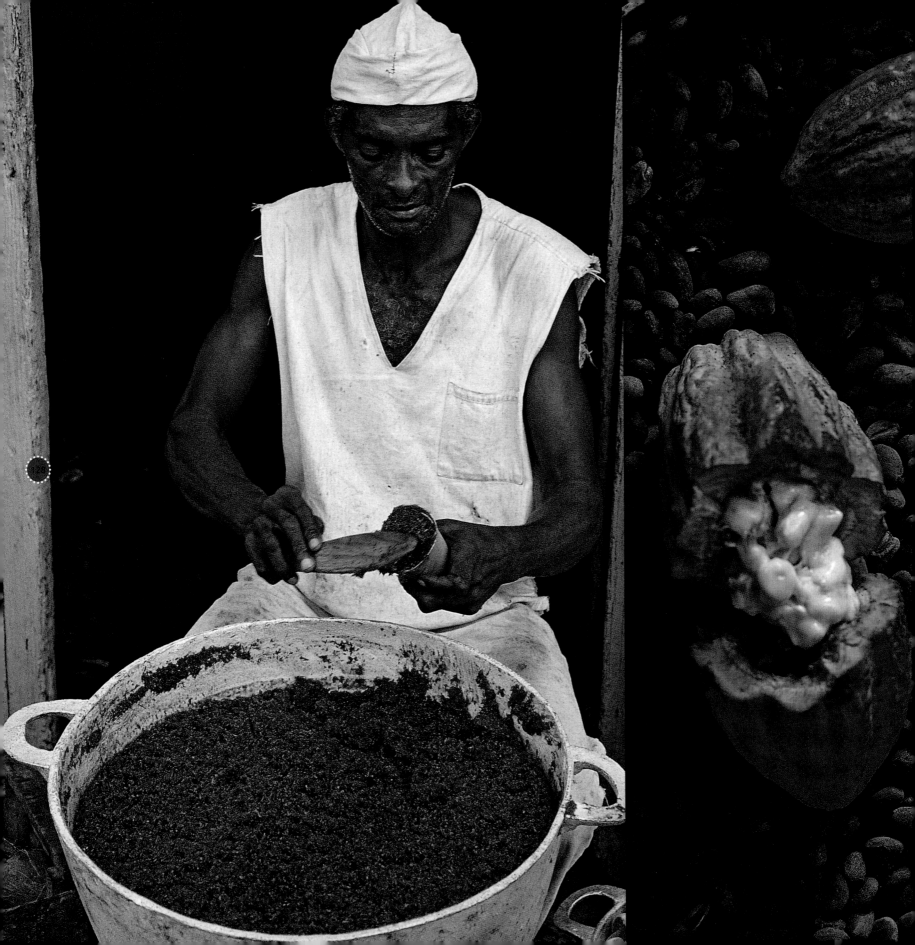

Sugar, following the more or less chaotic ups and downs of the stock market, is the country's major agricultural resource. Earmarked for export, in the hope for a miraculous *zafra* (harvest) every year, it does not stop the production of other foodstuff that are essential if the people are to have a balanced diet. Corn is on the menu every day, grated, cooked on the street in a *fogon* (charcoal stove), it fills the belly and calms the appetite, until something different and better comes along! And then there is cocoa, which is produced in Baracoa and then turned into ice cream and cake for the gourmet's delight.

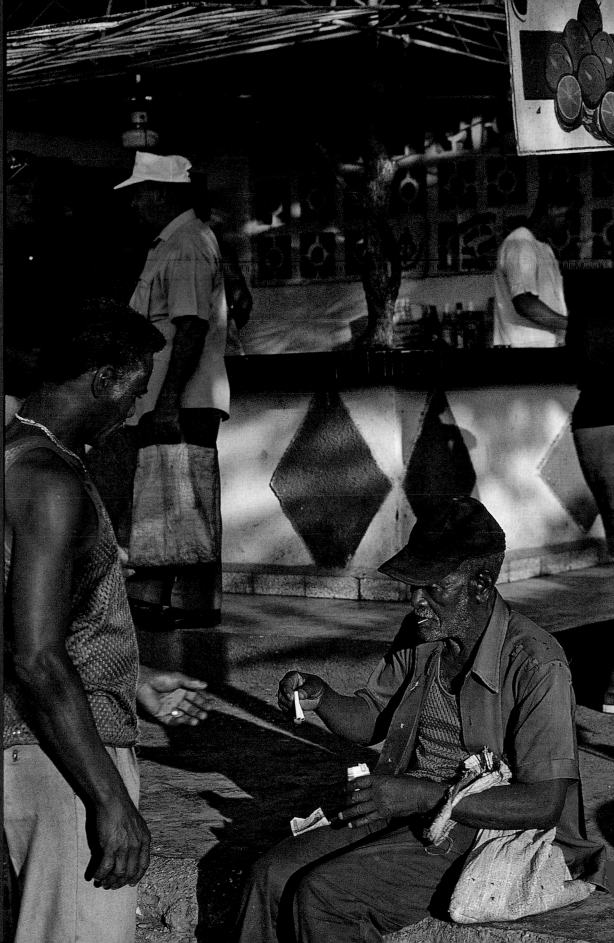

HELADO

How are people supposed to deal with the economic difficulties caused by the embargo and other political problems in the region? With bread and circuses, as the Romans used to do? Well, when it comes to games, sports and dancing fill their assigned roles to perfection; and as far as bread goes, demand is also satisfied, albeit at somewhat irregular intervals and under awnings that don't always tell the truth: no *helado* (ice cream) here, no matter what the sign says, but there are *panecitos*, fresh today or maybe yesterday's.

LEFT
It all depends on supplies: this ice-cream stand has turned into a sandwich bar.
RIGHT
In these stores, what you need is ration book to shop: the conservation is usually richer than the food on the shelves.

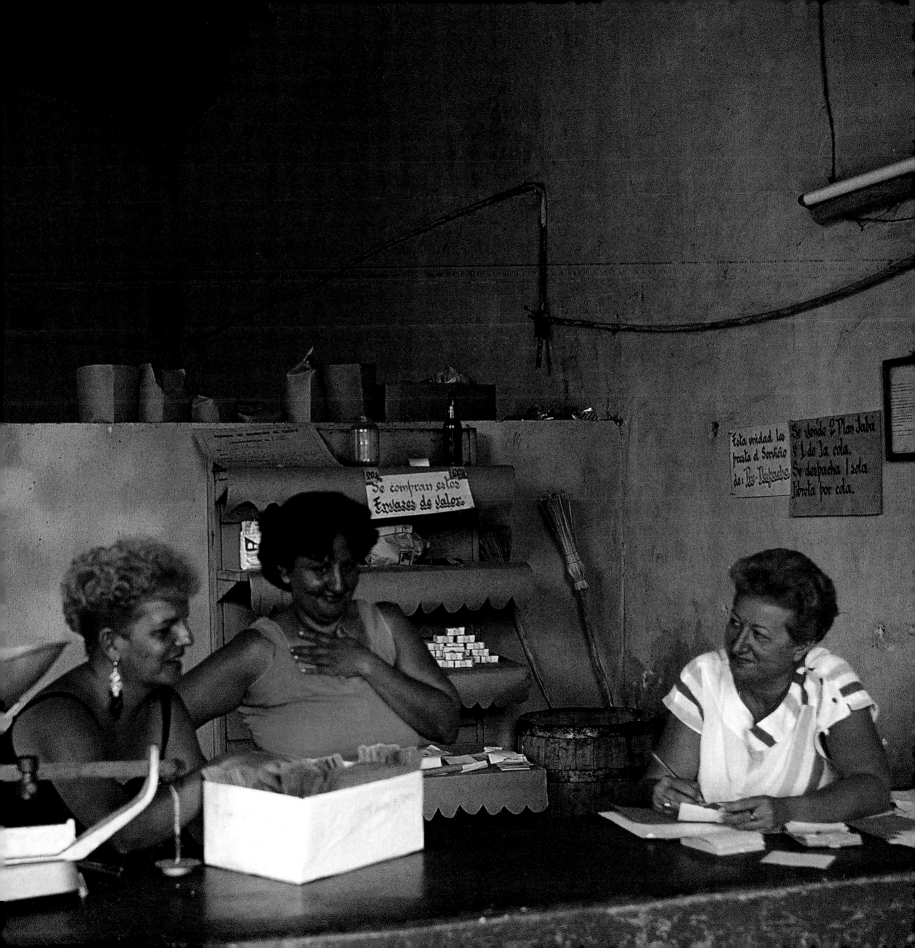

Cuba's streets are markets where you can find a mishmash of poor-quality wine imported from Italy and relabeled as Cuban vintages; whole stems of bananas (locally our guarantee) fresh cassava and fish at the day's prices. The bureaucratic line that goes along with the race for food ... line the innumerable waiting counters. When a vendor doesn't have an established stall he'll work out of a mobile cupboard that does not always return home empty. Here there are no clearance sales, but there are small flashes, bursts of solidarity.

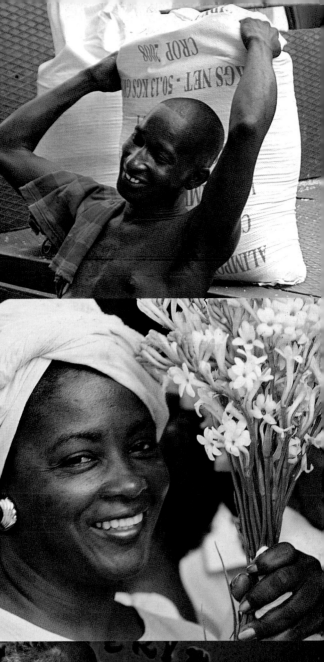

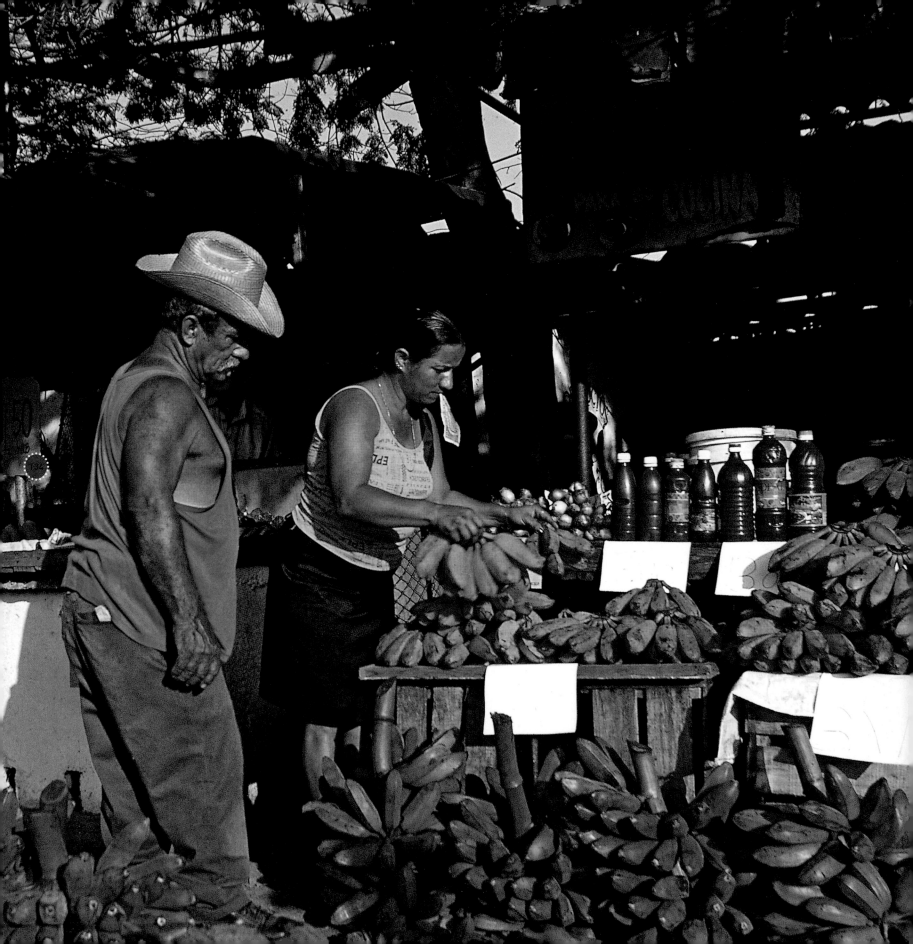

"Every time our neighbor made something delicious to eat,
she would call my mother to the window and give her some.
It was through her that I came to know various dishes typical of
her region (Baracoa), such as the coconut cone, a sort of coconut
jelly that is then poured into a cone made of *yagua*, with a banana
leaf as a stopper; or *bacán*, a pulp made of chopped banana stuffed
with pork and wrapped in plantain leaves, which is then cooked,
and it is delicious; or cobo, an enormous sea snail that my neighbor
used to cook in the manner traditional in her province."

—Karla Suárez and Francesco Gattoni,
Cuba: Les Chemins du Hasard

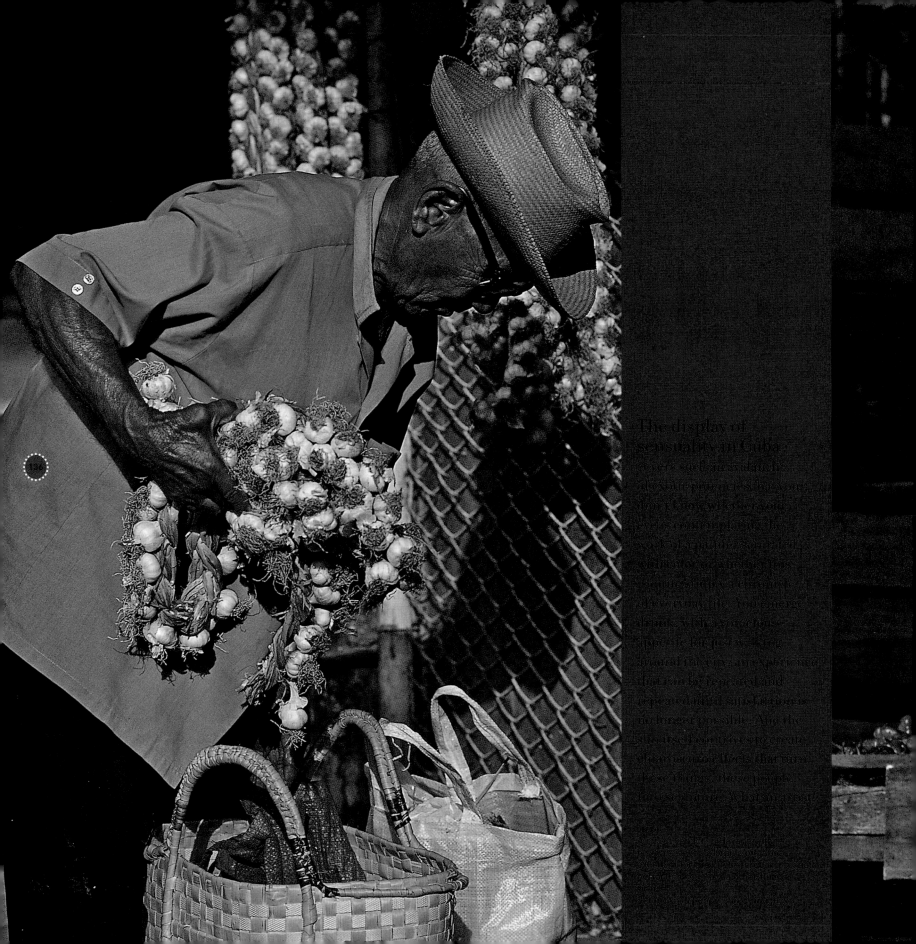

The display of sensuality in Cuba comes and is available to anyone, regardless of status, class, race, who observes people's eating and drinking, or their work at manual, sensorial, intellectual, or whether this respiration simply changes everything. You emerge already fully conscious simply to be just walking around the city, an experience that can be repeated and repeated until satisfaction is no longer possible. And the impulse continues to create pleasure in others that confirm themselves in their own corporeality. What impels us...

136

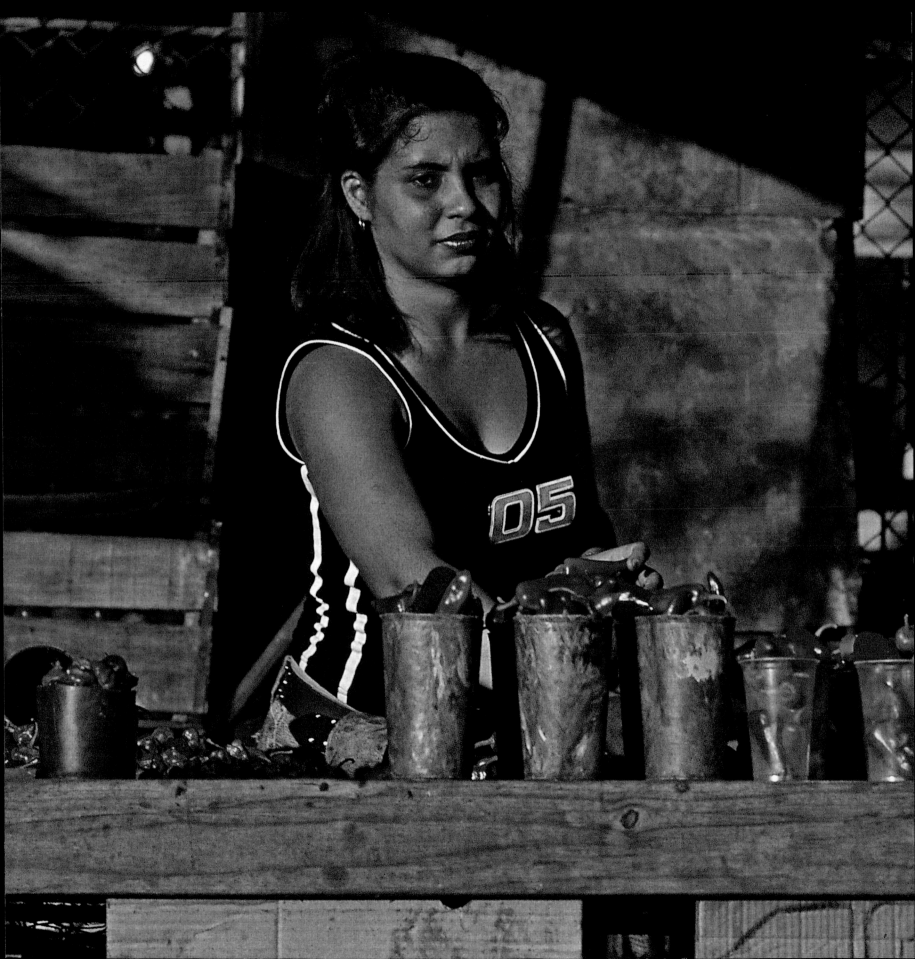

GOLDEN HANDS

What do Joe Smith from Wyoming and Heriberto Cañizares from Pinar del Río, both Harley-Davidson owners, have in common?

The question is a little unfair, you might say, because of the difference in income between your average American and a senior Cuban official. But that's not it. The correct answer is the frame—to be exact, the motorcycle's metal frame. For the rest, if Joe Smith's bike has piston trouble or transmission trouble, all he has to do is order spares from the factory.

For Heriberto, it's a whole different story. And for multiple reasons: the U.S. embargo, an insufficiency of dollars, the priority he gives to *frijoles* (beans), and the half liter of oil he is allowed by the government. The real problem is that you cannot go out with your ration book and buy a brake disc or a Delco distributor cap.

So what do you do? Even after you have woken up every morning with a sigh of "No, it's not easy," you still have to get the damned motorcycle running. So the time has come for post-lamentation operations.

Inventar. It's another magic word in the Cuban dictionary. A bit like a "MacGyverism" in the United States, "système D" in France, or "Heath Robinson"

in the U.K. There are probably equivalents in Chinese, Swahili, and every other language known to man, including Esperanto—because you need a healthy dose of hope to make a motorcycle piston out of a piece of scrap metal recycled from an old hydraulic pump. Heriberto deserves our trust.

One of the major problems facing Cuba is *el transporte*. Just take a look at the bizarre medley of motor vehicles in the country, the contraptions that make the tourists, with their love of unusual photographs, gape with delight. But the same foreigners never climb on board a *camelo*, one of those bizarre buses like a metal dromedary, with a single hump converted into a two-humped camel by special order to the coach builders. The *camelo* is in fact a rare breed, patented in Cuba, made up of a tractor and a trailer with a hump-shaped roof. But the comparison ends there, because the route the vehicle takes has nothing in common with a camel race across the Tibesti Mountains.

What the *camelos* do is ferry passengers from Alamar Station to Havana Zoo, a distance of

"It's not easy . . . time to start inventing."
Cuban proverb

twelve-and-a-half miles or so, in relative comfort, driven by anonymous hands and anesthetized by a tropical fragrance—the smell of the bus itself, nothing to do with ylang-ylang, lavender or jasmine.

Then there are the classic American automobiles from the 1950s, most common the 1956 Chevrolet Bel Air, but also Buicks, Impalas, Pontiacs, Plymouths, Mercurys and Fords. Yesterday they were suffering, but today they have been reborn and struggle on thanks to the magic wrought by ingenious mechanics, who will take the pistons out of a Lada and place them in a worn-out Lincoln, take the burner out of a gas heater and use it to replace the carburetor of a Ural motorcycle, or weld the engine from a lawn mower onto a Chinese bicycle frame. The sports announcer from a major national television program, who actually rides this unusual scooter, uses it to show up his bosses. He's always on time.

"No es facil . . . hay que inventar."

At the height of the "special period," after the Soviets left in 1990, there was a lack of everything. People made table oil out of waste engine oil, filtered a few times extra, with all the risks that could have entailed. Meats of uncertain origins, flavored with unknown spices, would be served up with roots of every kind. At the time, the vocabulary of muddling through acquired all sorts of new expressions only Cubans were in a position to decode, such as *coñejo*

de techos (rooftop rabbit) as a euphemism for cat, or *lechón de compañia* (companion suckling pig) for dog.

¡Buen provecho! Enjoy your meal! Bon appétit!

Another tragicomic tax paid for the upheaval during the shameful *periodo especial* was flight from the country, aboard every kind of floating object deemed capable of reaching Miami. This was the time of the *balseros* (rafters), during which large numbers of unfortunate people who had resolved to brave every danger in order to enjoy two real meals a day wound up as snacks for the *tiburones*, sharks that patrol the waters off Cuba. The rafters would leave from the Malecón or Cojimar on makeshift rafts. Some appeared to think that they could cross the South Atlantic on a motorized skateboard. A tank that had been designed to provide fresh water to the suburbs of Santiago was converted into a car ferry driven by a retractable propeller, an entire family wedged inside it.

The less imaginative ones would eye an inner tube from a truck and row out to chance their luck, using paddles carved out of palm trunks and not forgetting a baseball bat to ward off hostile fish.

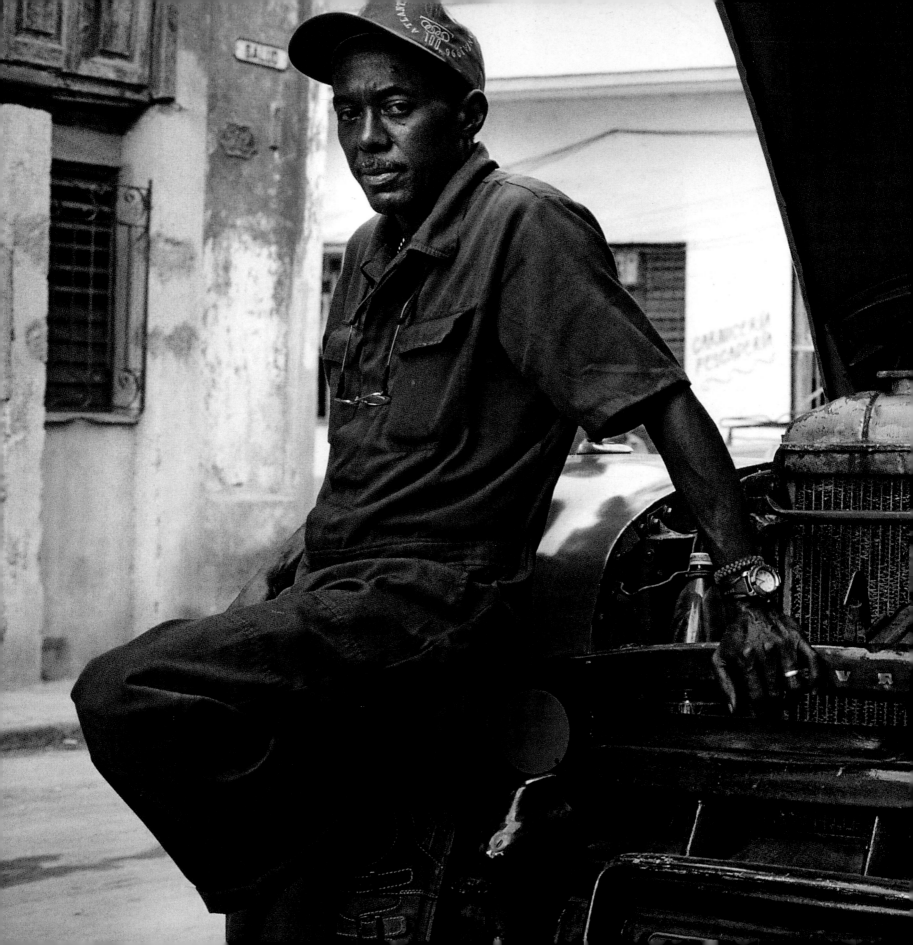

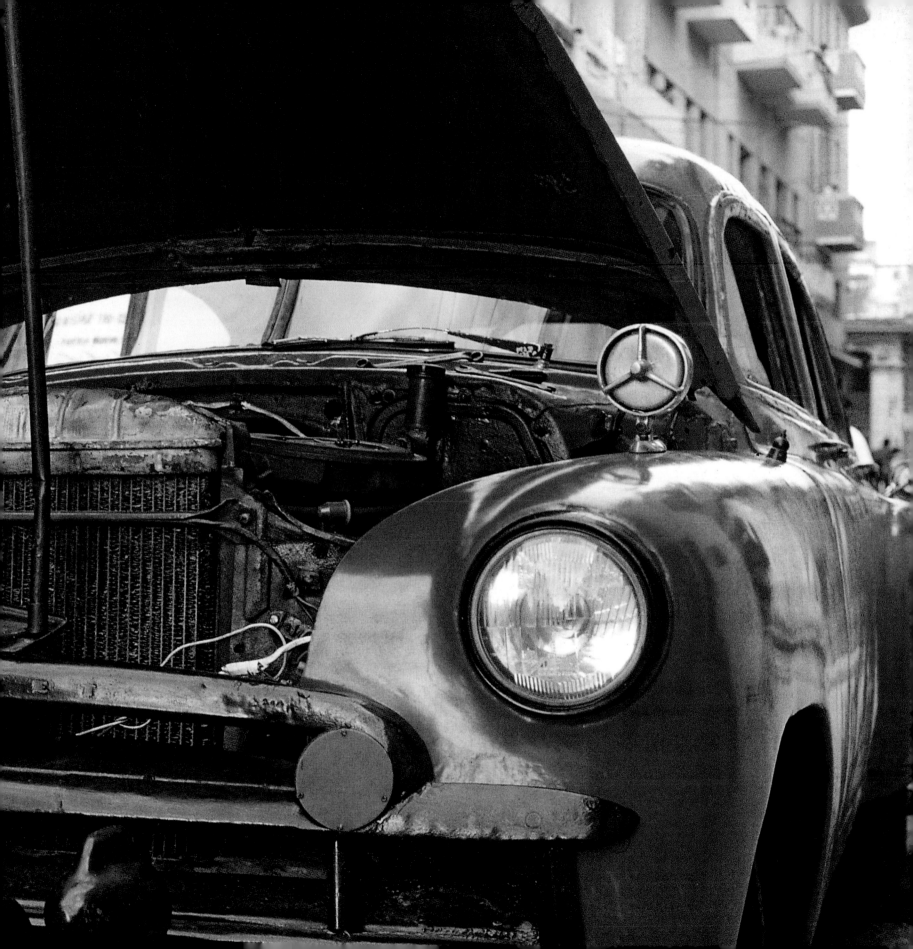

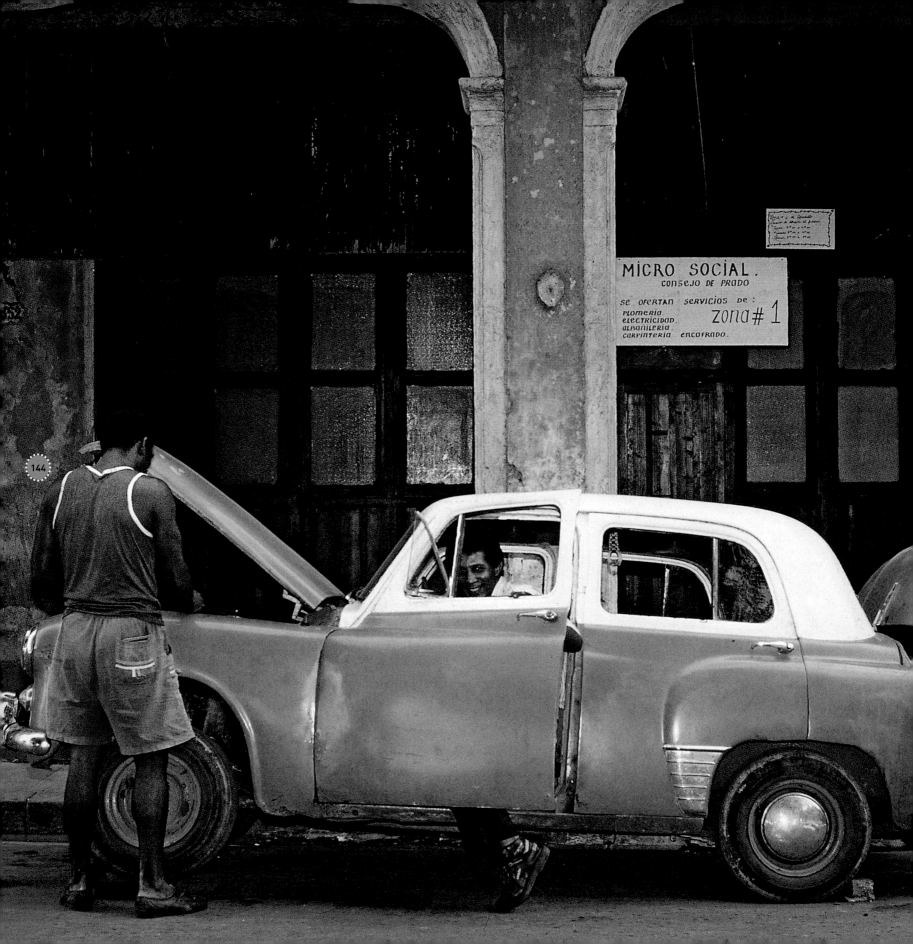

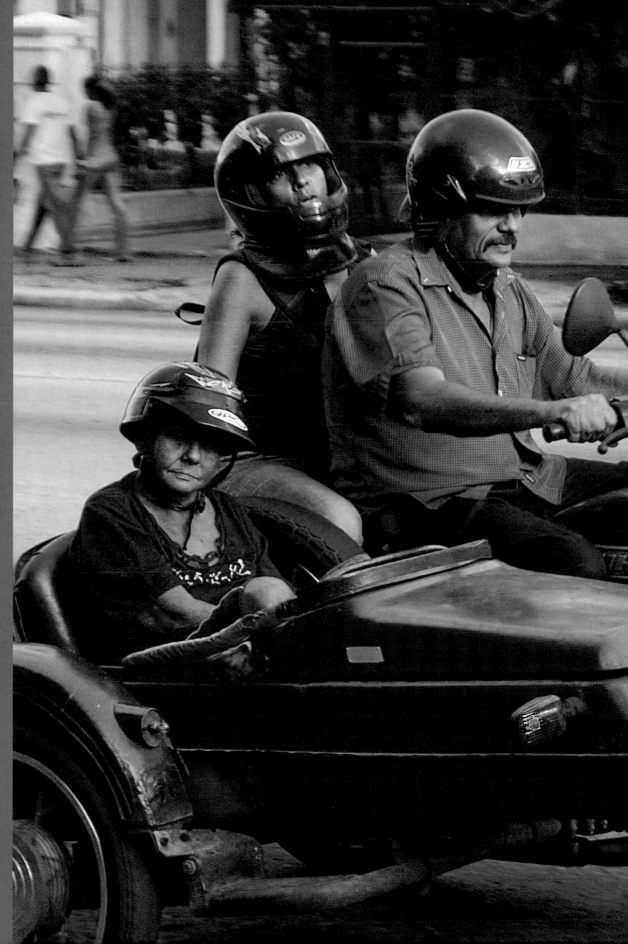

"Give me a screwdriver, or failing that an old knife; a hammer, or failing that a rock; a tire, or failing that a cow's belly; a lawnmower, or failing that the motor from a ventilator; a month, and if it's really necessary two weeks. If you give me your old flat cart, I can convert it into a Formula One car for you. If you can't get to a gas pump, I'll make it work for you using tap water"—from a publicity sheet put up by Heriberto in his garage in Santa Amalia, a suburb of Havana. As it turns out, he never gets it wrong.

PREVIOUS SPREAD
Frankie repairing his Chevy, Havana.
LEFT
An improvised street garage, Old Havana.
RIGHT
A family out for a ride on a Ural motorcycle and sidecar.

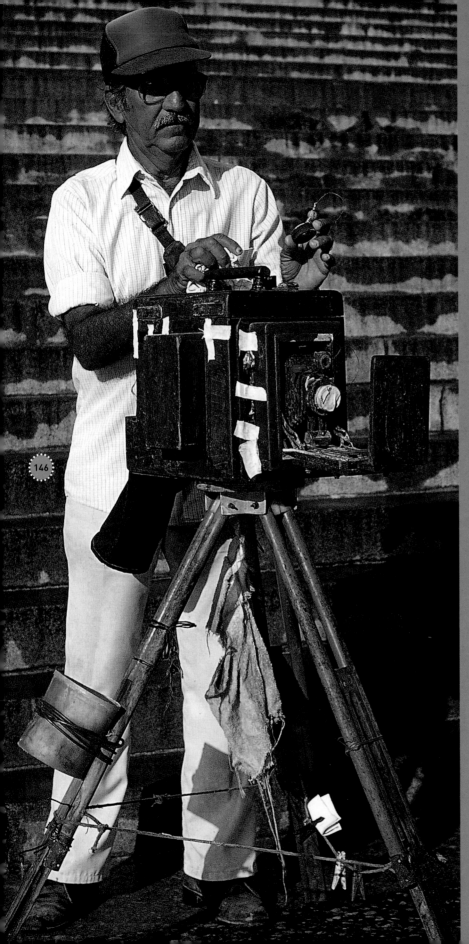

146

They invent pretty much everything, and fabricate the rest. All it takes to become an expert watchmaker is to set up on the Calle Obispo in Old Havana, repair the Rolex you bought in Taiwan, and show it off for its contraband quality. All it takes are six strings and a guitar to become Compay Segundo and a world-famous singing star with sales of millions of records. All it takes to attract the attention of passersby is to be beautiful and pose for a sculptor friend, remaining still as a statue. What did you think, *compañero*?

LEFT
A photographer, Plaza del Capitol, Havana.
RIGHT
Selling religious objects, Regla.
Camilo Cienfuegos and Che, reunited on a wall in Santiago.
A photography studio, Trinidad.
Sculpture in a Miramar garden.
A cigarette-lighter repairman, Havana.
The Santeto Arsis House of Culture, Santiago.
Handicraft market, Havana.
An embroidery workshop, Havana.
VINTAGE PHOTOGRAPHS
LEFT Carnival float, Havana, 1909.
RIGHT Hosiery peddler, 1907.

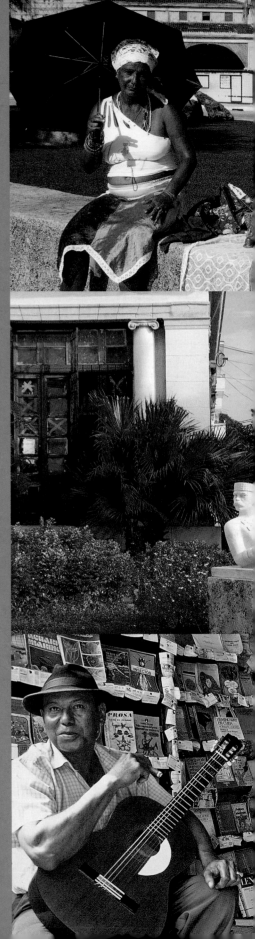

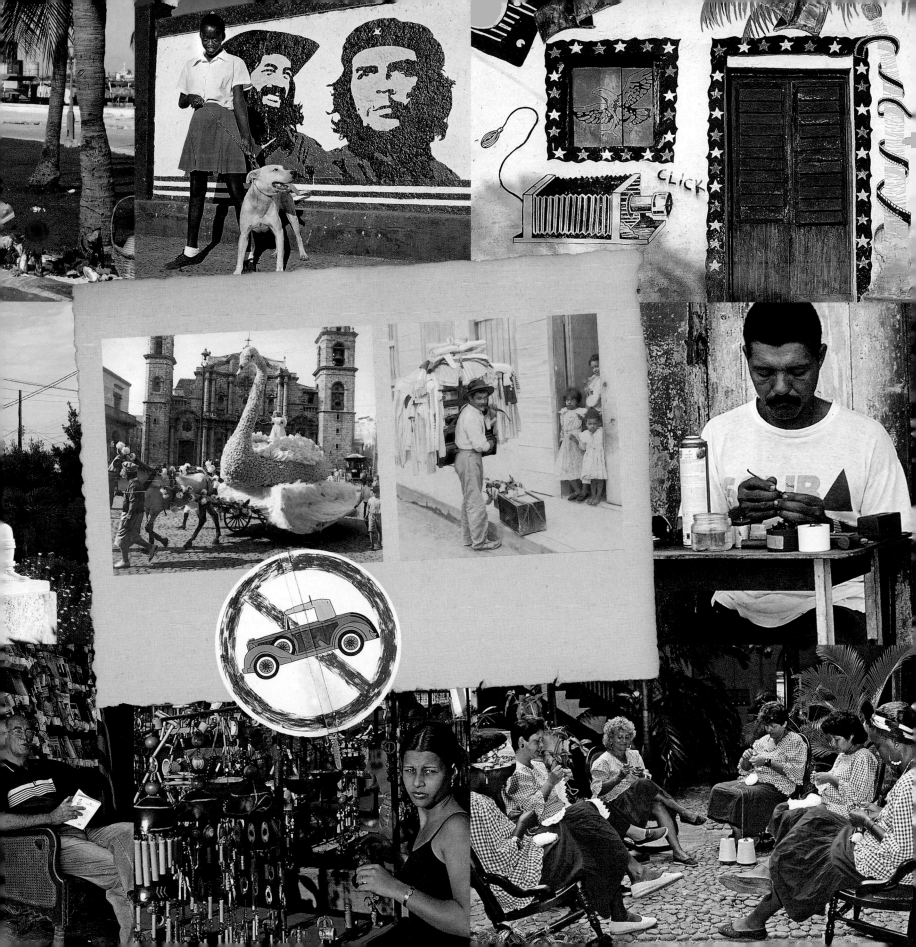

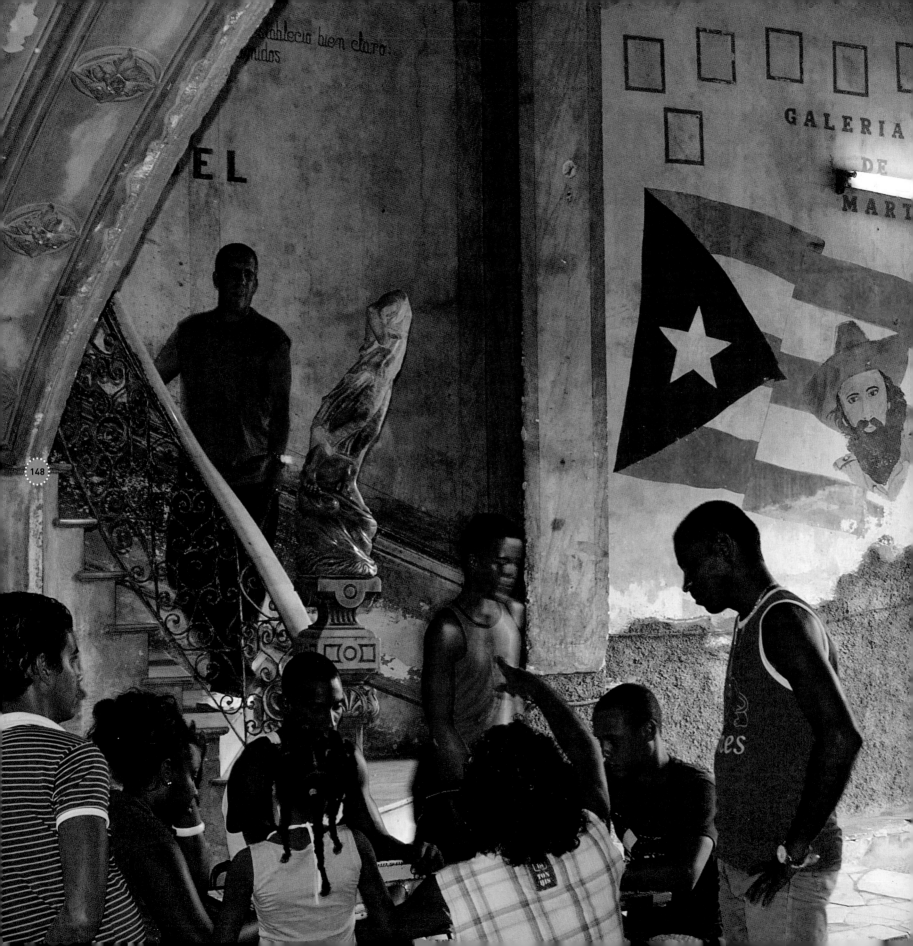

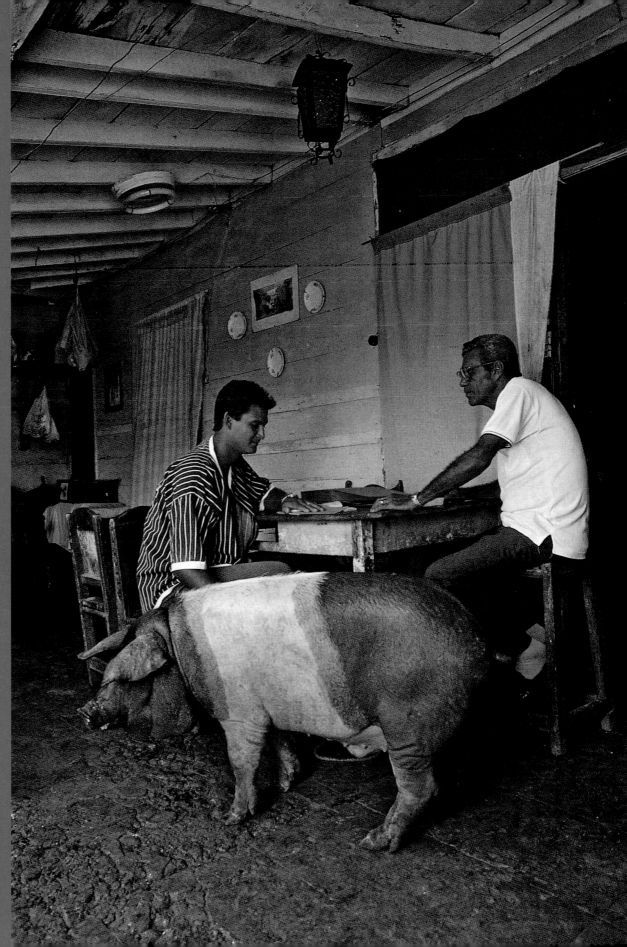

By the light of a dim neon lamp, Camilo Cienfuegos, an iconic figure of the Cuban Revolution, watches over his children in a courtyard in Las Tunas. There was no wall space available for works by a band of daubers pompously proclaiming to be artists. So a cracked wall and a pale light would become a dedicated art gallery, and part of the nation's cultural heritage. These masterpieces, however, will never leave the premises. Art dealers don't bother to come, walls in Cuba are not for sale.

LEFT
Chess game in the entrance hall of La Guarida, a *paladar* that was used as a set for the Cuban film *Fresa y Chocolate* (*Strawberry and Chocolate*).

RIGHT
After a year, this macho pig, much loved and fattened in this Manzanillo house, will end up as sausages and *chicharones*!

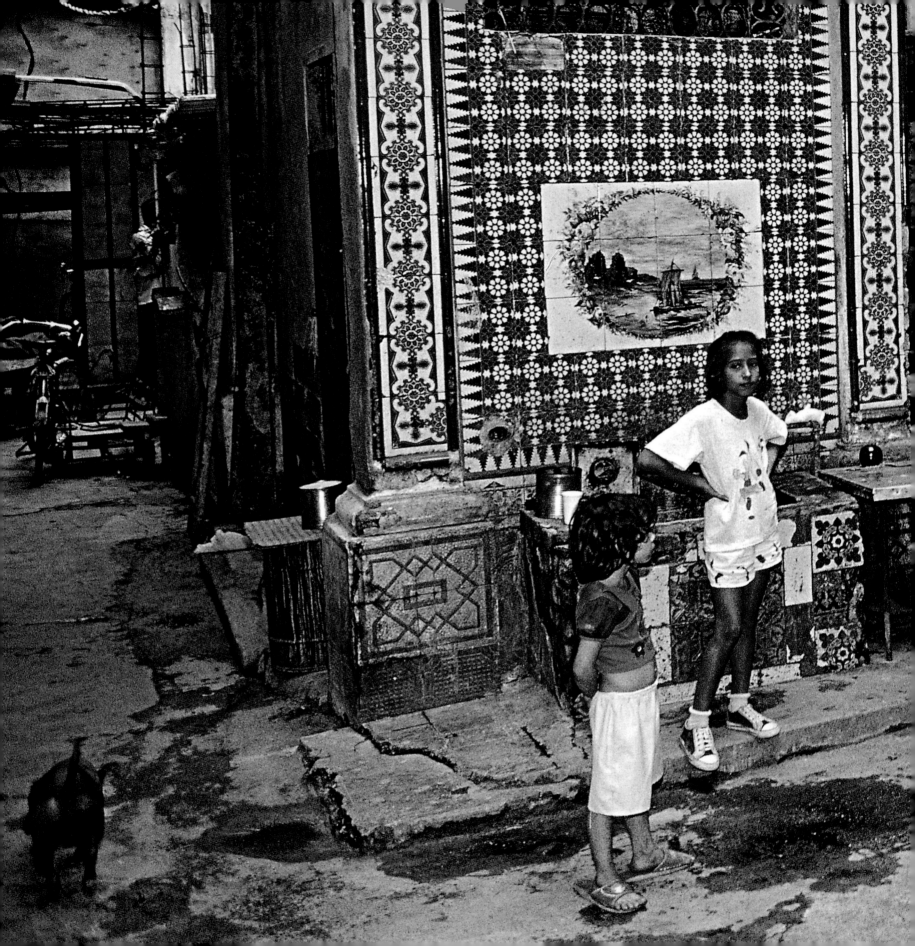

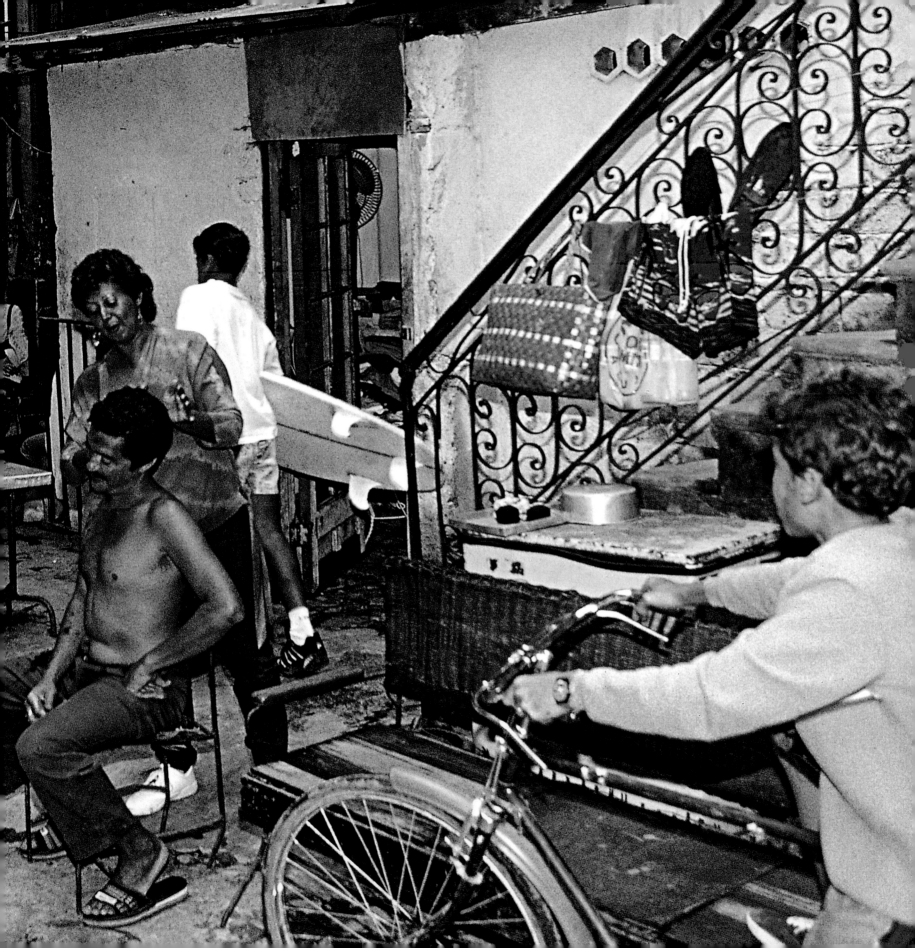

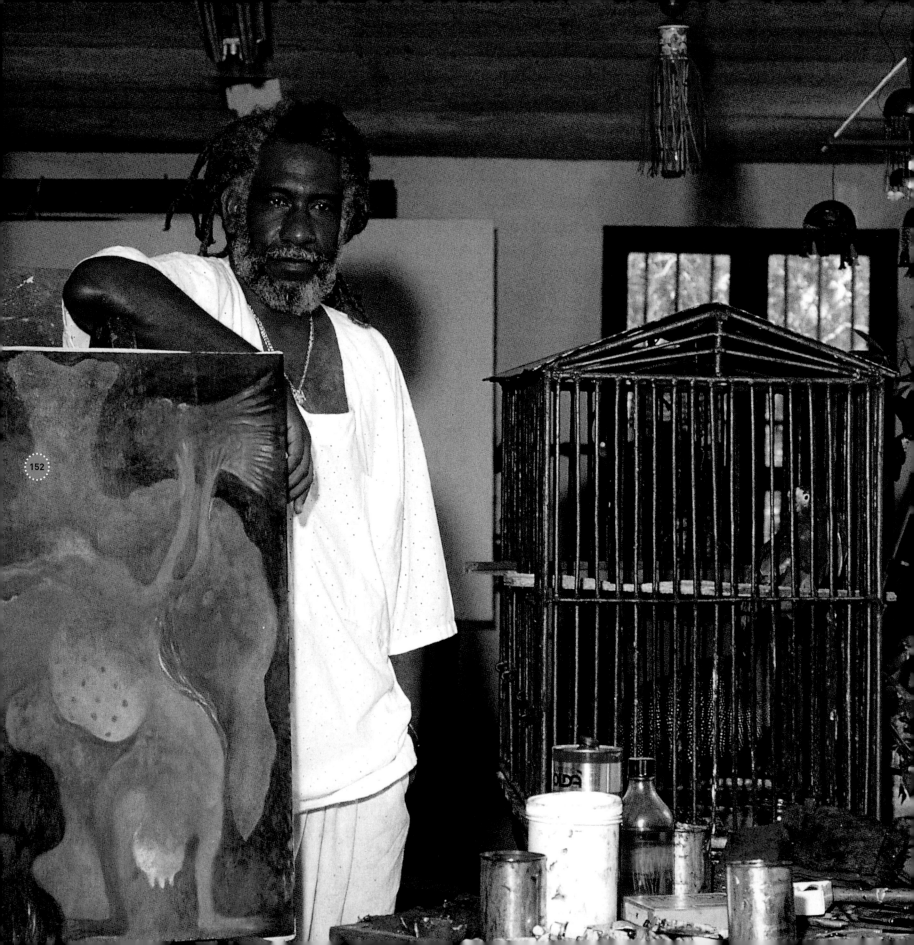

Manuel Mendive,
one of Cuba's great
living painters, lives
thirty miles from Havana
in Cotorro, in an ancestral
Africa he has reconstructed
in the middle of lush
vegetation and among
animals—a motley colony
of birds of all species—
that cheep and twitter
about: the luck of living
far from the city. A far cry
from the dwellings in the
capital, where people,
animals and bicycles are
crammed into courtyards
in which the tiles tell of
the opulence of a not-so-
distant past.

PREVIOUS SPREAD
One good turn deserves another:
neighbors in the courtyard of a building
in central Havana.
LEFT
Manual Mendive in his studio.
RIGHT
An official sculptor, Manzanillo.

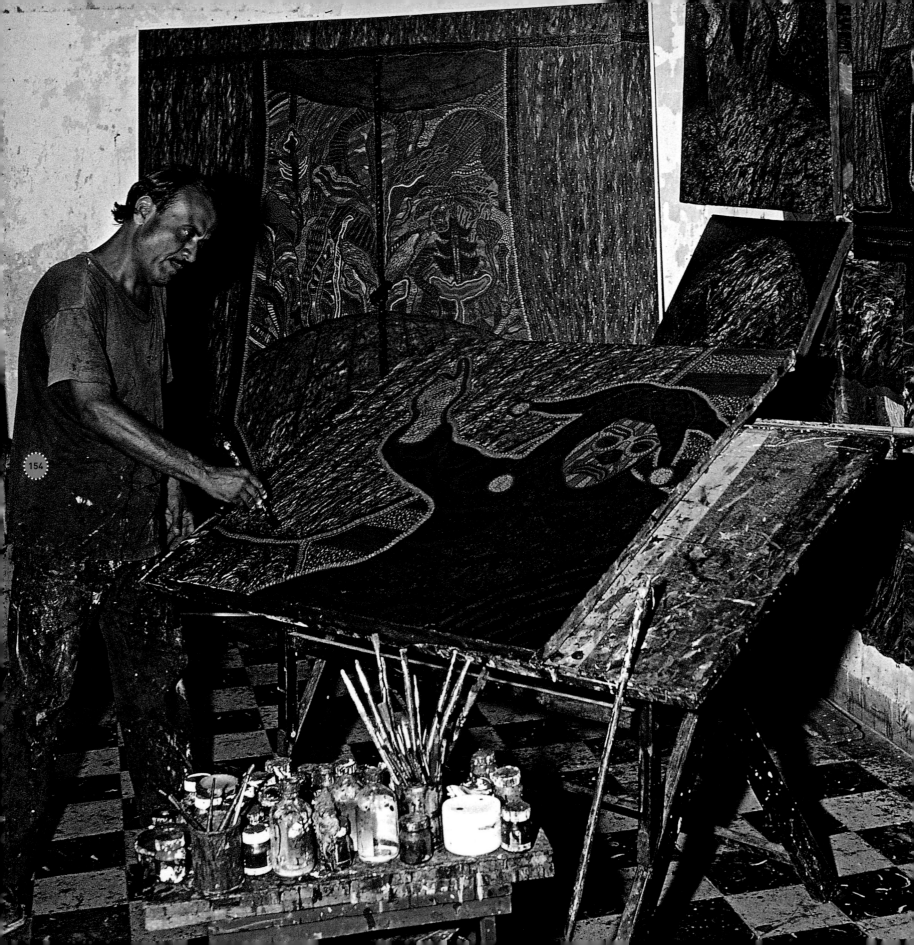

"Give me a night of fantasy
With your trees
Like birds from a hallucination
Settled on a happy mist
And the Roman divinities
Sheltered beneath a low veil
Of silence and of death."

—Cleva Solis, *Los Sabios Días*

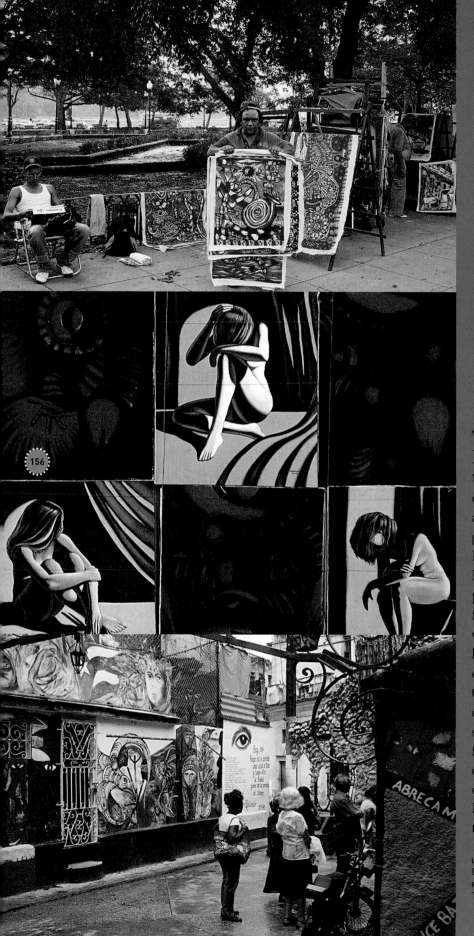

The Callejón de Hamel—located where two of the major districts of the city, central Havana and Vedado, meet—is an art gallery of unbridled freedom. Here mobiles like Calder's, Fauve-style paintings, and pictures of characters from a forgotten world rub shoulders with one another in a setting like a Luna Park for children or precocious adults. Here, Olivia rehearses her dances on stilts that enliven the streets of Old Havana. Poetry fits right in on the fronts of cafeterias, where they serve only nostalgia and hope. "The Boat of Forgetfulness" reads this one. And why not?

LEFT
Craft market, Havana.
RIGHT
The Callejón de Hamel, Havana.

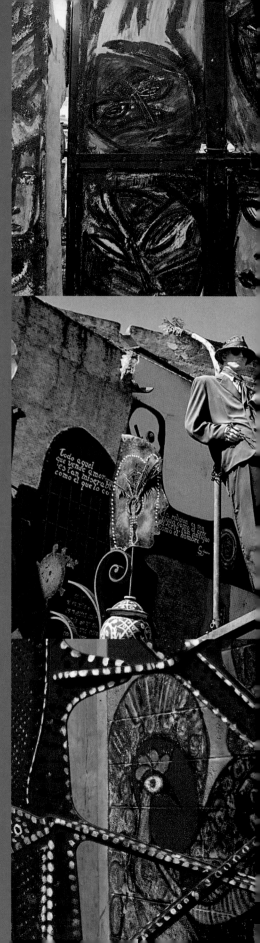

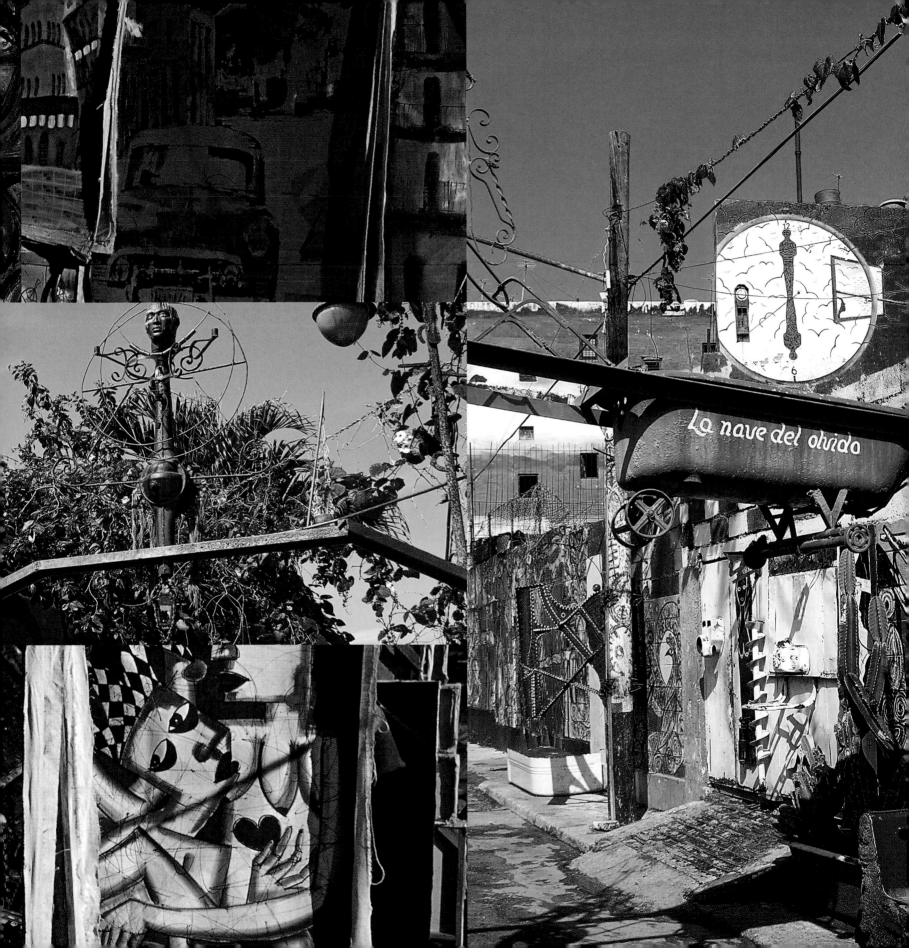

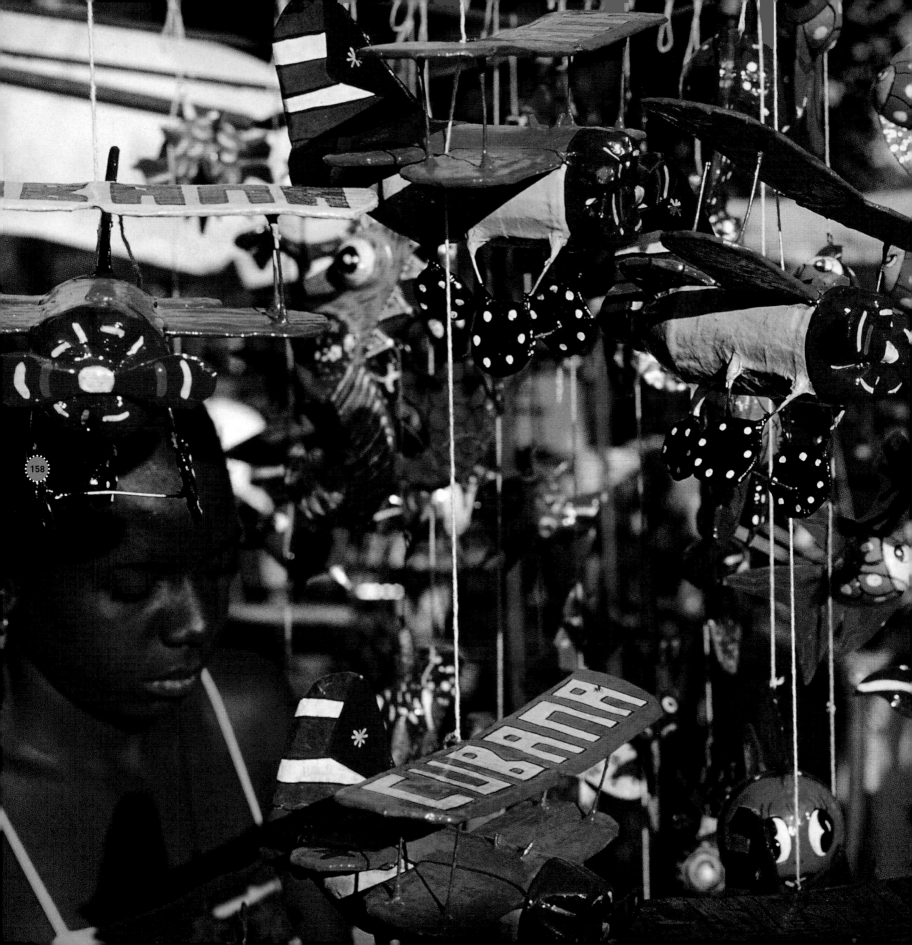

A must for any tourist discovering Havana, the Cathedral Fair is the realm of craft workers, some of whom will become recognized artists, such as Yanoski and Filiberto Mora, two brothers from Regla who are now world renowned as the grand masters of papier-mâché. They make life-size Harley-Davidsons and cars, and with their skillful hands have shaped figurines of the saints of the *Santería* religion, which are on display at the Musée International des Arts Modestes, in Sète, France.

LEFT AND RIGHT
Papier-mâché ornaments, craft market, Havana.

CUBAN HOSPITALITY

161

The yuma is a person who, if not sincerely respected, is at least strongly desired to be present. He haunts the dreams of every *Havanero, Santiaguero, Baracoén, Camagüeyén* or other Cuban in search of a couple of *fulas* to help him embellish his *congri* (rice and black beans) with lardoons, for him usually a rarity. The term belongs to and typifies the relationship between the Cuban, whose bank account is permanently in trouble, and the passing foreigner, whom he sees as Croesus in person.

"Hey, blessed foreigner—*yuma*—this is your house." Leave your dollars—*fulas*—behind, and my rice and black beans—*congri*—will taste better than ever.

During the shameful years of the *periodo especial*, which followed the brutal departure of the Soviets, a new side was added to the Cubans' reputation for warm hospitality, a more business-like hospitality. The standard hotels and restaurants were out of reach of the hordes of tourists who swarmed here in search of a party atmosphere and real cigars. So the locals developed the *casa particular* and invented the *paladar*, each benefiting from the other.

The *casa particular* enables foreign clients to stay in more affordable accommodations. At the same time, and even more important, it enables the average tourist from Calabria, Burgundy, Munich or Seville to stay with his recently met and local fiancée, be she a temporary Messalina or a woman truly in love and well on her way to getting married. In either case, she would be prohibited from staying at one of the hotels. So in this way, the *jinetera* would earn her daily bundle, which sometimes could be quite considerable, but not without the owner of the *casa particular* noting down all the details from her identity card. Ah, security, always security!

A *paladar* is a small private restaurant for foreigners, intended to compete with the official restaurants. The owner must comply with two conditions: no more than twelve people can eat at the same time, and there must not be lobster or shrimp on the menu. When it comes to the number of people permitted at any given time, the rules are scrupulously obeyed . . . which doesn't mean, of course, that it's always the same people at the table: there is a constant flow of new customers. And when it comes to shellfish, the subject of every tourist's fantasies from the time they sign a contract with the Canadian or European tour operator, well, there are ways and means for everything. The delicious aroma of forbidden but much-loved shellfish makes the *yumas* drool all the way down the Calle Maceo in Trinidad, where there isn't a single official restaurant. Go figure . . .

 Yuma bendito, esta es su casa.
Blessed foreigner, this is your house.

Cuban saying

At Santiago, beneath the fortress that dominates the entrance into the harbor, we line up at the quay where the *lancha* waits to take us to Cayo Granma. This ten-minute boat ride is part of the menu we hope to enjoy in a *paladar*, with *langosta por debajo, compañero* (lobster under the table, my friend). So we huddle together, push and shove, rub against one another, mutter and curse that damn bike whose handlebars keep stabbing us in the thighs; when we're halfway across, a rooster whose vocal cords were out of action at dawn suddenly finds them again; and old women grumble about the scarcity of oil, which you can only buy *por divisas, ay mi hija* . . . (with dollars, my poor baby . . .).

At lunchtime, which features *camarones* (shrimp) deliciously seasoned with garlic and parsley, the musicians strike up *Hasta Siempre*. Che's song is on every tourist menu.

How are you supposed to believe in better days ahead if you don't pray to Changó, Yemayá, Orula, Obatala, Ochun, Elegua? These the names of some of the most honored saints in the *Santería*, the most popular religion in Cuba, if you go by the numbers of faithful. People come from far and wide to consult the *babalao* in Trinidad. He makes the *cocos*—white snails—dance and can carry you along with his divining skill. *Fulas* required, of course. A *toque de santo*, an annual ceremony for a devotee of the

Santería, is a pilgrimage to the Church of Our Lady of Charity in El Cobre, near Santiago, to ensure the good graces of the saints. Together with Church of the Virgin in Regla, which overlooks Havana, the Church of Our Lady of Charity, which is also dedicated to Ochun, the goddess of love, is one of the religious sites to which every *santero* is obliged to go. So too go agnostics, fascinated by this sensual, festive religion. The saints eat, stuff themselves with sweetmeat, fornicate, promise mountains and miracles, and hand down cruel punishments. You don't mess around with Changó or Obatala. And you prostrate yourself before Ochun, covering her with ex-votos, thanks, and oaths of fidelity. Ernest Hemingway himself left his Nobel Prize medal at the church in El Cobre.

His soul at peace, he could go back to his countless cats and his typewriter at La Finca Vigía, the superb villa he owned at San Francisco de Paula, ten miles from the capital, where the metallic clatter of his typewriter would accompany the twittering of the *tocororos* perched in the royal palms, Cuba's national tree. "Cuba is my greatest love story," he told his longtime friend Fernando Campoamor.

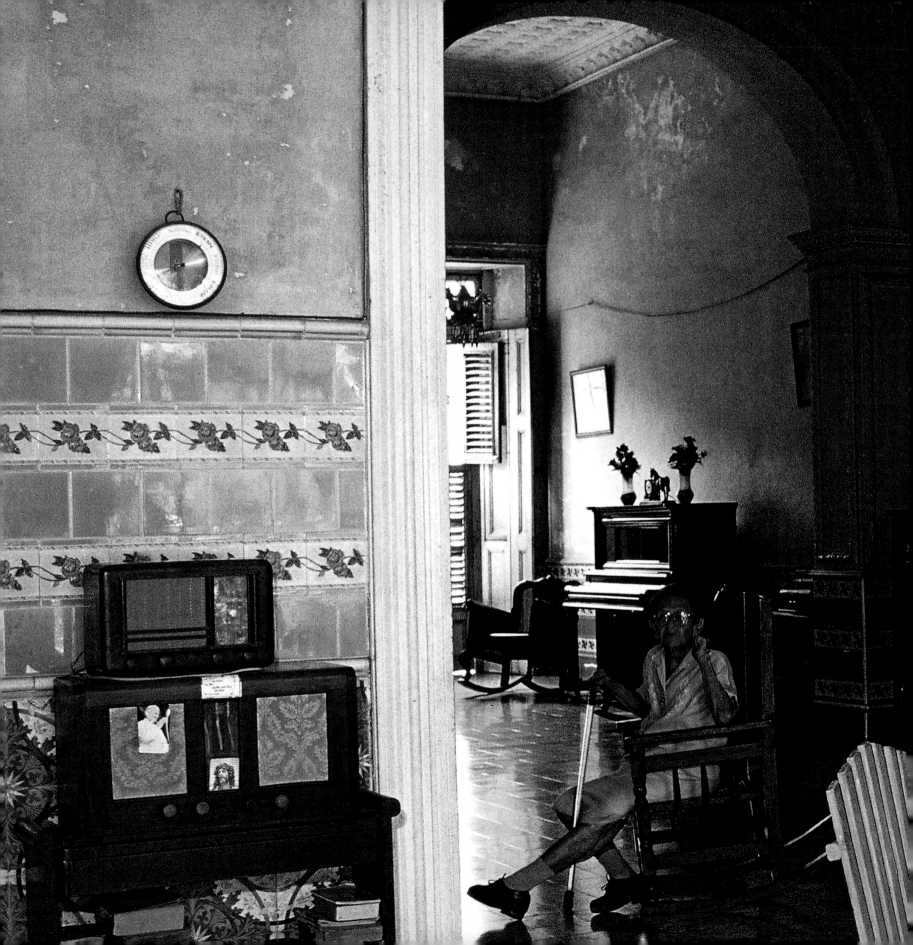

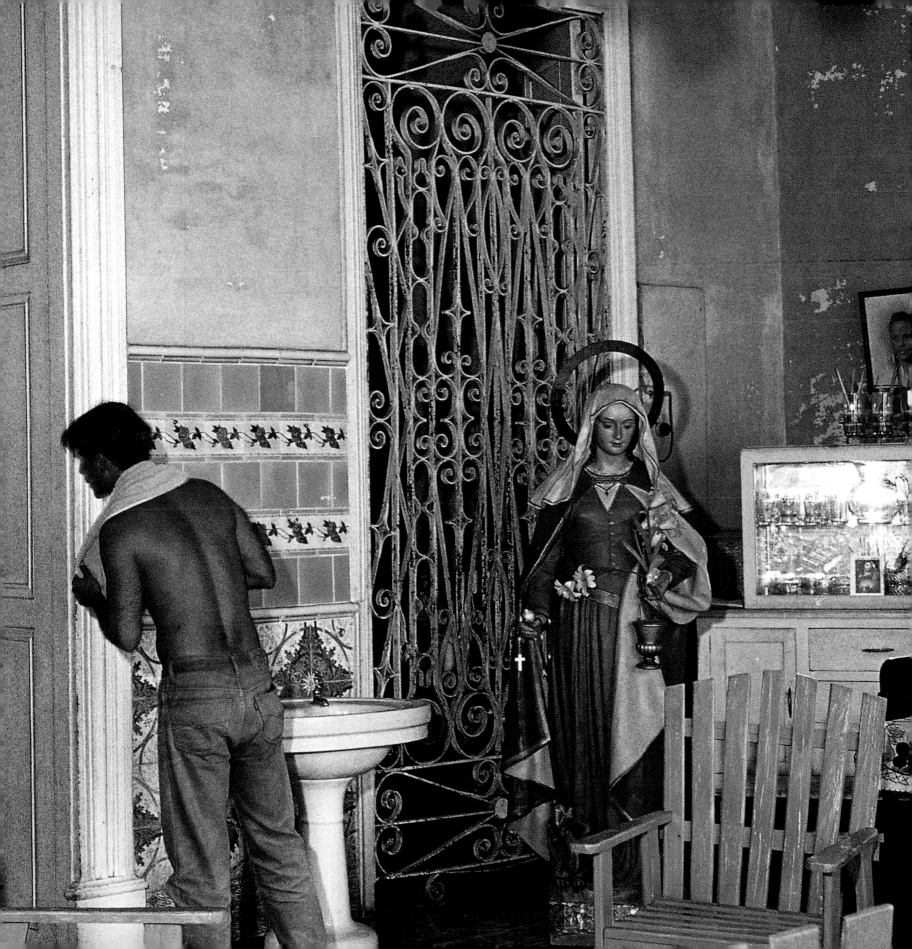

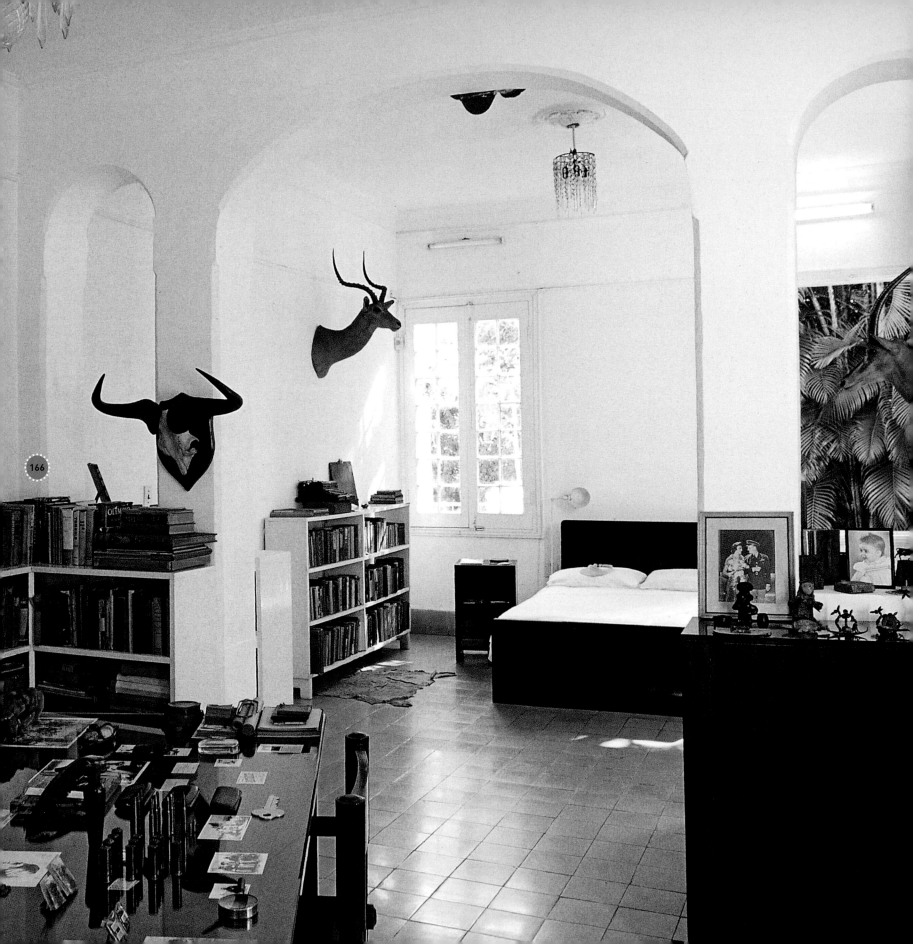

"Getting up to close the shutter
you look across the harbor to the flag on the fortress
and see it is straightened out toward you.
You look out the north window past the Morro
and see that the smooth morning sheen
is rippling over and you know
the trade wind is coming up early."

—Ernest Hemingway, "Marlin Off the Morro: A Cuban Letter,"
in *Esquire*, Autumn 1933

¡Esta casa es suya!
"This house is yours!"
If only.... Nevertheless, you
can't help liking this Cuban
expression of hospitality. In
the same way, your ears tingle
when a postal worker you've
never seen before welcomes
you with, *"¿Que quieres, mi
amor?"* ("What would you
like, my love?"). As the poet
Jacques Prévert said, "I love
everyone who loves me, even
if I don't know them." He
would have found people to
talk to here, and probably
would have changed his
passport. There's no embargo
when you receive a welcoming
smile and welcoming words.
And for the rest, there's
always a drink to share.

LEFT
A postcard from the 1930s.
RIGHT
Beneath a porch in the Vedado district,
Havana.
A caged cockerel in the Casa Meyer,
Trinidad.
The house of the poet José Maria
Heredia, Cuba.
A patio, Santiago.
The drawing room of a colonial house,
Cuba.
The interior of a private house, complete
with colonial furniture, Trinidad.
Indians cooking in their family home, the
Casa Meyer, Trinidad.

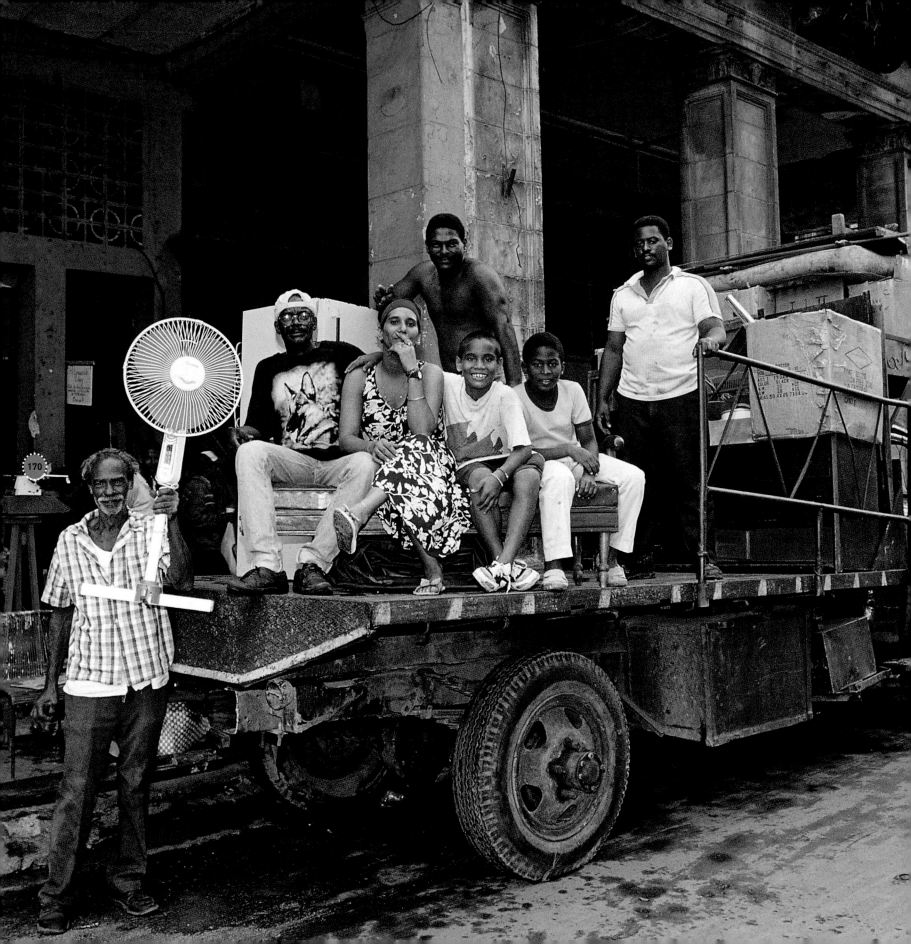

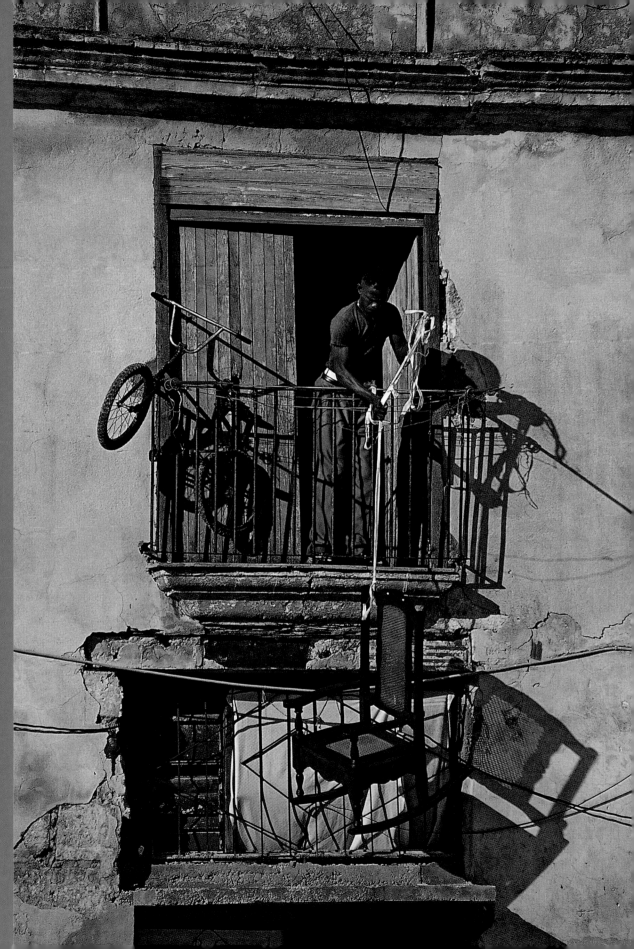

¡Ay compay! What luck! I've found a four-room apartment in Alamar for my wife and three children in exchange for my old love nest in central Havana. Of course, I had to slip them a few thousand *fulas* (dollars). It just wasn't possible anymore, you know. The boys have *novias* (girlfriends) of their own now. So what were we supposed to do? Now Gustavo is moving my stuff to our new place in his truck. *¡Ay compay, la mudanza* (moving), *que problema!*

LEFT AND RIGHT
Exchanging apartments in Old Havana (better known as *la permuta*).

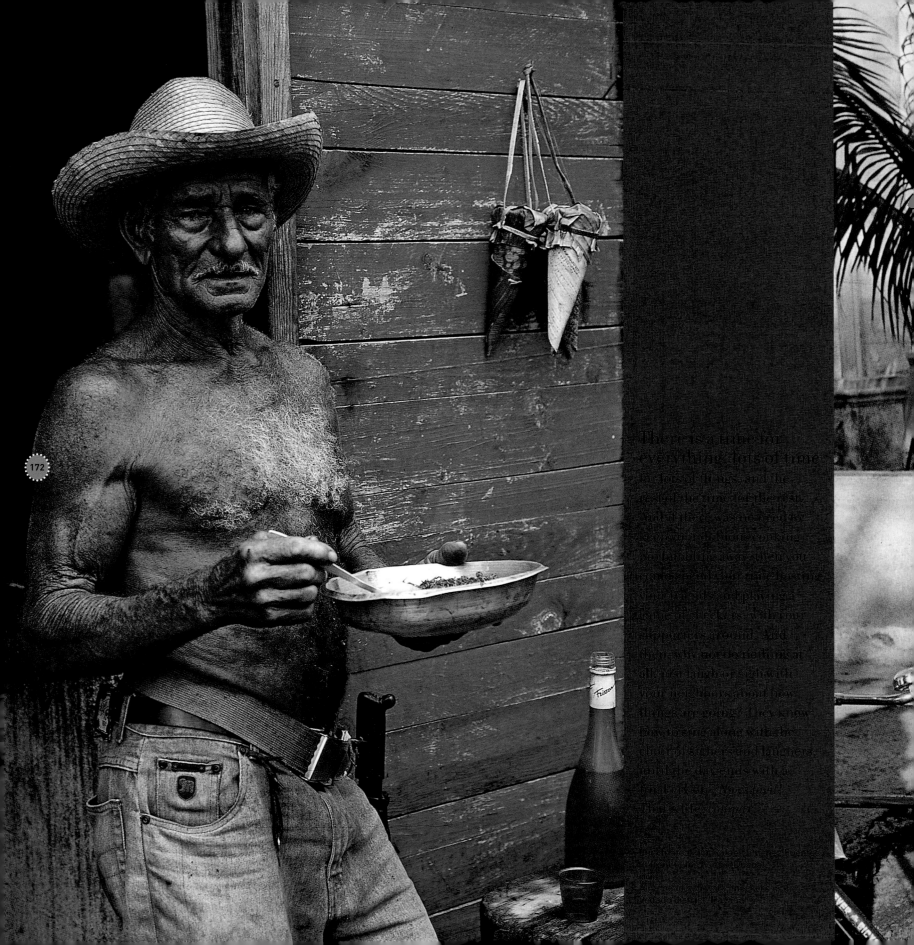

There is a time for everything, lots of time for lots of things, and the second the time for the rest. And it is very important for keeping your fabric in working order and life away, when you are worn out. But more resting at that kind of playing it is like one looks good with your appearance to one. And then why not celebrating at all, just laugh or sigh with friends. Chat about how things are going? They know how to sing along with the chords of others and laughter, and the rest ends with a small smile. How about a little coffee?

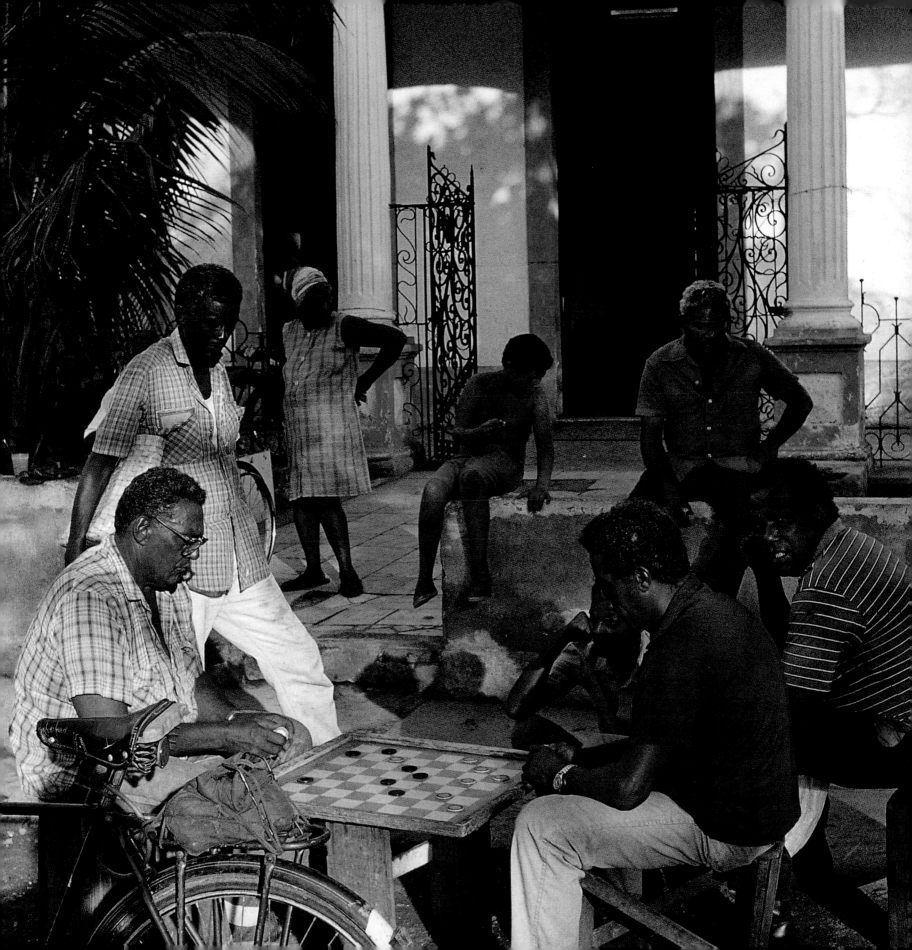

"My father's name was Nazario. He was a *lucumi* from Oyo.
My mother's name was Emilia Montejo. They told me
that they had died at Sagua La Grande. To tell the truth,
I would really have liked to have known them, but to save
my skin, I couldn't. If I had come down from the mountain,
to be sure they would have caught me."

—Miguel Barnet, *Biografía de un Cimarrón*

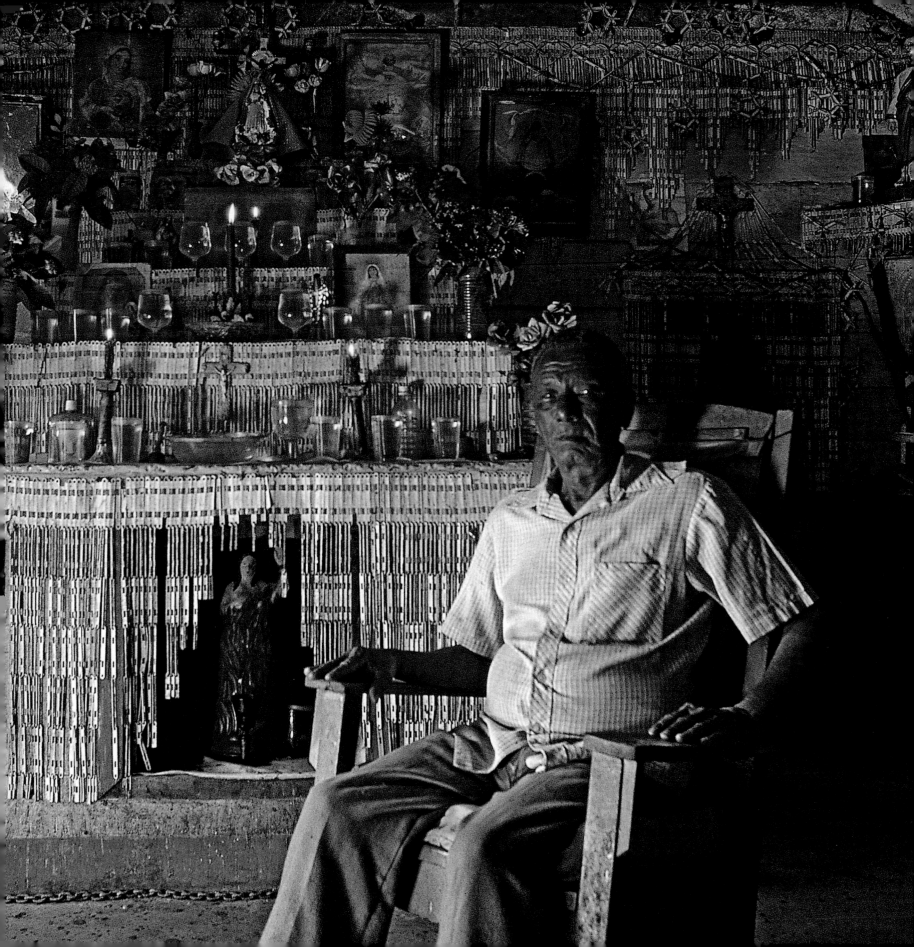

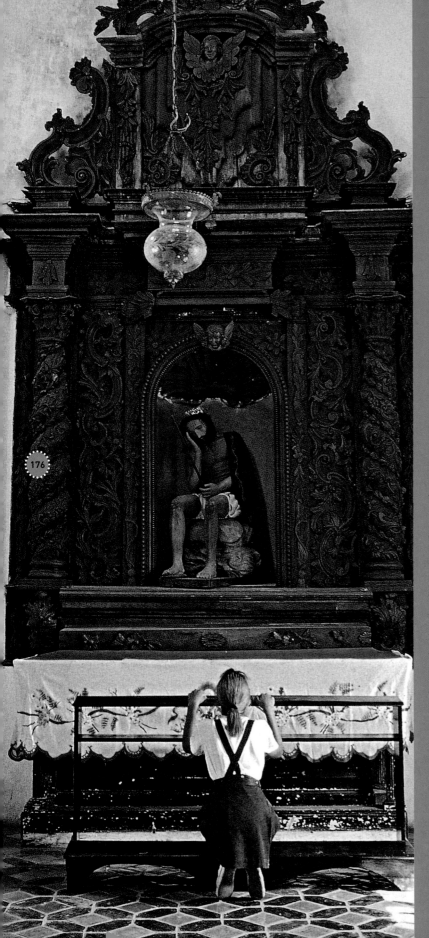

It was a funny week, Holy Week in 1997, an unforgettable week. Before Pope John Paul II planned his trip here, the church had no idea what sort of access the authorities would give to a faith that until then had been underground and clandestine, but now would be openly manifest. In Trinidad, the debate about whether processions would be permitted around the Plaza Mayor raged on right until the afternoon of Good Friday. The procession was discreet, and people kept watch as they saw fit. The old debate: religion and politics!

LEFT
The Church of Sancti Spiritus.
RIGHT
Good Friday procession, Trinidad.

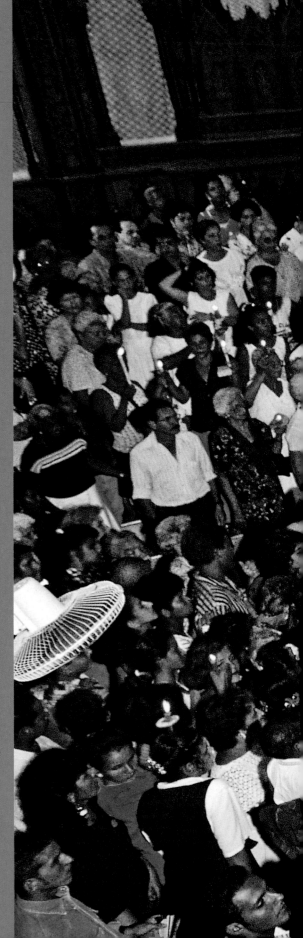

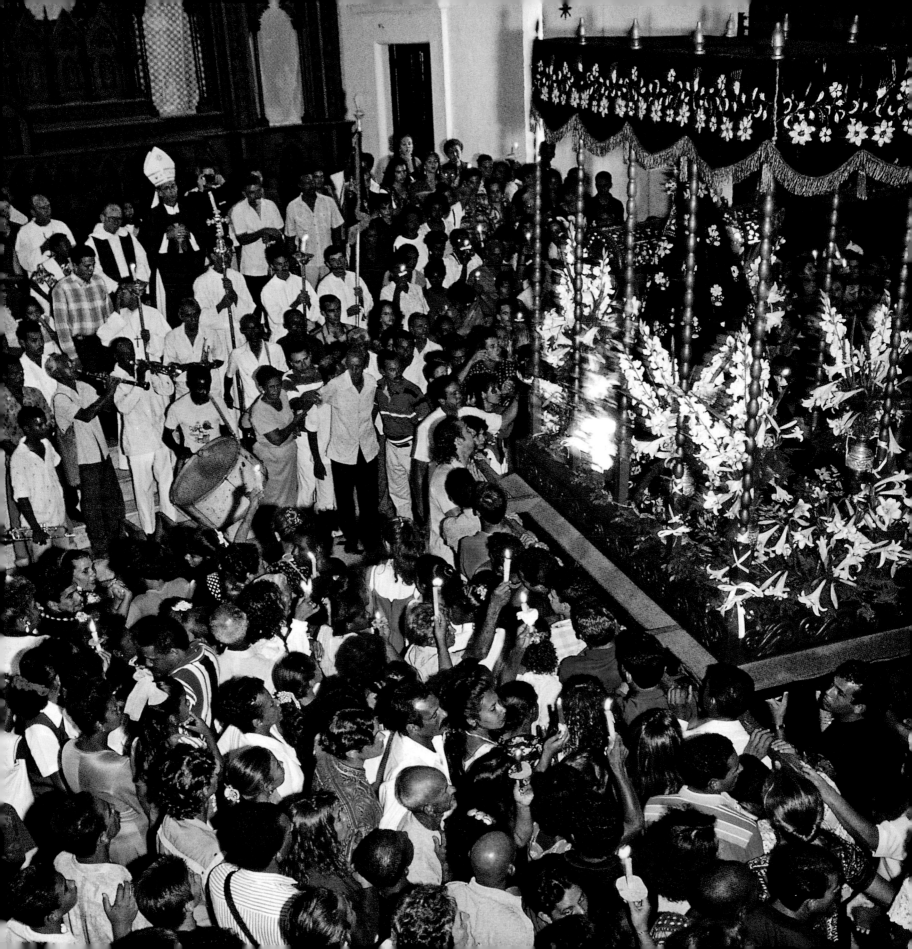

La Niña
**Yolanda Luisa Shombert
Burgo**
Nació el día 25 de Agosto
de 1927.

PADRES:
*Juan Shombert Balboa
Caridad Burgo de Shombert*
PADRINOS:
*Rogelio Reyes
Anita Villalañe*
Fué bautizada en el Santuario
del Cobre, el día 8 de Abril
de 1928

In his book *The Palm Tree and the Star*, the Cuban writer Leonardo Padura Fuentes has his protagonist say, on returning from exile: "How can one forget Cuba? How can one remain Cuban? How can one be the voice of a country after having been excluded from it for some time?" Padura has never contemplated leaving Cuba. It would be a mortal blow to him were these palm trees, these colors, this conviviality to disappear. He has said so. In one of the rare interviews he has granted to the press, Cuba cannot be lived by proxy.

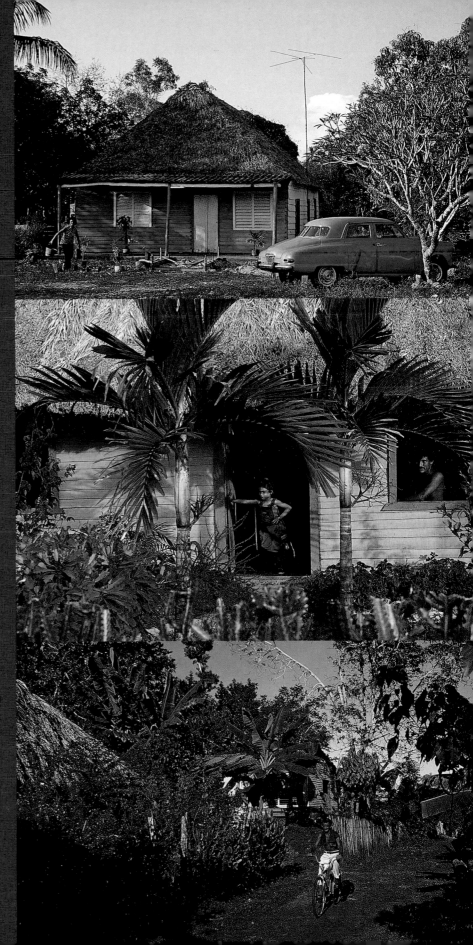

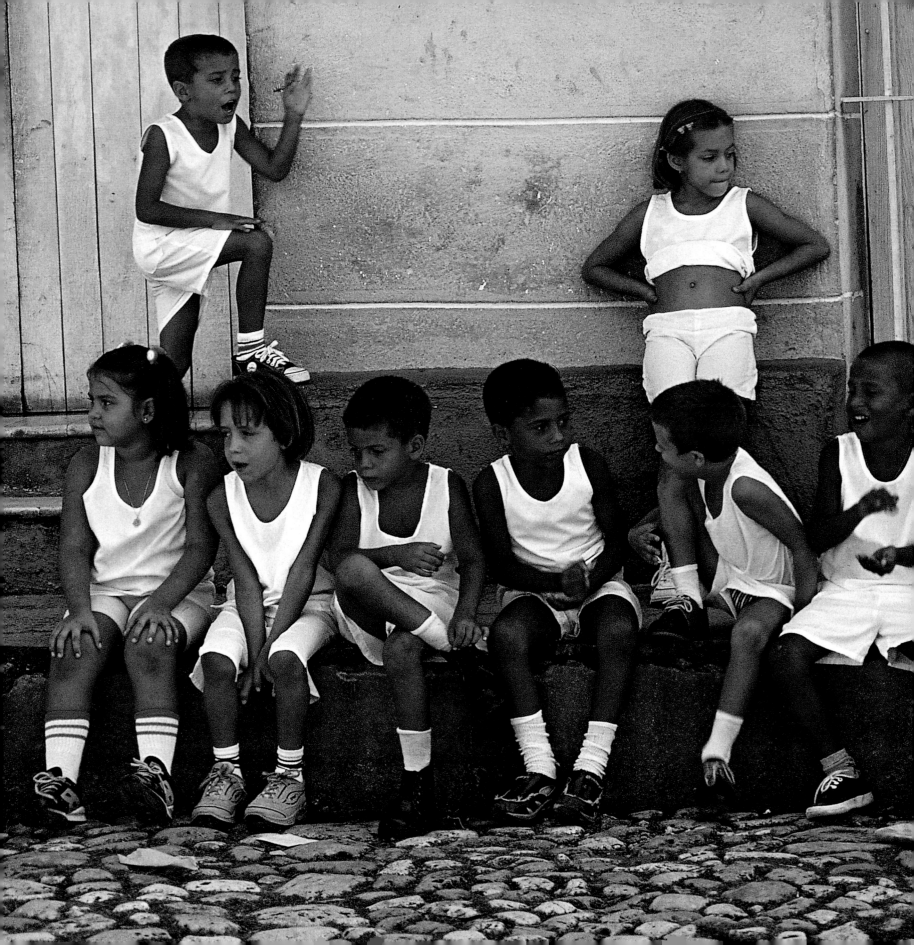

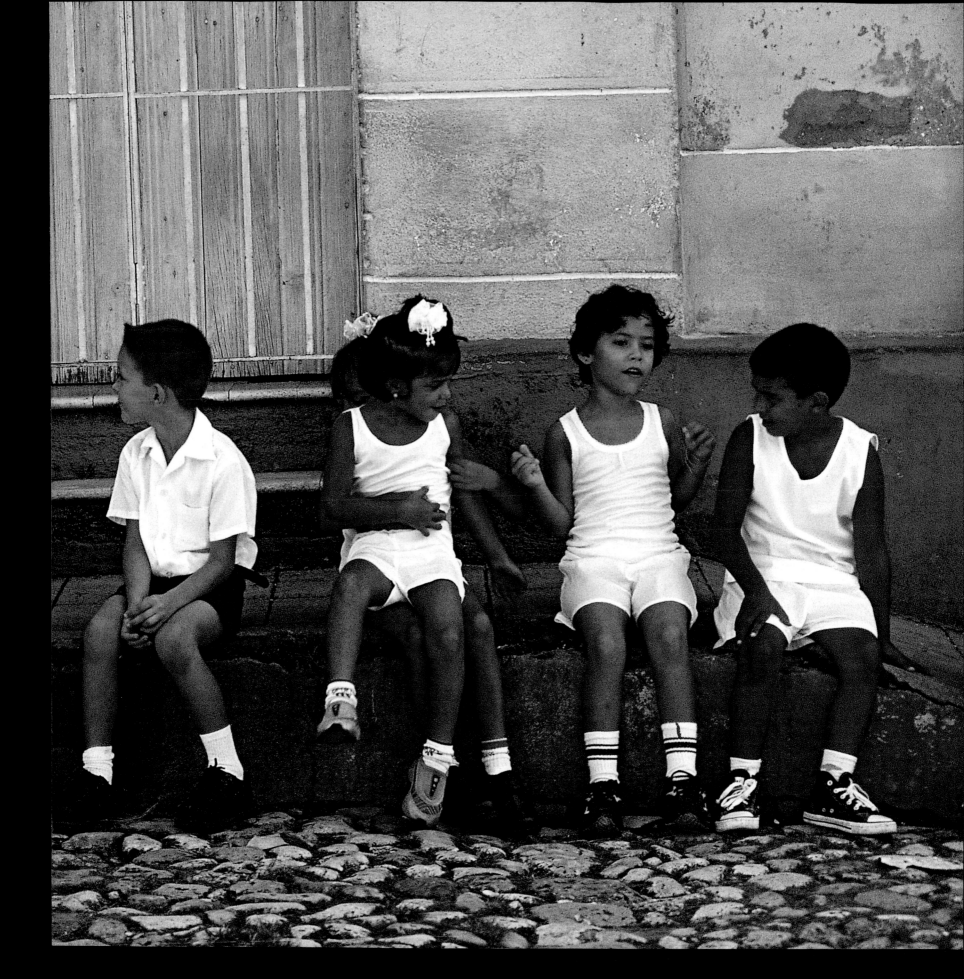

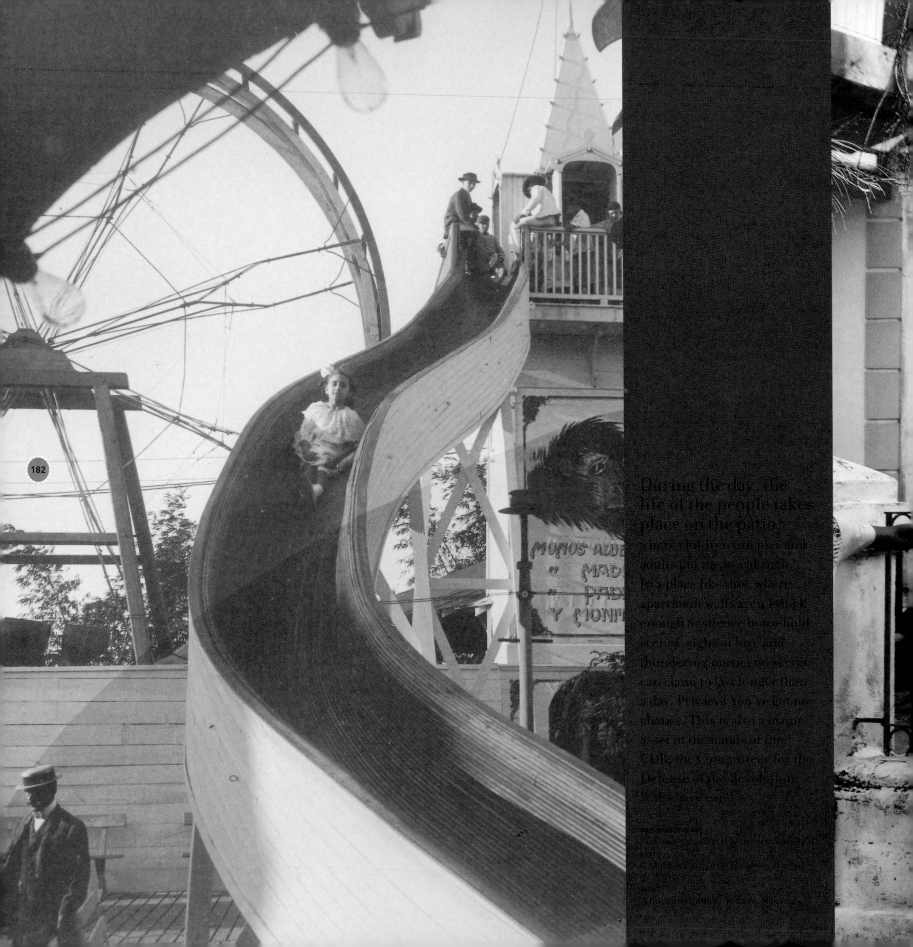

182

During the day, the life of the people takes place on the patio, where children can play and adults put the world right. In a place like this, where apartment walls aren't thick enough to silence household scenes, sighs of love and thundering music, no secret can claim to last longer than a day. Privacy? You've got no chance. This is also a major asset in the hands of the CDR, the Committees for the Defense of the Revolution. Walls have ears.

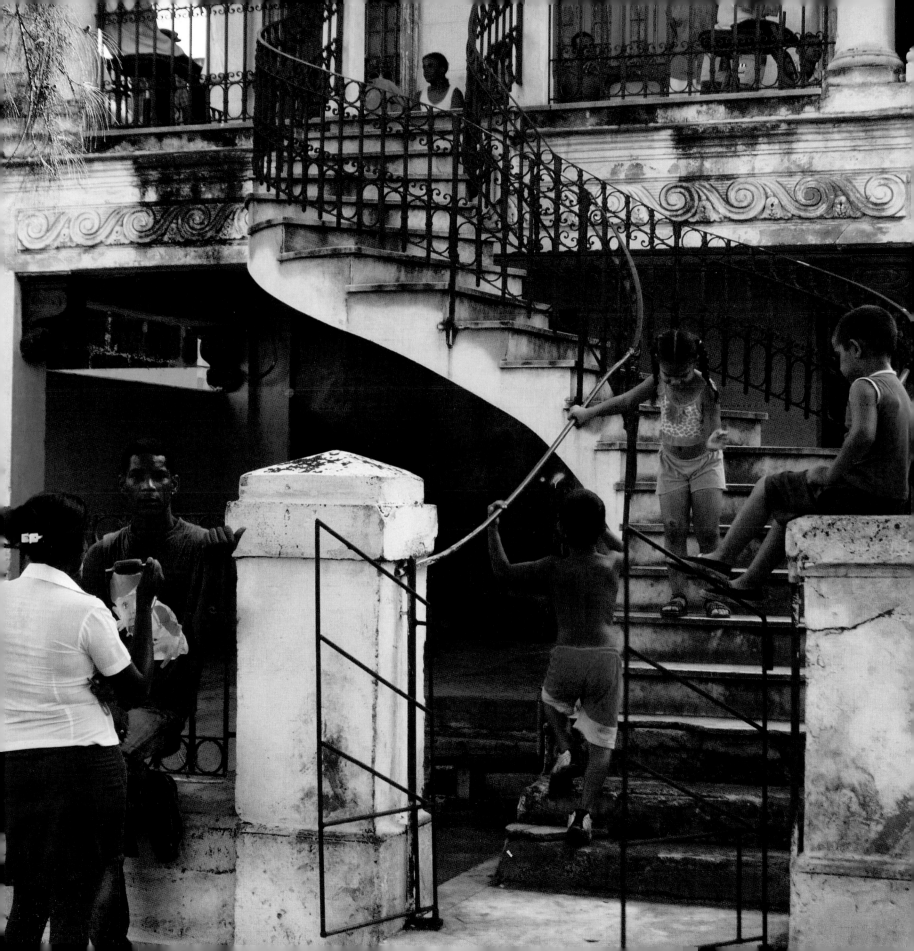

TILLERS OF THE SOIL

185

"No es facil, compañero . . . " The rights to this observation belong to millions of Cubans. It is neither a complaint nor an expression of resignation, just a way of sighing at the end of a conversation. In English we'd say, "Hey, that's life."

"No es facil, compañero," says Iluminato. He is a *machetero*, a cane cutter. To see him and listen to him, you'd think the saying was a punishment. His head looks as if it has been cast in bronze. Furrows crisscross his ageless face. Are they the natural result of the passing years, of too much time spent working like a dog under the Caribbean sun, or of a life spent in the midst of violence, gunfire and political fighting?

"¿Quien sabe?" Yet another diplomatic way of defusing a complicated question by means of a circumspect answer. Who knows? And yet, by the time the conversation comes to an end, you have learned that this bloated, seamed, furrowed face is part of the natural heritage of a nation that believed, sometimes wrongly, that all its economic woes could be solved by this one word: sugar. The word that Iluminato intones. Its life, his life, is Cuba's memory.

Like a tennis player who says her racket is an extension of her hand, Iluminato's machete is the sixth finger of his right hand; his mistress, and his paycheck. For as long as he can remember, he has never left it behind. The two are joined by a marriage contract that specifies they cannot live without each other. Since the 16th century, from Trinidad to Las Tunas, from Santiago to Matanzas, a man's muscle and this blade of steel have been at war against a plant that mocks them from a height of twenty feet and will never admit defeat until it is brought low and sprawls on the ground, a pile of humiliated bagasse that will serve as fertilizer out of which new shoots will grow—sugarcane for the next *zafra*, the Caribbean symbol of the sugar harvest. And life begins again.

Sugarcane is inextricably tied to the history of the country, not only because of the dreams of economic development through sugar, but also because its cultivation needed a labor force that was inured to hardship. The solution—which the Spaniards, the first conquerors of the island, found all by themselves—was Africa, and there followed raids across the countryside of Benin, Nigeria, Senegal and elsewhere. Africans were driven into the caravels of misery, herded into *encomiendas*, which were no more or less than concentration and labor camps,

 **I see a group of men putting
the bagasse of shredded canes into the furnace.**

Jean-Marie Le Clézio

and placed under the orders of the *encomendero*, a Spaniard to whom the crown had assigned a piece of land he could exploit but did not belong to him. They became slaves in order to drive the *ingenios*, Cuba's sugar refineries.

The most emblematic of these *ingenios* lies about ten miles from Trinidad. It is called El Valle de los Ingenios and is now a UNESCO World Heritage Site. And there they spilled their blood and tears until October 10, 1868. On that historic date, in the Declaration of La Demajagua, Carlos Manuel de Céspedes, a landowner in the southeast of the island, freed his peasant slaves and declared Cuba a free country. That would be the end of the factories of suffering. And it comes as no coincidence that when, on October 2, 1956, the conspirators aboard the *Granma*, the motor launch carrying Fidel Castro, Che Guevara and their *barbudos*, landed, it was on the Playa las Coloradas, a cable length from La Demajagua.

Iluminato is the heir to these leaden centuries. He does not shrink from revealing that he got his first shoes and first learned to read when he was forty years old, when his beloved guerrillas arrived. He is the spiritual cousin of Don Alejandro Robaina, the sole heir to the tiny remnant of the Cuban nobility that has managed to survive all the political tsunamis that have beset the country.

Don Alejandro is the archetypal tobacco plantation owner. With his furrowed visage, tanned skin and darting eyes, he recounts the story of the glories of the Cuban soil, to himself alone. He reigns over the fields of San Luis, in the region of Vuelta Abajo. Here was born the cigar aristocracy. The plant the Indians used to chew on when Christopher Columbus arrived at Baracoa in 1492 has seen far greater success than the gold the Spanish conquistadores sought in vain. The province of Pinar del Río contains the best acres that provide the binders, fillers and wrappers of the *vitolas* lovingly rolled by the torcedores of Partagás, Hoyo de Monterrey, and H. Upmann.

The plants grow in soil in a land that looks as if it comes straight out of the Bible, surrounded by the *mogotes* of Viñales. Enormous bulls yoked together with wooden frames obediently follow the beam, held by the farmer. Don Alejandro likes to direct this task himself. Here tradition has not yielded to camshafts or carburetors: better by far the droppings of Rocinante and Apis than the diesel fuel of Massey Ferguson. A definitive strategy to get around the uncertainties of the energy market.

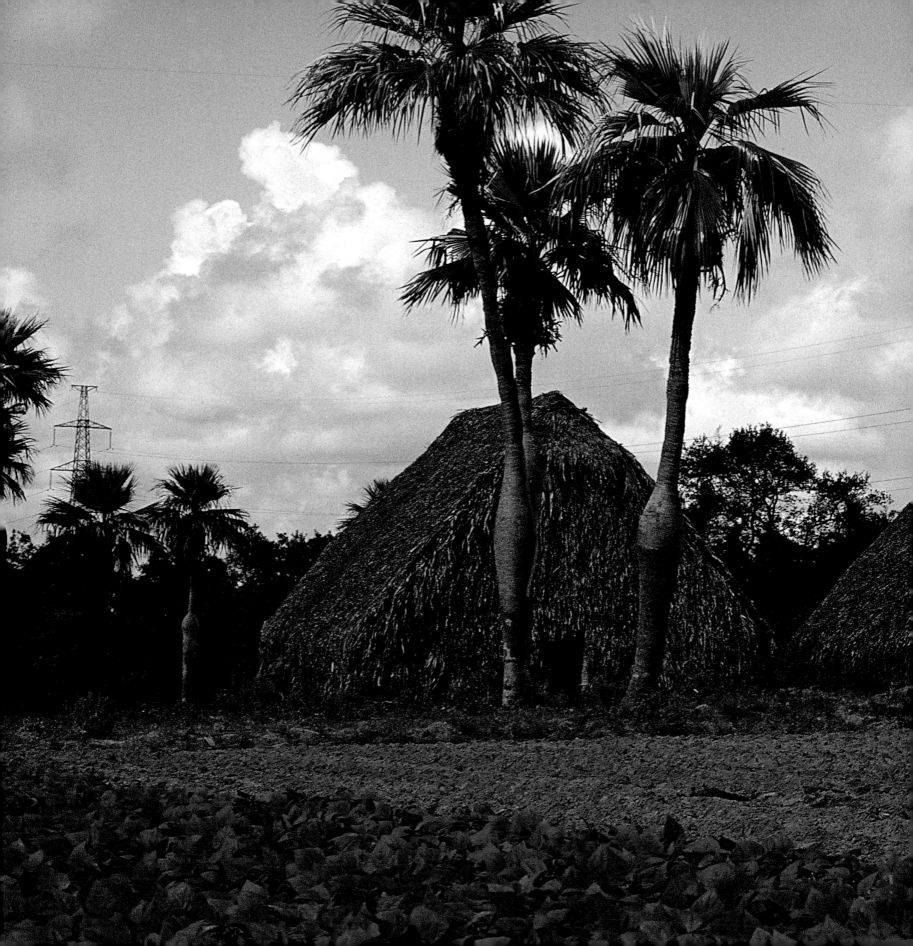

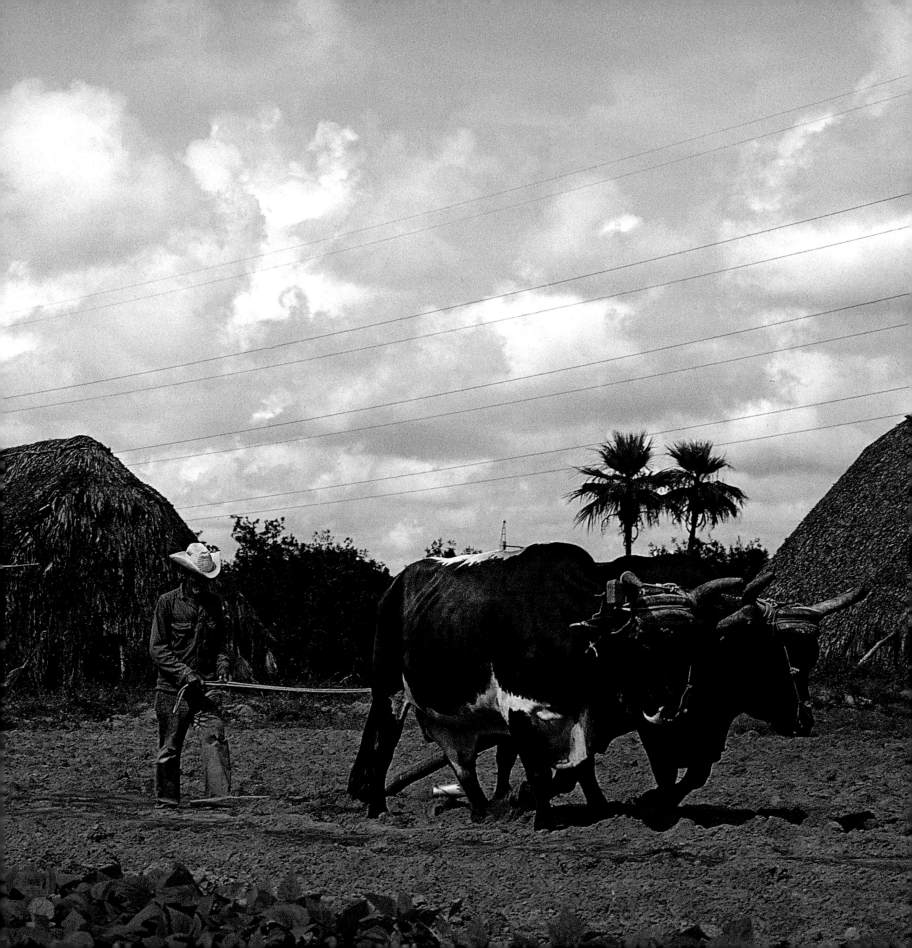

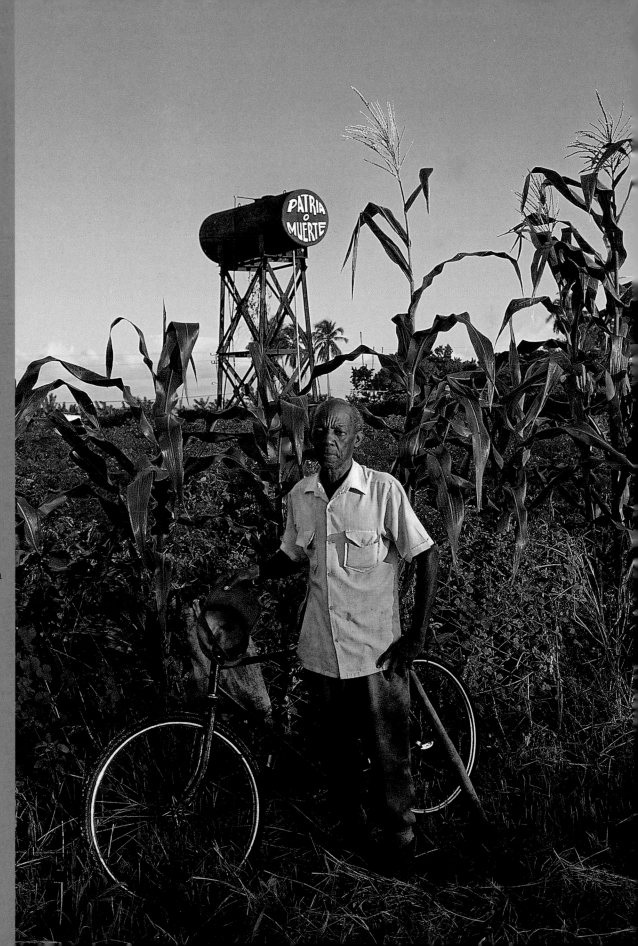

Hardly are you out of the towns, and sometimes when you are still in them, when you can see the land soften into a series of Impressionist paintings. How good it would be to stretch out under the shade of a convenient mango tree, or laze away beside a singing stream. But the dream comes to an abrupt end. A cart, a bull and a man braced on top expose the lie to the bucolic beatitude of the place. The fragrant Cohiba you smoke in a Paris salon or on Wall Street comes at the cost of hundreds of hours spent by a *guajiro*, tearing the treasure from the soil in some plot of land in Pinar del Rio.

PREVIOUS SPREAD
A farmer working his field in the Viñales Valley.
LEFT
Drying sisal, Laguna de la Leche, near Morón.
RIGHT
A market gardener, Manzanillo.

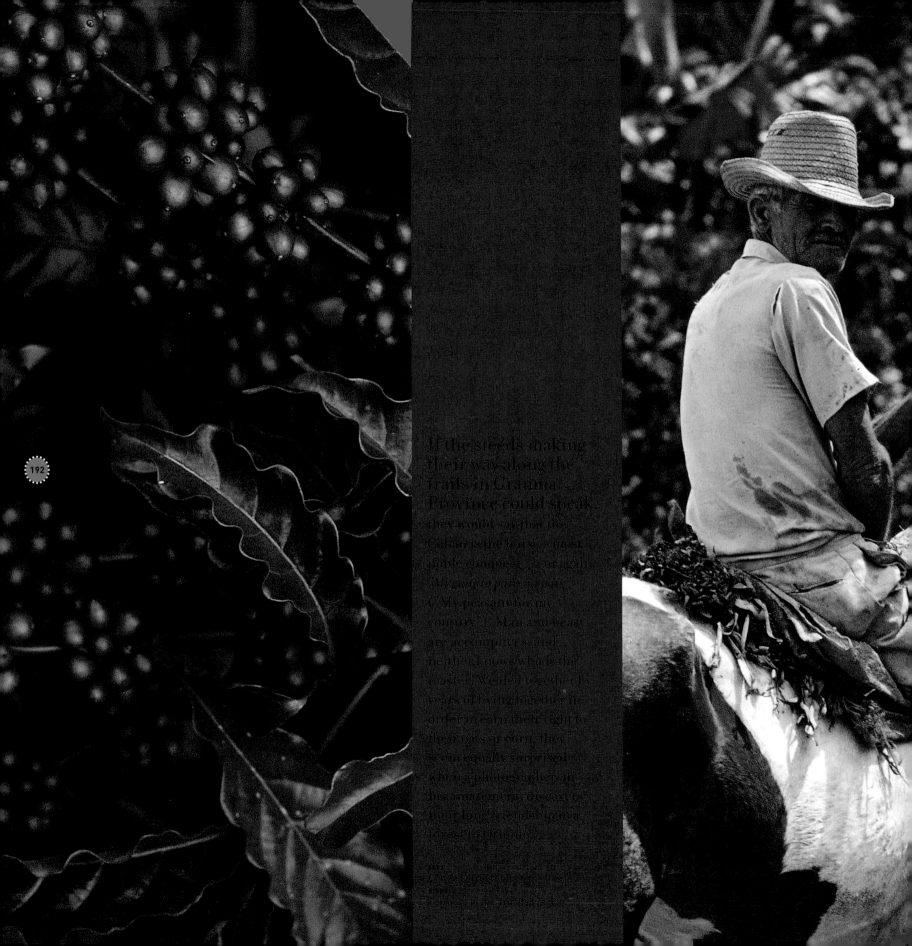

If the steeds making
their way along the
trails in Granma
Province could speak,
they would say that the
Cuban is the horse's most
noble conquest . . . or again:
"Mi negro es mi negros"
("My peasant for my
century"). Man and beast
are accomplices, and
neither knows who is the
master. Welded together by
years of living together in
order to earn their right to
their oats or corn, they
seem equally surprised
when a photographer, in
his amazement, discovers
their bond. I understand a
foreign phrase:

Levez-vous gens de
[illegible]
Peasants of the Granma region

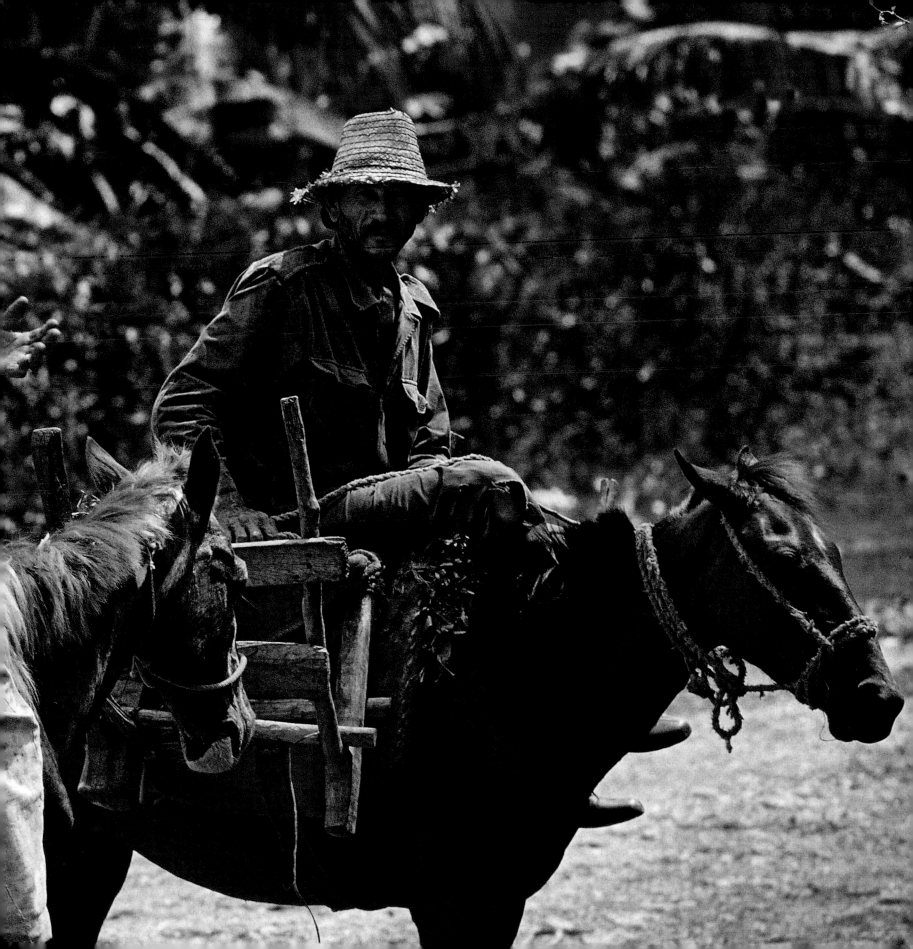

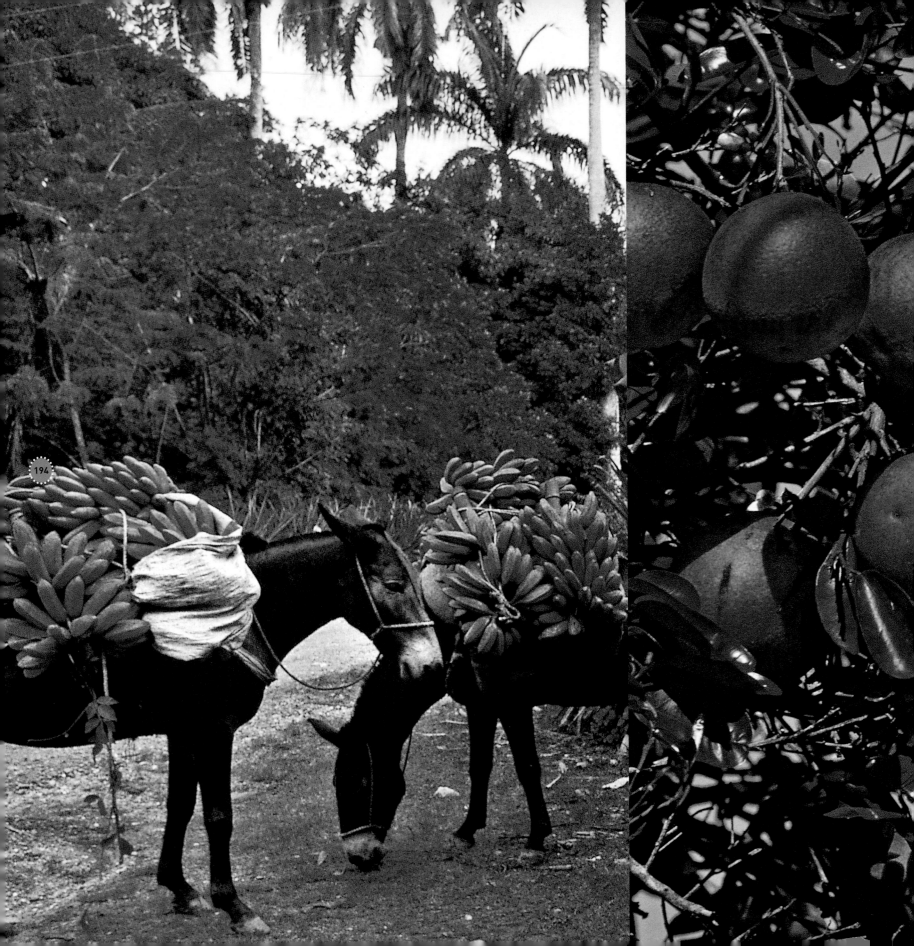

While it has been shown, unfortunately, that local oil will never be able to balance Cuba's trade account, the country's real fortune lies in its green gold. Since the revolution and the establishment of the embargo, it continues to alleviate the hardships of what is known as the *periodo especial*. Rafael, shown here on the beach at Duaba, in Baracoa, is a national champion recognized throughout the country. At eighty-five years old, he still clambers up a coconut palm as easily as a child goes to school.

LEFT
Plátanos (plantains) and grapefruit: the contributions of a generous nature.
RIGHT
Since he was eight, Rafael has being climbing up coconut palms every day.

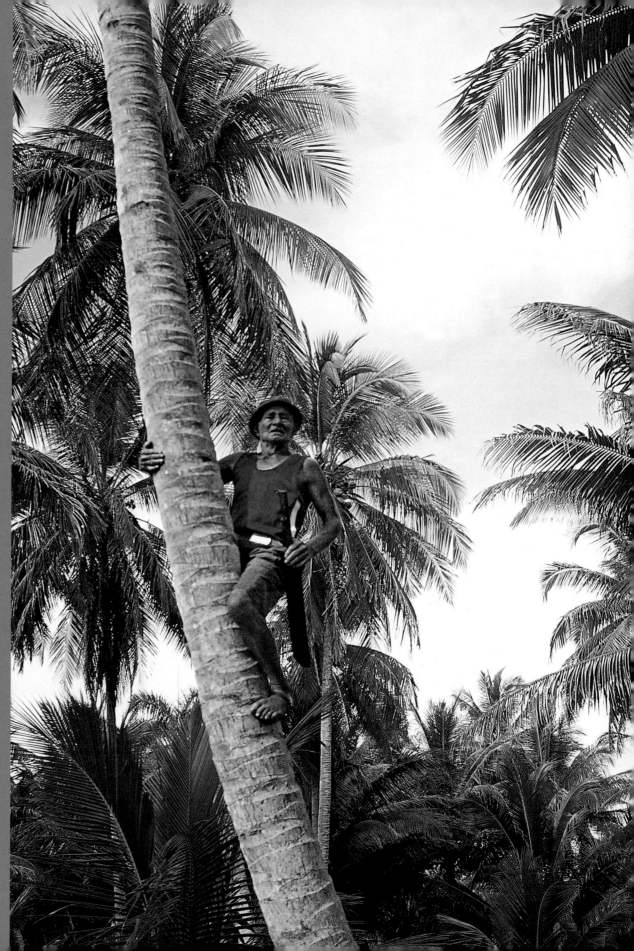

"My bull is white, like the fish
I have seen tonight
Crossing the river against the current; white as the crane
That pecks at insects on silver banks.
White as the taste of yams
Or the wandering song of clouds."

—Albert Serret, *El Árbol que Cantaba Cuentos Africanos*

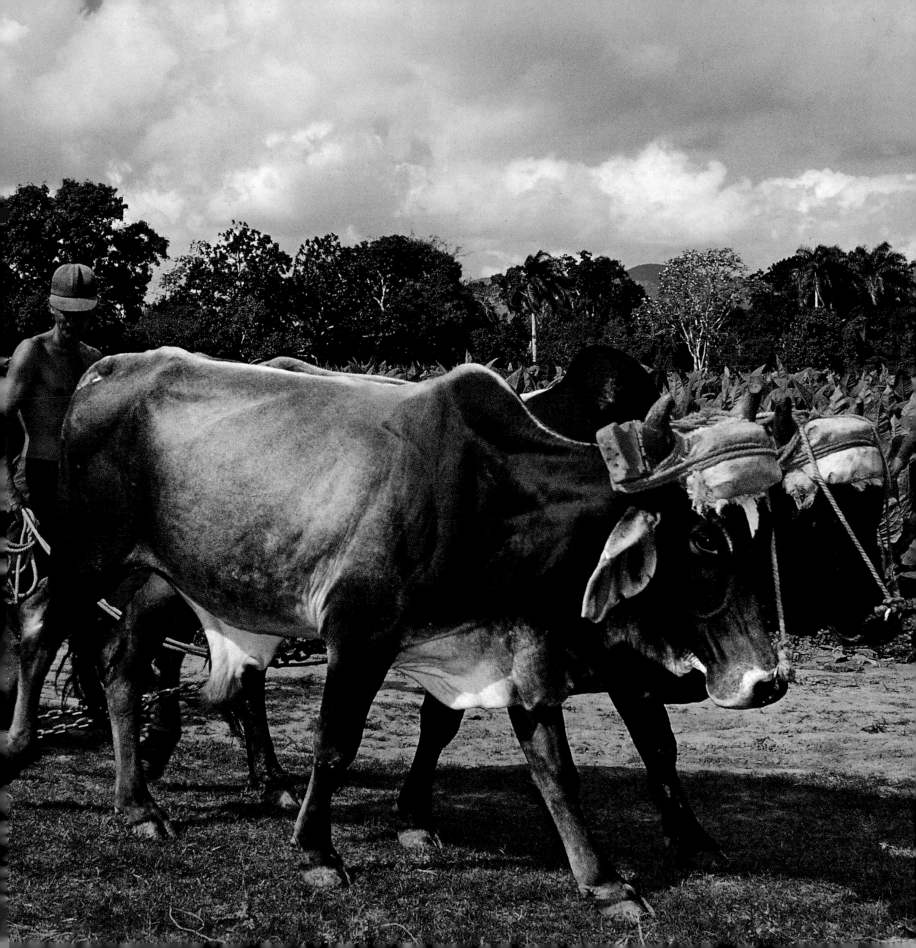

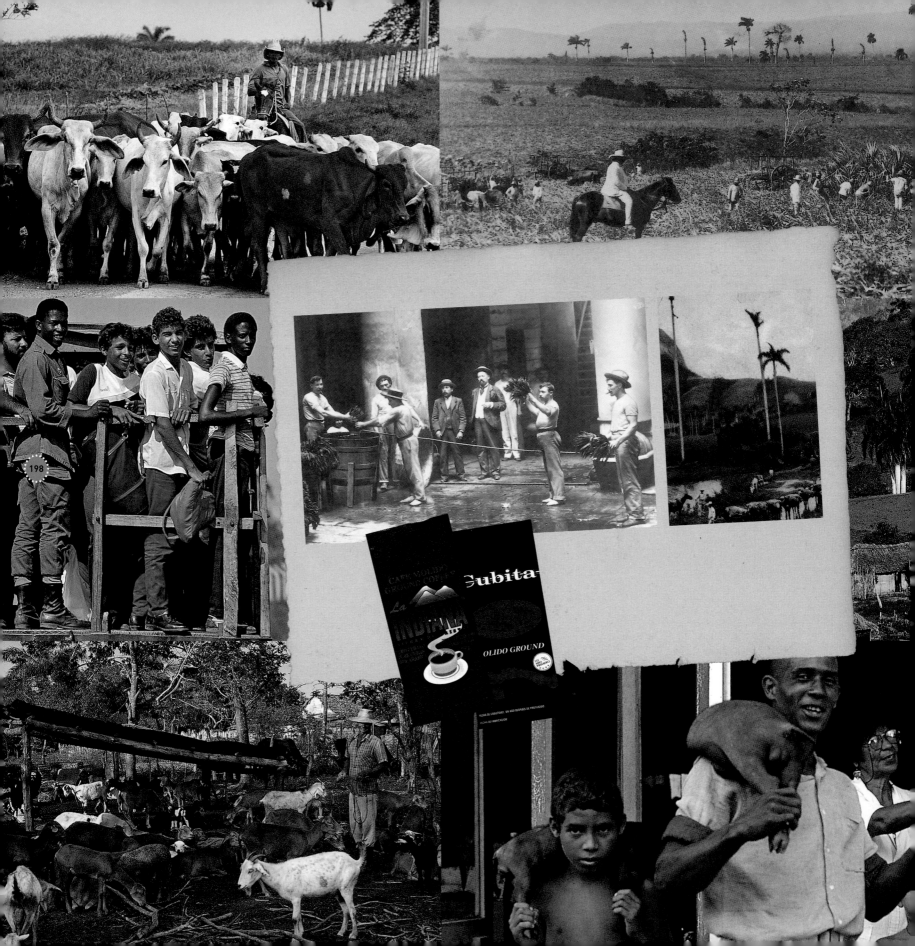

A *bohio* is a rustic hut. As a symbol of peasant life, it has been in a thousand songs. People live in them, sing in them, dance in them. As Celina González writes in her song *"Guateque Campesino"* ("Peasant Fiesta"):

"There is a *guateque* (fiesta) in the *bohio* / of Godfather Don Ramon.
The pig is already on the spit / the crowd is already arriving.
Today the *bohio* will tumble down, / it's Don Ramon's saint's day.
Today light shines on the *guayaberas* (peasant costumes) / on the leggings and
machetes,
The *guajiros* and farmer's wife / adorn the *guateque* . . .
It has been a peasant custom since colonial days."

LEFT
A cattle ranch, Camagüey region.
Harvesting sugarcane, 1910.
In the countryside, trucks often replace buses.
A typical village in Oriente.
A farmer watching over his goats.
Market day in Santiago.
RIGHT
An old Baldwin locomotive still used for transporting sugarcane in Holguín region.
A traditional *bohio* near Banes.
Market day at Camagüey.
VINTAGE PHOTOGRAPHS
LEFT Wetting tobacco leaves to be used in manufacturing cigars, 1907.
RIGHT Horsemen in the countryside in Oriente.

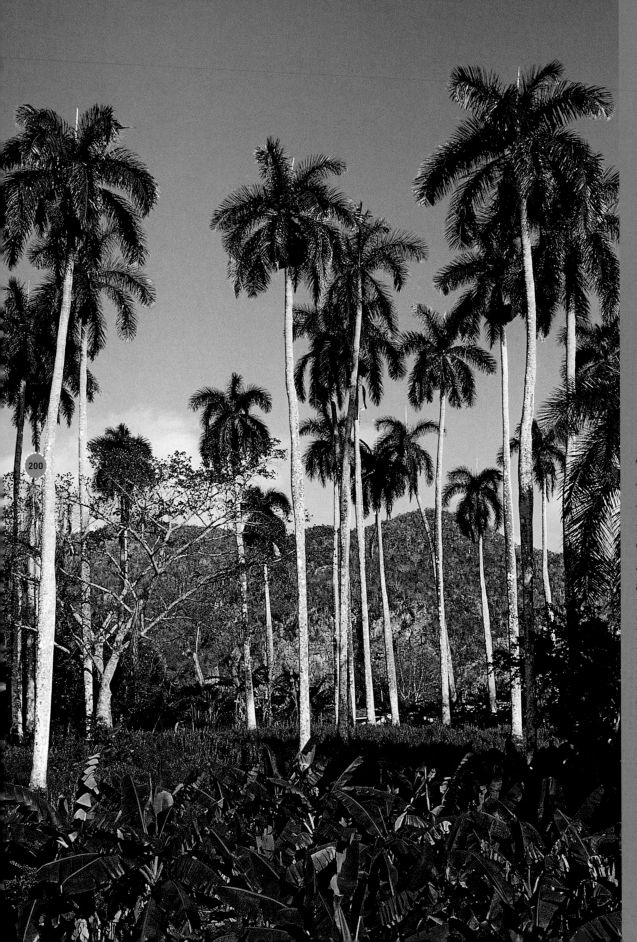

The picture is just as valid for the plains west of Pinar del Rio as for the escarped slopes in Oriente, between Bayamo and Santiago. The *palmas reales*—royal palms—look like the necks of ostriches haughtily watching over a landscape where change is not permitted. All it takes to give birth to one of these trees and the star-shaped tuft that sways like a fan in the local breeze is a twig blown by the wind and scattered on the grassy carpet here. The palm has given its name (*palma*) to a chain of hotels and a town in Oriente.

LEFT
Royal palms and banana trees on the road to Bayamo.
RIGHT
Out for a Sunday ride near Media Luna.

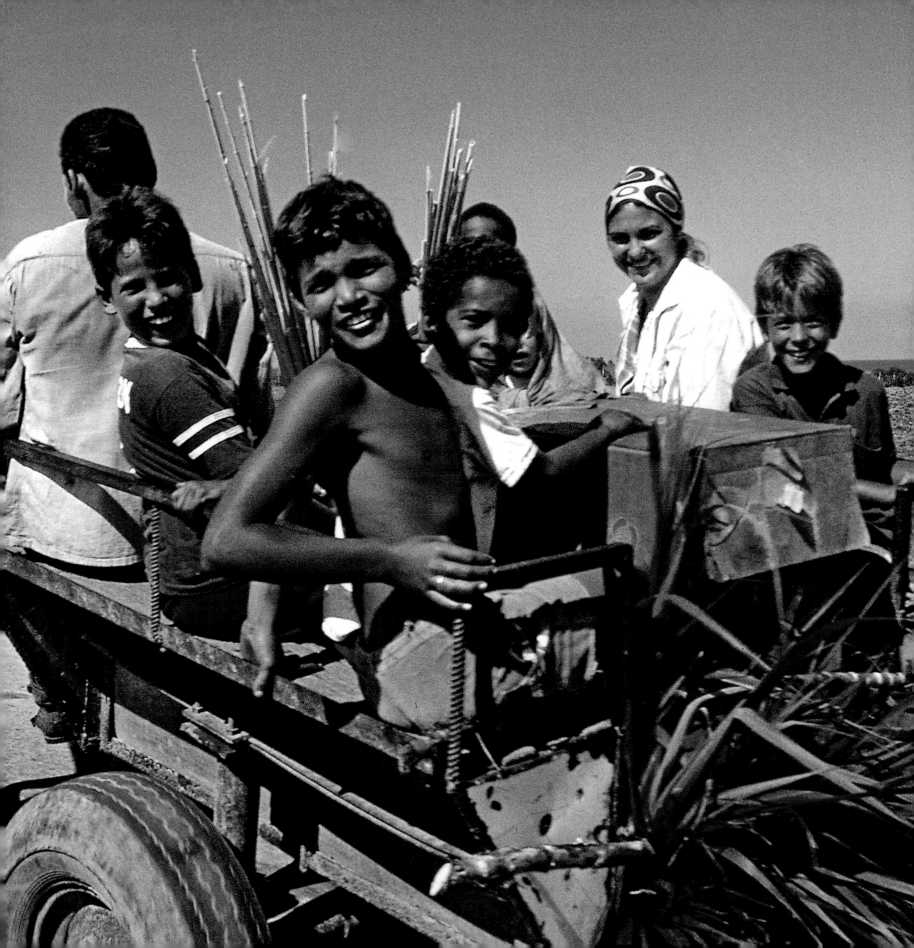

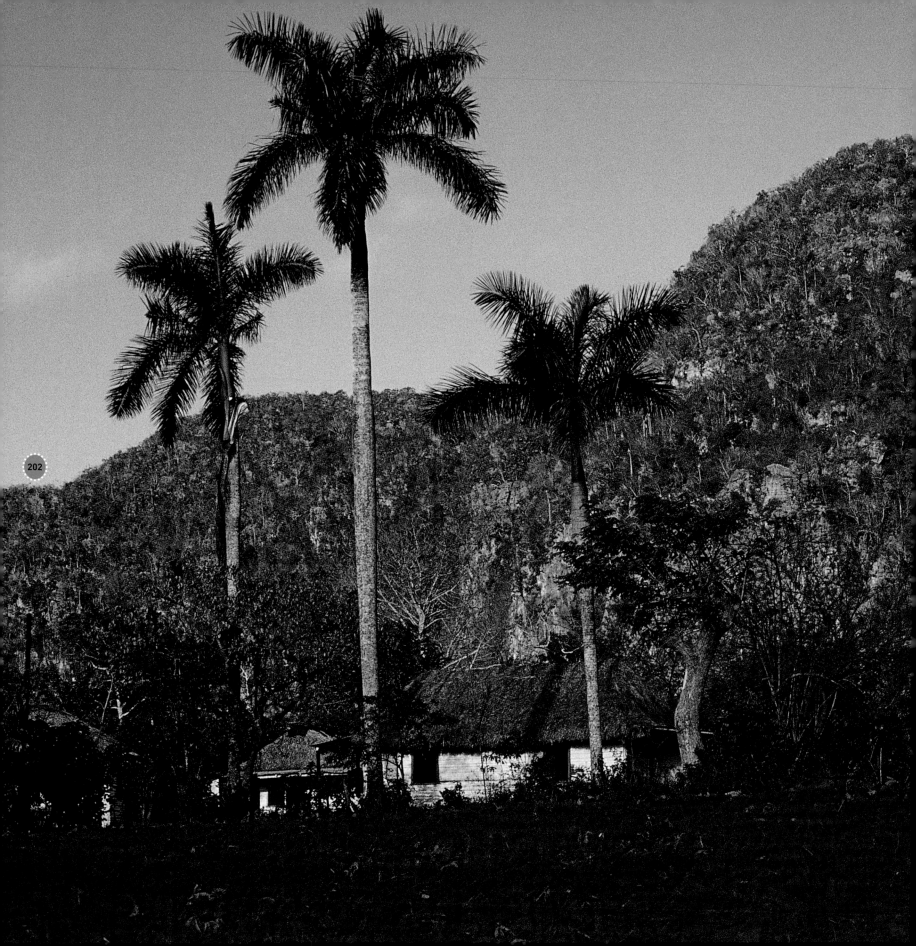

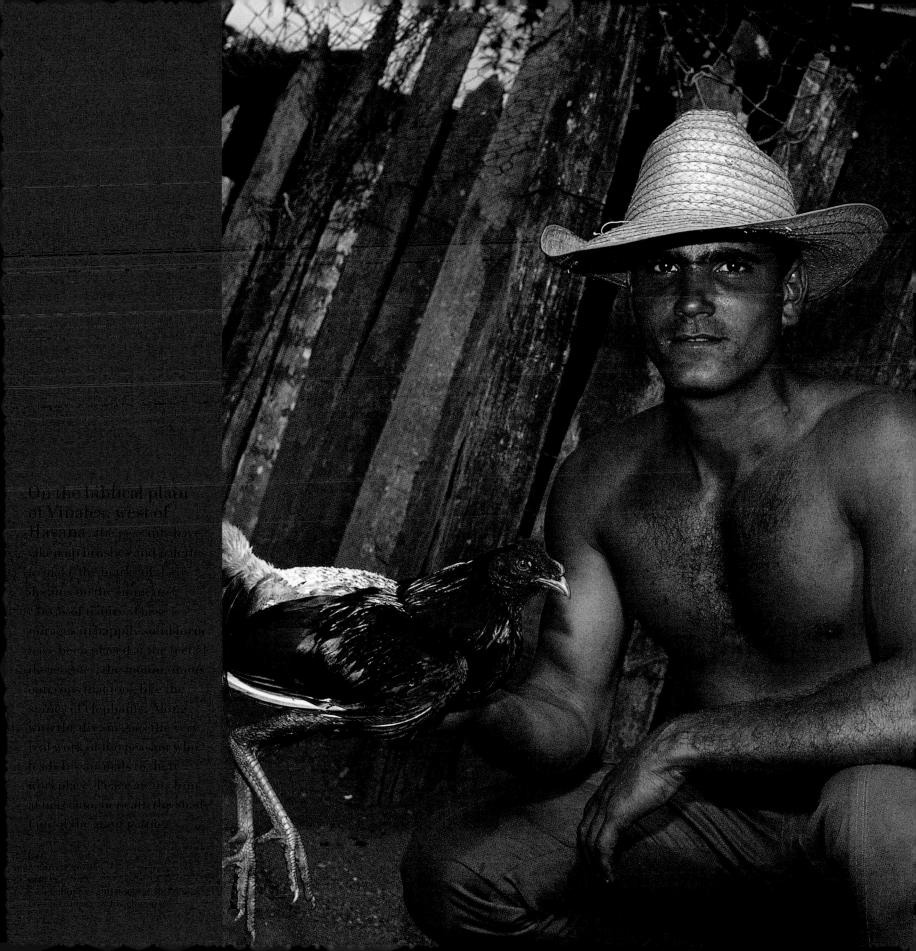

On the biblical plain of Viñales, west of Havana, the peasants have taken up brushes and palettes to make the marks of their dreams in the immense canvas of nature. These images in happily solid form have been placed at the feet of the mogotes, the mountainous outcrops that look like the spines of elephants. Along with the dream goes the very real work of the peasant who leads his animals to their workplace. Peace awaits him at his point..., in neath the shady hats of the giant palms.

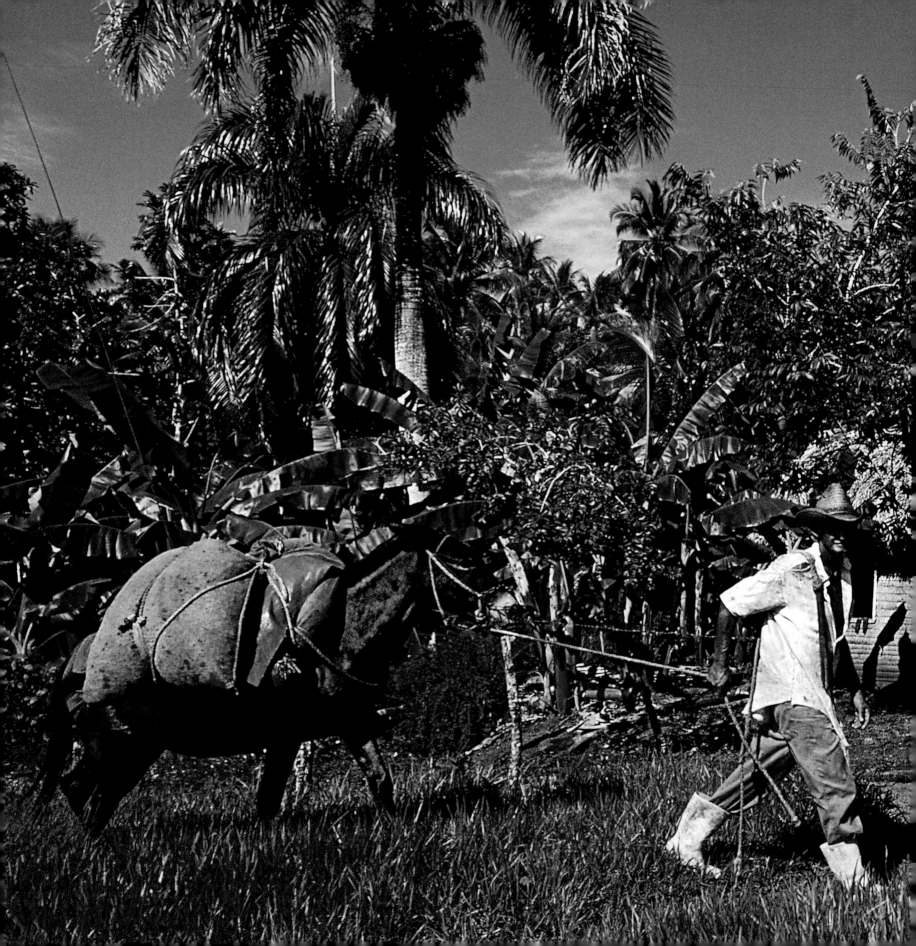

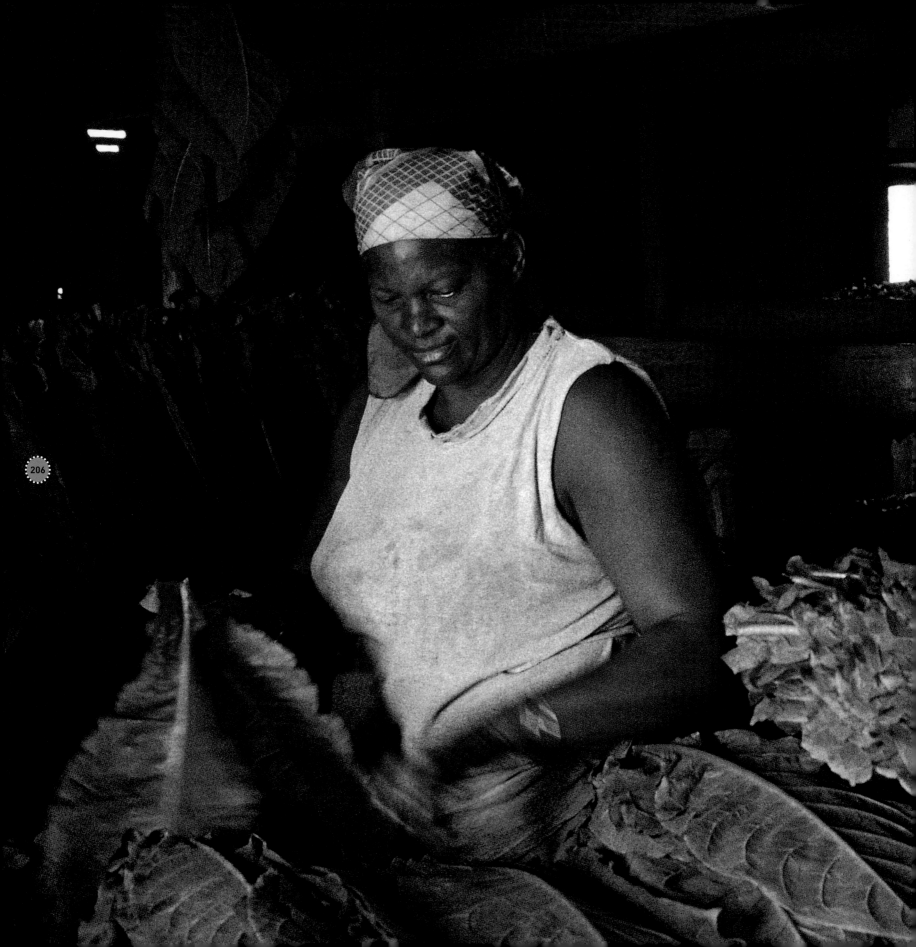

"And everywhere in the factory,
the powerful smell of brown leaves gorged with humidity,
that musty mix of cowsheds and ammonia
that impregnate everything until reverie.
When time becomes slower to kill far from the workshops
then even wood, paper, cloth and hair
seem to set off a last fermentation."

—Adargelio Garrido, Christophe Loviny and Jean-Yves Martinez,
Le Havane: Portraits Hechos a Manos

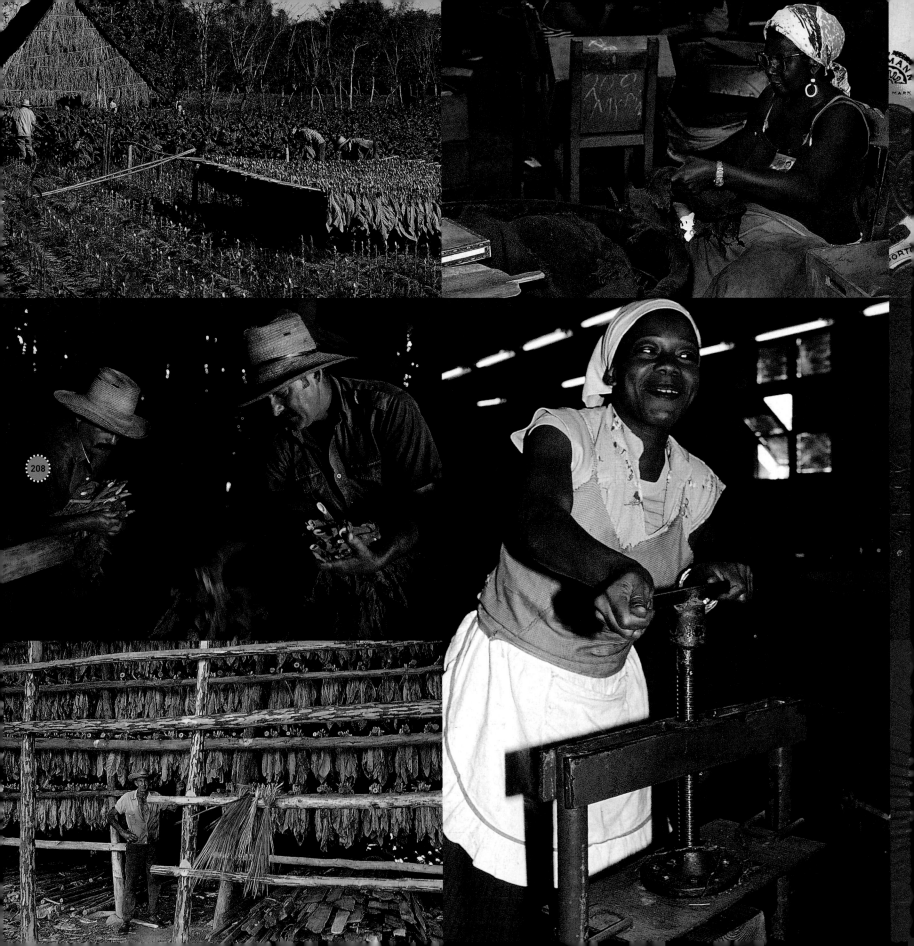

All the fantasies of cigar lovers . . . These, of course, are the precious tobacco leaves harvested in the San Luis valley, on the property of the local landowner, Don Alejandro Robaina. Then the drying sheds, where the leaves to be used as *capa* and *tripa* are hung. And then the rollers, who roll the raw *vitolas* that will later be turned into Romeo y Julietas to astound the salons. And the fantasy that needs to be wiped out from tourist folklore once and for all: the women do not roll cigars on their amber thighs.

LEFT
The tobacco harvest in the Viñales Valley lasts from January until late March.
In the strip house, the tobacco strippers reshape the leaves that were crushed after fermentation in the Partagás factory, Havana.
H. Uppmann cigar box label.
Drying: the leaves, tied in twos on the drying frames, are placed in stacks in dryers covered by palm leaves, in a *casa del tabaco* in the Viñales Valley.
Pressing the filler, the product of the first stage of rolling, Partagás factory, Havana.
The Partagás and Ramon Allones cigar box labels.
RIGHT
A worker sorting leaves in the Partagás factory, Havana.
Rolling the wrapper, Partagás factory, Havana.
The head color sorter sorting cigars using the factory's own color code, Partagás factory, Havana.

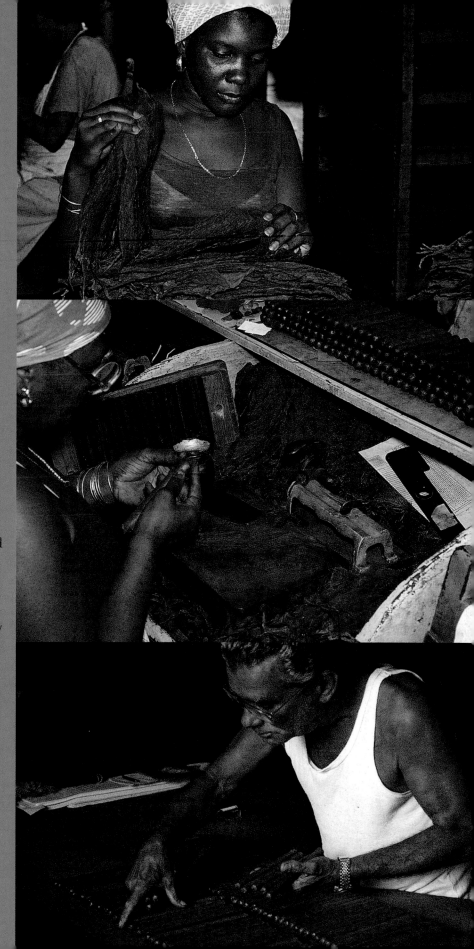

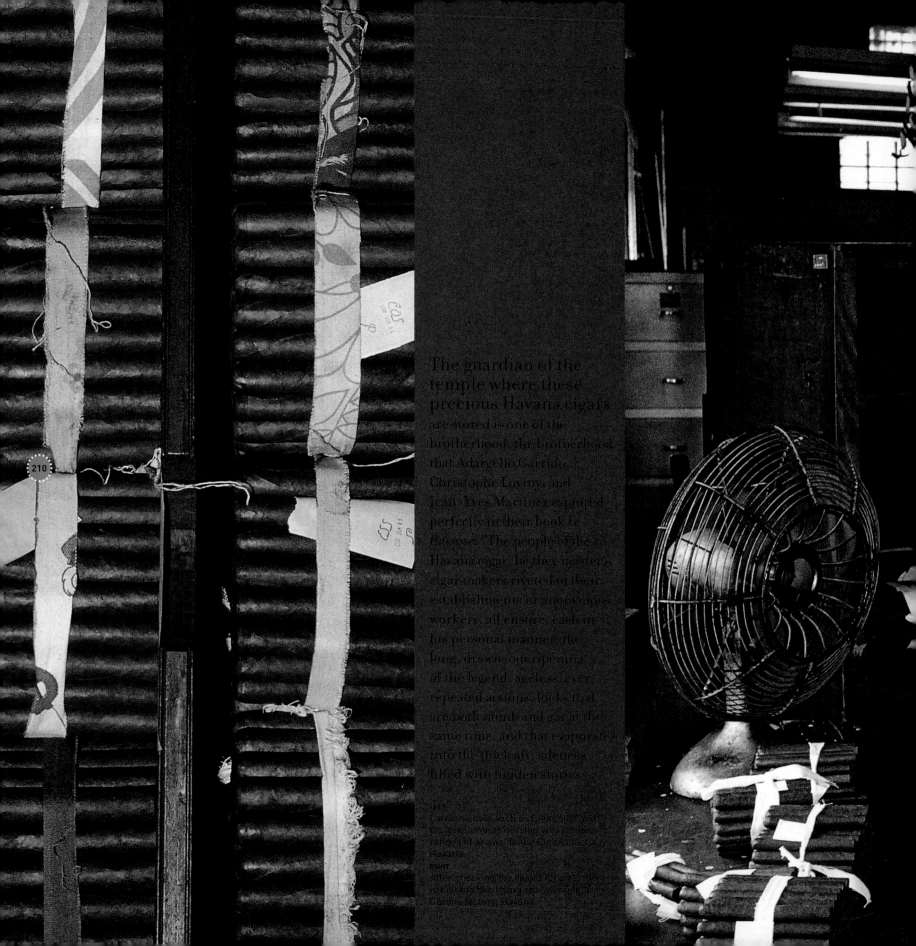

The guardian of the temple where these precious Havana cigars are stored is one of the brotherhood, the brotherhood that Adargelio Garrido, Christophe Loviny, and Jean-Yves Martinez captured perfectly in their book *Le Havane*: "The people of the Havana cigar, be they master cigar-makers riveted to their establishments or anonymous workers, all ensure, each in his personal manner, the long, drawn-out ripening of the legend: ageless, ever-repeated actions, looks that are both numb and gay at the same time, and that evaporate into the thick air, silences filled with hidden stories."

LEFT
Large models such as Churchills and Double Coronas develop very complex ranges of aroma. In the Corona factory, Havana.
RIGHT
After checking the cigars for smell, it's something like trying one yourself. In the Corona factory, Havana.

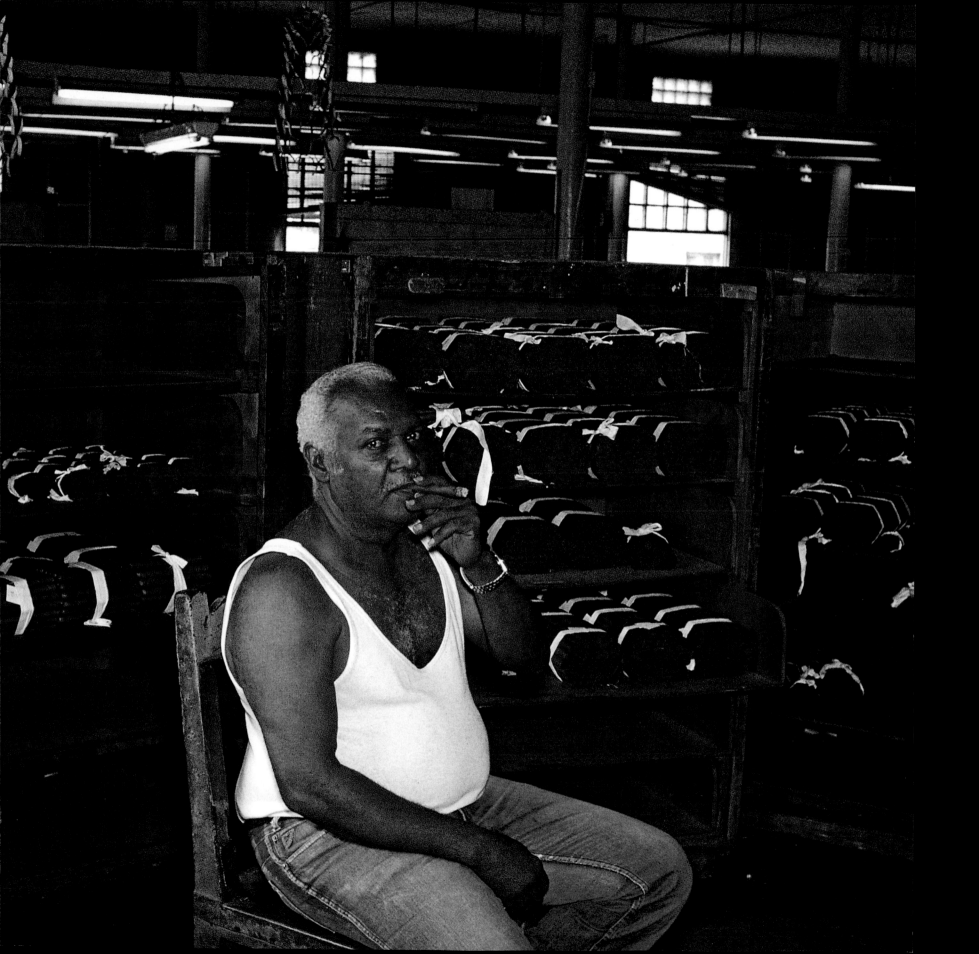

COLONIAL ATMOSPHERES

When the name of Trinidad arises, indifference simply no longer applies. Declared and recognized by experts as one of the most beautiful towns in Latin America, entered on the list of UNESCO World Heritage Sites, Trinidad is truly inseparable from the history of the country. Here are to be found all the ingredients of Spanish colonization: conquest, proselytism, slavery and riches—all the parameters of the so-called colonial towns. And it comes as no coincidence that both of the towns that lay claim to this title are Trinidad, on the Caribbean shore, and Camagüey, to the center of the island. Both are symbols of wealth, and both have a strongly marked colonial character: they made their fortunes on the backs of the settlers who came from Europe on the baggage train of the conquistadores, and who dedicated themselves to raising cattle, in the case of Camagüey, and sugar in the case of Trinidad.

Trinidad is like a living museum, one still active thanks to the tourist flood that sends thousands of foreigners into its glorious houses, living witnesses to the splendor of its past years. People push and shove and press close together all around the Plaza Mayor, a jeweled casket in the historic center of town. All around stand grand houses and palaces, which are now museum, such as the Palacio Brunet,

built for Mariano Borrell, a sugar baron of immense wealth, and now the Museo Romántico (Romantic Museum). A church has been converted into a smugglers' museum. On the street leading to the Plaza Mayor stands the Casa de los Sánchez Iznaga, a sugar factory hiding behind labyrinthine metal grilles and balustrades, the property of another family synonymous with sugar back in the good old days.

The fact that the heritage of this bygone era has been preserved is thanks to the courage of some of the sons of the town. The cobblestones in the streets are just one case, but such an important one! During the 1930s, the government decided that the main streets in the town, which were deadly to the axles of carts and carriages, were to be paved over with asphalt. A town lawyer by the name of Lopez Bastida opposed the project, paying for his opposition by spending several years in prison. But the cobbles remained and, naturally enough, the architect of the restoration was Macholo, the son of the lawyer, and a conservationist revered by his compatriots. They owe it to him that the town has been spared the perverse modernization demanded by international tourism.

> **The waters of the Táyaba, like the waters of Lethe—wretches drink it, do not forget—have the precious virtue of bringing oblivion.**
>
> Lydia Cabrera

The principal church in the town, the Most Holy Trinity (*La Santísima Trinidad*), stands at the heart of the town and its history. Considered less than favorable, if not downright hostile, to the Revolution, this deeply Christian region suffered reprisals by the Castro regime. Over the years, catechumens had to engage in tricks and ruses in order to go to church and pray. A time when this ideological friction was at its height came during Holy Week in 1997, the year before the pope visited Cuba. Would there be a procession? Would it be allowed to go around the Plaza Mayor? At the end of the day, the decision—there would be a brief walkabout, but the procession would not be allowed to stray from the church plaza—came from high places, from Fidel Castro himself, it was said.

When you leave the town and take the road to the Valle de los Ingenios, the suffocating heat tends to dispel slightly. Now converted into a living museum, complete with the planter's mansion, the *barracones* (slave quarters), and the slave pen, where the unfortunate *cimarrones* (runaway slaves) were held, El Valle has been placed on the list of UNESCO World Heritage Sites.

As soon as they arrived on the island, the Spanish took it upon themselves to tell the natives about their religion by setting up altars dedicated to the glory of Christ. That was part of the contract imposed on them by Queen Isabella the Catholic.

Camagüey, which has returned to its native name after having been called Santa María del Puerto del Príncipe, was founded in 1514 by Diego Velázquez. The Christian cousin of the Most Holy Trinity, Nuestra Señora de la Candelaria (Our Lady of the Presentation of Christ), has also had her political difficulties. The cathedral has, in fact, had a long and troubled life. Built in 1530, it burned down, was rebuilt, collapsed, and was rebuilt again before being used as a refuge for the generals who won glory during the wars of independence during the late 19th century. In its time, the cathedral has sheltered quite a number of people now in the who's who of Cuba, such as Generals Antonio Maceo and Máximo Gómez, or Dr. Carlos Finlay, who discovered the link between the mosquito and the yellow fever virus. But the great son of Camagüey is without question Ignacio Agramonte, the hero of the Cuban War of Independence, who fought ceaselessly before dying, sword in hand, in 1873. He shares his glory with the terra-cotta pots found on the porches of countless private houses and government offices. These are the *tinajones*, which are used to store oil and water. In the past, they were an indicator of the social status of their owners, the owners of the greatest *ganaderías*—ranches—in the country.

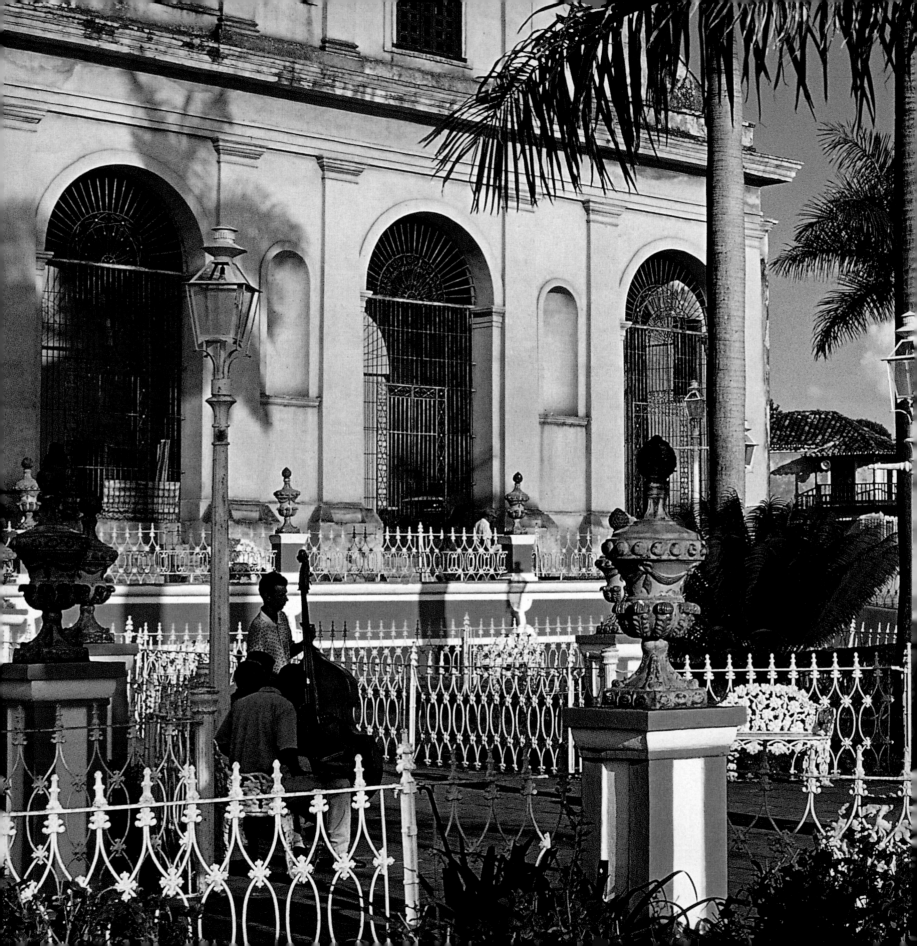

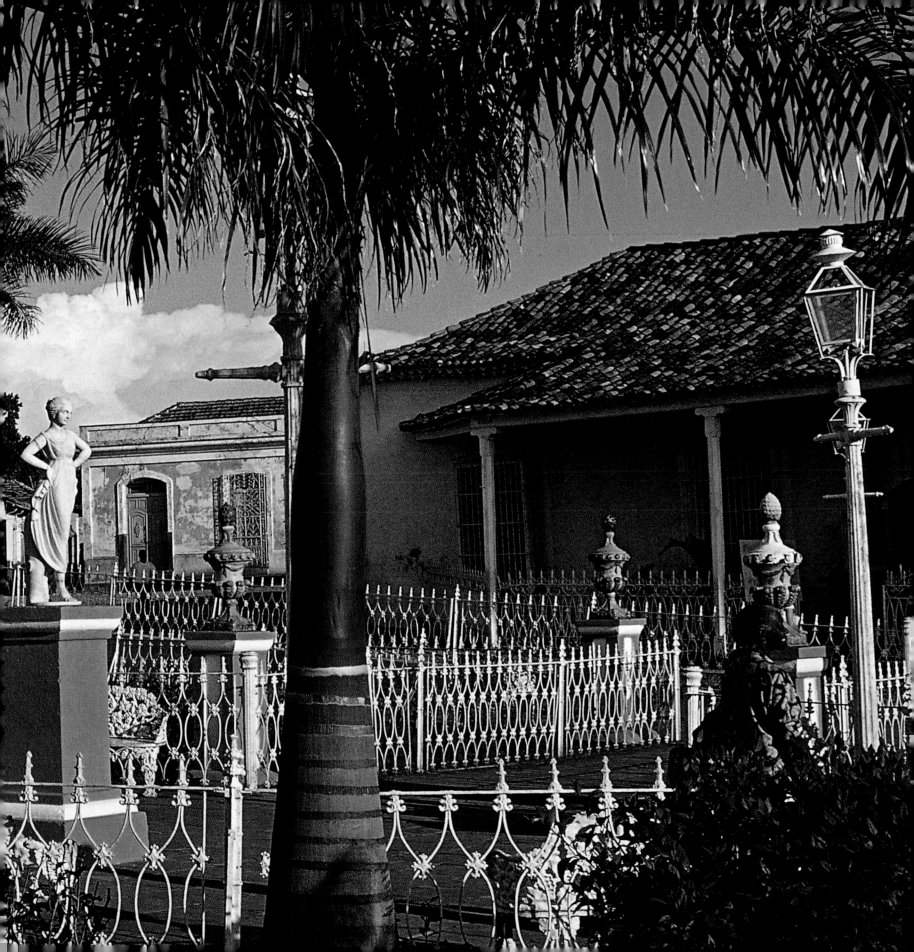

218

The Plaza Mayor in Trinidad could be looked upon as the dream come true of the artist who drew such architectural perfection. People come from around the world to lose themselves in the nave of *La Santísima Trinidad*, to pray or take photographs of this treasure of the world's heritage, between the altar and the palm trees that have withstood every hurricane. To capture the true splendor of this place, one would have to invent new superlatives. Holy Week and the *paseo* around the square are an event not to be missed.

PREVIOUS SPREAD
La Santísima Trinidad on the Plaza Mayor, Trinidad.
LEFT
A *vaquero* (cowboy), Trinidad.
RIGHT
The portal of the Church of Regla, Havana.
El Castillo de Jagua, a restaurant in Cienfuegos built in the Arab style, not a common sight in the Spanish Caribbean.

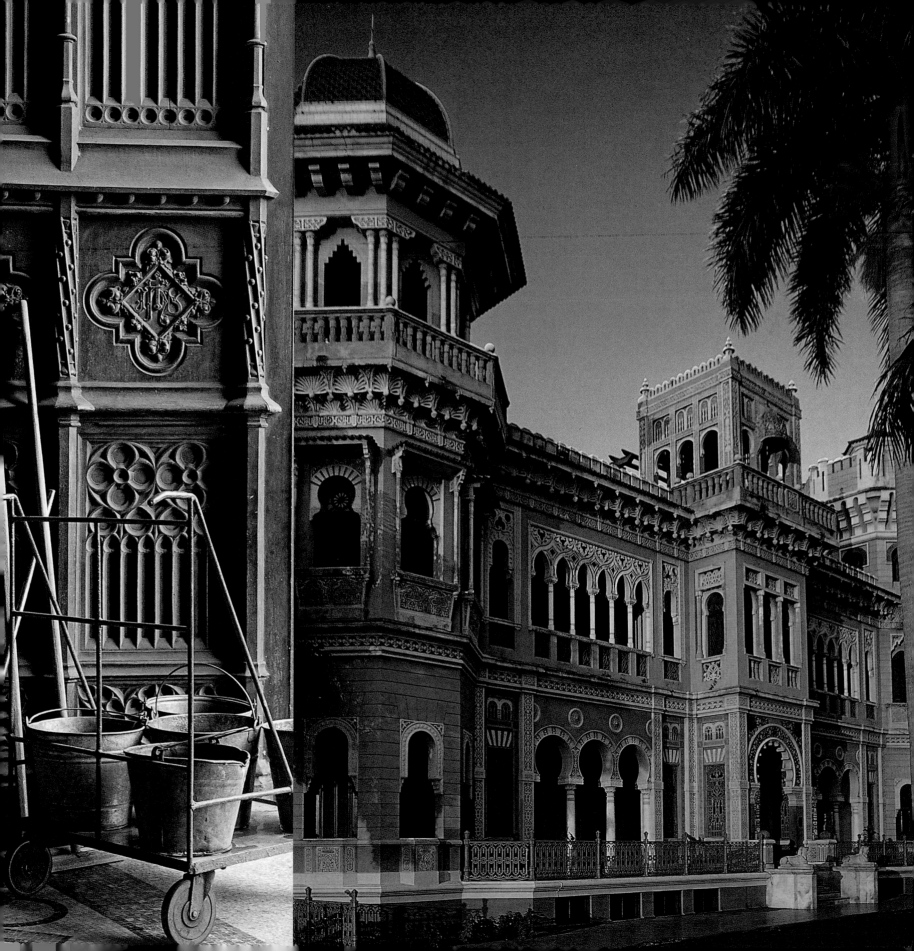

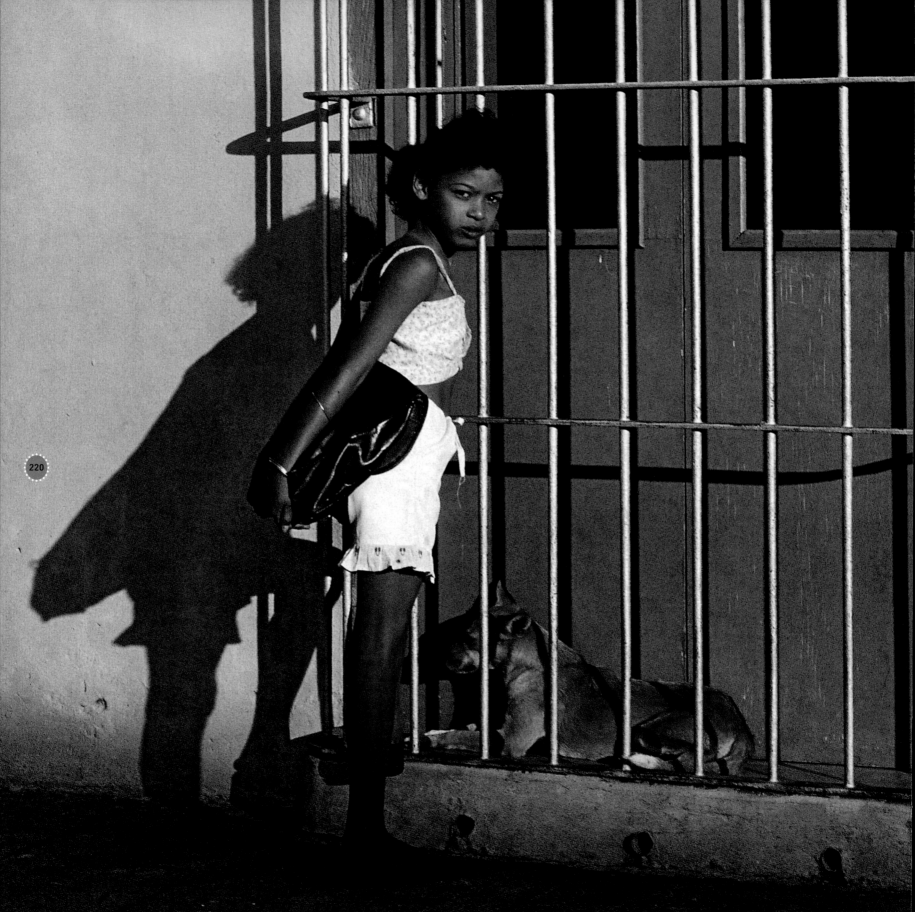

"The *carriole* always carries on its seat

Three ladies dressed as lightly

As the flowers that adorn their hair . . ."

—Ildefonso Estrada y Zenea, *El Quitrín*

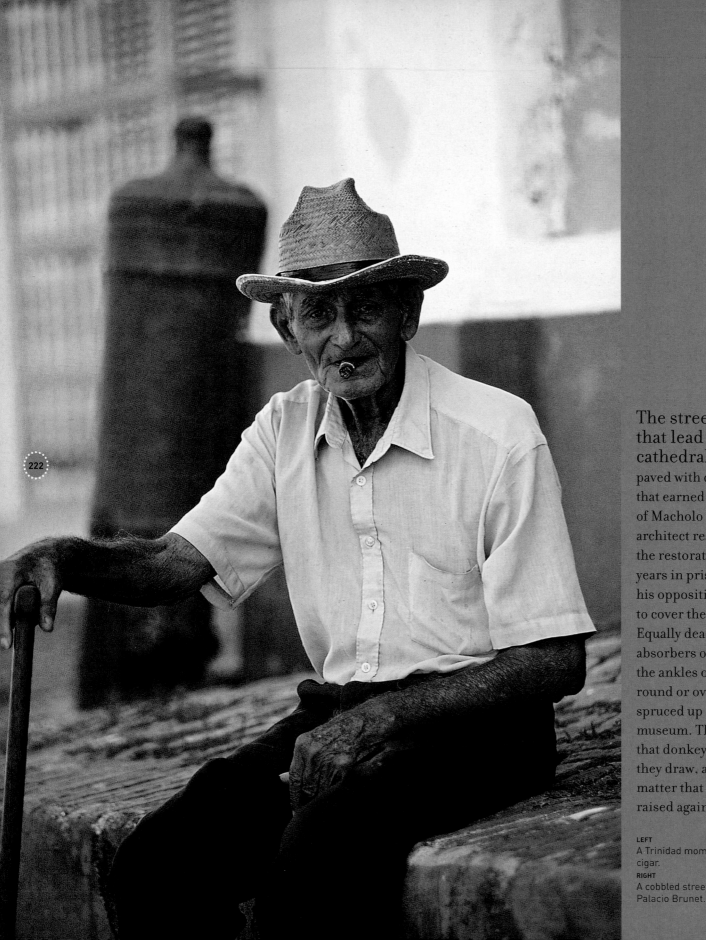

The streets of Trinidad that lead up to the cathedral square are paved with cobblestones that earned the father of Macholo Bastida, the architect responsible for the restoration of the town, years in prison because of his opposition to the plans to cover them with asphalt. Equally deadly to the shock absorbers of automobiles and the ankles of tourists, these round or oval stones are as spruced up as pictures in a museum. They also ensure that donkeys, and the carts they draw, are everywhere, a matter that has never been raised again.

LEFT
A Trinidad moment: a straw hat and a cigar.
RIGHT
A cobbled street in Trinidad by the Palacio Brunet.

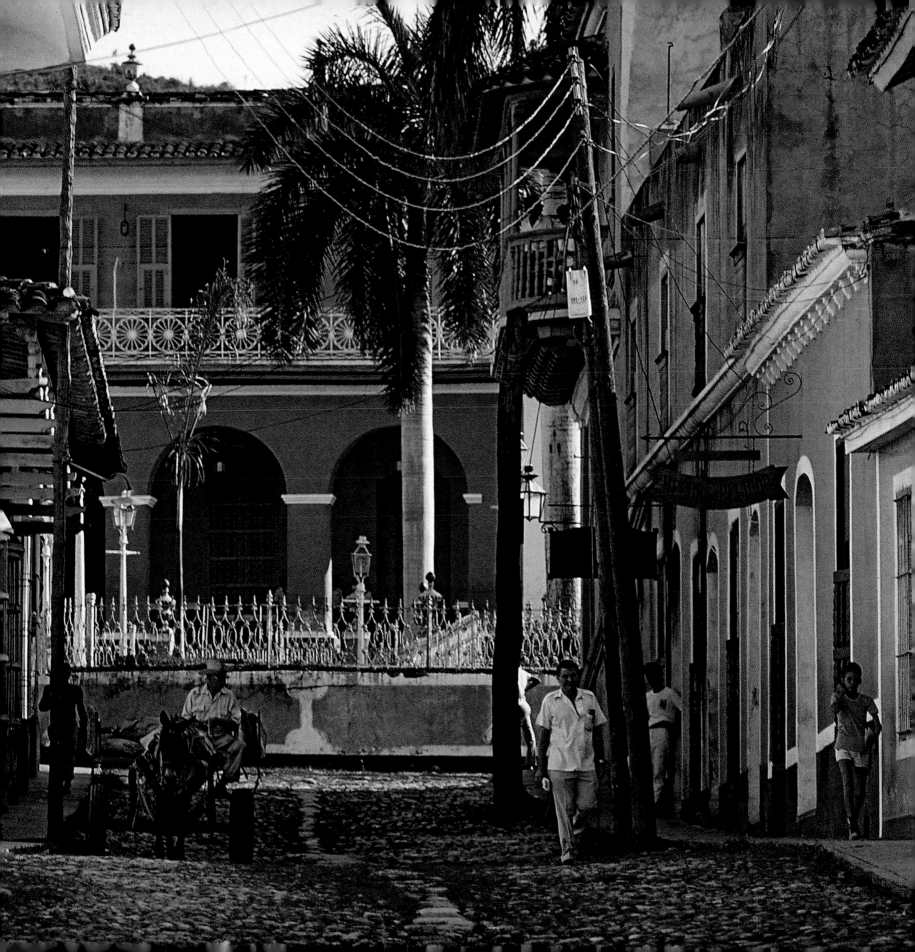

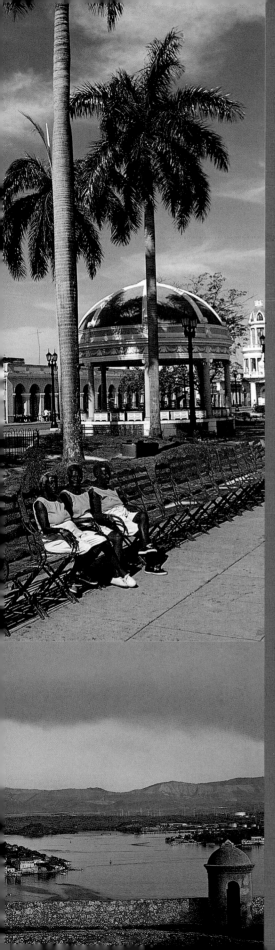

Quiet days in Cuba . . . Postcards don't come only in cardboard form. At El Cobre, the cathedral to which *Santería* pilgrims come rises regally, dazzling white, like a jewel set in the greenery of the hamlet. El Morro, the fortress that dominates the entrance to the harbor of Santiago, speaks more of peace than of war. And the carriages play a stubborn partita, that of bucolic music set to the rhythm of boots stomping down the streets. Time stands still. When the clock starts again, it will still tell the hours of a past that never dies.

LEFT
The chapel built at the spot where Columbus landed in Havana, c. 1909.
Detail of a facade, Havana.
Cárdenas, the carriage town.
Taking a break in José Martí Park, Cienfuegos, surrounded by 19th-century buildings.
The end of another school day, Viñales.
A carriage, Trinidad.
El Castillo del Morro, Santiago.
RIGHT
El Cobre Basilica, Santiago.
The Cathedral of the Immaculate Conception, Cienfuegos.
The entrance to the cemetery, Trinidad.
VINTAGE PHOTOGRAPHS
LEFT Villanueva Station, Havana, c. 1909.
RIGHT A street in Mariano, c. 1909.
POSTCARD Mayarí Church, in Oriente.

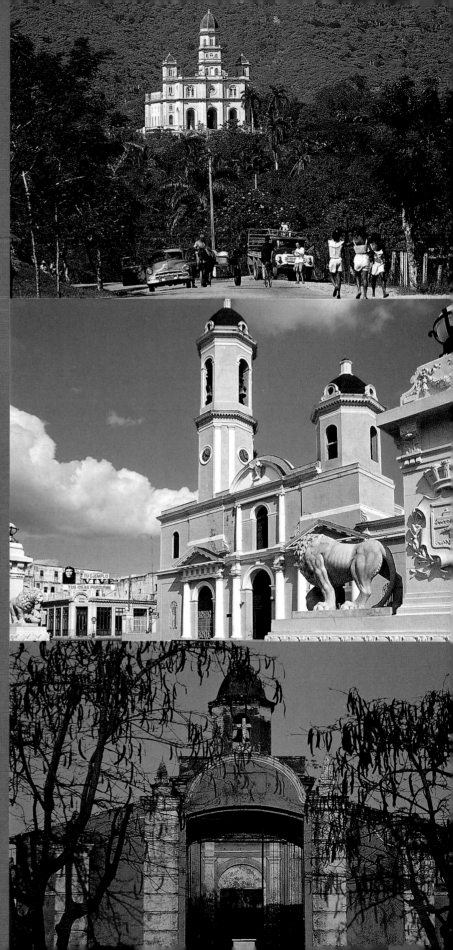

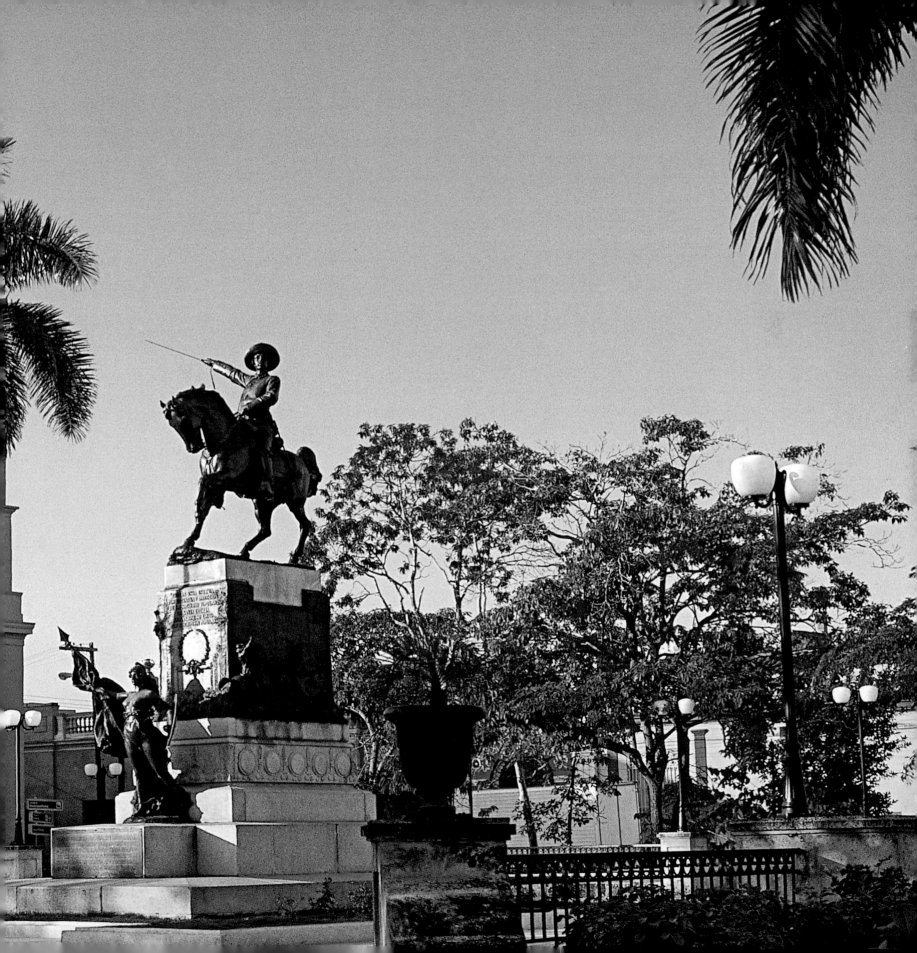

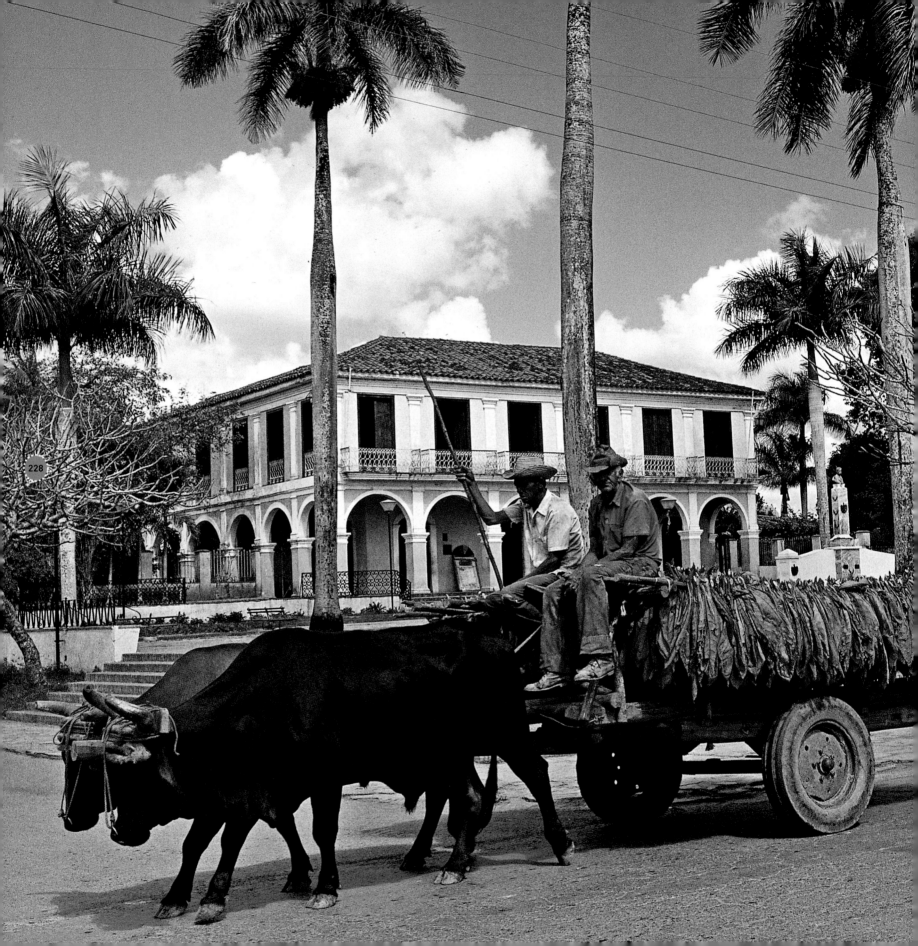

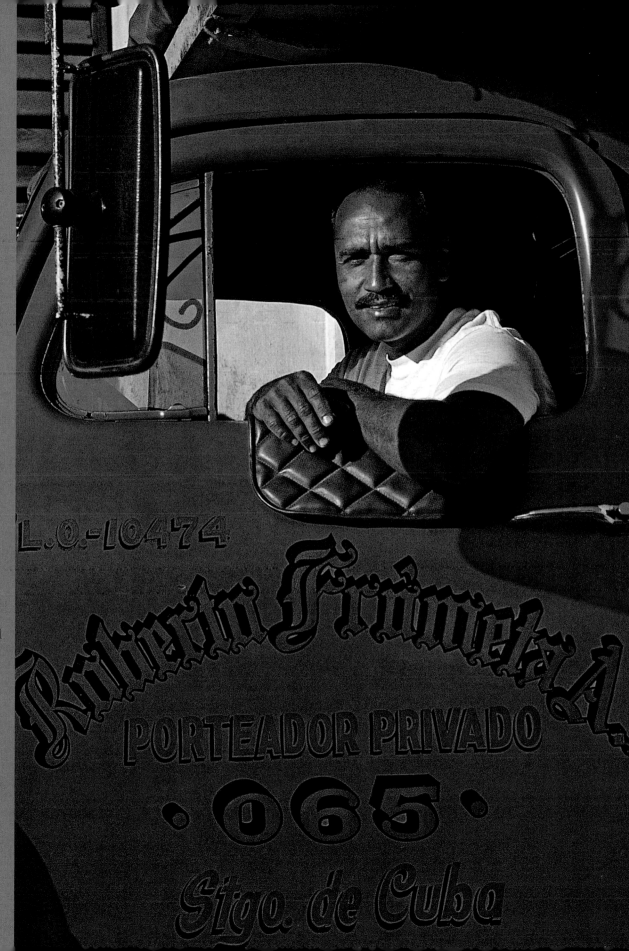

To get around the failings of the Cuban economy, the people use their inventiveness, but also have to make do with means that anywhere else in the world would have been thrown away. Oxen pulling a load of tobacco leaves to the drying sheds are a more familiar sight for Cuba's consumers than a refrigerated truck supplying the nation's microwaves. And if you have to keep your truck going, whereas elsewhere it would have been sent to the scrap yard, you can turn to your trusty mechanic, who has magic fingers.

PREVIOUS SPREAD
The equestrian statue of Ignacio Agramonte on the square named after him, Camagüey.
LEFT
Transporting tobacco, Viñales.
RIGHT
A truck driver, Santiago.

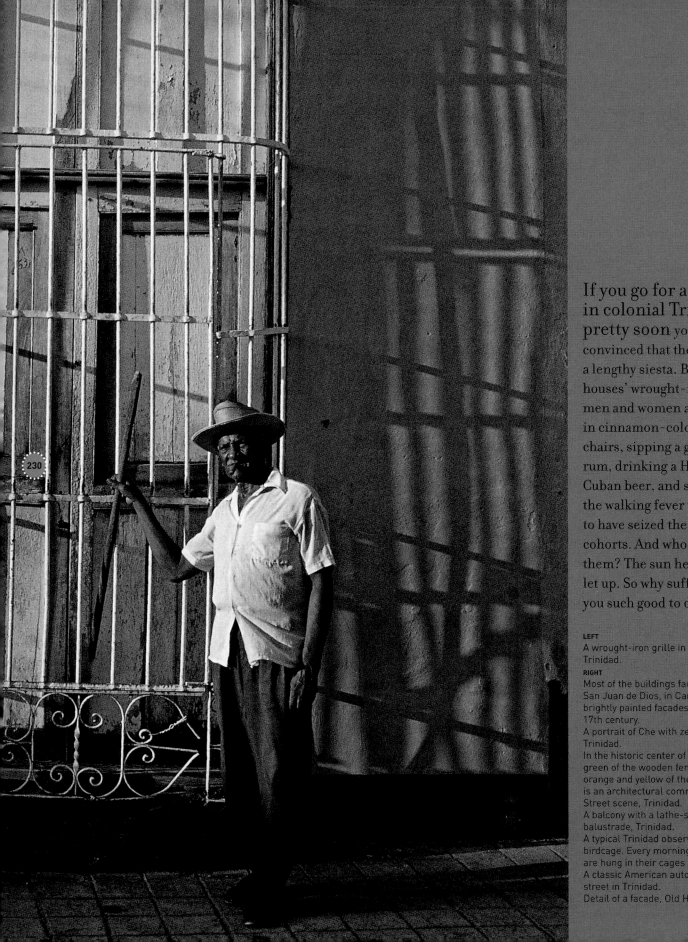

230

If you go for a walk in colonial Trinidad, pretty soon you become convinced that the town takes a lengthy siesta. Behind the houses' wrought-iron gates, men and women are swaying in cinnamon-colored rocking chairs, sipping a glass of rum, drinking a Hatuey, a Cuban beer, and smiling at the walking fever that seems to have seized the tourist cohorts. And who can blame them? The sun here doesn't let up. So why suffer? It does you such good to dream . . .

LEFT
A wrought-iron grille in a window in Trinidad.
RIGHT
Most of the buildings facing the Plaza San Juan de Dios, in Camagüey, have brightly painted facades, typical of the 17th century.
A portrait of Che with zebra stripes, Trinidad.
In the historic center of Trinidad, the green of the wooden fences against the orange and yellow of the house facades is an architectural commonplace.
Street scene, Trinidad.
A balcony with a lathe-shaped wooden balustrade, Trinidad.
A typical Trinidad observation post: a birdcage. Every morning, the pajaritos are hung in their cages outside the door.
A classic American automobile on a street in Trinidad.
Detail of a facade, Old Havana.

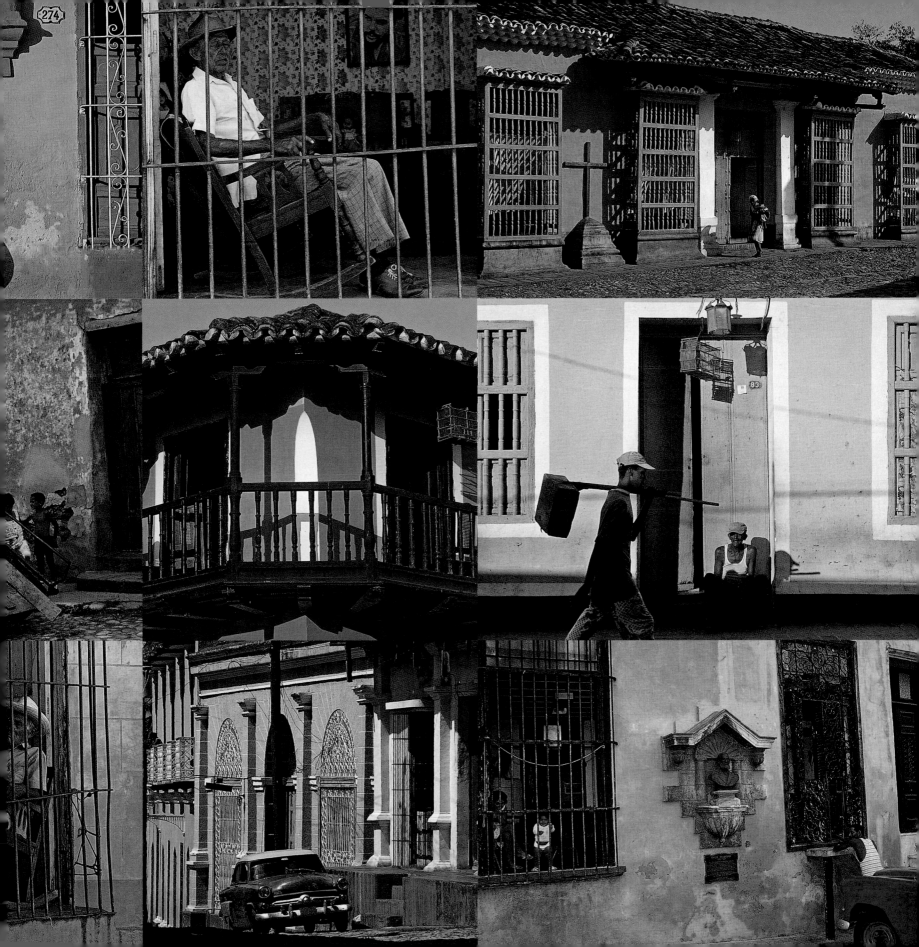

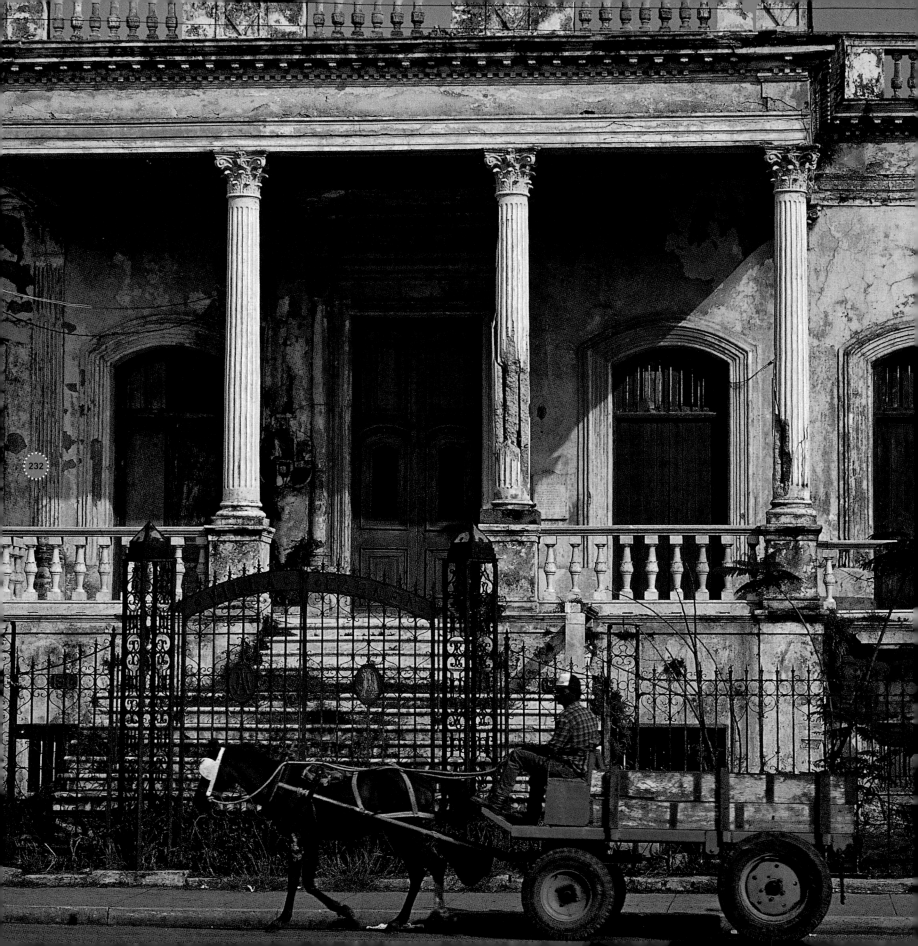

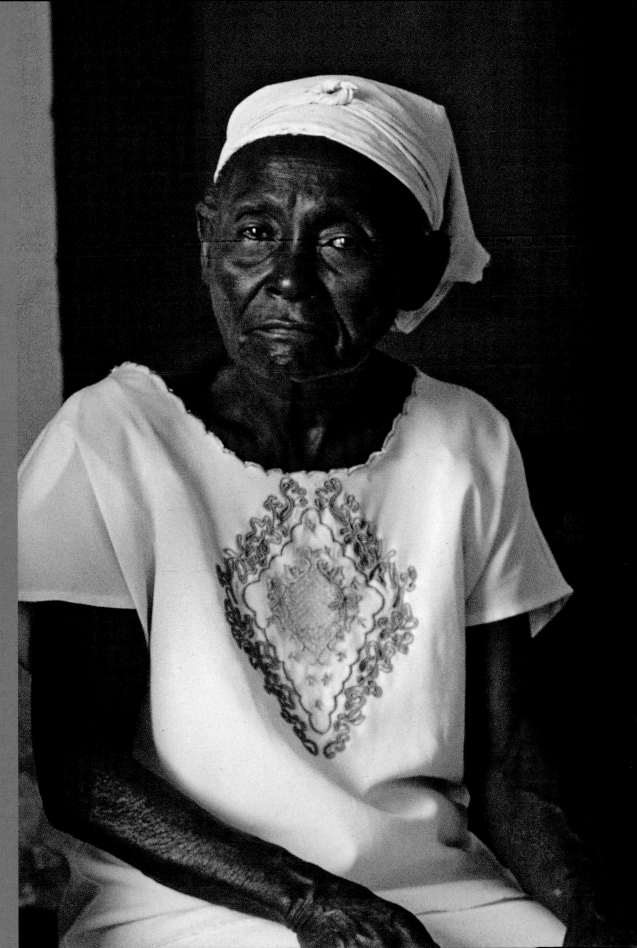

Age brings respectability. With the exception of the horse, which is blind to faded splendor, the cart and the balustrades of this house have been through a lot. When it comes to his vehicle, the driver can still *inventar* tires for his wheels out of old inner tubes recovered from Hondaladatoyotamazdas that are sent to the auto wreckers when they reach the end of their lives. But for the pillars supporting this pockmarked canopy, which are just begging for a little freshness and threatening to collapse forever into oblivion, where are you supposed to find a successor in good condition?

LEFT
A neoclassical facade, Cárdenas.
RIGHT
An old lady, Trinidad.

234

For tourists, the major attraction of a stay in Trinidad is a visit to the colonial mansions, which are now readily accessible as part of the packages offered by tour operators, who stress the authenticity—miraculously preserved—of the furnishings and knickknacks, and the owners who are skilled in the art of aging in good condition and of lasting longer than the average age found in the rest of the country. These houses, which used to belong to the great Spanish families, now belong to their descendants, the *azucareros*, who still own the sugar refineries in the Valle de los Ingenios.

LEFT
Postcard from the 1930s.
RIGHT
A colonial interior, Trinidad.

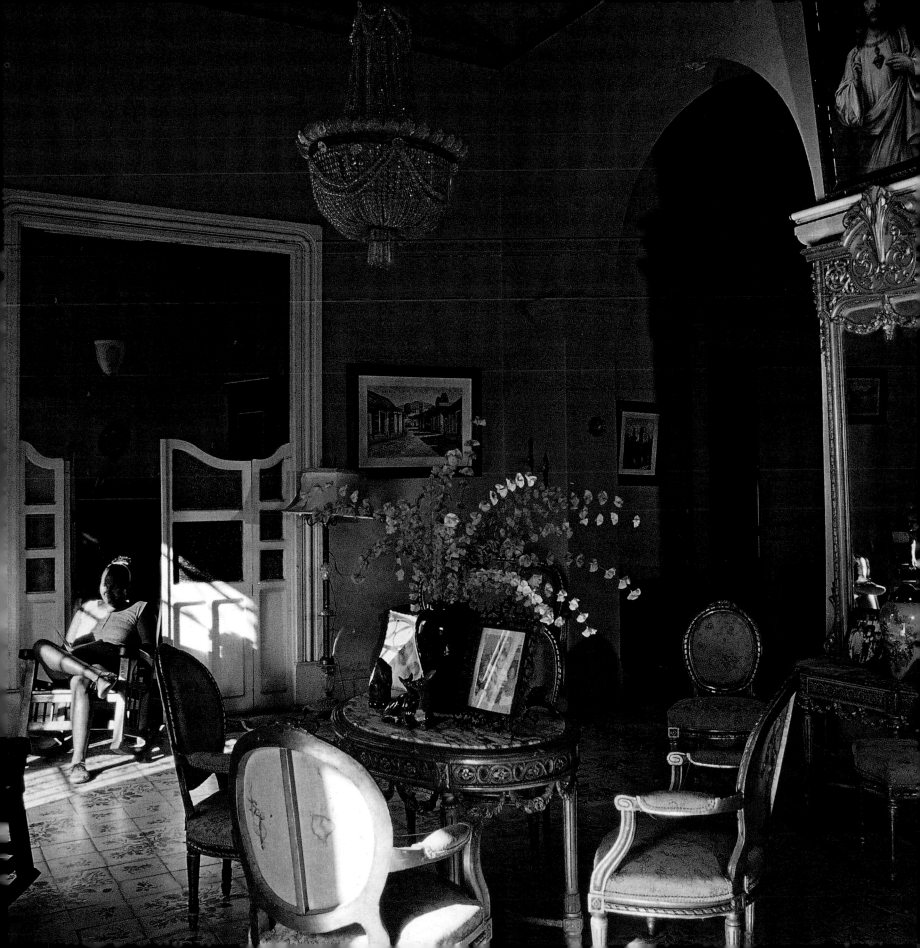

"I have, let's see,
that being Black,
no one can stop me
at the door of a dance hall or a bar,
or at the desk of a hotel
have someone yell at me there are no rooms,
a little room, not a palace,
a little room where I can rest."

—Nicolás Guillén, "Tengo" ("I Have"), *Le Chant de Cuba*

RIGHT
A rainy day on the main street of
Baracoa.

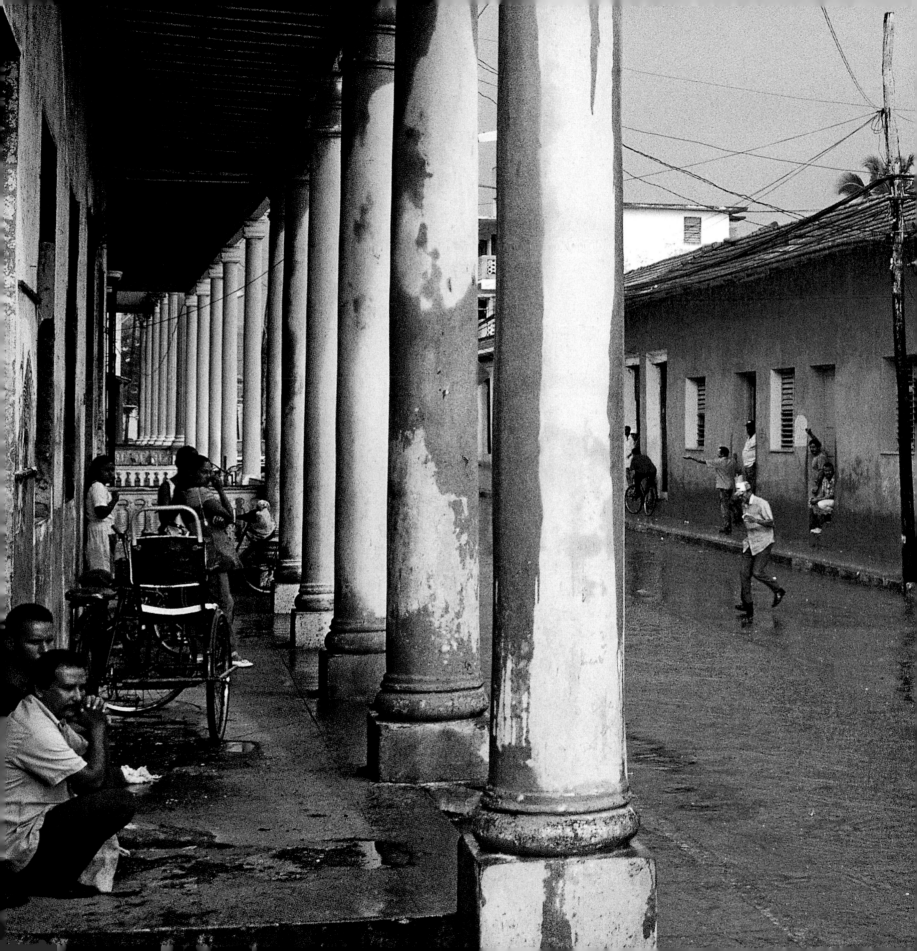

238

Beside the houses of
the rich stand far more
modest huts that bear witness
to the social inequalities that
underlie the wealth of the
masters of the valley. Here
were housed the first slaves
to be freed after abolition.
Losing their leg irons also
meant finding a roof. So they
built these shacks under the
tropical skies—which now
bear UNESCO plaques—just
like the dwellings of their
illustrious masters. Yes,
indeed, Trinidad is a living
museum.

LEFT
A Havana youth.
RIGHT
A lively street in Trinidad.

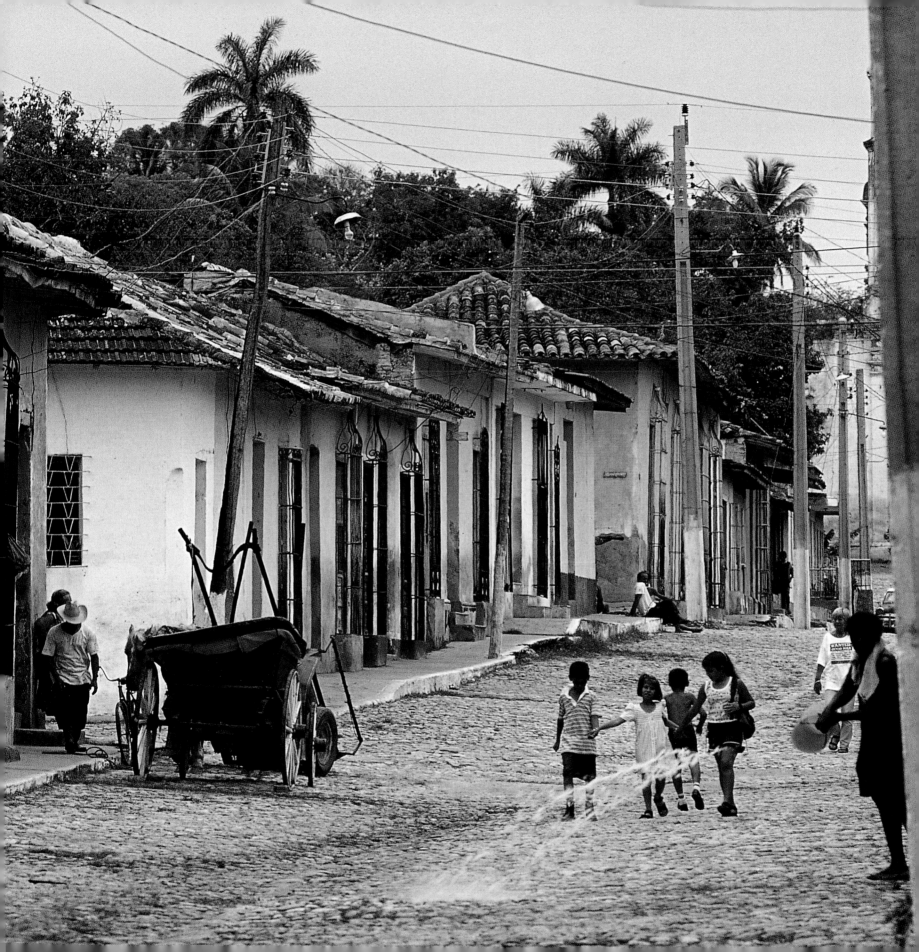

FRENZIED FIESTAS

Manzanillo, Sunday morning. The *glorieta* (music stand) in the square looks like a strawberry pie on a table, and it is bubbling. A motley choir has the *compañeros* and *compañeras* on fire, and they are twirling, embracing each other, kissing, welded together, blazing with passion. This man–woman mutual belt-buckle-polishing session is the ablution of the other Cuban religious service, dancing. As everyone knows, God will recognize His own, but to this aphorism the *manzanilleros* have added a category all their own: a state competition for choreography instructors. And if the Good Lord had in mind to be a judge at this competition, He would surely have His work cut out for Him.

Music and the rumba are stuck to this rambling town in the south of the island like permanent glue. It is no coincidence that El Original de Manzanillo is one of the best-known orchestras in Cuba. Its conductor, Cándido Fabré, is as well known throughout the country as Che and Matusalem Rum. The great Eduardo (El Tiburón) Morales himself, the singing star of the Conjunto Son 14, often takes time off from his Santiago group to cheat on them and sit in with the musicians here, and that's saying something. But this November morning, the party that started in the Parque Central has a surprise in store. The musicians, blazing with brass and drums,

are suddenly swallowed up in a rattletrap jitney. As the bus continues on its way, it attracts an escort of cyclists carrying bandoleers made of flowers shaped like guitars.

The convoy comes to a halt at the top of a rise overlooking the town. We are at the cemetery. Carlos Puebla, the composer of *Hasta Siempre*, was born in Manzanillo and is buried here. In this town, the second week in November is dedicated to celebrating his memory: political speeches are accompanied by solemn, pious choral music. The strains of *Hasta Siempre, Comandante* are picked up over and over again by the trumpets, trombones and helicons. Bronzed cheeks glisten with tears. Then, discreetly, a few individuals slip flasks out of their *guayaberas*, take a healthy swig at the end of each verse of this patriotic song, and start moving their feet in time with the music. The funerary prayer ends as a joyful dance that makes its way toward the exit of the cemetery.

And it's not over yet. The next thing we do is clamber on board various dubious *guaguas* (minibuses) already crammed with passengers, and head off to Guasimal, a fishing and farming village about six miles away. The people know it's a feast day today. El Guasimal orchestra is a hundred years old, just like its leader—steady on his feet, but his eyes are a bit of a problem (he's totally blind)—who plays the bass, a single string stretched between a bit of reed and a tree trunk—you make do with what you

have. The other musicians are also playing bizarre, rudimentary instruments. But they work just fine. There is a *güiro* (the jawbone of a cow that is rubbed with a piece of wood), maracas, and of course drums and bongos, while they make coffee the old-fashioned way—one woman piles up the beans, another filters the liquid, while two men crush sugarcane to obtain the juice, the sugar destined to sweeten the full-bodied brown beverage. Rum flows down everyone's throats. No, not brand stuff—no Havana Club, no Matusalem, no Marineros, not even the locally distilled Pinilla. No, this is homemade rum, and it goes by various names: *chipetren* (train spark), *salta patras* (jump back) or *hueso de tigre* (tiger bone). Just what you need to keep going during a four-day party, a four-day *descarga* (unwinding session). And if somewhere along the way you manage to come up with a few dollars, you can have yourself a *lechón con arroz* (roast suckling pig with rice).

¡Hasta siempre, guajiros!

And so back to town.

Lino has set up his monumental organ on the plaza. He is last in line of the Borbolla family. His great-great uncle developed a passion for the musical machine that some Frenchmen who settled in Cienfuegos had brought in their baggage. So Lino inherited one of these machines, a veritable locomotive ten feet long. With his nephew beside

him at the controls, he has the *manzanilleros* dancing around the *glorieta*, besotted with music and nostalgia to the strains of "Chattanooga," and as nightfall puts the finishing touch to the evening with "La Vie en Rose."

This evening, Eduardito is topping the bill at the Casa de la Trova. At eighty, this former tailor, dancer, singer and guitarist will be stealing the show with maracas in his shoes.

¡Hasta siempre, compañeros!

When El Tiburón returns to Santiago, he finds it difficult to regain his balance, and his fellow musicians in Conjunto Son 14 won't forgive him his day of musical infidelity, so he heads off to the Calle Heredia to say hello to his old friend, the guitarist Gerbe at the Casa de la Trova. This is a national institution that had already seen better days back in the 1990s when, in the name of modernizing, they replaced all the old wood, redolent of rum and cigar smoke, with plastic in pastel shades.

Ah, the shame of it all. The shades of Beny Moré, Maduro, Pepe Sánchez, Compay Segundo, Ibrahim Ferrer and Pepín Vaillant should drink to it. With his *ranchero* hat eternally on his head, El Tiburón sometimes runs into Eliades Ochoa there, the other Cuban who always has a Stetson on his head, and the two musicians embrace each other and sigh about the trashy *desastro*.

No es facil . . .

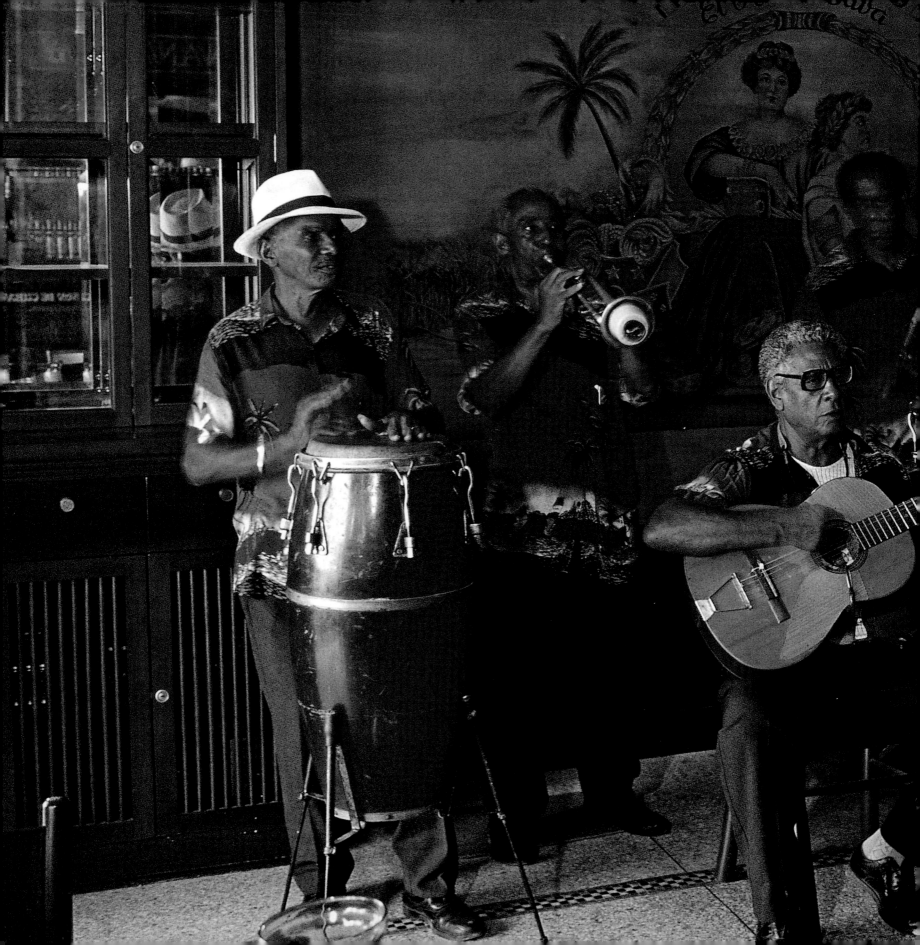

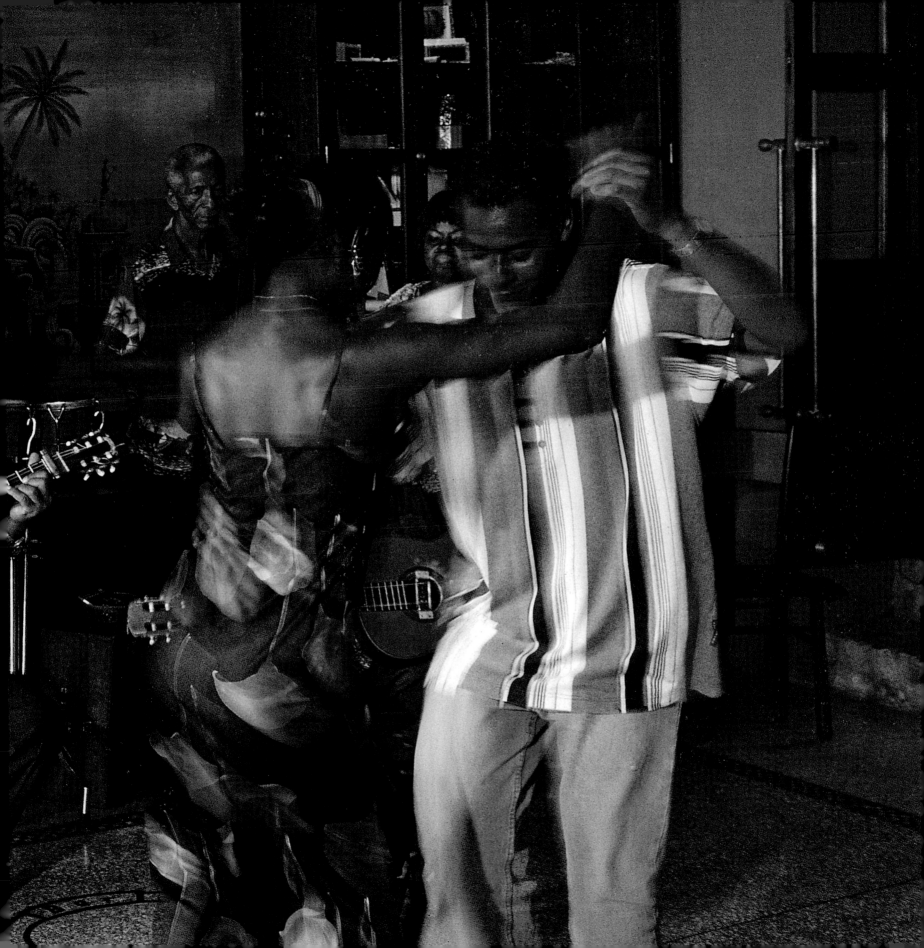

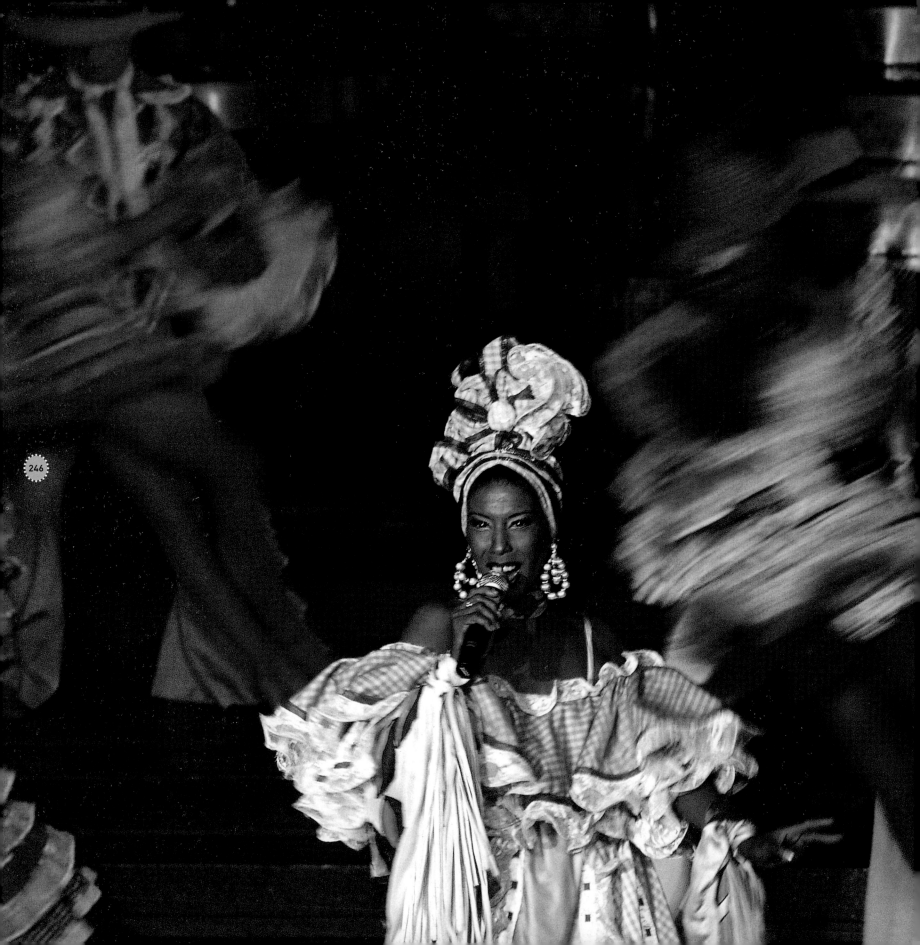

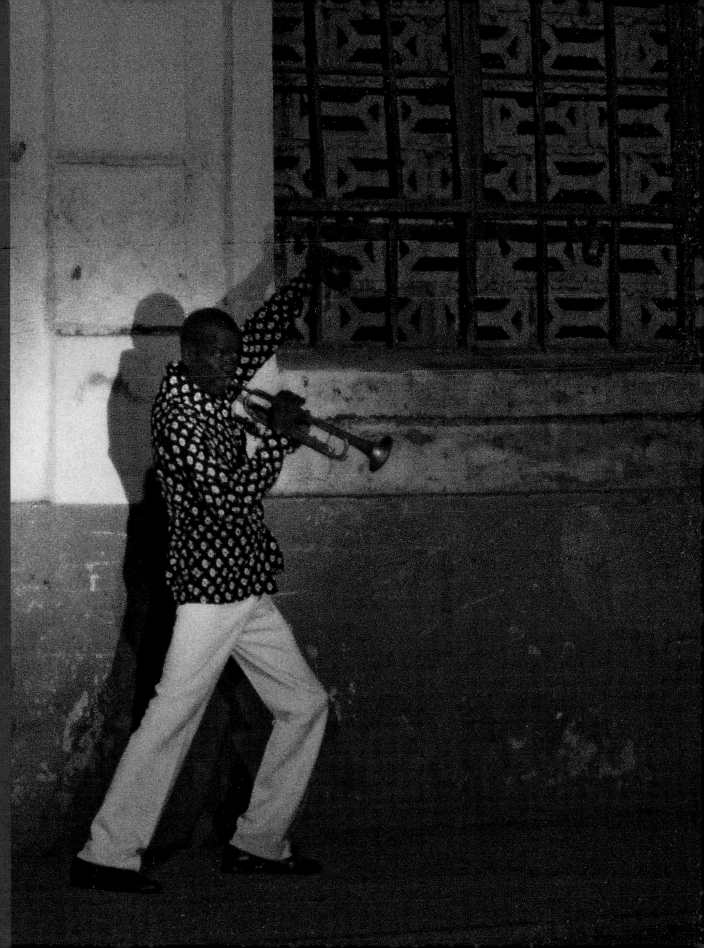

Is it possible to land
in Havana without
hearing a *guaracha*
and admiring a few salsa
steps, all washed down by a
cinco años at the *Museo del
Ron* in the harbor? The reply
does not take long to come.
¡A la batalla! as Manolín, the
Medico de la Salsa, yelled
before he left Cuba for Miami.
What medicine this is, for
disturbed spirits and end-of-
month anguish, a fiesta in this
singing, dancing island.

PREVIOUS SPREAD
A salsa number in the Havana Club Bar.
LEFT
Fireworks, music, and dancing the salsa
at El Parisián, the famous cabaret in the
Hôtel Nacional.
RIGHT
The late Pepin Vaillant, who enchanted
the world with his trumpet at the mythic
Tropicana in Havana and at the Casino de
Paris, in Pigalle.

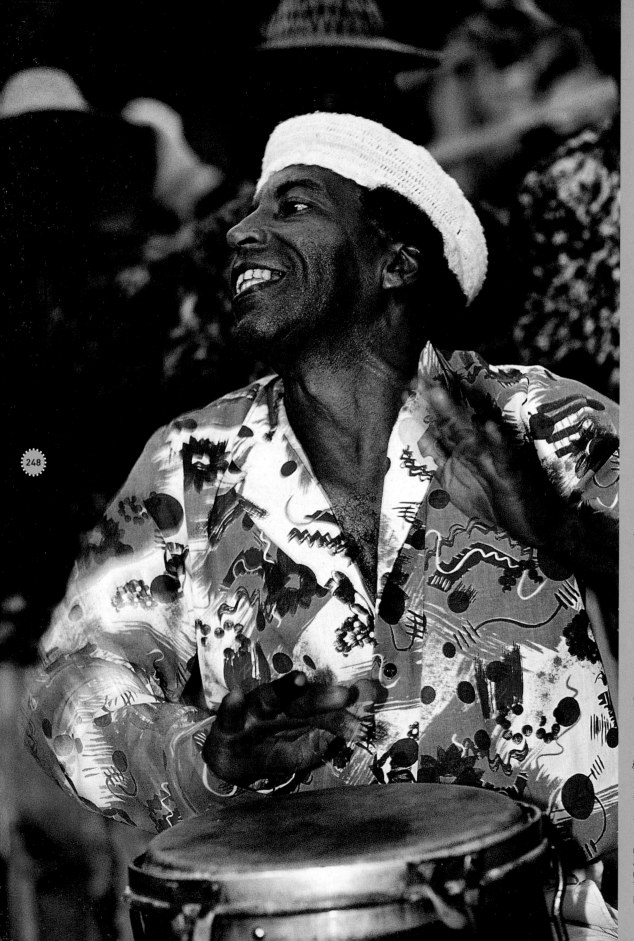

248

Bongocero, beat the skin with your hands of flesh and metal. Call on Changó, Yemayá, Obatala and all your saints to enter into your veins and feed your fevered fingers. This blood, which comes from the *orishas*, your godparents who never abandoned you or your ancestors when they were painfully torn from the shores of Africa—this blood, let your heart pump it in powerful jets down to your drum. The adrenaline in the music draws in the spectators, and when the feet of the *guaracheros* draw their patterns on the floor, you will have passed through to eternity. *¡Asi es!*

LEFT
A conga player at a Santiago Carnival.
RIGHT
The last touches before the carnival parade.

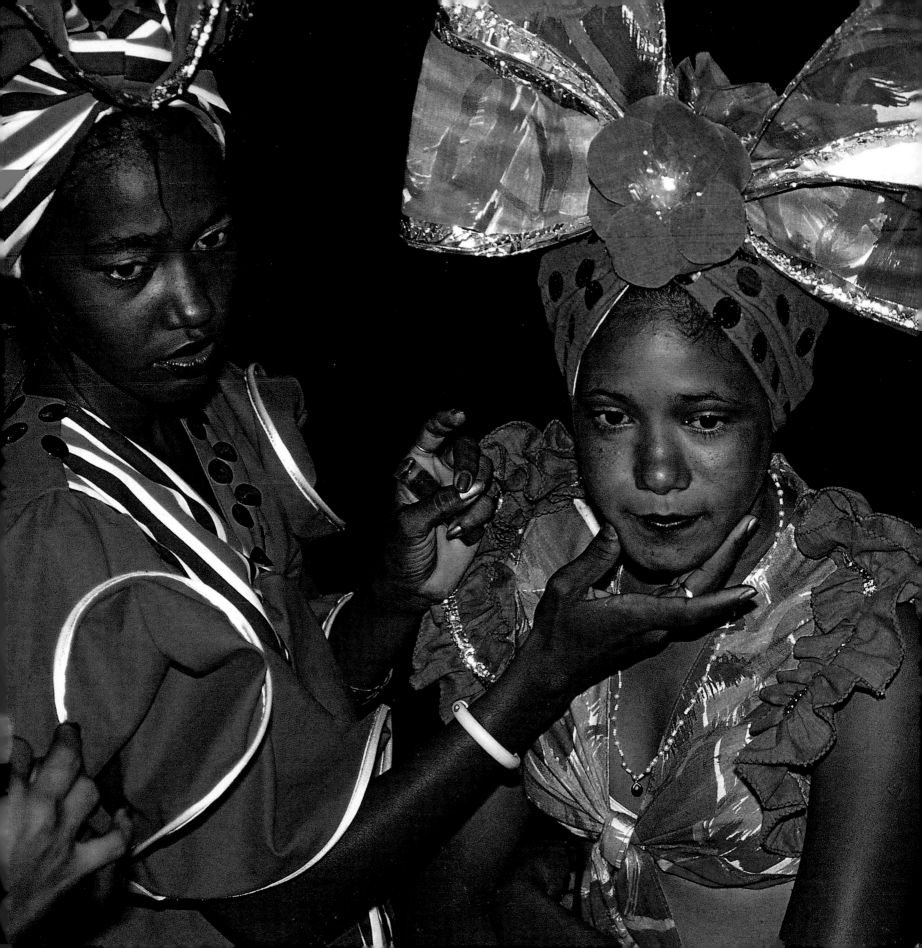

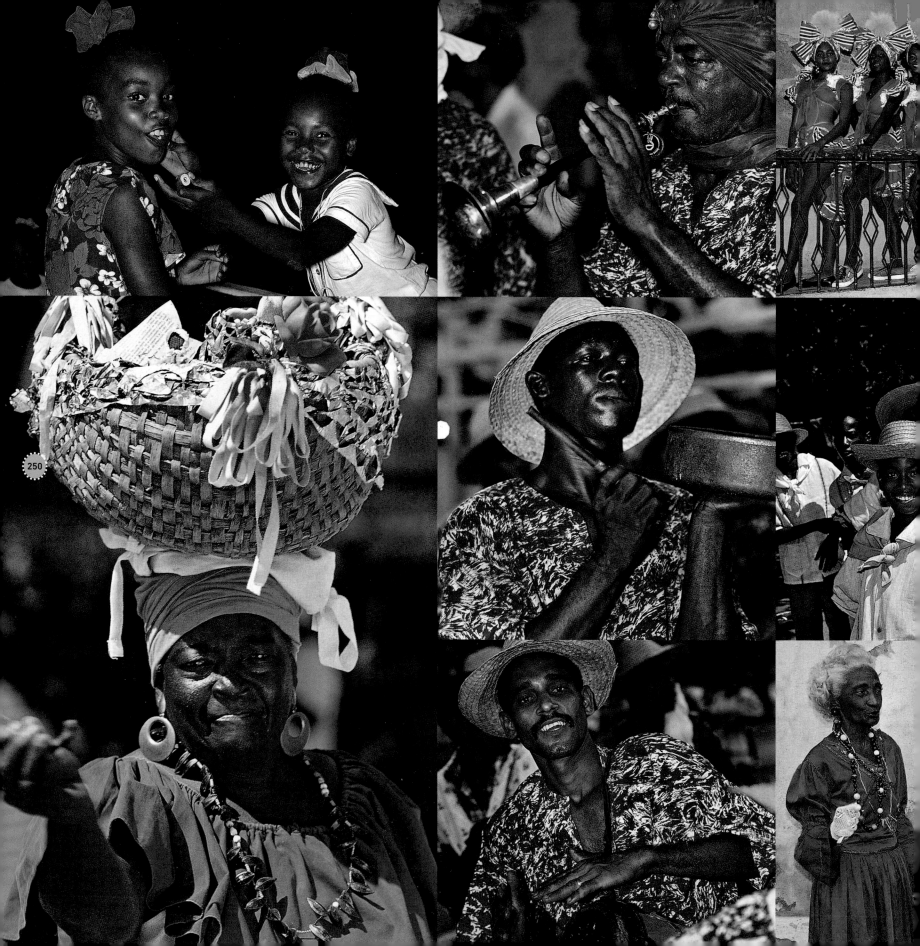

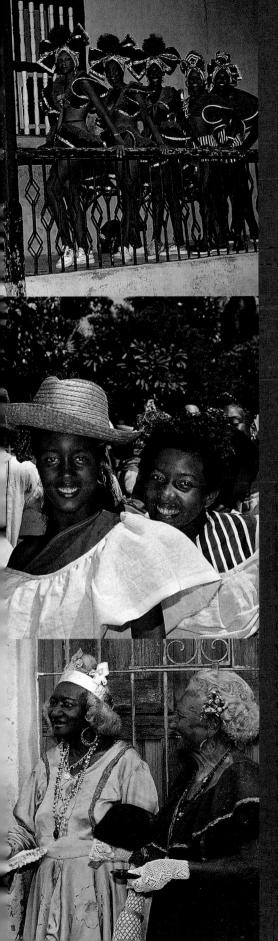

The Tibetan rag-dung (or Chinese brass trumpet) is a cousin of the *yana* from the Maghreb. Its strident tones incite the carnival dancers to join in the parade of the *comparsas*, especially in Oriente. Thus the signal is given for a week of unbridled joy in the streets of Santiago. In the dark night, to the play of multicolored cotton fabric, appears the maddening beauty of countless Venuses swelling with provocative sensuality. Watch your blood pressure. Unusually violent heart attacks are frequent here.

Left
Carnival scenes, Santiago.

Right
An *estrella* dancer on the catwalk at the Tropicana, Santiago Carnival.

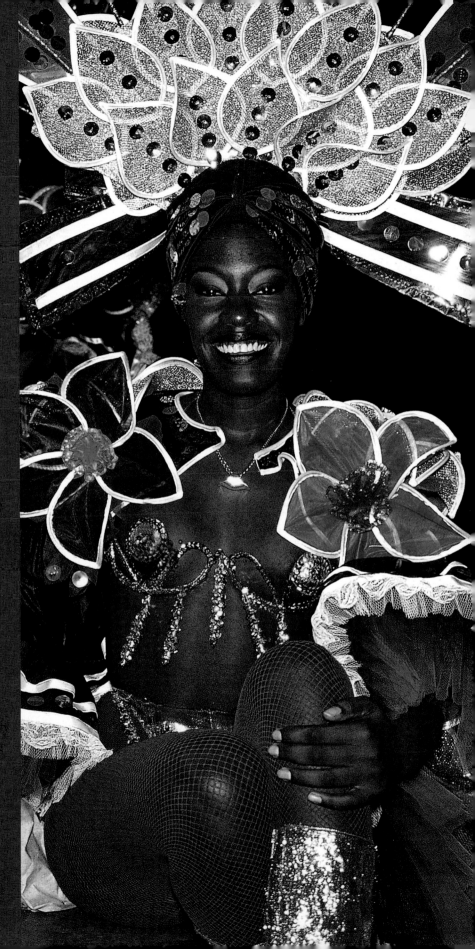

"I am a showman
A lame devil
Don't ask more of me
This is what I want
To celebrate
Chuas . . . chuas . . . chuas."

—Chorus of a Santiago Carnival song

RIGHT
Carnival masquerade, Los Hoyos,
Santiago.

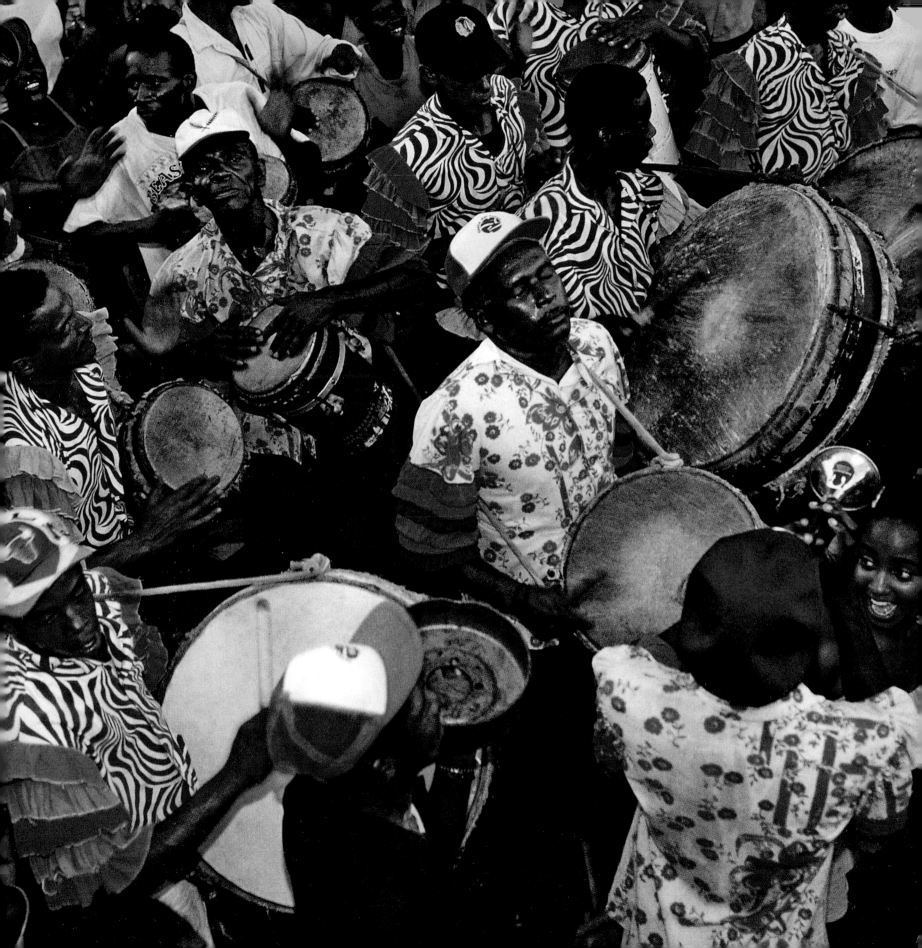

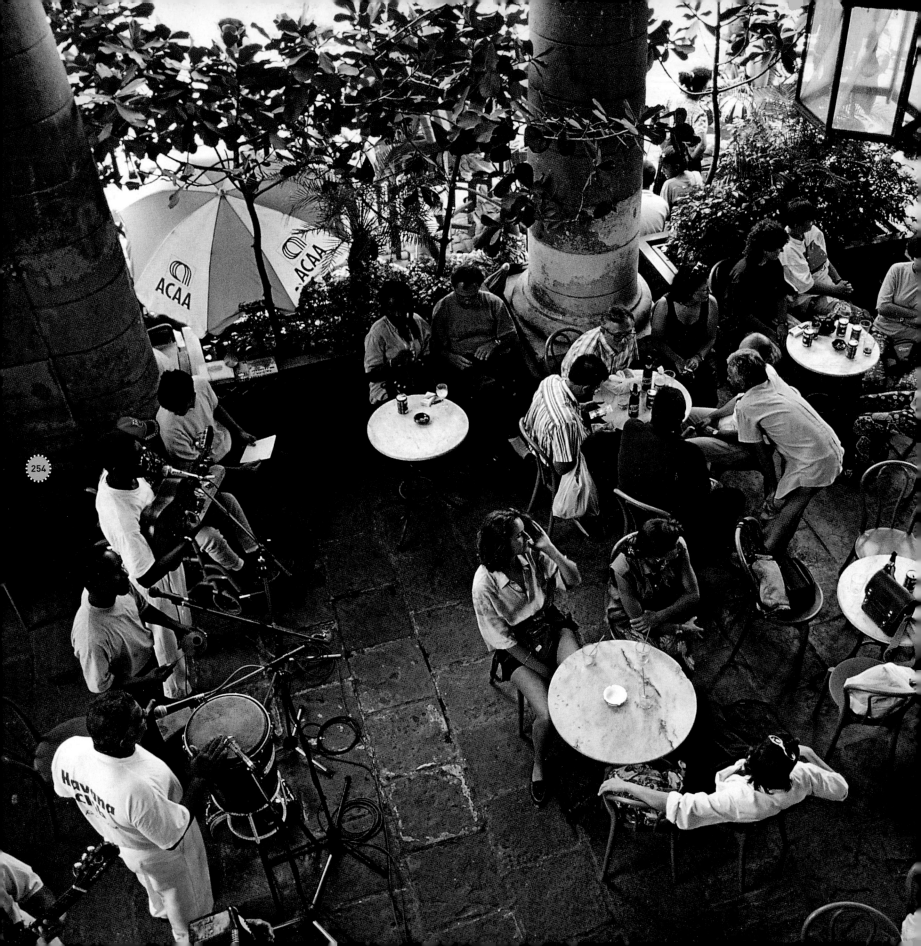

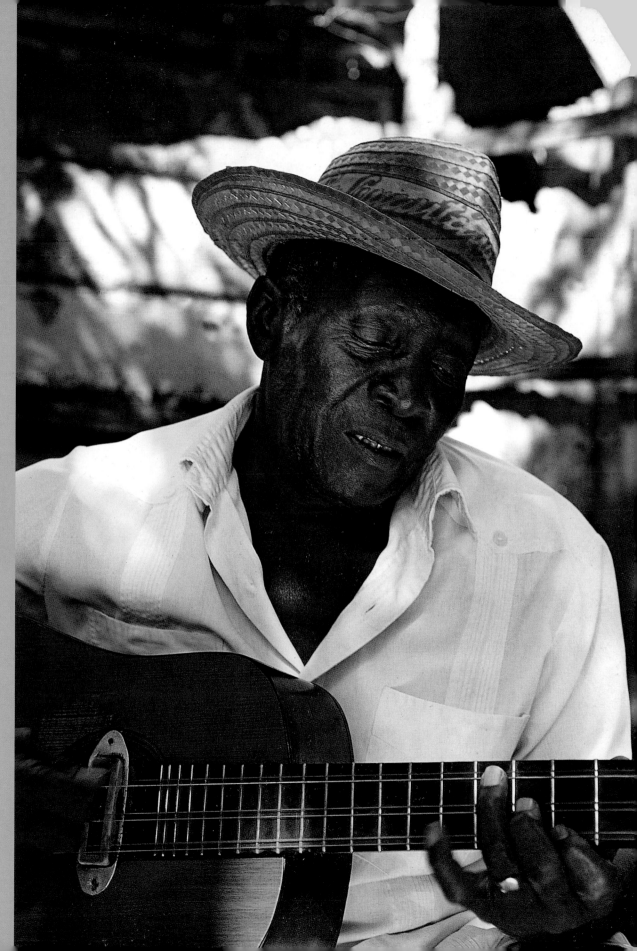

People come from all around the world to share the Cubans' sense of hospitality. It comes at a price, of course, but it is inventive and always musical. Around the tables of El Patio on the Plaza de la Catedral in Havana, you can hear people speaking English, French, German or Italian. First of all, they'll have knocked back a *mojito* or two at La Bodeguita del Medio right by the Calle Empedrado, no doubt reflecting that the bar stools on which they're sitting have also been sat on, once upon a time, by Brigitte Bardot and Sophia Loren, and of course the pioneer, Ernest Hemingway.

LWEFT
El Patio, Plaza de la Catedral, Havana.
RIGHT
A *trovador*, Guantánamo.

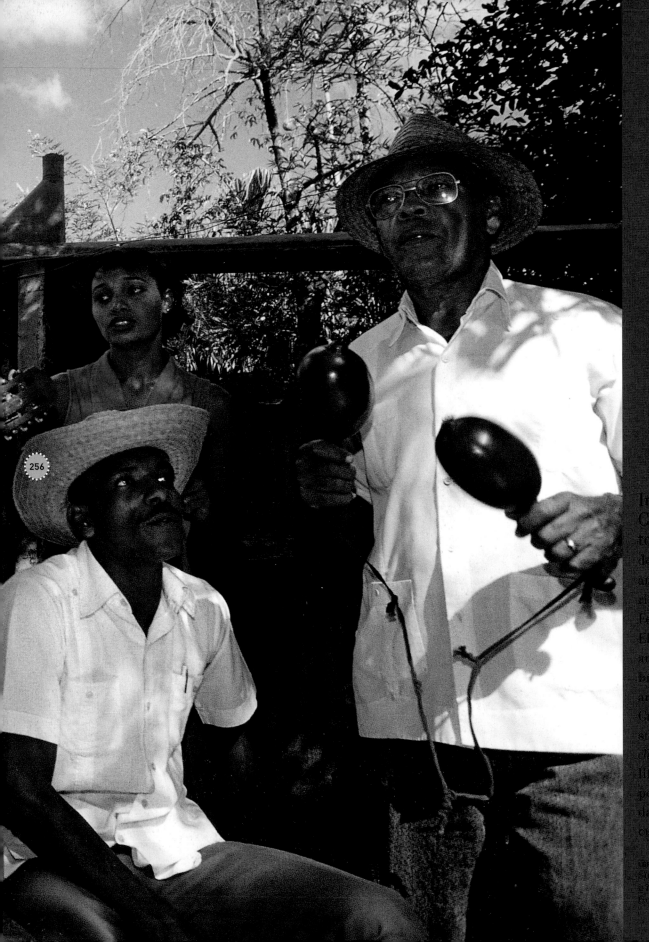

256

It has taken ages for Cuba's singing stars to emerge finally from decades of painful oblivion and enjoy the glory that is rightfully theirs. Yet Ibrahim Ferrer, Compay Segundo, Eliades Ochoa, Maduro, Gerbe and many others have musical brothers and cousins who sing and enchant people both in Cuba and on the international stage. At Guantánamo, *changüí* musicians bring back life into this dance, which is performed in farmyards by dancers who are also cane cutters. *¡Auténtico, compay!*

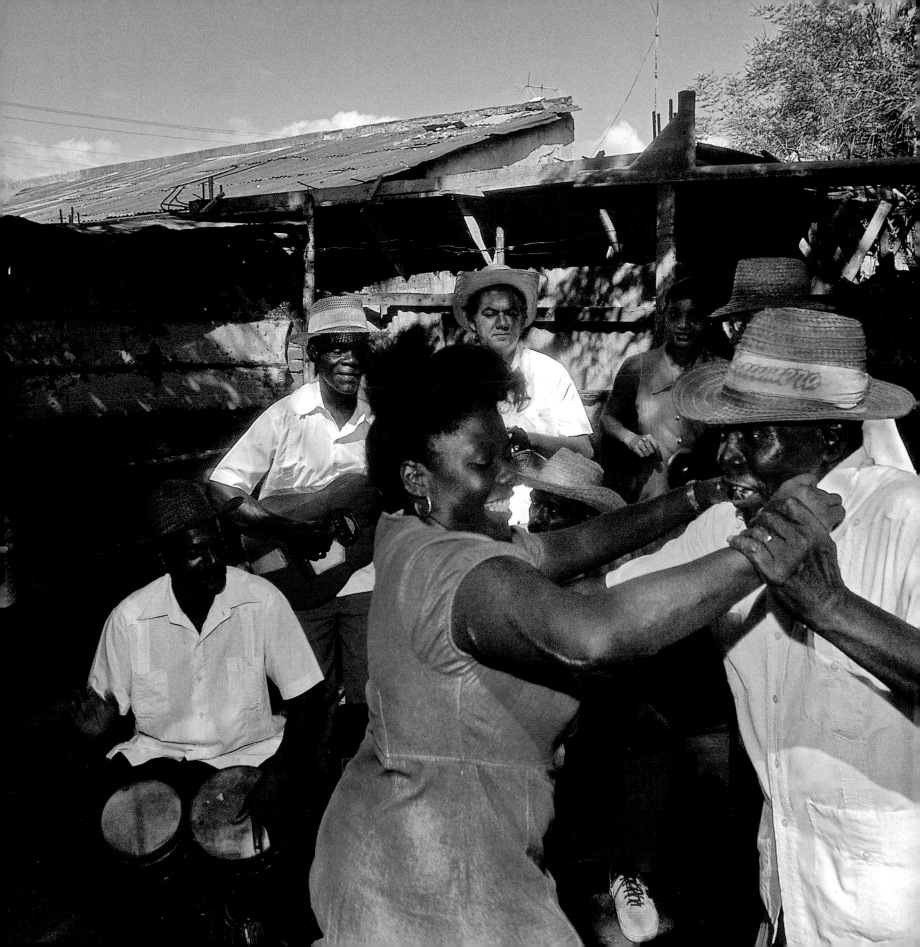

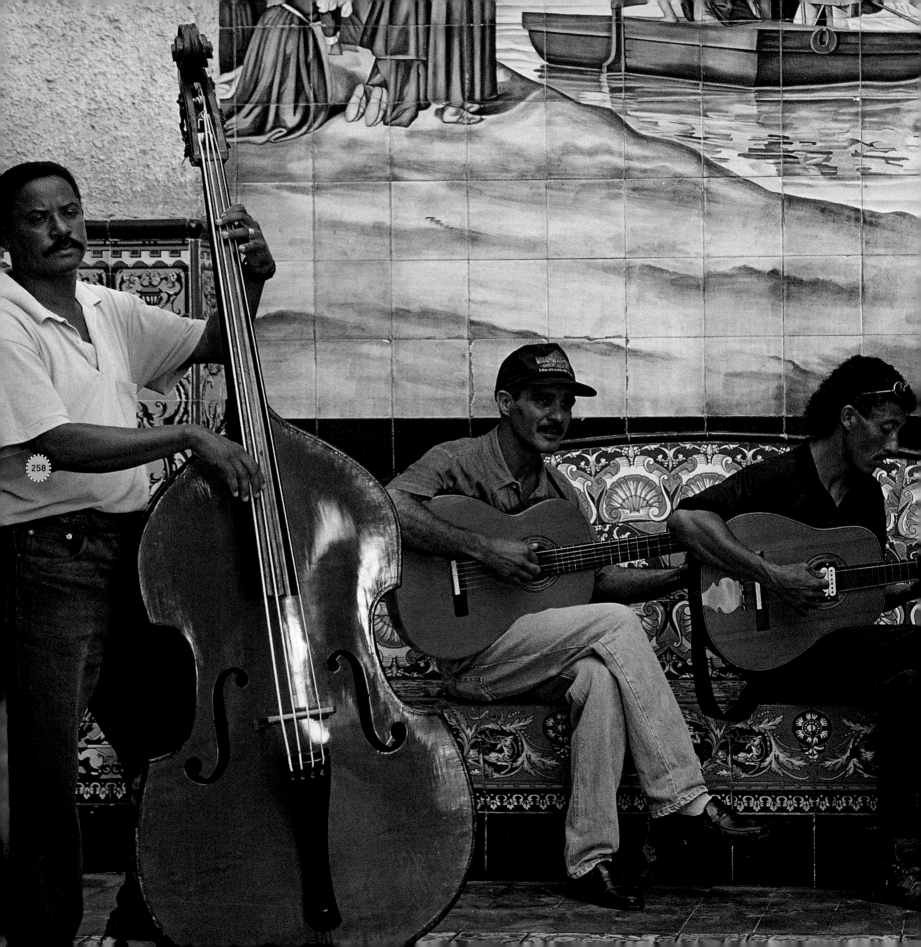

Under the benevolent ceramic gaze of Christopher Columbus landing at Nipe Bay, guitarists from Manzanillo's *casa de cultura* sing of the good fortune of living in a town dedicated to music and recognized as the unquestioned cradle of the *son*. On Sunday, they will be dancing on the plaza where the *glorieta* stands, and where Lino Borbolla will be twisting the handles on his giant organ to make the *manzanilleros* dance to "Chattanooga," "La vie en Rose," and "Chan Chan." Manzanillo is also the birthplace of Carlos Puebla, the composer of *Hasta Siempre, Comandante*, the song of Che Guevara.

LEFT
Rehearsing for the evening concert at the *casa de cultura*, Santeto Arsis de Manzanillo.
RIGHT
Postcard from the 1940s.

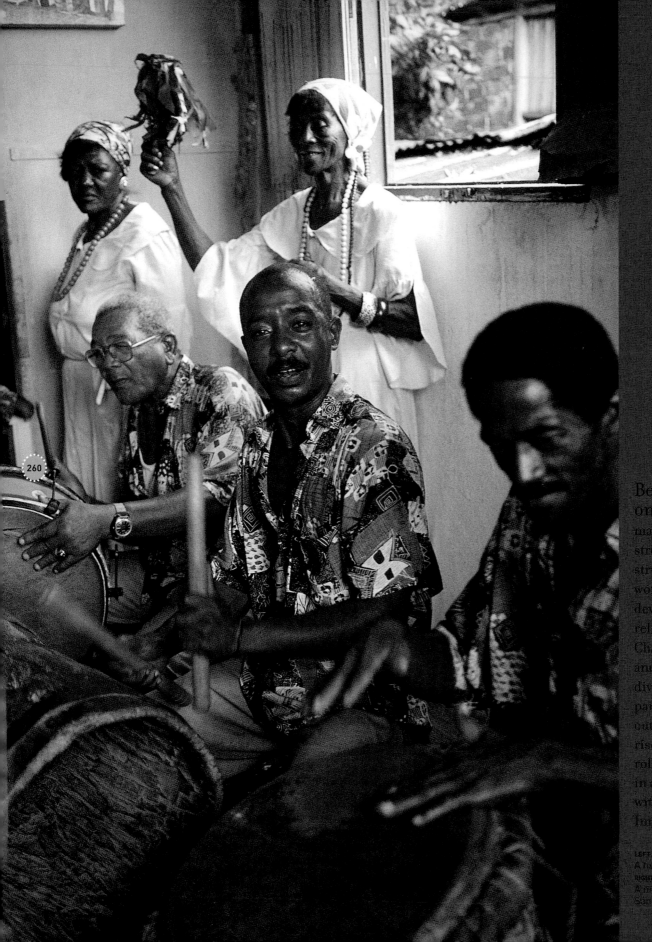

Beat your drums, call on the *orishas*, and may their spirit give you the strength to get through the struggles of life. These are the words of the *toque de santo* that devotees of Cuba's syncretic religion use to call upon Changó, San Lázaro, Ochun and the other venerated divinities in the national pantheon. As the drums beat out their rhythm, the tension rises. Soon the *santeros* will be rolling about on the ground in a trance and communing with their respective saints. Impressive. *¡Que viva Changó!*

LEFT.
A *tumba francesa*, Guantánamo.
RIGHT.
A musical group at the Casa de la Trova, Santiago.

260

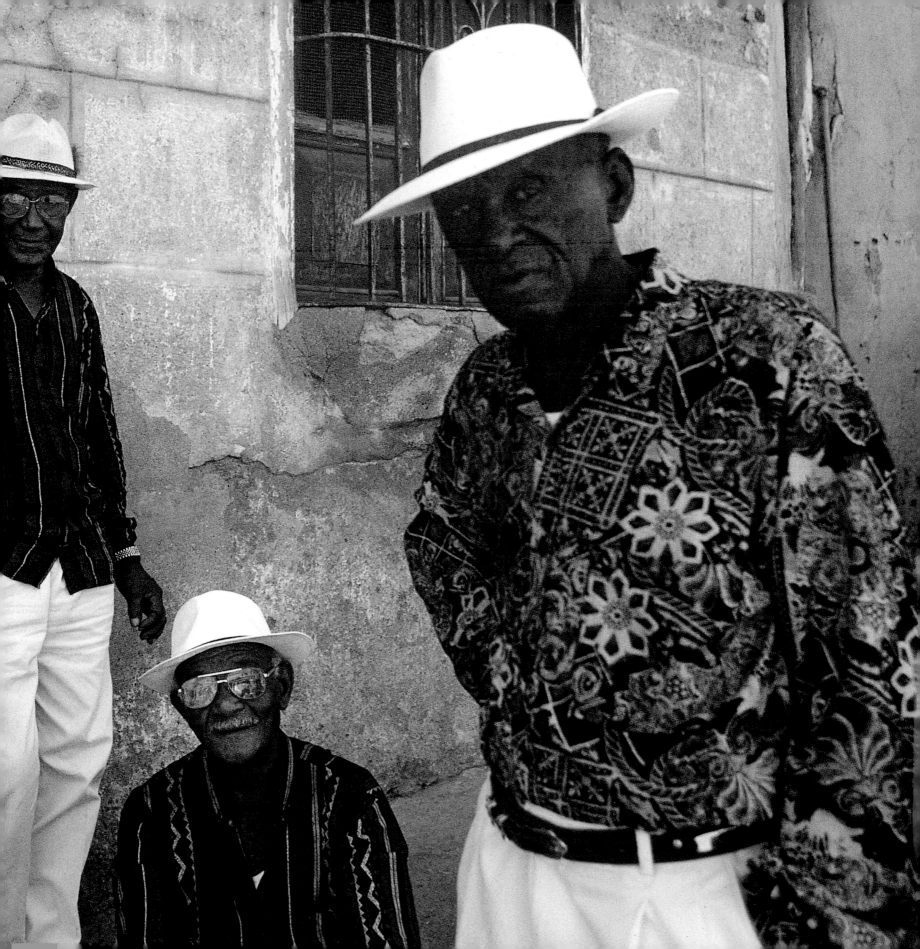

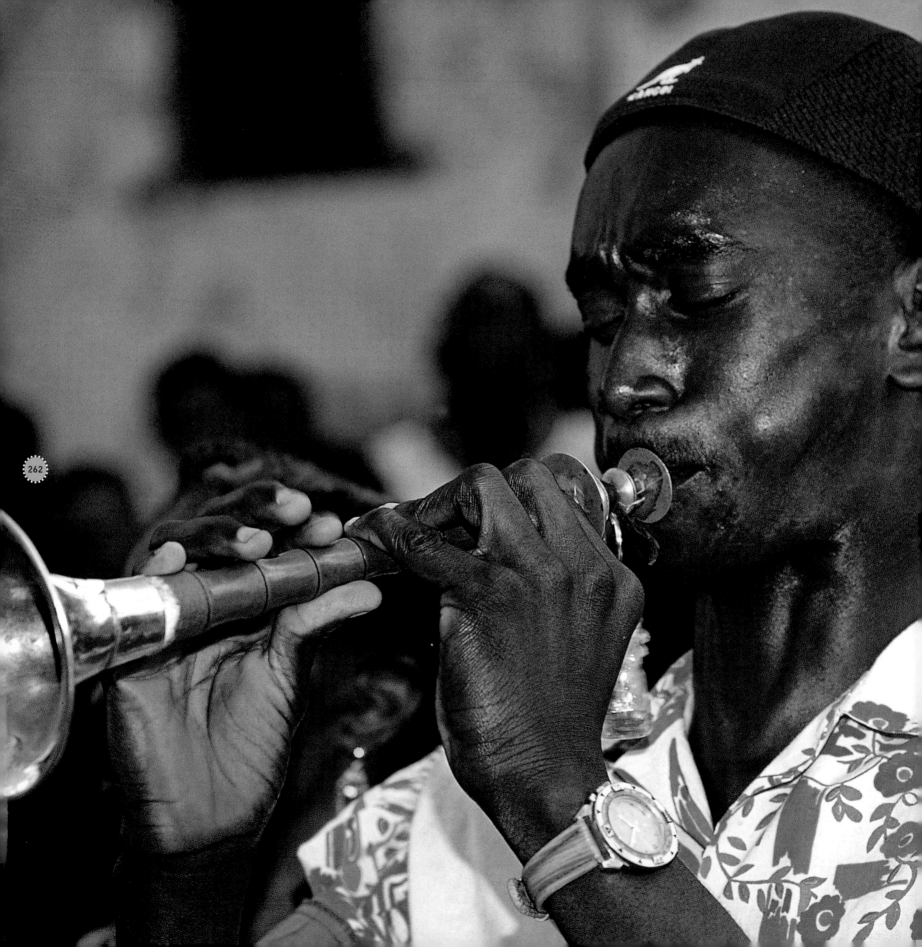

"Bravo for the little fanfare,
For the good little people
Who have played their little rumba
To perfection without desks or sheet music
In the district of Carmes."

—Miguel Martín Farto,
Las Parrandas de Remedianas

The noise of the drums and bongos manages to mask even the thunderous racket of engines on Cuba's streets. More than the guitar, this instrument is the symbol of music here. When there is no drum, there is always the *cajon*, a drawer that keeps time with the beating of the musicians' hearts. These rhythms seem to invade the paving stones in the towns and convince the customers they need to receive the sacrament with their heads, their hands and their feet. *Acha!*

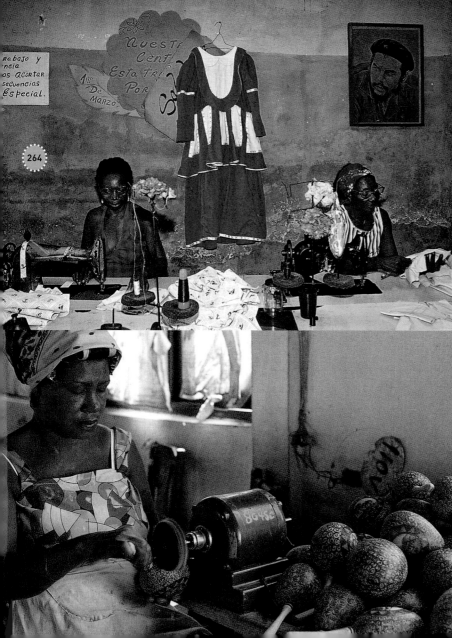

264

LEFT
In a guitar factory, Havana.
Making carnival costumes, Santiago.
A maracas workshop, near Baracoa.
RIGHT
The Plaza Mayor, Trinidad.
Lino Borbolla and his orchestra in a street in Manzanillo.
A barrel organ, Manzanillo.
Taking turns singing, Havana Club.
Edcardito in front of the Casa de la Trova, Manzanillo, since demolished.
An improvised rooftop concert, Santiago.
VINTAGE PHOTOGRAPHS
LEFT A music stand on the Malecón, Havana, c. 1900.
RIGHT The promenade in the Parque de Batabanó, Havana, c. 1900.
PAGE 266 Musicians at the Hotel Nacional.

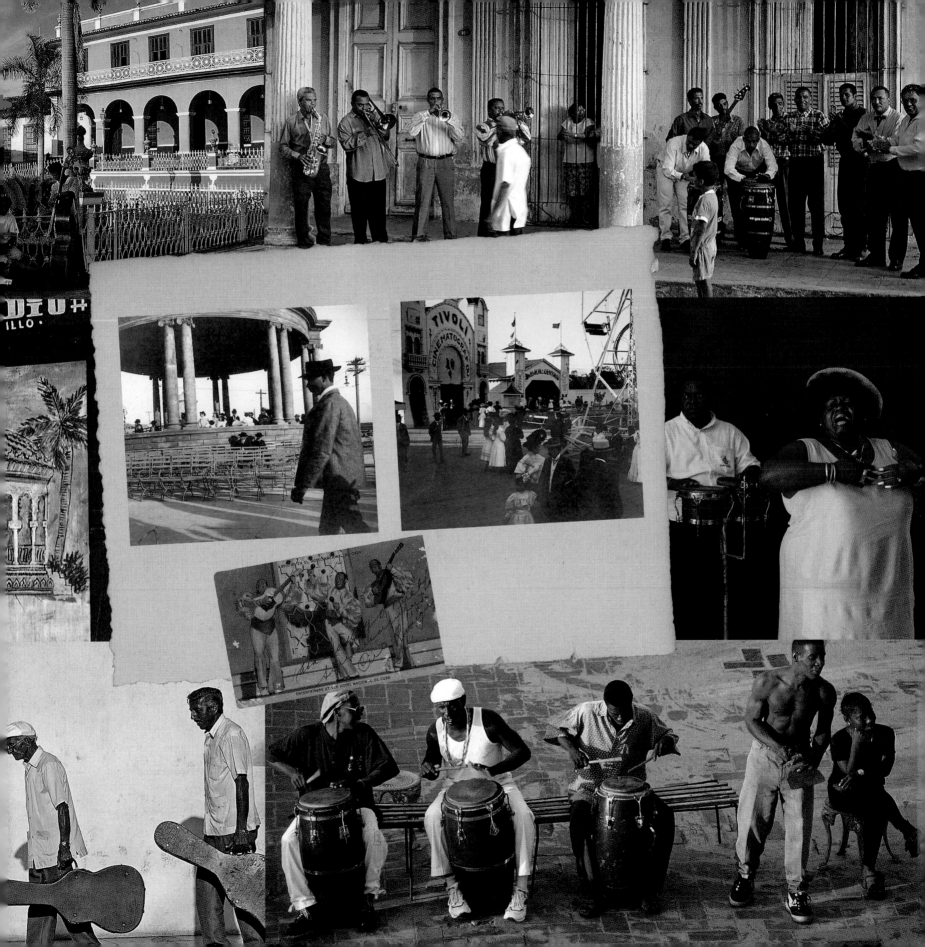

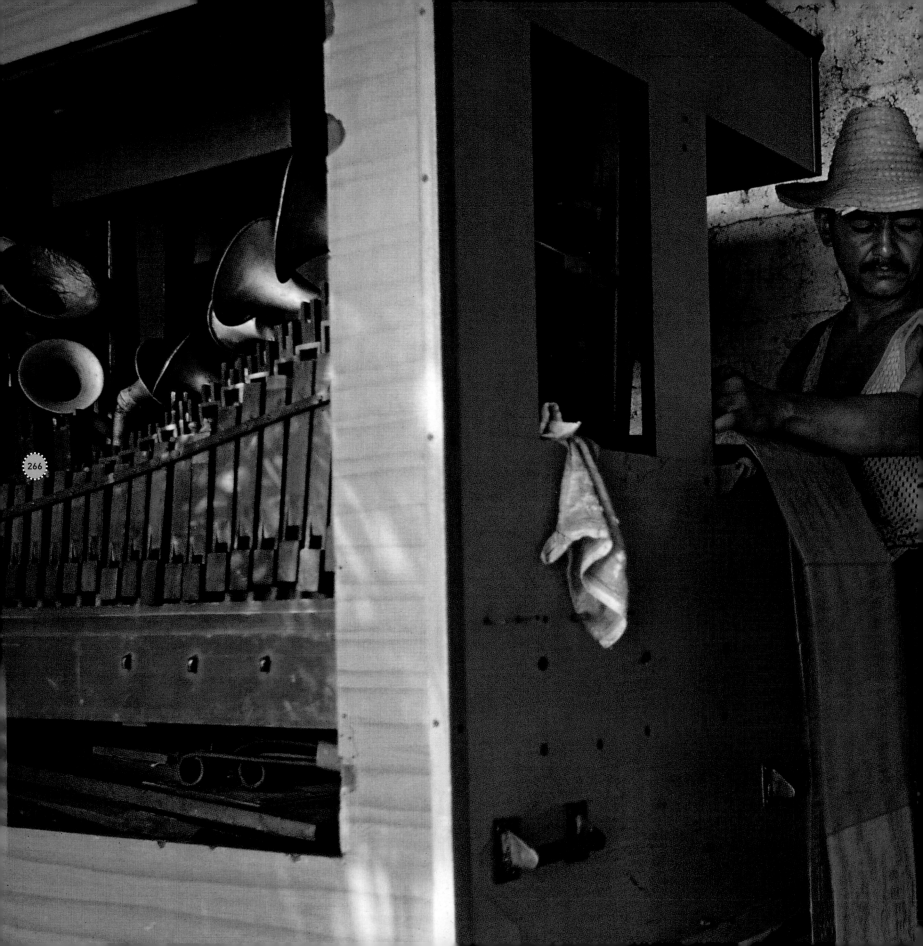

Manzanillo organist Lino Borbolla's musical box is worth a fortune. By some miracle, it has managed to escape its owner's despair, which at times reached the point of setting fire to the whole thing when he needed to replace missing punch cards and special wooden parts . . . in short, everything that makes an instrument from another age not just valuable but also fascinating. Instead, Lino restored the organ—there are only three more of the same kind in the country—and with it gets the *manzanilleros* dancing until they cannot take any more Hatuey or nostalgia.

LEFT
Organ, Bartolomé Masó.
RIGHT
Lino Borbolla tuning the organ in a Manzanillo church.
FOLLOWING SPREAD
The Casa de la Trova, Santiago.

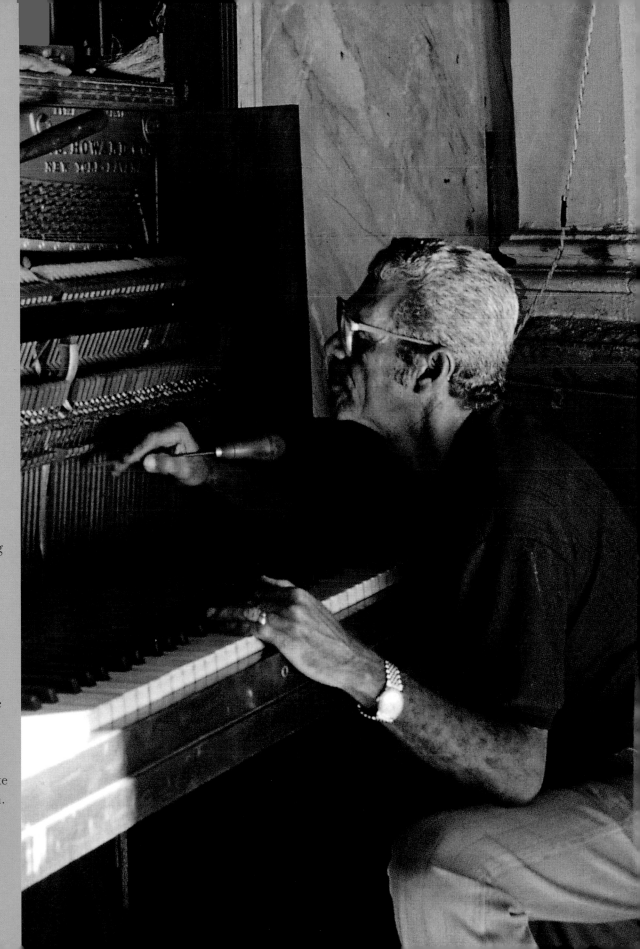

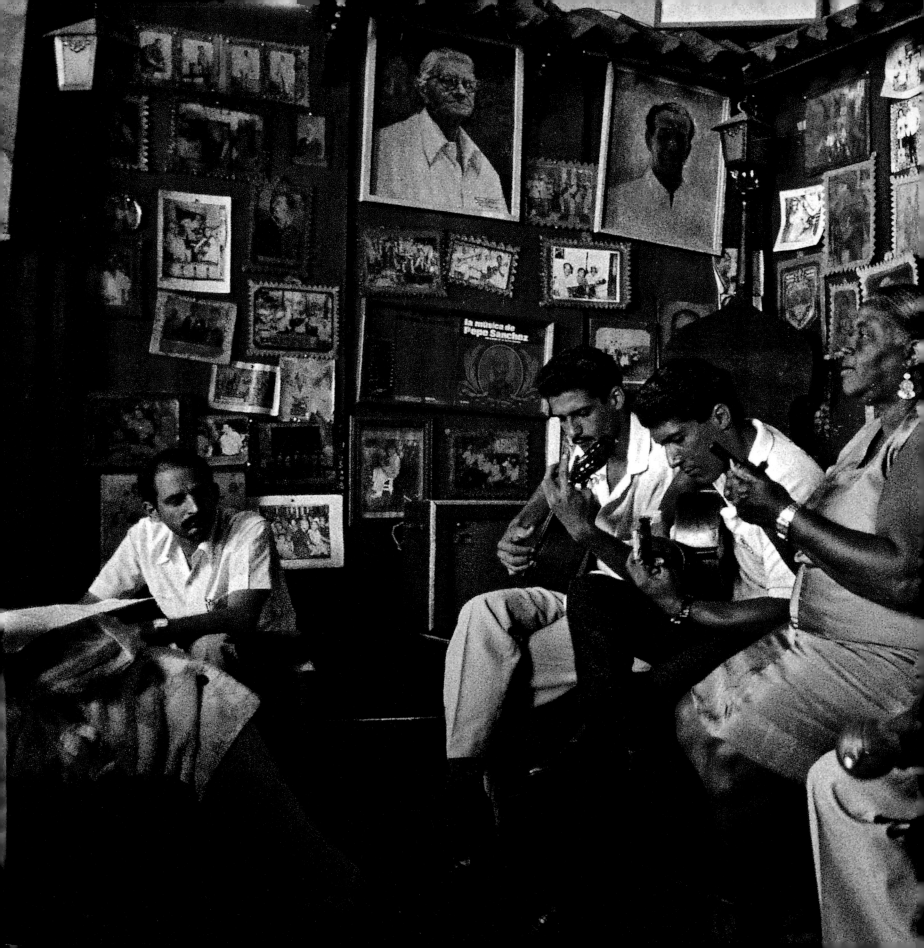

Acknowledgments

In the time that they have come to know and love Cuba, Pierre Hausherr and François Missen have made countless friends whom they wish to associate with this book. Keeping a low profile, steering well clear of local *apparatchiks*, they have truly had their enthusiasm for this unique country enriched. They especially revere Perkunas Liutkus, "Mr. Cuba" in Europe and further afield, of Havanatour, who had the chutzpah to bring attention to the country during difficult times. And the authors wish to say *¡Hola!* to Lino and Robertico of Manzanillo, Carlos of La Troya, Juan Antonio Picasso and Luis Adrián Betancourt of Havana, Candidita of Camagüey, El Cacique del Guirito of Baracoa, Arelys of Santiago, the *changüi* musicians of Guantánamo, Pepín Vaillant, who should be playing the trumpet with Compay Segundo and Ibrahim Ferrer in the San Pedro Orchestra somewhere in paradise, not to forget Eduardito and his *compadres* from Manzanillo. And they have promised to celebrate Rafael and Carmen's diamond wedding anniversary with them on the beach at Duaba, ten minutes from Baracoa. And thanks once again to our friend Noel Adrian, and to Jean-Marc Ville and Gretchen, Macho de Casilda, the unforgettable Macholo from Trinidad, and Raul, our maître d'hôtel in the Vedado.
And hats off to the folks in the Cuban Ministry of Tourism and its Paris office.

References

Page 29 José Martí, *Moncada*, Edición Homenaje al Vigésimo aniversario del 26 de Julio de 1953. Havana: Editorial de Ciencias Sociales del Instituto Cubano del Libro.

Page 43 Wendy Guerra, *Tout le Monde S'en Va*. Paris: Stock, 2008. La Cosmopolite.

Page 54 Nicolás Guillén, "Comme un Long Crocodile Vert" in *Le Chant de Cuba*. Paris: Le Temps des Cerises, 2002.

Page 66 Hermann Bellinghausen, text published in *Ojarasca Ojarasca*, August 1993.

Page 83 Manuel Moreno Fraginals, "Diario de La Havana, el Lunes 25 de marzo 1835," *El Ingenio, vol. 2*. Havana: Editorial de Ciencias Sociales.

Page 97 José Martí, *La Edad de Oro*. Publicación mensual de recreo instrucción dedicada a los niños de América, ed. A Dacosta. New York: Gomez.

Page 134 Karla Suarez and Francesco Gattoni, Cuba, *Les Chemins du Hasard*. Manosque: Le Bec en l'air, 2007.

Page 155 Cleva Solis, *Los Sabios Días*. Havana: Ediciones Unión, 1984.

Page 167 Ernest Hemingway, "Marlin Off the Morra: A Cuban Letter," in *Esquire*, Autumn 1933.

Page 174 Miguel Barnet, *Biografía de un Cimarrón*. Havana: Editorial Letras Cubanas, 1966.

Page 196 Albert Serret, *El Árbol que Cantaba Cuentos Africanos*. Havana: Ediciones Ahril.

Page 207 Adargelio Garrido, Christophe Loviny and Jean-Yves Martinez. *Le Havane: Portraits Hechos a Manos*. Paris: Éditions Plume, 1998.

Page 221 Ildefonso Estrada y Zenea, *El Quitrín*. Havana: Edición Letras Cubanas. 1980.

Page 236 Nicolás Guillén, *Tengo*. Havana: Universidad de Las Villas, 1964.

Page 252 Chorus of a Santiago carnival song.

Page 263 Miguel Martín Farto, *Las Parrandas de Remedianas*. Havana: Fundación Fernando Ortiz, 1982.

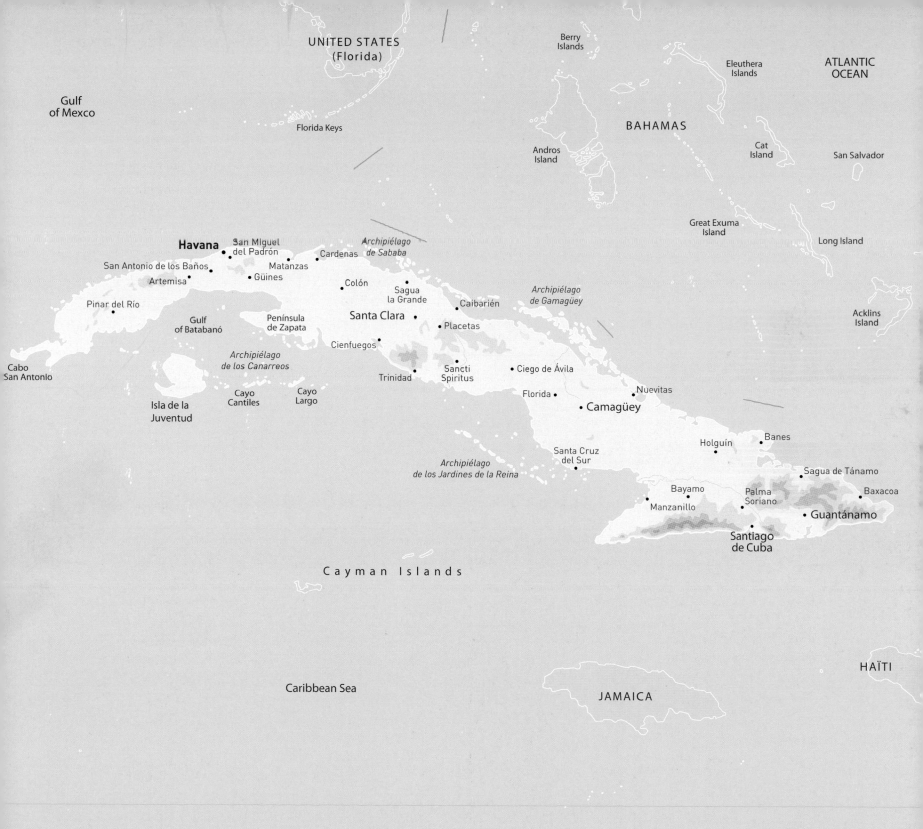

UNITED STATES
(Florida)

Berry
Islands

Eleuthera
Islands

ATLANTIC
OCEAN

Gulf
of Mexco

BAHAMAS

Florida Keys

Andros
Island

Cat
Island

San Salvador

Great Exuma
Island

Long Island

Havana
San Miguel
del Padrón

Cardenas

*Archipiélago
de Sababa*

San Antonio de los Baños

Matanzas

Artemisa
Güines

Colón

Sagua
la Grande

*Archipiélago
de Gamagüey*

Caibarién

Acklins
Island

Pinar del Río

Gulf
of Batabanó

Península
de Zapata

Santa Clara

Placetas

*Archipiélago
de los Canarreos*

Cienfuegos

Sancti
Spiritus

Ciego de Ávila

Trinidad

Cabo
San Antonio

Cayo
Cantiles

Cayo
Largo

Isla de la
Juventud

Florida

Nuevitas

Camagüey

*Archipiélago
de los Jardines de la Reina*

Santa Cruz
del Sur

Holguín

Banes

Sagua de Tánamo

Bayamo

Palma
Soriano

Baxacoa

Manzanillo

Guantánamo

Santiago
de Cuba

Cayman Islands

HAÏTI

Caribbean Sea

JAMAICA

0 50 200 km

Graphic illustrations on the two-page spreads at the beginning of each of the chapters.
During the colonial period, gracious Creole ladies and the crowned heads of Europe smoked unashamedly, even though they were nervous about losing the pure white of the skin on their fingers because they were touching tobacco. To meet this concern, a paper band was wrapped around the cigar to protect these elegant hands. Over time these bands acquired decorative elements and motifs symbolizing the quality of the tobacco and giving the manufacturer's name and the region of origin. Nowadays, cigar bands are much sought after by collectors.

PROJECT EDITOR Odile Perrard
EDITORIAL CONTINUITY Cécile Beaucourt
ART DIRECTOR Nancy Dorking
GRAPHIC DESIGN AND PRODUCTION Anne-Marie Bourgeois
GRAPHIC DESIGN AND PRODUCTION ASSISTANT Ilanit Illouz
MAPS Cyrille Suss
COPY EDITING Dominique Montembault
PHOTOTHÈQUE HACHETTE Sylvie Gabriel

PHOTOGRAVURE (INTERNAL) Reproscan
PHOTOGRAVURE (COVER) APS Chromostyle
PRINTED IN China
DEPOSIT IN NATIONAL LIBRARY March 2009

Copyright © 2009 Editions du Chêne-Hachette Livre

Photographic credits
All the photographs in this book, except as stated below, are by Pierre Hausherr.

© Photothèque Hachette
P. 118; P. 120 BOTTOM; P. 147 RIGHT ON PARCHMENT; P. 178 LEFT AND RIGHT ON PARCHMENT; P. 198 LEFT ON PARCHMENT.

© Vérascopes Richard – Photothèque Hachette
D REINBURG: P. 21 LEFT AND RIGHT ON PARCHMENT; P. 53 LEFT AND RIGHT ON PARCHMENT; P. 76 LEFT AND RIGHT ON PARCHMENT; P. 101 LEFT AND RIGHT ON PARCHMENT; P. 132 RIGHT ON PARCHMENT; P. 147 LEFT ON PARCHMENT; P. 182; P. 224 UPPER LEFT; P. 224 LEFT AND RIGHT ON PARCHMENT; P. 265 LEFT AND RIGHT ON PARCHMENT.

© François Missen Collection
P. 76 CENTER; P.168; P. 178 CENTER; P. 198 RIGHT ON PARCHMENT; P. 234; P. 259; P. 265 CENTER.

© Musée du Rhum / Havana Club
P. 121 UPPER LEFT; P. 121 UPPER RIGHT; P. 132 LEFT ON PARCHMENT.

© Istockphotos
DANIEL KRYLOV: P. 53 CENTER RIGHT.
JUDY WATT: P. 101 CENTER.
MARKUS LIEBSCHER: P. 106 UPPER LEFT.
SOPHIE LARIGOT: P. 106 CENTER LEFT.
JEREMY STERK: P. 106 LOWER LEFT.
BOB BALESTRI: P. 106 UPPER RIGHT.
MIKADX: P. 107 CENTER.

ILLUSTRATIONS ON OPENING PAGES OF CHAPTERS
Georges Boudic

Black Dog & Leventhal Publishers
Hachette Book Group
1290 Avenue of the Americas
New York, NY 10104

www.blackdogandleventhal.com

Printed in China

First Edition: October 2010
10 9 8 7 6 5 4 3 2 1

Black Dog & Leventhal Publishers is an imprint of Hachette Books, a division of Hachette Book Group.

The Black Dog & Leventhal Publishers name and logo are trademarks of Hachette Book Group, Inc.

ISBN 978-1-57912-854-8

Library of Congress Cataloging-in-Publication Data on file.